THEORIES OF ART

MOSHE BARASCH

THEORIES OF ART
From Plato to Winckelmann

NEW YORK UNIVERSITY PRESS
NEW YORK AND LONDON

Library of Congress Cataloging in Publication Data

Barasch, Moshe.
Theories of art.

Includes bibliographies and index.
1. Art—Philosophy. I. Title.
N70.B22 1985 701 84-19006
ISBN 0-8147-1060-3 (alk. paper)
ISBN 0-8147-1061-1 (pbk.)

Clothbound editions of New York University Press books are Smyth-sewn
and printed on permanent and durable acid-free paper.

Designed by Ken Venezio

p 10 9 8 7 6 5 4 3 2
c 10 9 8 7 6 5 4 3 2

For Berta

Contents

Introduction

In the following chapters I attempt to describe the major stages in the development of European art theory. Art theory is made up of different strands, often in complex interrelation, and constantly changing. Though the term is familiar, no comprehensive definition of the concept has yet been given, and I shall not undertake to propose one. More than in most other areas of historical study, the subject itself is in need of demarcation. The materials usually collected under the heading of "art theory" are so diffuse and of such varied nature that one sometimes wonders what it is that determines that they belong to one and the same subject. What, for instance, does a medieval workshop prescription for the grinding of color have in common with a seventeenth-century drawing recommended as a model for the depiction of joy? At first glance, they seem so disparate as to cast doubt on the very unity of our field of study.

As a scholarly concept, indicating a field of study or an area of literary sources, art theory is of modern origin. To be sure, its ancestry goes back to the Renaissance. In the fifteenth century, as is well known, some artists and humanist-scholars were already speaking of *scienza della pittura,* but there are significant differences between the Renaissance and the modern concepts. The *scienza della pittura* was focused on specific problems of painting (such as perspective and color). Not

only did it not deal with the specific problems of the other arts, such as sculpture, but it omitted many general aspects of image making and image reading that now seem part and parcel of art thoery.

Even in the minds of twentieth-century scholars the outlines and character of art theory are not always perfectly clear. One of the earliest discussions of the subject, Achille Pellizzari's *I Trattati attorno le arti figurativi* (Naples, 1915), employs *trattatistica* as equivalent to "art theory," thus referring to the external literary form rather than to the central problems of art theory. Schlosser's classic *Die Kunstliteratur* (Vienna, 1924, and updated Italian translations) includes art theory among other types of texts dealing with the visual arts (guidebooks, local histories, biographies, etc.) and calls the whole phenomenon "art literature." Schlosser made important contributions to the study of art theory, yet he saw the whole field largely as an area of "sources."

Interest in the development of art criticism has led to the study of art theories from a particular point of view. Thus, in Albert Dresdner's *Die Entstehung der Kunstkritik* (Munich, 1915), some art theories are discussed as sources of art criticism. This is also the case in the interesting work by Lionello Venturi, *The History of Art Criticism* (New York, 1936). Venturi is thoroughly familiar with the texts of art theory, but the questions that guide him refer to the contribution of these texts to the formation of canons of judgment, and whether one cannot see them as art criticism *avant la lettre*.

Histories of aesthetics have also taken notice of the special domain of art theory. To mention just one recent example: Wladislaw Tatarkiewicz, whose valuable *History of Aesthetics* has recently been translated into English (The Hague and Warsaw, 1970–1974), adduces quite a few passages from texts that belong to the core of art theory. From his comprehensive point of view Tatarkiewicz can afford to disregard the differences between these texts and those of philosophical aesthetics and the aesthetics of poetry or of music.

The difficulties of definition I have mentioned should not detain us too long. As we follow the course of reflection about the visual arts, particularly the notions originating in close contact with the work of art itself, we become aware of a domain that, though bordering on and partly overlapping other areas, never fully coincides with any of

them. In this book, while following the path of art theory in history, I shall only incidentally touch on questions of value or canons of criticism, and considerations of a broad aesthetic nature will also remain marginal. On the other hand, I shall frequently have to show that meditations on art range into matters pertaining to the sciences, technology, perception, and practice. From our history, art theory will emerge, I hope, as a field of study of unique—though not unified—character; at its center are problems that cannot be dealt with adequately by any other discipline. The production of paintings or statues and their appearance and function, it will appear, have rarely been taken for granted. In most periods they have caused wonder, have called for explanation, and have often led to the articulation of rules to direct the artist in his creative work. The comments containing such questions, explanations, and rules, usually emerging from a close contact with the emerging or completed work of art, make up the core of art theory.

It hardly needs stressing that the term "theory" should be used only with many qualifications. A student embarking on the investigation of art theory should not expect the systematic, comprehensive, and well-ordered presentation that is the usual connotation of any theory in the usual sense. The materials I shall present do not form a consistent doctrine. Yet what they lack in overall consistency they often compensate for by their vividness of testimony. Most of the texts on which this book is based are lively reflections of the attempts that artists made to understand their own work and to come to terms with what was required of them; they also show the efforts made by the public, those who look at works of art and use them to grasp, interpret, and direct the art of their own time (as well as the art of the past).

I now owe the reader some indication of the frontiers of the map I shall draw. I have imposed two major restrictions on my presentation of the history of art theory.

The first concerns the scope of the subject matter. This book deals with the theories of the image-producing arts, that is, primarily painting and sculpture; it does not include theories of architecture. It is a matter of historical knowledge—and will be amply borne out by the testimonies here adduced—that the artist who carved his work in

stone and his colleague who shaped an image by putting color on a panel or a wall were largely faced with similar problems. This is not to suggest that the similarities between painting and sculpture altogether overshadow the differences between them. Painters and sculptors have, of course, specific problems, which are unique to each medium; and these problems, distinguishing between the two arts, occupy an important place in their respective theories. Yet any historical study of the theories of painting and sculpture shows that in the thought of most periods they had a strong common basis: this basis was frequently described by the much-used, worn-out formula, "representation of nature." The enterprise of representing nature—that is, of depicting a piece of reality known from everyday (extra-artistic) experience in an artistic medium—is to a large extent the same in the two- and three-dimensional arts. The close relation between theoretical reflections on painting and on sculpture results from the similar tasks imposed on both.

Architectural functions are different. To be sure, some periods, especially those dominated by "the humanistic tradition," have tried to include architecture among the imitative arts. Architects, we sometimes read, imitate nature; individual architectural forms are derived from the patterns of the human body or of other organic forms. Such assertions, however, are metaphorical in character, and they mainly testify to the powerful impact of nature imagery on the thought and aesthetic concepts of such periods. The genuine problems of architectural reflection, one ventures the generalization, lie somewhere else; they are sufficiently removed from the problems posed by the imitation of nature as to constitute a realm of thought not easily merged with those of painting and sculpture.

My second restriction concerns time span. I shall attempt to trace the history of art theory from ancient Greece to the early eighteenth century. That I begin with ancient Greece will hardly need justification; like so many other branches of intellectual endeavor and artistic creation, art theory starts in Greece (though some even earlier attempts may be discovered.) But that I come to a stop in the early eighteenth century may require a word of explanation.

Until the eighteenth century, as will emerge from this book, art

theory may change in intellectual outlook and artistic aims, but it remains a whole in which the different attitudes and traditions are so intricately interwoven that they cannot be separated from each other. In a great historical process that became manifest in the eighteenth century, art theory broke up into different disciplines, which, to a considerable extent, developed independently. Beginning with Winckelmann, the study of the history of art came into its own; increasingly disregarding the desire to shape the art of the present (and the future), it eventually grew into a full-fledged academic discipline. At about the same time, a purely theoretical discussion of beauty, possibly connected with some thoughts on how it is perceived, became established as a field in its own right: totally divorced from actual art, and without any smell of the workshop, it became "aesthetics," a legitimate part of philosophy. Perhaps what is most important is that during the eighteenth century art criticism came of age. What used to be judgments on trends, artists, or individual works of art fully embedded in, and organically connected with, other parts of art theory became an intellectual activity far removed—in subject matter as well as in intellectual and emotional tone—from scholarly art history and from philosophical consideration of beauty in general. Diderot is the central witness to the early stages of this development. To sum up: traditional art theory broke up into its parts; it disintegrated during the eighteenth century; and rich, comprehensive, and many-sided concepts of painting and sculpture that crystallized in the period between Winckelmann and Diderot and our own time will have to be studied within conceptual frameworks altogether different from those appropriate for the art theory of a more distant past.

My experience in teaching art history has made me aware of how much we need a renewed acquaintance with art theory and its history. This book actually grew out of courses I have given over the years. In the book (as in my teaching) I did not aim at bibliographical completeness; nor did I try to list all the authors and artists who contributed to our subject. I wished to bring out the great lines of the historical developments and to present as clearly as possible the core problems of the different periods in the history of the subject. All quotations are

given in English, and I have kept the references to scholarly literature to a minimum.

In writing this book I incurred many debts. My late friend, Professor H. W. Janson, was a constant source of encouragement; he read the manuscript with his usual care and discrimination and gave me the benefit of detailed discussion and of his superb editing. A term as Senior Fellow of the Society for the Humanities of Cornell University provided ideal surroundings for the formulation of large parts and for rethinking the whole.

1

Antiquity

I. INTRODUCTION

A student of ancient classical thought on painting and sculpture cannot avoid a certain perplexity in examining the scattered texts and fragments that have come down to us, for an apparent paradox seems to emerge with increasing insistence. Greek and Roman authors, of almost every period from Homer to late Antiquity, were obviously familiar with many works of the visual arts; they describe works of painting and sculpture, or they refer to them in an astonishing variety of contexts, often displaying an intimate acquaintance with the techniques employed in the production of such works. Moreover, philosophers, poets, and rhetoricians laid the basis for the critical discussion of the visual arts by coining such key concepts as imitation, expression, harmony, and the like, concepts that have remained fundamental in the whole tradition of European aesthetics. Yet such familiarity with the works, and even the techniques, of the visual arts does not necessarily imply a clear and comprehensive conceptual structure; it does not prove that the ancients had a theory of art, in any modern sense. What we sometimes rather loosely call the ancient theory of art is often elusive; in attempting to present, in succinct form, ancient views on painting and sculpture, one cannot avoid a certain feeling of vague-

ness. Does this vagueness result simply from the loss of texts, or does it perhaps reflect some profound ambiguity of the concepts themselves?

Classical literature, as everybody knows, has come down to us in a fragmentary state, and the literary historian sometimes resembles the archaeologist attempting to reconstruct a whole work from a few sentences that have happened to survive, frequently as a quotation in another work of literature. Art theory is no exception to this rule. The *De architectura* by the Roman architect Vitruvius (late first century B.C.) is the single completely preserved ancient treatise that deals directly and exclusively with art, but its subject matter is architecture; it refers to the representational arts only in passing, and it does not provide a theory of painting and sculpture. Yet can we really assign the absence of treatises on the representational arts only to the randomness of survival? As Jakob Burckhardt has noticed, among the numerous titles of lost books transmitted to us by Diogenes Laërtius not a single one indicates a treatise on painting or sculpture. And the Sophists, who paid such careful attention to technique in all fields of human endeavor, seem to have disregarded the representational arts altogether (with the exception of Hippias of Elis, who is said to have "talked about painting and sculpture"; cf. Philostratus, *Vitae sophistarum* I. 11).[1] Compare this state of affairs with the many treatises (extant or known to have existed) on music, poetry, and rhetoric, and the absence of discussions of the representational arts becomes clearly not merely a matter of texts that happen not to have survived.

Is it not possible, one is tempted to ask, that the paradox of familiarity with the works themselves and the absence of a coherent theory reflect an ambiguity inherent in the Greek and Roman view of the representational arts?

The elusiveness of ancient thought on the visual arts is compounded by the strange fact that classical culture did not have a specific term for what we now call art. Probably closest to our modern concept is the Greek term *technē* ($\tau\acute{\epsilon}\chi\nu\eta$) and its Latin equivalent, *ars*. When examining these terms, one is struck by their exceedingly wide scope, which almost makes them unusable in our discussion. *Technē* (or *ars*) is not limited to fine arts but rather denotes all kinds of human skills, crafts, or even knowledge. Thus, one can speak of the art of agricul-

ture, of an art of medicine or an art of carpentry, as well as of an art of painting or of sculpture. The specific values now attributed to the fine arts—values that themselves are far from unequivocal—are missing from the classical usage of *techne*.

Nevertheless, it is of some interest to examine what is implied in this classical concept. Most important, *techne* is frequently opposed to nature *(physis)*. Thus, Hippocrates contrasts nature (life) with art (medicine). In Greek thought it is generally assumed that whereas nature acts out of sheer necessity *techne* involves a deliberate human choice. For this reason *techne* can also be opposed to instinctive ability (as is suggested by Plato in *Republic* II. 381c and in *Protagoras* 312b ff.), and at the same time it can also be contrasted with mere chance. Broadly speaking, then, *techne* can indicate the procedure of deliberately achieving a preconceived goal.

This leads us to another aspect of art. Especially in the Aristotelian tradition *techne* is geared toward production *(poietike)* rather than merely action. Aristotle's basic statement of what art is may be found in his description of it as a purposive process that produces a final form out of preexisting matter *(Physics* 194b. 24 ff.). But in order to be purposeful *techne* must follow rational rules. The system of such rules, the organized body of knowledge related to some kind of production, is an essential part of *techne,* and this term can also denote such a body of knowledge. Speaking of architecture, in the *Nicomachean Ethics* Aristotle (VI. 4. 1140a) gives a definition of *techne:* "Now since architecture is an art *[techne]* and is essentially a reasoned state or capacity to make, and there is neither any art that is not such a state nor any state that is not an art, art is identical with a state of capacity to make, involving a true course of reasoning." Stressing the intellectual overtone of the concept, Cicero *(De oratore* II. 7. 30) says that *ars* cannot be cut off from science because it always refers to things that are *known.*

What this brief summary shows is that the paradox encountered in the classical literature regarding the visual arts (familiarity on the one hand, lack of any specific theory on the other) is not the result of the loss of treatises; the paradox indicates a basic problem inherent in the classical approach to the representational arts.

How did the classical views of painting and sculpture develop? What

opinions were held regarding the artist? Two great cultural traditions form our principal sources: the doctrines of the philosophers and the teachings of the workshop. Let us now turn to these sources.

II. THE PHILOSOPHERS

The philosophers of Greece and Rome did not contribute directly to the theory of the visual arts. They were usually quite removed from the workshop experience, and whatever they may have had to say about painting and sculpture is fragmentary and marginal to their thought, although sometimes indeed they offer surprising insights into the artist's work, and, above all, they formulate the conceptual framework for the discussion of art in most later ages. But they reflect and helped to establish the broad cultural context in which the visual arts were viewed in Antiquity.

1. PLATO

Nowhere does the paradox in the ancient conception of art become as manifest as in Plato's thought. Plato never expounded a theory of the visual arts, yet perhaps no other philosopher in history had such a profound impact on artistic thought.[2] It was Plato who based any discussion of the arts on the concept of imitation. In speaking of imitation, to quote the well-known classical scholar, Wilamowitz, Plato "rapped out a fatal word."[3] Up to our own day the concept of imitation, whether accepted or rejected, has remained the focus of any interpretation of art. But what does imitation mean? There are few concepts as chameleonlike in their significance. Richard McKeon correctly says that Plato used the term "imitation" *(mimesis)* sometimes in order to single out some specific human activity, sometimes to denote all human activities; sometimes he even applied it to nature, to universal cosmic and divine processes.[4] Now, what did Plato mean when he used the term in connection with the visual arts?

Plato's view of pictorial imitation must be pieced together from brief observations always made in a specific context. Under such circumstances certain contradictions in detail are inavoidable, yet some broad, general tendencies can clearly be discerned.

Plato's conception of reality, as is well known, is hierarchic. Empir-

ical reality is but an approximation of "absolute existence" (i.e., of the Ideas) but falls short of them (*Phaedon* 74b ff.) and is therefore only their "image" (*Phaedros* 250b). Plato's use of the term "image" shows that his theory of imitation is closely related to his hierarchical conception of reality. The pictorial image is never more than an approximation of the material object that it imitates; it is never a true copy of it. "I should say rather that the image, if expressing in every point the entire reality, would no longer be an image. . . . Do you perceive that images are very far from having qualities which are the exact counterpart of the realities they represent?

"Yes, I see." (*Cratylus* 432b, d).

Imitation is, then, never more than a suggestion or evocation.

The classical formulation of this view is an often quoted passage in Book X of the *Republic,* where Plato introduces the famous example of the couch.[5] There is only one form or idea of the couch. The carpenter imitates this idea by making a certain couch of a specific material and in a concrete form. The painter who represents the couch does not actually reproduce the craftsman's product; he portrays only its optical appearance, the couch as he sees it from a certain angle, in a certain light, and the like. The painter is thus twice removed from lasting reality, that is, from the idea.

Plato's rejection of pictorial imitation is based on the illusionistic character of painting. Sense perception is confused, and the realm of optical experience, on which painting is based, is devoid of truth. "And the same objects appear straight when looked out of water, and crooked when in water; and the concave becomes convex, owing to the illusion about colors to which the sight is liable. Thus every sort of confusion is revealed within us; and this is that weakness of the human mind on which the art of painting in light and shadow, the art of conjuring, and many other ingenious devices impose, having an effect upon us like magic" (*Republic* X. 602c–d). Skillful uses of perspective and polychromy are therefore denounced as imposture and jugglery. The painter is also compared to a revolving mirror: "you would soon enough make the sun and the heavens, and the earth and yourself, and other animals and plants, and furniture and all the other things of which we were just speaking, in the mirror."

Imitation as such is inferior, not only because of the status of the image in the hierarchy of being, but also because the imitator, clinging to appearances, does not know the object he is representing. The poet and the painter produce likenesses of a cobbler without knowing anything about cobbling. Only the horseman knows the forms of the reins; the leatherworker who manufactures them has only an "opinion" or "true belief"; the painter who represents them does not have even such an opinion; he is acquainted only with their appearance (*Republic* X. 601).

Within pictorial representation, however, Plato sometimes distinguishes between two kinds. One type is called "likeness making," and its criterion is the striving for correctness and faithfulness to the object represented. Likeness making is achieved whenever the artist produces an image "by following the proportions of the original in length, breadth, and depth, and giving, besides, the appropriate colors to each part" (*Sophist* 235d, e). With reference to painting, Plato here seems to be thinking of a flat, linear style in which easily identifiable local colors are applied.

"Fantastic imitation," the other type of pictorial imitation, is characterized by a complete adherence to deceiving appearances corresponding to no external reality, or by the intentional creation of convincing optical illusions. Perspective illusions are the best-known examples of fantastic imitation. Adjusting a monumental statue to the conditions under which it will be seen is an example adduced by Plato himself. If some sculptors "reproduced the true proportions of beautiful forms, the upper parts, you know, would seem smaller and the lower parts larger than they ought, because we see the former from a distance, the latter from near at hand" (*Sophist* 236a). Elongating the upper parts so as to create a correct *appearance* is fantastic imitation. Another example mentioned by Plato is a certain kind of impressionistic painting, making use of strong effects of light and shade, and is intended to produce striking illusionistic effects, especially when seen from a distance (*Sophist* 235e). Fantastic imitation is of course "falsehood" (*Sophist* 266e–267e). It is worth remarking that music and the literary arts are not mentioned in this context; apart from painting and sculpture, only acting is suggested.

6

Behind Plato's condemnation of visual imitation one sometimes senses a different attitude, an awareness of the symbolic significance of the act of artistic creation. This attitude is only vaguely intimated—it can never be firmly established—but, given Plato's overwhelming impact on European thought, even this shade of meaning was influential. It can perhaps best be grasped in Plato's view of the universe as a work of art created by the divine artist. By imitating the world of Ideas the divine artist fashions the real world. The word used for the divine artist, "Demiurge," is a word the Greeks, and Plato specifically, also applied to an artisan engaged in useful activity, as a rule of a manual type. The physical world created by the Demiurge is of course not able to match the world of unchangeable ideal patterns at which the Demiurge looked when he was shaping the cosmos, but within its own limitations it is "likely and analogous" to the world of Ideas (*Timaeus* 29c). It is somehow implied, though never expressly stated, that the artist may sometimes be granted the ability to envision ideas or eternal patterns.

Within the specific medium of painting Plato distinguishes between artists who are altogether dependent on sensory impressions and *poietic* painters who are not wholly engulfed by the world of physical objects and optical appearances, but retain a certain independence. The *poietic* painters, deliberately directing their glance to one side or the other of what they represent, and thoughtfully and attentively blending their colors, "produce . . . that human image in the conception of which they let themselves be guided by what Homer described as divine and godlike when met with among mankind" (*Republic* VI. 501). The *poietic* painter is perhaps endowed with the ability to create images of examplary figures, in a sense "likely and analogous" to the unreachable ideal. Here Plato does not speak of individual, historical artists. But in another context he refers with admiration to Phidias as an "outstandingly fine craftsman" (*Meno* 91d). In his admiration for Egyptian art Plato attributes to it some of the qualities—especially rationality and permanence—that are characteristic of the real or the eternal patterns. "Ten thousand years ago . . . paintings and reliefs were produced that are no better and no worse than those of today, because the same artistic rules were applied in making them" (*Laws* II. 656e ff.).

The modern reader, acquainted with Plato's harsh condemnations of the visual arts, especially painting, is surprised to learn of an ancient tradition according to which Plato himself studied painting. This tradition, whether authentic or not, contributed to the image of the venerated sage, as it was handed down through the centuries, and, by implication, may have had considerable influence on the ways in which painting was considered. Perhaps the first source of this tradition is Diogenes Laërtius, who, writing around A.D. 150, relates in his *The Lives and Opinions of Eminent Philosophers*—something of a best-seller in Antiquity—that Plato "applied himself to the study of painting, and that he wrote poems, dithyrambics at first, and afterwards lyric poems and tragedies" (III. 6). This passage is also interesting because it relates painting to noble and venerated types of poetry and literature. Another author of the second-century A.D., Apuleius, flatly states that Plato "did not reject the art of painting," intimating that he studied it in his youth. In a later period, around A.D. 500, the Byzantine author Olympidorus wrote that Plato derived from the painters whom he visited the knowledge of blending colors, a knowledge displayed in the *Timaeus*. Whether Plato studied painting or not, it has recently been pointed out that he did indeed use the language of painters, the technical vocabulary of the workshops, with competence and a professional understanding.[6]

Plato's intimate acquaintance with painting cannot be doubted, but his attitude toward it is deeply ambivalent. On the one hand, as we have seen, he rejects it as inferior imitation, devoid of inherent value. In *Laws* (797b) an interlocutor is assured that, by not having any knowledge of painting, he has not "missed anything"; in the *Statesman* (277c) it is said that speech can better represent animated life than can be done "in painting or by any other handicraft." On the other hand, Plato's fascination with the process of painting and its many intricacies cannot be ignored by an attentive reader. In *Timaeus* (55c) the Demiurge is described as creating the cosmos by painting or "delineating" it, and in *Timaeus* as well as in other works we find detailed descriptions of the process of producing a picture that are often surprising in their minute observation and correct detail. Plato distinguishes three main steps in creating a picture (best related, to take an

example, in *Republic* VI. 501a–c): the first consists in preparing a clean, probably white surface; the second is the outlining, the drawing of a contour. (Plato does not actually say much about this step, but his remarks seem to have some relation to "measuring"—perhaps the establishing of correct proportions—and from the context it follows that he endowed this stage with particular significance.) The third step is "shading and coloring." A picture, finished as regards its outlines, reaches completion only by the addition of the appropriate and correct colors (*Statesman* 277b). Of shading and coloring, though they are only "completion," Plato speaks more often than of the other stages, and he shows greater familiarity with the details. Thus, he is aware that this particular step is open-ended. In the *Laws* (769b) the Athenian says in the tone of somebody presenting common knowledge: "You know how painting a picture of anything seems to be a never-ending business. It always seems as if the process of touching up by adding color or relief (or whatever it's called in the trade) will never finally get to the point where the clarity and beauty of the picture are beyond improvement."

In summarizing our brief observations we can say that the conflict indicated at the beginning of this chapter is clearly manifested in Plato. Both his attitudes to the visual arts—the outright condemnation, and the half-mystical fascination—became authoritative sources of inspiration in the history of ideas and, at different periods, were factors of great weight in determining the appreciation of the arts and of artists.

2. ARISTOTLE

Aristotle paid only slight attention to the visual arts, and the few remarks that are pertinent to our subject cannot be construed as an articulate theory of art; unlike Plato, he does not seem to have been fascinated by the visual arts.[7] But some of his general concepts became crucial in the art theory of later periods, and they should be briefly discussed.

Aristotle's general philosophy is a fertile soil for the growth of art theory. Broadly speaking, in his thought on nature and the human arts, he replaced Plato's dualism of Idea and Appearance with the notion of a relationship between Matter and Form. The concepts of Becoming and Producing therefore play an important part in his doctrine. Unlike

Plato, he does not conceive of the process of producing an object as the fading of an image, a reflection lacking distinct and sufficient artic- ulation, and far removed from its ideal model; rather, he conceives of it as a process in which an object becomes real by achieving distinct articulation and definite shape. For this reason, the individual object emerging from the process of making is endowed with full reality. "Production" is conceived in the widest possible sense, to be found in both nature and human activity. Everywhere it has the same structure. In a classical passage in his *Metaphysics* (VII. 6. 1032a) Aristotle distin- guishes three major elements of this structure: every object (or crea- ture) is formed by an "agency"; it is formed "from something" and it is formed "into something." This general structure is also to be found, as many later generations have shown, in the process of artistic crea- tion.

It is, of course, not surprising that Aristotle devoted much attention to the different techniques, or "arts." His treatises on *Poetics* and *Rhet- oric* have come down to us (as well as some discussions of particular problems of rhetoric), and we know of writings, now lost, on literature and music. He seems never to have written a treatise on the visual arts, but from isolated observations, scattered in his works, we can piece together an outline of his views on painting and sculpture.

Let us begin with the relationship between the maker and the object he makes. When the carpenter produces an object, Aristotle says (*De generatione animalium* 730b 10 ff.), "no material part comes from the carpenter to the material, i.e., the wood in which he works." Watch- ing the carpenter at work, we see that the wood he works on is moved by his tools and that the tools are moved by his hands. But, one cannot help asking, who moves his hands? ". . . it is his [the carpenter's] knowledge of his art, and his soul, in which is the form that moves his hands." While (in modern parlance) the carpenter here obviously is the creator of the object he carves, no material substance, however subtle, is transferred from the carpenter into his work. The mediators between carpenter and shaped object—namely, the tools and the hands— in fact also separate the form existing in the carpenter's soul and the final shape of the object he produces. But what precisely *is* the source of the object's shape?

Aristotle's answer is ambiguous. His formulation—"it is his knowledge of his art, and his soul, in which is the form, that move his hands"—reflects a problem rather than gives an answer: Is it the individual artist's personality, or is it art as an objective, superindividual tradition that is considered the creator of the work of art? In other treatises he seems to suggest the individual artist, or craftsman, as the source of the work. In Book VI of *Metaphysics* Aristotle, speaking of the causes of different things, says, "but from art proceed the things of which the form is in the soul of the artist" (1032a 32). In *De anima* he calls the soul "the place of forms" (429a 27 ff.), and earlier in the same work he defines more precisely the place within the soul in which the form dwells: it is "the thinking part of the soul" (429a 15 ff.). Bernard Schweitzer, in his study, "The Artist and the Artistic in Antiquity,"[8] stresses the significance of this last sentence: Aristotle, he says, sees in a specifically intellectual element the origin of the creative process; the "form" that dwells in the soul is not just a group of impressions gathered from the external world and stored in one's memory; it is an "idea," something one knows. But, whatever the precise meaning of "form" and "soul" in this particular context, it is clear that Aristotle here seems to consider the individual artist or craftsman, rather than an impersonal *technē,* as the moving force of the process.

Elsewhere, however, Aristotle seems to suggest tradition itself as the creator, some kind of collective, impersonal artist. His examples refer to architecture (*De generatione animalium* 734b 17), but they can also include sculpture. Thus, he says once that what happens in nature spontaneously—for example, the restoration of health—must be premeditated in art, and the premeditation should be of the same kind as the work produced. "The products of art, however, require the pre-existence of an efficient cause homogeneous with themselves, such as the statuary's art, which must necessarily precede the statue; for this cannot possibly be produced spontaneously" (*De partibus animalium* 640a 30 ff.). The cause of the statue, then, is not the spontaneous artist, motivated by emotions or even by forms dwelling in his soul, but the statuary's *technē* itself.

Aristotle's appreciation of sculpture (which can sometimes be sensed) is probably related to his conceiving this art as governed by rules.

Thus, in the *Nicomachean Ethics* he says: "Wisdom in the arts we ascribe to their most finished exponents, e.g., to Phidias as a sculptor and to Polyclitus as a maker of portrait statues, and here we mean nothing by wisdom except excellence in art" (1141a 10 ff.). Schweitzer has correctly stressed that art here remains completely separated from the individual artist.[9] What differs from one artist to the next is only the degree of competence, the capability or "virtue" *(arete)*. No indication of a personal style transcending the objective rules can be found here.

From Aristotle's scant remarks on painting too, we can gather some general impression of his ideas. The distinctive element of painting is color, but while Aristotle appreciates color he obviously does not place it high in the scale of values. We can enjoy coloring even when we do not know the subject of a painting (*Poetics* 1448b 19), but we cannot learn from the picture. The most beautiful colors are less valuable than a clear outline (1450b 2). Order and clarity (and, in this case, the ability to identify the figure portrayed)—the highest values of a work of art—are achieved not by color but by line. "Beauty depends on magnitude and order," says Aristotle; in other words, it depends on measurable units that can properly be expressed only in lines.

Line also represents (or reveals) the structure of the work as a whole, while color has a local and limited significance. In discussing the individual elements of tragedy, especially the plot and the characters, Aristotle stresses the superiority of overall structure to individual character. "The plot, then, is the first principle, and, as it were, the soul of the tragedy; character holds the second place. A similar fact is seen in painting. The most beautiful colors laid on confusedly will not give as much pleasure as the chalk outline of a portrait" (*Poetics* 1450b 2). By implication we have here a hierarchy of styles: the linear style, or the linear elements in painting, is the superior value in the whole art of painting.

Aristotle's theory of imitation becomes the most influential feature of his aesthetics. Even in periods when Aristotelian philosophy as a whole was rejected (as in Renaissance humanism), his concept of imitation was of the utmost significance. In Aristotle's thought the notion of imitation has not the broad validity it has in Plato's; it is often restricted to the arts. The object of imitation, as Aristotle says in the

Poetics, is the action of men. He is thinking mainly of the arts using "rhythm, language, and harmony," that is, of the theater, but he finds the same definition also valid for the arts employing "color and form" (*Poetics* 1447a 18 ff.). Such imitation can have different levels. The objects the imitator represents are actions of men: "it follows that we must show men either as better than in real life, or as worse, or as they are. It is the same in painting. Polygnotus depicted men as nobler than they are, Pauson was less noble, Dyonisus drew them true to life" (*Poetics* 1448a 3 ff.). Whomever the artists referred to may have been— a matter of dispute among classical scholars—Aristotle clearly has a hierarchy in mind. But a hierarchy of what? Did the painters mentioned differ from each other by portraying different people and/or actions, or did they represent the same people and actions but in different manners? Is the difference between them one of ideas and subject matter or one of form and style?

Partisans of the first interpretation may perhaps find some support in Aristotle's view (not directly related to painting) that Homer's personages "are better than we are," whereas those appearing in parodies are worse (*Poetics* 1448a 12 ff.). In a remarkable passage of the *Politics* (1340a 32 ff.) we read that "young men should be taught to look, not at the works of Pauson, but at those of Polygnotus, or any other painter or sculptor who expresses moral ideas." Those who favor a more formal interpretation may invoke a tradition (formulated in writing later than Aristotle but persistent throughout Antiquity) that ascribed measurability and precision to Polygnotus. Quintilian (*Institutio oratoria* XII. 10. 3) attributed to him *simplex color* (which can only mean that he used few and pure colors, and this in turn suggests a linear style); and Aelian (*Variae historiae* IV. 3) ascribes to him "precision," which also suggests a linear style. And the predominance of line, as we have seen, was considered superior, and may well also have carried some moral connotations. The meaning of these passages has not been sufficiently elucidated in the many discussions from Seneca to Boileau, nor has modern philological research achieved any definitive clarification.

As we have seen, the visual arts had only marginal significance for Aristotle, and his acquaintance with them was rather limited. His ma-

jor contributions to the philosophy of art (such as the concept of imitation in its full scope, the problem of the beholder and especially the idea of catharsis) are beyond the specific domain of the visual arts and need not be discussed here. However, even within these limitations he formulated some of the great and lasting problems in the interpretation of painting and sculpture. But a certain ambiguity remains both in these problems and in their formulation. The paradox we noted at the beginning of this chapter remained unsolved in classical philosophy.

III. TEACHINGS OF THE WORKSHOPS

1. XENOPHON

So far we have concentrated on the great philosophical systems. But the period of Plato and Aristotle has also left us literary testimony of a different nature, philosophically less significant but deriving from sources closely related to the actual art, posing new problems and bringing us into direct contact with the thought of the workshops. Testimony of this nature is found in Xenophon's writings.

Xenophon, an attentive observer and prolific writer, was Plato's contemporary, and one of Socrates' most trusted disciples. None of Xenophon's works deals specifically with art, but he touched upon problems of artistic creation several times. When speaking of art, he has mainly the visual arts in mind. Occasionally he also discusses the theater, or dance (accompanied by music), and he describes the buildings he has seen in distant lands, but only when speaking of painting and sculpture does he ask original questions and produce his specific contribution to the concepts of art.

Such a question, hardly mentioned by the philosophers, is raised in a remarkable passage (*Memorabilia* III. 10. 1–8) describing a visit of Socrates to the workshops of the painter Parrhasius and the sculptor Cleito. At the beginning of his conversation with the painter, Socrates defines painting as "making an image of the things we see with our eyes." Xenophon is, of course, aware of the existence of mental images, as we shall shortly see, but he bases painting completely on direct visual experience. This experience abounds in different qualities and

facets. The painter represents bodies "that are high and low, in light and in shadow, hard and soft, rough and smooth, young and old." These qualities are not only structural but are also textural, and since Xenophon never implies the sense of touch, the textural qualities ("hard and soft, rough and smooth") should also be understood as *visual* qualities.

However, the main question that Socrates raises transcends the realm of the visible or, perhaps, shows its profundity. Is the visible diaphanous so that what is hidden behind it can shine through? Turning to the painter, Socrates asks: Do you also represent the "disposition of the soul," or is this impossible? Now it is the painter's turn to insist on sheer visibility. "How could such a thing as a state of mind be represented," since it "has neither proportion nor color . . . and which it is not even possible to see at all?" But Socrates considers the expression of emotions (and of character, we should add) an essential quality of the work of art. "And the representation of the passions of men engaged in any act, does it not excite a certain pleasure in the spectators?" he asks in Cleito's workshop. Of course it does. But how can this be achieved? How can the invisible be made to appear on the level of visual experience?

Socrates'—or Xenophon's—answer is a formulation of both the problem of expression, as discussed in aesthetic thought ever since, and of a fundamental principle of classical art, and of the art that follows the classical tradition. Let us speak in modern terms: Socrates does not assume any *direct* contact between a mood and an artistic form. To use a formulation favored by some contemporary philosophers: sadness itself is not black; nor is joy itself bright. What Socrates suggests is that the artist portray real human beings, as they really look and as they change under the impact of emotions. Everybody daily reads people's moods from their faces and gestures. "Is it not often observable in a man that he regards others with a friendly or unfriendly look?" Socrates asks. Everyone knows that it is. This look *can* be represented in shapes and colors because it appears in our visual experience. Aristotle, as we know, also considered the expression of emotions a principal task of "imitation," but for him the medium of imitation was action, and he therefore saw the actor's art—an art that

unfolds on the stage—as the appropriate form of representation. Xenophon formulated the principle of the painter's and sculptor's approach to visualizing emotions: not an unfolding action but an intuitive, immediate grasp of the soul and the feelings as they are revealed in *one* brief glance.

2. POLYCLITUS

Xenophon tells us of a philosopher's visit to a painter and a sculptor; in their workshops the sage and the artists talked of the significance of expressing emotion and of how it could be achieved. Was it perhaps the philosopher, one wonders, who imposed this theoretical problem on the artists? But at roughly the same time formulations of art theory were emerging directly from talk in the workshops. Though not referring, so far as we know, to expression, this theorizing shows that philosophical problems must have exercised the artists themselves. In the third quarter of the fifth century B.C. the sculptor Polyclitus composed a theoretical treatise that was the most renowned classical text on the visual arts. Polyclitus' *Canon,* as the treatise was called, has not survived (except for one incomplete sentence), but there are enough references to it in extant texts to enable us to grasp its major tendencies. One important source of our knowledge of Polyclitus' theory is a passage in a text by Galen, the physician who lived in the second century A.D. Although five or six centuries had passed since Polyclitus worked, the tradition of the *Canon* was still alive.

Greek medicine, as we have learned from Werner Jaeger and other scholars, was not only an empirical science but also had a broad cultural meaning;[10] it is therefore not surprising to find observations on beauty in a physician's work. Following a common trend in Greek thought, Galen believed that beauty does not consist in any particular substance or body but in the commensurate, balanced relationship among the parts of a whole. As an example he mentions the relation of "the finger to the finger, and of all the fingers to the metacarpus, and the wrist [carpus], and of all these to the forearm, and of the forearm to the arm, in fact of everything to everything, as is written in the *Canon* of Polyclitus. For having taught us in that treatise all the *symmetriae* of the body, Polyclitus supported his treatise with a work, having made

the statue of a man according to the tenets of his treatise, and having called the statue itself, like the treatise, the *Canon.*"[11]

Polyclitus' *Canon* is the first Greek treatise on art of which we know, but one will probably not go wrong in assuming that similar manuals were composed and used in the workshops of his time, and had most likely already existed at an earlier period. Polyclitus' concentration on the human body reflects the focus of archaic and early classical sculpture, the sculpture that culminated in the images of the *kouroi* (youths). That the *Canon* was expounded not only in a literary form but also in a statue further proves, if proof be needed, the origin of this theory in a sculptor's workshop.

Polyclitus' treatise, however, seems to have been different from what we would nowadays expect of a workshop manual. Nothing of what survives of it suggests that it was composed mainly of recipes for the production of statues. Instead of explaining how to carve a specific figure in stone, the *Canon* lays down the proportions of the human body; instead of aiding the artist to produce foreshortenings or to suit his work to the conditions in which it would actually be seen, the treatise provides sheer anthropometry. Did Polyclitus assume that the artist, equipped with a knowledge of human proportions, would be able to adjust to any task with which he might be faced? We cannot give a positive answer, but the question poses a serious problem.

Even more surprising is that, as seems to follow from the full text of Galen's passage, the very aim of the *Canon* was to achieve beauty. Philosophical discussion of *technē* in the broad sense of the term did not refer to beauty, nor did the Platonic or Aristotelian observations on the visual arts. Transforming the visual arts into a medium in which beauty is realized was largely the intellectual achievement of the artists themselves, and they thereby propounded a major theme in European thought. We know too little to account for the forces that motivated this specific development of the workshop, but it is clear that beauty itself was conceived as symmetry, as a system of harmonious, balanced proportions.

The character of the Polyclitan system is "organic," to use Panofsky's felicitous term.[12] By comparing the *Canon* with surviving Egyptian workshop schemata of the human figure, Panofsky has shown that the

latter divided the surface to be painted or carved into a grid pattern and placed on it the outlines of the figure to be represented. Grid pattern and body structure remained alien to each other, some of the grid's lines hitting completely irrelevant parts of the body. Polyclitus' point of departure, on the other hand, is the body as a whole, structured into torso, organs, and suborgans. He did not build up the body from small units of equal size (the multiplication of a "modulus"); rather, he focused on the relations between the different shapes and sizes of the individual organs that form the body. The mathematical formulation of this attitude, to cite Panofsky again, is in fractions, that is, parts of a whole, while the formulation of the Egyptian approach is by addition. Polyclitus' attitude allows for almost infinite variations, while the Egyptian system may help explain, and certainly reflects, the rigidity of Egyptian art.

3. XENOCRATES

The early Hellenistic period saw the beginnings of a critical history of art, probably forming part of some general theoretical reflections on image making. During that period historical surveys were introduced in many fields, the best-known example probably being the brief account of the development of Greek philosophy with which Aristotle preceded his *Metaphysics*. None of the treatises of art then composed has survived, but a reflection of what they were like can be seen in Roman writings, mainly in Pliny's encyclopedic work, the *Natural History*. Pliny, a well-educated author of the first century A.D., used, though sometimes rather carelessly, many technical and scientific texts that have since disappeared; he is thus a witness to lost literature. He mentions, among others, two artists who wrote on the visual arts, Antigonus of Karystos and Xenocrates of Sicyon. Since Antigonus of Karystos is too problematic a figure (the sources giving information on him are scarce and dubious), the views of these artists, as reconstructed by modern scholarship, are now generally attributed to Xenocrates. Archaeologists and ancient historians often speak of a "Xenocrates problem."[13]

Very little is known of Xenocrates, except that he was a sculptor who flourished around 280 B.C., was considered a master in bronze

casting, and was an enthusiastic patriot of his adopted home, Sicyon. He seems to have claimed that clay modeling started in Sicyon, that bronze casting attained its full bloom there; and even that the art of painting, especially its finest technique, encaustic, also originated in the same city. Schweitzer, the German archaeologist, sees in Xenocrates' love and adulation for his adopted city an indication of the new social position of the artist: in the third century B.C. the artist is no longer bound to his native city; he freely chooses the place of his activity. A century earlier this would have been unthinkable. Sicyon did indeed play a major part in the political and cultural life of the period. The almost legendary Apelles received his training in this city, and Lysippus, one of the most influential sculptors of Antiquity, lived and created his large oeuvre there. In the third century B.C. the school of Sicyon took a decisive step beyond the classical style. Some of Xenocrates' thought may well reflect formulations of the problems that dominated the Sicyon school.

Xenocrates represents his period also in a broader sense. Early Hellenism was the age of systematic collections and summaries in many fields. Attic inscriptions were collected, and so were Attic court decisions, to give only two examples. The literary form of the handbook, or the "abridged edition," ready for use, may also have emerged in this period. This tendency must also have penetrated the field of the arts. There were many arts in earlier periods, but in early Hellenism we find the systematic collection of the arts, and a term for this *(technon synagogē)* was coined. Xenocrates' theory was probably part of this general trend.

The idea of historical development probably played a major role in Xenocrates' doctrine, although it is likely that he was not interested in history as such. Like Aristotle (*Poetics* 1451b), he may have believed that history is inferior to science or poetry because it is knowledge of only individual events and is therefore devoid of universal validity. He most probably viewed the history of the visual arts as a sequence of artistic problems and their answers, beginning with the crude solutions of early periods and leading to the refined and "final" formulations of Lysippus and Apelles. The Greek concept of progress is rather controversial,[14] but in the field of the arts the notion of cumulative improve-

ment can be observed. "In any *technē* the latest invention always has the advantage," Thucydides maintained (*The History of the Peloponesian War* I. 71. 3), and though this was said with reference to the "art of politics," it was certainly believed to be true also for the visual arts. The theory of Xenocrates was undoubtedly meant to be more than a merely historical survey.

Xenocrates' doctrine, as reconstructed by modern scholarship, was probably dominated by four concepts: symmetry, rhythm, precision, and what has been called the optical problem. We shall briefly survey each of these.

Symmetry was a common concept in Greek thought, and it was therefore also of a variable character.[15] Its specific meaning differed according to the particular realm to which it was applied, but two pervasive characteristics always seem to have been present. Symmetry is based on the belief that everything—in the cosmos as well as in art—is cast in definite and measurable shapes; the overall balanced relationship of these shapes forms symmetry. But symmetry is not only a universal principle; it was also thought to be endowed with value: "for measure and symmetry are beauty and virtue all over the world," Plato said (*Philebus* 64e). As we have already learned from the *Canon* of Polyclitus, the artistic workshops of the classical period were familiar with this meaning of symmetry. In using it, Xenocrates, far from revolutionizing workshop thought, merely followed an established tradition. Symmetry continued to be a technical term, and Pliny, conceding that there was no proper Latin equivalent, used the Greek word in this sense.

Xenocrates' second concept, rhythm, is even more complex. Rhythm suggests a sequence, a repetition of sounds, words, or movements, and thus refers to the dimension of time, a dimension alien to the medium of the visual arts. The etymology of rhythm is apparently not well established; linguists do not agree among themselves as to the precise origin of the word. It is derived either from *rheo,* meaning "flow," and thus suggesting a sequence, a flow of time, or from *eryo,* which means "to draw, protect, guard, hold," and thus indicates a static rather than a changing nature. Thus, Jaeger, an eminent classicist, interprets the Greek concept of rhythm as "that which imposes bonds on movement

and confines the flux of things."[16] If one accepts this interpretation, one can understand why Aristotle substituted "schema" for rhythm (*Metaphysics* 985b 16). We cannot be certain what the specific meaning of rhythm was in Xenocrates' theory. Schweitzer believes that here the term was mainly applied to the sphere of organic life; it may have meant some kind of animation, the suggestion of movement—and thus of life—in a resting, static figure.

The third concept of Xenocrates' theory, *akribeia,* is the least familiar to the modern mind, but it was a key notion of professional art criticism in classical Antiquity. This concept, too, had a rather broad range of meanings. It is derived from words denoting sharpened things (*akis,* pointed object; or *akron,* peak or point); it suggests sharpness, precision, and exactitude. But what does it mean when applied to art? The most obvious meaning of *akribeia* is the artist's professional skill and his sovereign proficiency. Aristotle believed that "wisdom" can be attributed only to those sculptors "who are most precise . . . like Phidias the stone-carver and Polyclitus the maker of statues"; wisdom, he says, here means "nothing other than excellence in art" (*Nicomachean Ethics* 1141a 9). Lucian, the famous Greek writer of the second century A.D., makes the legendary Colossus of Rhodes excel in the "art and precision of workmanship" embodied in its enormous size. And even in the tenth century A.D., Suidas, the Byzantine scholar to whom we owe so much of what we know of the classical tradition, said that "among the image-makers," Lysippus, Polyclitus, and Phidias were "exacting" artists.[17] This sense of *akribeia* also reflects the artist's professional pride and is thus an expression of his emerging self-esteem.

Akribeia not only denotes a faculty of the artist; it also describes a certain character of his style, as embodied in the work he creates. In ancient criticism this term seems to have indicated a crisp, sharp, linear style. Dio Chrysostom, a Greek rhetorician of the late first century A.D., juxtaposes "shading, which is weak and deceptive to vision," with "a distinct outline which approaches being the most precise" means of representation (*Oration* XII. 44). Demetrius, another Greek rhetorician of the same period, compares the style of classical sculpture with that of earlier periods; the works of the earlier artists are characterized by

"compactness and spareness"; Phidias's works have a certain "grandeur and precision." And Dionysius of Halicarnassus, in his *Roman Antiquities* (published in A.D. 8), describes the paintings in a Roman temple by saying: "The paintings on the walls were both precise in their outlines and also pleasing in their mixture of colors."

A third meaning of *akribeia,* finally, is that of an extreme naturalism, especially an exceedingly faithful and deceptive representation of the details of nature. Thus, Dionysius of Halicarnassus mentions sculptors who represent "veins, and the down [on the cheeks] and the bloom [of the skin] and other such minute details" as examples of *akribeia* (*De compositione verborum* 25). Lucian gives high praise to "representations of horses and men, executed with the utmost exactitude" (*Dialogi mortuorum* 24. 1) or speaks of a statue that is "exceedingly beautiful to look upon, and a likeness of the greatest exactitude" (*Phalaris* 1. 11).

IV. THE PROBLEM OF THE ARTIST

In the first section of this chapter we discussed, however briefly, the classical period of Greek aesthetic reflection and the fundamental concepts and patterns of thought it produced. When we pass from the high classical period (the fifth and fourth centuries B.C.) to the later stages of Hellenism (encompassing the complex culture of almost half a millennium, from the late third century B.C. to the second century A.D.), we enter a perceptibly different atmosphere. There is no falling off in creative energy, in the arts themselves or in the theoretical reflections on them; there is no break in the tradition: Platonic and Aristotelian concepts continued to dominate any discussion of art, and the painters and sculptors of the early age—Zeuxis, Apelles, Phidias, Polyclitus, Lisyppus—remained ideal models held up for the emulation of later generations. Yet it is difficult to disregard the significant transformation in intellectual attitude toward the arts that confers on this later period its specific character. Nowhere does this process become more clearly visible than in the emergence of new questions and new focuses of thought. The most important of the new themes is the artist himself. It is no exaggeration to claim that only in later Hellenism did the artist become a central problem and that only during this period

did philosophical thought seriously attempt to penetrate the mystery of the act of creating an image.

1. SOCIAL CONDITIONS

To grasp the full scope of the "problem of the artist" in the history of ideas, it may be useful to remind ourselves of the social conditions in which painters and sculptors lived and worked in Antiquity. The investigation of these conditions is a task more complicated than one would expect, and this may explain why we still lack a comprehensive study of this important subject. Basing myself on some partial studies (a lecture by Burckhardt, an article by Schweitzer, and a brief but important chapter in Zilsel's book on the concept of genius),[18] I shall attempt an outline of the subject, or at least part of it.

The low regard in which artists were held in the classical period is amply attested. The sculptor or painter was called a *banausos,* that is, a mechanic. In a broader context the term carried the meaning of low and vulgar. Burckhardt traced the derivation of this attitude toward the visual artist to the alienation of classical Greek society from any kind of manual work. The sculptor and painter, working with their hands, are merely mechanics. Even among the gods, Hephaistos, blacksmith and armorer (and thus some divine projection of the artist), is a limping and sooty figure; he plays the cuckold and evokes laughter. As mechanics, artists are excluded from any participation in higher realms or values. To Plato the poet and the musician are inspired, and inspiration is transmitted even to the bards who only recite the poets' songs, but sculptors and painters are seen as working solely according to the established rules of mechanics. In his grandiose vision of the transmigration of souls Plato sees the soul of Epeios, the mythical sculptor who carved the Trojan horse, passing "into the nature of a woman skilled in some craft," thus suggesting that sculpture has an affinity to, or is the equivalent of, some kind of feminine skill such as needlework (*Republic* X. 602c). Xenophon, in the same chapter in which he lays the ground for all further theory of the expression of emotions in art, unhesitatingly places Parrhasius, the painter, and Cleito, the sculptor, on the same level as a skilled and competent blacksmith who produces body armor (*Memorabilia* III. 10).

Greek culture as a whole made a distinction between the work of art as a self-contained object and the artist who produced it, but nowhere is this distinction as sharp as in the visual arts. Phidias was condemned by an Athenian court because he smuggled his self-portrait into his famous statue of the goddess Athena, placing it on the figure's shield. He was also explicitly forbidden to sign his name on another work (though artists' signatures on sculpture and vase paintings are known since the sixth century B.C.). Seneca, the Roman philosopher of the first century A.D. who transmitted so much of Greek Stoic thought to Latin culture, frankly admits that, while we adore the images of the gods and offer them sacrifices, we despise the sculptors who produced them (*Epistolae Morales* 88. 18). Similarly Plutarch, the influential Greek biographer of the same period, maintained as a matter of common consent that no educated young man who admired the statue of Zeus in Olympia would wish to be a Phidias or a Polyclitus. "We enjoy the work and we despise the master" (*Vitae parallelae Pericles* 1). Perhaps most outspoken is Lucian, who was originally apprenticed to a stonemason. In his autobiographical essay he warns any young man not to become a sculptor. The personification of Culture, appearing to him in a dream, says that "the advantages that the profession of being a sculptor will bring with it . . . amount to no more than being a worker with your hands. . . . You may turn out to be a Phidias or a Polyclitus, to be sure, and create a number of wonderful works; but even so, though your art will be generally commended, no sensible observer will be found to wish himself like you; whatever your real qualities, you will always rank as a common craftsman who makes his living with his hands" (*Somnium* 9).

In the Hellenistic age some changes of outlook emerged. The old attitude showed a surprising strength (some of the sources just quoted are from those very centuries, others even later), but a different view of the artist slowly took shape. In some cases the change was really social, such as Lysippus' position at court (as a friend of Alexander the Great), but in many cases the essence of the artist's activity—what we nowadays call his creativity—was discussed. Perhaps the most important topic in this field is the question of the artist's imagination.

2. THE ARTIST'S IMAGINATION

The general meaning of imagination in ancient psychology and philosophy need not detain us here. In an explicit form it appears only late in the history of Greek thought, and it is considered both as a faculty of the mind and as an image appearing before the mind. A long historical development is summed up by Origen, the Alexandrian Church Father of the early third century A.D., who, echoing Stoic opinions, said that, in creatures endowed with a soul, fantasy is both an image seen by the mind's eye and a will or feeling arousing to orderly and regular motion in imitation of this image; spiders produce their webs by fantasy, and in a similar manner bees produce their honeycombs.[19] Such a view forms the background to connecting imagination with the artist who produces a new reality.

In classical literature the artist's imagination is sometimes discussed in relation to a specific theme, the visual representation of the gods. Stoicism, a most influential school of thought in the latter part of classical Antiquity, did not break with traditional religious forms and symbols, but it often questioned their validity; thus, it did not reject the images of gods, but it sometimes asked why they were represented as they were. For example, Chrysippus, a Stoic philosopher of the third century B.C., said that it was childish to represent the gods in human shape, and at a later period some highly educated groups in Rome declared that, since the gods were invisible, they could not be properly represented in visual form. These trends of thought inevitably led men to ask how the artist could portray the gods and what happened in his mind that made him perceive the divine shape.

This question figures explicitly in the writings of Dio of Prusa, a teacher of rhetoric around A.D. 100, whom his contemporaries called Chrysostomus (Golden Mouth). Among his surviving eighty speeches (essays in philosophy, morals, and politics) the Twelfth Oration (also called Olympic Oration because it was allegedly spoken at the opening of the Olympic Games) deals with the visual arts, especially sculpture. The fact that the visual arts are the primary subject of an oration is of historical significance. Observations on painting and sculpture by Greek

authors of former centuries are in the nature of passing remarks, often made as comparisons employed to explain something other than art. Dio's Twelfth Oration, devoted explicitly to sculpture and painting, shows that by the first century A.D. art had become a problem in its own right.

Dio, a disciple of the rhetorical school, presents his argument within a traditional literary framework. In classical literature the praise of Phidias's statue of Zeus is a common topos, and the story is also frequently told of how Phidias was jailed because he misappropriated the gold supplied to him for the decoration of another statue, that of the goddess Athena. Fusing the two stories, Dio gives them a new and original twist. The literary framework of the Twelfth Oration is that Phidias has to defend himself before a court, consisting of the whole of Greece, not because of the money spent "for gold and ivory, and for cypress and citronwood," but because of something both more serious and less tangible. Addressing Phidias, the imaginary plaintiff asks: "was the shape [of the statue of Zeus] you produced by your artistry appropriate to a god and was its form worthy of the divine nature?" By a "shape appropriate to a god and worthy of the divine nature" Dio does not mean any external embellishment or elaborate decoration, but whether the shape makes visible the nature of the god. Phidias is aware of this; what he is being called on to prove in court is that his statue of Zeus is a "true likeness" of the god.

Men's images of the gods, Dio informs us, are derived from four sources: from an innate picture dwelling in the soul, from the images presented by the poets, and from the images presented by the lawgivers. And now, the rhetorician makes Phidias say, "let us name the fourth, that derived from the plastic art and the work of skilled craftsmen who make statues and likenesses of the gods—I mean painters and sculptors and masons who work in stone, in a word, everyone who has held himself worthy to come forward as a portrayer of the divine nature through the use of art." The images derived from art are particularly dangerous, the plaintiff says, anticipating medieval beliefs in the demonic powers inhabiting statues. The issue of Phidias's statue, he says, "is no small one." In times past, when no visual model of the god was available to men, everybody could form his own image of the

god. Turning to Phidias, the imaginary plaintiff says: "But you, by the power of your art, first conquered and united Hellas and then all the others by means of this wondrous presentiment, showing forth so marvellous and dazzling a conception that none of those who have beheld it could any longer easily form a different one" (*Oration* XII. 53). Art, then, molds the imagination of the beholder; once a person has seen a powerful representation of a figure, he cannot imagine that figure differently; art is also a unifying cultural factor in giving to "Hellas and all the others" the same image of the god.

But what is the *origin* of this powerful image? Where did the artist take it from? On the one hand, Dio echoes old suspicions against the maker of images. Artists adhere to tradition, especially to literary traditions, because they do not want to appear "as untruthworthy and to be disliked for making innovations." But, on the other hand, he suggests that the artist has creative faculties that are the source of images. While following the poets in the representation of the gods, the sculptors sometimes "contributed their own ideas, becoming in a sense the rivals as well as the fellow-craftsmen of the poets." The "creative artist," together with the philosopher, the poet, and the lawgiver, are interpreters of divine nature. Phidias is a "wise and divinely inspired creator." There is a resemblance between the artist producing his work and god creating the world: Zeus "is indeed the first and most perfect artificer," shaping the universe in a way comparable to the sculptor's procedures.

Dio's discussion of the artist's creative power does not refer in detail to *fantasia,* but he gives the impression that the artist, in shaping his work, is following the image in his mind. The sculptor's work is difficult; the hardness of the stone makes the carving of a statue a "laborious and slow" process. "But the most difficult thing of all is that the sculptor must keep the very same image [eikona] in his mind continuously until he finishes his work, which often takes many years." The image in the mind is then his ultimate model.

What Dio intimated but did not spell out—that pictures and statues representing the gods originate from the artist's imagination—was fully articulated a century later in Philostratus' work, *The Life of Apollonius of Tyana.* In the early third century A.D. Julia Domna (a lady who cared

much for pagan religion), the cultivated wife of the Roman emperor Septimius Severus, asked the well-known Sophist Philostratus to write a "life" of Apollonius, who lived in the first century A.D., was the founder of a religion of sorts, and made a considerable impact on the intellectual and emotional life of the eastern provinces in late Antiquity. Modern scholars agree that Philostratus' work is a "romantic fabrication" rather than a reliable account of Apollonius' life and teachings. But for this very reason it clearly reflects some of the opinions current among certain groups in the early third century A.D.

In *The Life of Apollonius of Tyana* art is not an important subject discussed in its own right, but occasional remarks reflect a significant development in the philosophy of art: the explicit acknowledgment of imagination as a source of artistic imagery. Phidias's statue of Zeus still excited people's minds (some eight centuries after it was actually carved), and in Philostratus' work it provides the theme for a brief but interesting discussion of art. Thespesion, an Egyptian disciple of Apollonius, defending his native tradition of depicting the gods with heads of birds and beasts, questions the "correctness" of the Greek representation of divine figures as perfect human beings. "Did your Phidias and your Praxiteles," he mockingly asks, "ascend into heaven and sketch the gods . . . ? Or did they acquire their skill in representing them by some other method?" But what could be a better and more reliable method than copying the original? "Imagination," replies Apollonius, "a wiser teacher than imitation, has created those statues. Imitation portrays what it sees but imagination what it cannot see" (II. 19).

Philostratus, intent upon exposing the fallacy of a grossly material notion of imitation, shows that no sharp line can be drawn between *mimesis* and *fantasia*. Speaking in modern terms, we could say that our perception of reality—that is, of the object of imitation—is full of projections from our imagination. When we see appearances in the sky, when in masses of clouds we discover "centaurs, and goat-stags, and wolves and horses"—would we not say, in present-day parlance, that here perception is permeated by projections? Such psychological language is certainly not the idiom of Philostratus; he would have preferred the expression "images made by chance," to use Professor Janson's fortunate phrase.[20] But obviously Philostratus seems to be say-

ing that imitation is not just making a copy of a solid object; it is also a kind of conception in which there is an element of spontaneous creativity. Moreover, even the reading of a picture is not possible without some degree of reliance on the spectator's imagination: we cannot praise the depiction of a horse or a bull unless we compare it to the images of these creatures we carry in our mind. The same would seem to hold true for figures and scenes that we have not directly experienced. "No one would be a competent judge of the Ajax whom Timomachus has painted as mad unless he had formed a mental conception of Ajax, and how he sat despairing and meditating suicide after slaying the sheep of Troy" (II. 22).

The fascination that the problem of fantasy exerted on the minds of writers and critics in the first centuries of our era suggests that the focus of art theory as a whole was shifting. As long as imitation was the central concept, the theory of art was primarily concerned with the finished work, or with the unchangeable shapes the work of art was supposed to depict. The conception of the work of art and the stages of its growth before attaining completion—these were questions of marginal interest. In the first three centuries A.D. the process of creation was becoming a problem of ever increasing significance; now critics and philosophers asked: What actually takes place when an artist conceives and executes a picture or a statue? What is the origin of the shape into which he casts his material, and how is that shape transferred from his mind to a piece of marble or a stretch of wall? These questions are the background of, and are crystallized in, the absorbing contemporary interest in the artists' imagination. At this stage classical culture was ready to develop a psychology of the creative artist.

Such a psychology was not formulated as a well-rounded doctrine, but some of its elements emerged and took on shapes that were to endure through all periods of European culture. Most significant is the view, frequently repeated, that the image in the mind is endowed with shapes as clearly outlined as those of any material object in the external world. This sense of the full presence of the mental image was explored mainly in the tradition of rhetoric. Quintilian, the Roman teacher of rhetoric and codifier of rhetorical theory in the first century A.D.,

provided the definition: "What the Greeks call *phantasiai* [φαντασίαι] we call *visiones;* images by which the representation of absent objects is so distinctly represented to the mind, that we seem to see them with our eyes and to have them before us" (*Institutio oratoria* VI. 2. 29). The same interpretation of fantasy as the capacity of vivid presentation of images is also found in descriptions of scenes, painted or imagined. A century after Quintilian, Aelian (*Variae historiae* II. 44) described a charging warrior in vivid detail and called the whole description a "fantasy."

Fantasy was also directly related to the *conceiving* of a mental image (see *Institutio oratoria* VIII. 3. 88) and could therefore be regarded as the origin of the artist's work. Cicero, referring once again to Phidias's statue of Zeus, maintains that when the artist shaped his figure he did not follow any model in the world around him but contemplated the image dwelling in his mind; his hands he employed in imitating this mental image (*De oratore* II. 7). And Seneca (*Epistolae Morales* 65. 7), putting forth his Stoic view of Plato's theory of Ideas, speaks of the "pattern" that the philosopher called "Idea," and as an example he adduces the artist who has such a pattern in himself and gazes upon it when creating the work. With the utmost clarity he then says that "it makes no difference whether he [i.e., the artist] has his pattern outside himself, that he may direct his glance to it, or within himself, conceived and placed there by himself." Fantasy is then not only the immediate, direct perception of the image in the artist's mind; it also becomes the spontaneous creation of that image.

These concepts became commonplaces in the history of ideas; they have been repeated time and again. In later eras they assumed certain features that are absent in Antiquity. Thus, in Mannerism the emphasis on the artist's vision led to the total rejection of "rules" and of scientific methods in the shaping of a work of art; in Romanticism the worshiping of the artist as a visionary who contemplates the fathomless depths of his soul went together with a rather low regard for skill and dexterity. But in late Antiquity, even in the centuries that saw the rise of the concept of the artist as a visionary, technique, skill, and the mastery of rules remained his essential characteristics. The creation of a work of art, though often based on some internal perception, remained the shaping of a real, material object. In order to be an artist,

therefore, it was not enough to be capable of vividly perceiving a mental image, or of projecting one's fantasies upon nature; one had to be able to transfer one's vision to matter. This is made abundantly clear in Philostratus' *The Life of Apollonius of Tyana.* Everybody, Apollonius indicates, is able to discover shapes in the clouds and to see images in his mind. Calling the perception of such a mental image "imitation," Apollonius says that "the faculty of imitation comes to men by nature, but painting by art" (II. 22).

Philostratus also wrote another book, more directly related to our subject. It is the *Imagines,* a collection of descriptions of sixty-five paintings. Such descriptions were an accepted form of literary exercise, known as *ekphrasis.* Scholars are not agreed as to whether the pictures described were actually executed or perhaps only figments of the author's invention; although interesting in themselves and of influence in the Renaissance, they are not a subject to be explored here. We should record, however, that in the introduction to his descriptions Philostratus gives the rudiments of a theoretical system of the visual arts; he points out the characteristic features of each art, grouping together the different kinds of sculpture (carving in marble, modeling in bronze, carving in ivory, and gemcutting) and juxtaposing them with the different kinds of painting. The expressive values of a work of art are central to his appreciation. Painting especially "both reproduces light and shade and also permits the observer to recognize the look, now of the man who is mad, now of the man who is sorrowing or rejoicing."

Philostratus' grandson, Philostratus the Younger, also wrote a book of descriptions of pictures, explicitly stating that he was following in his grandfather's footsteps. The grandson's literary gifts are much more modest than those of his ancestor, but what he says in his introduction throws intense light on how art, and especially the artist, was seen in the late third century A.D. The painter, he says, in order to be a true master of his art, "must have a good knowledge of human nature, he must be able to discern the signs of men's character even when they are silent, and what is revealed in the state of the cheeks and the expression of the eyes and the character of the eyebrows and, to put the matter briefly, whatever has to do with the mind." The painter's main task is to show character, emotions, and states of mind ("that a

man is insane, perhaps, or angry, or impulsive, or in love"). There is, of course, a deep difference between the view accepted in earlier periods, that an artist's main aim is the embodiment of symmetry and the realization of harmonious beauty, and the new, almost complete concentration on the expressive functions and values of the work of art. The new appreciation of expression, physiognomic or otherwise, almost by necessity militates against the sacrosanct values of symmetric beauty. The rejection of symmetry and correct proportions—so well known from Plotinus, to whom we shall shortly return—seems to have been common in the third century A.D. Philostratus the Younger adheres to this attitude, common in his time, rejecting what "learned men of olden times have written . . . about symmetry in painting" mockingly saying "as if it were impossible for an artist to express successfully the emotions of the mind" without depicting his figures in correct proportions.

Another common motif, found in Philostratus the Younger's introduction, is that painting has "a certain kinship with poetry, and that an element of imagination is common to both." Such views concerning the similarity of poetry and painting were, of course, neither new nor original at that time. Horace had already pronounced the famous simile *Ut pictura poesis* ("As is painting, so is poetry"), and Plutarch defined painting as mute poetry, poetry as a speaking picture.[21] Philostratus only shows a little more clearly what that common quality of poetry and painting is: it is the artist's imagination. The fundamental character of art is thus derived, at least in part, from the pervasive quality that all artists have in common.

The unfolding of the new view of the artist reached a climax in a little book by Callistratus, another Greek rhetorician of the third century A.D. This book consists of the descriptions of fourteen statues by celebrated artists of the classical period, such as Scopas, Praxiteles, and Lysippus. Since Callistratus is familiar with the works of Philostratus the Elder and the Younger, he cannot have lived before the late third century, and some scholars believe that his work should be dated even later. His descriptions are conventional and betray little direct observation; it is not even certain that he actually saw the statues he described. But Callistratus marks an important conceptual development;

he is, to my knowledge, the first, and actually the only, classical author who explicitly attributes inspiration to the sculptor. Since Callistratus certainly was not one of the original and creative minds of his period, one may assume that in his time literary groups existed that held this view, a rather revolutionary one for Antiquity.

Early Greek culture was familiar with the notion of a certain kind of madness *(mania)* that is a blessing of the gods; poets and musicians are particularly prone to receive this gift. Plato explains (*Ion* 533c ff.) that poets and musicians do not produce their songs only by following the rules of *technē;* it is divine interference that makes them capable of creating their works. He distinguishes different kinds of madness (interestingly analyzed in a modern context by E. R. Dodds in his work, *The Greeks and the Irrational*),[22] one of them being "poetic madness," inspired by the Muses. The divine power infuses poets with *enthousiasmos* and even makes them "possessed." Like the Bacchantes who draw milk and honey from rivers of water, so are the poets who themselves assert that they draw their songs from the sources of honey and the groves of the Muses; they cannot compose before they become full of the god and their reason has left them. Edgar Zilsel, in his study on the origins of the concept of genius, to which I have already referred, points out that here we are faced not so much with a social glorification of the poet as with understanding him as a medium for the divine.[23] But, whatever the conclusions of classical scholars may be concerning all these questions, in our context it is of crucial importance that in the intellectual world of the classical period a contradiction was seen between *mania* and *technē,* between inspiration and the following of rules and their execution in physical labor, as required by the art of sculpture. Following the rules of *technē* cannot lead the artist into the temple of the Muses. In a famous passage in *Phaedrus* (245a) Socrates says: "But he who, having no touch of the Muses' madness in his soul, comes to the door and thinks that he will get into the temple by the help of art—he, I say, and his poetry are not admitted; the sane man disappears and is nowhere when he enters into rivalry with the madman." We may conclude (what Plato himself does not say) that the painter and sculptor with "no touch of the Muses' madness in his soul" will not be able to get into the temple.

33

In the long stretch of time between the fourth century B.C., when Plato lived, and the third century A.D., the status of the artist in the intellectual world underwent many changes, as we have seen in the preceding pages. Yet, despite these transformations, the painter and sculptor were never recorded as inspired. One could even imagine that Phidias went up to heaven in order to behold Zeus, but it seems to have been too bold a step for the period to believe that a god would dwell in an artist who was following rules and working with his hands. Callistratus took this step. Opening the description of a "Statue of a Bacchante" (*Descriptions*, chapter 2), he says: "It is not the art of poets and writers of prose alone that is inspired when divine power from the gods falls on their tongues, nay, the hands of sculptors also, when they are seized by the gift of a more divine inspiration, give utterance to creations that are possessed and full of madness. So Scopas, moved as it were by some inspiration, imparted to the production of his statue the divine frenzy within him."[24]

These are startling phrases indeed. Not only are sculptors here equated with poets in being human receptacles of divine inspiration; even the "hands" of the sculptors are capable of being seized by divine inspiration and of being filled with madness. We have already pointed out the conventional character of Callistratus' descriptions, and one should also mention his frequent use of rhetorical formulas. If this impression of Callistratus is correct (and the few scholars who have explored his little book agree on it), he is not likely to have taken this daring departure from tradition by himself; it seems probable that here, too, he is the mouthpiece of his period and that views like those he expresses were accepted in certain groups and circles, though no other written testimony of them has come down to us. The development of the concept of the artist has run its full course.

V. PLOTINUS

As I frequently had occasion to point out in the previous sections, observations made in Antiquity about art and visual beauty were fragmentary; none of the great philosophers discussed the arts as a problem in their own right. Only in the last stages of Antiquity, when the

spirit that had prevailed for centuries was being radically transformed, did aesthetics become a more or less acknowledged branch of philosophy. Aesthetics was, as has often been said, the evening star on the philosophical firmament of classical culture. The philosopher who more than any other embodied this development was Plotinus (A.D. 205– 270). Born and educated in Egypt and teaching mainly in Rome, an heir of the intellectual trends and religious moods and experiences of late Antiquity, he became the founder of Neoplatonism, the powerful intellectual movement that has left such a deep imprint on the history of European literature, art, and ideas up to our own days. In his collected writings (called *Enneads* by his pupil and biographer, Porphyry, who also edited his essays) Plotinus discussed Beauty as an independent subject (*Enneads* I. 6; V. 8). These two treatises are often considered as the foundation of aesthetics.[25]

The Beauty Plotinus speaks about is, of course, not confined to any one art. It is an emotional quality (the beautiful is that which is lovable) as well as a broad philosophical concept (*Enn.* V. 8 deals with Spiritual Beauty). It is, however, important to notice that visual experience in general and the visual arts in particular play a rather significant part in his imagery. In these two essays we find not a single reference to literary beauty, to the loveliness of a poem or a verse, nor is music referred to as an embodiment of Beauty (though in other places one can perhaps detect a reference to the "music of the spheres," carrying a rather metaphorical meaning). But these two essays abound in suggestions of visual experiences and even in references to the visual arts: symmetry is mentioned; light, color, and the brilliance of shining materials belong to Plotinus' most common imagery; the shape of a house is also mentioned, and a stone block carved into a statue is elaborately discussed; we hear of Phidias and of Egyptian hieroglyphics, the visual symbols of the wisdom of the Egyptian sages. It is obvious, I think, that Plotinus was intimately familiar with, and gave a great deal of thought to, the character and fascination of visual experience, and that he knew the visual arts, their history and technique. While the two essays are discussions of philosophical aesthetics, they are so rich in associations with painting and sculpture that, in fact, they almost provide a framework for art theory.

Plotinus' high esteem for the visual arts, however, was more than an unconscious by-product of his natural inclination toward painting and sculpture; he explicitly defends their position. Clearly referring to Plato's denigration of the imitative *technai*, Plotinus says that "the arts are not to be slighted on the ground that they create by imitating natural objects" (V. 8. 1). Nature itself works by way of imitation, and, therefore, the imitating artist is employing a universal principle. In so doing, the artist becomes the fellow workman as well as the competitor of nature, an intellectual status never before granted to him in Greek philosophy. In a complete reversal of the Platonic attitude, Plotinus describes the arts (and the artists) as "holders of beauty, and [they] add where nature is lacking" (V. 8. 1).

In his essay on Spiritual Beauty, Plotinus gives a striking example of the superiority of art over nature. Imagine, he says, two blocks of stone, one placed next to the other. One of the blocks is "unpatterned, quite untouched by art"; the other is "minutely wrought by a craftsman's hand" and shaped into a figure of a god. The carved block is more beautiful than the crude one, and this "by virtue of the Form or Idea introduced by the art." This Form, Plotinus says in a passage that has become a classic formulation of the creativity of the artist, "is not in the material: it is in the designer before it ever enters the stone; and the artificer holds it not by his equipment of eyes and hands but by his participation in his art. The beauty, therefore, exists in a far higher state in the art; for it does not come over integrally into the work; that original beauty is not transferred; what comes over is a derivative and a minor beauty; and even that shows itself upon the statues not integrally and with entire realization of intention but only in so far as it has subdued the resistance of the material" (V. 8. 1).

The revolutionary originality of Plotinus' thought is revealed in many respects. Perhaps most striking is the concept of matter as the realm of the amorphous, a force obstructing form, a substance that can never be completely cast into shape. This negative attitude toward matter, though perhaps not altogether without roots in former stages of Greek thought, foreshadows major trends in the intellectual world of the Middle Ages. In medieval thought, as we know, matter was often "the Evil." Plotinus' emotional disposition must have been similar. Porphyry

begins the biography of his master by relating that Plotinus "seemed ashamed of being in a body." When asked to sit for a painter or sculptor, he answered: "Is it not enough to carry about this image in which nature has enclosed us? Do you really think I must also consent to leave, as a desirable spectacle to posterity, an image of the image?" This is precisely the answer we would expect of a medieval saint, and indeed of some of them similar replies are recorded.

No less important is the placing of the creative principle *(logos)* above the created object. What we long for is the originating power, not the originated thing. For this reason, nature, having an immediate relationship to the creative power, also has a precedence over art. "Why is a living ugly thing more attractive than the sculptured handsome thing?" Plotinus asks, and answers, because it has a soul and is "more nearly what we are looking for" (VI. 7. 22). In a similar trend of thought he says that "art is of later origin than soul; it is an imitator, producing dim and feeble copies—toys, things of no great worth— and it is dependent upon all sorts of mechanisms by which alone its image can be produced" (IV. 3. 10). It is interesting that this very fact—that art is further removed from the creative principle than nature—becomes a criterion for appreciating works of art. Precisely because the living is more attractive than what is artificially produced, even if the latter conforms to established norms, "the most living portraits [are] the most beautiful, even though the other happen to be more symmetric" (VI. 7. 22). It is "animation" that creates the value of the portrait.

In the philosophy of Plotinus the precedence of the Creative Logos over all created objects is, of course, a comprehensive principle, intending to outline a universal hierarchy; however, it necessarily also reflects on his art theory. Within the context of art the artist represents the creative principle, and it therefore follows that he is superior to the work he creates as the origin is superior to what flows from it. In a complete reversal of the attitude common in Antiquity, as expressed, for example, by Lucian and Plutarch, that one admires the work of art but despises the artist, Plotinus situates the artist on a higher level than the work he creates. Being the origin of the work, he is closer to absolute perfection than the material picture or sculp-

ture he produces ever can be. The creative principle is in one phase the Form of the Soul; in another phase it is the "giver of shape" as the sculptor gives shape to the piece of sculpture (V. 9. 3). It has correctly been said that Plotinus' aesthetics is a theory of an "intrinsic form"; every work of art presupposes an intrinsic form, that is, a form or image the artist carries in his mind before he embodies it in amorphous matter. Whatever value (beauty) the material work of art possesses is derived from that form in the artist's mind. The intrinsic form is the *one,* the created works are the many. In his early treatise *On Beauty* Plotinus says that the house the architect built is beautiful because it corresponds to the idea of the house in his mind. The house actually built in stone is "the indivisible exhibited in diversity" (I. 6. 3). Time and again Plotinus emphasizes that within the context of art the creative principle is in the artist. A mirror image of an object, or its reflection in water, is produced by the body of that object, and it is called by Plotinus the "image of the archetype." This is not so with an artist's picture, even if that picture is a self-portrait. A self-portrait is produced not by the painter's body (VI. 4, 10) but by the image dwelling in the artist's soul.

How should one understand this image in the artist's mind? Does it have the objective truth and validity of a Platonic Idea, or is it only a subjective appearance in an individual artist's mind, something to be explored by psychology? There is no clear-cut answer to these questions, as Plotinus' distinction between these concepts is not as sharp as it is in modern thought. But, while Plotinus made an essential contribution toward forming a psychology of the artist, he did not conceive of the image in the artist's mind as a private, personal vision. Phidias, he says, did not create his *Zeus* after any model in nature; he drew the figure's shape from his, the artist's, mind. Nevertheless, that shape is not merely subjective; Phidias gave Zeus the shape the god himself would necessarily have assumed had he chosen to become manifest to sight (V. 8. 1). The image in the artist's soul, impressed—however incompletely—into amorphous matter, is thus not merely "subjective"; rather, it is some kind of revelation of the god's true "essence"; it is a theophany.

Plotinus' philosophy of art, then, is a philosophy of the artist, not

of the work of art. Sometimes, however, he assigns to the work of art a meaning and function that go far beyond the mere realm of aesthetic experience. Particularly interesting is one passage that was quoted and interpreted in the Renaissance and had a far-reaching influence on symbolic interpretations of visual forms in European thought. In this passage (IV. 3. 11) Plotinus attributes to the material work of art a revelatory, theophanic function. "Those ancient sages," says Plotinus, "who sought to secure the presence of divine beings by the erection of shrines and statues, showed insight into the nature of the All; they perceived that, though the Soul is everywhere traceable, its presence will be secured all the more readily when an appropriate receptacle is elaborated, a place especially capable of receiving some portion or phase of it, something reproducing it, or representing it and serving like a mirror to catch an image of it." The work of art, then, is capable of receiving a portion of the Divine, of representing it, and of catching an image of it.

But is the work of art, the shrine or the statue, an altogether dia-phanous veil of the Divine, an object completely translucent for the revelation to shine through? We recall that, according to Plotinus, matter is not capable of being completely formed; every work of art, being necessarily cast in some kind of material, must therefore always contain a residue of amorphous—that is, ugly and evil—matter, and this must be true even for the statue of a god. The ambivalence in the attitude toward the completed work of art is here obvious. The power inherent in the shaped work of art must in some way be the force that makes the spectator go beyond what is materially present and imme-diately visible. And indeed spectators looking at pictures "are deeply stirred by recognizing in the objects depicted to the eyes the presen-tation of what lies in the Idea" (II. 9. 16). Plotinus' warning against the captivating charm of material beauty is contained in a passage that has become famous. Recalling the story of Narcissus who fell in love with his reflection and was swallowed up into the depths of the waters, Plotinus continues: "so too, one that is held by material beauty." For physical beauty is "an image and a vestige and a shadow." He who holds on to physical beauty "will sink, not with his body but with his soul into the dark abysses, horrible for the mind to behold, where he

will languish blindly in Orcus, consorting with shadows there as he did here" (I. 6. 8). Although this is said of physical beauty in general, it certainly holds also for the work of art.

Here we must ask in what beauty consists. As we have already said, Plotinus was the first philosopher to make beauty the principal subject of an essay, and thus instituted aesthetics as an independent branch of philosophy. Drawing on the great philosophic tradition to which he saw himself heir, he originated new concepts and views that made a decisive impact on European thought. "Beauty," of course, is a broad and general subject much wider than painting and sculpture, and it is not a subject for us to explore in its whole breadth. Yet, analyzing the concepts of beauty in the philosophy of Plotinus, one discovers tendencies and trends of thought that have a specific significance for the interpretation of the visual arts.

As we recall, Greek philosophy interpreted beauty mainly as symmetry. It is not the individual elements that compose an object or a body that are beautiful but the relation between these elements, and between them and the whole. This view was considered valid also for the beauty of works of art. Vitruvius, a Roman architect who composed his *De architectura* in the years 16 to 14 B.C., drawing on a large body of Greek professional literature that is now lost, provides an explicit application of this definition of "beauty" to the visual arts. Symmetry, he says, is the "appropriate harmony [*consensus*] arising out of the parts of the work itself; the correspondence of each given part among the separate parts to the form of the design [*figura*] as a whole" (*De arch.* I. 2. 4). Without going into a discussion of this concept, we might say that symmetry suggests the measurability of both the individual form (or part) and of the whole composed of those parts. Measurability, in its turn, suggests that symmetry is capable of being rationally apprehended (and in some periods it was even believed that it can be proved). Further, one is induced to believe that symmetry, being a structural relationship, is of an inherent constancy and is not prone to quick and sudden changes.

But how can a face, constant in its symmetry, now appear beautiful, and now devoid of beauty? The most radical turn in thought on beauty brought about by Plotinus is his explicit rejection of symmetry as the

definition of "beauty." Presenting the accepted theories, he calmly opens his early treatise on *Beauty* (I. 6) by concluding that, if symmetry is indeed the essence of beauty, only a whole composed of individual parts can be beautiful, whereas the individual parts, or elements, cannot be so, since they are devoid of parts and thus have no internal relation. But, Plotinus argues, nothing beautiful can be composed of parts that are not beautiful in themselves. His train of thought leads to the conclusion that the beautiful is—ultimately—simple, not compounded, and therefore cannot be sharply defined. Plotinus strives to deprive beauty of fixed borders, to make it a fluid quality.

Beauty is instantly recognized by the beholder; we perceive it directly, grasp it intuitively, and react to it immediately. It is worth listening to Plotinus' vivid formulation: Beauty is "something that is perceived at the first glance, something which the Soul names as from ancient knowledge, and, recognizing, enters into unison with it. But let the Soul fall in with the Ugly and at once it shrinks within itself, denies the thing, turns away from it, not accordant, resenting it" (I. 6. 2). Beauty, then, is essentially a simple, indivisible quality, discerned by us because it is of a similar nature as the Soul itself. In a passage quoted throughout the centuries Plotinus made this clear in an example: "To any vision must be brought an eye adapted to what is to be seen, and having some likeness to it. Never did eye see the sun unless it has first become sunlike, and never can the Soul have vision of the First Beauty unless it itself be beautiful" (I. 6. 9).

This broad concept of beauty conjures up a view of the visual arts in which the expressive power, though hard to define, is considered as the decisive value. What captures the beholder is neither the carefully balanced symmetry nor the virtuosity of the artist or his perfect skill of execution; it is, rather, a quality that "shines through" and to which the soul has a direct link. The examples Plotinus adduces suggest an even more specific tendency of style that he must have felt was in accordance with his general theory of beauty. The Pythagorean-Platonic tradition draws its artistic examples from the realm of measurable shapes (speaking in modern art-historical terms, we could almost call them linear). Plotinus takes his from observations of light, color, and brilliance, and his examples clearly show how fascinated he was

with these phenomena. The loveliness of color and the light of the sun are his principal examples of a simple, uncompounded beauty; nor can the glitter of gold and the brilliance of the stars in the night sky be explained by symmetry (I. 6. 1). Among all material bodies fire is the most splendid, and it actually goes beyond the realm of the material: "hence the splendor of its light, the splendor that belongs to the Idea" (I. 6. 3). The sun, overflowing with light and yet never decreasing in its luminosity, becomes the primary image of emanation, a kind of incessant creative act (VI. 7. 22).

Though it is true that Plotinus often uses the imagery of light and brilliance in a metaphorical sense, this imagery can also be seen to indicate a tendency in the appreciation of art. Among the variety of features that the visual arts present, the glittering and brilliant are clearly the most fascinating; they replace the examples of former periods in which the linear character or the quality of a statue's solid matter is suggested. It is interesting to note that the new emphasis on the artist and spectator, on expression rather than on measurable structure, goes together with the emphasis on the "painterly" effects of luminosity, color, and brilliance. They all foreshadow the development—in thought as well as in art—of some periods to come, and they also show that Plotinus was a decisive turning point in the philosophy of art as well as in the prominence he gave to certain specific elements of artistic creation.

NOTES

1. Classical texts are quoted according to the conventional division; references are given in the text.
2. Almost every history of aesthetics includes a discussion of Plato's philosophy of art. Among modern investigations emphasizing the visual arts see esp. P. M. Schuhl, *Platon et l'art de son temps* (Paris, 1933); W. J. Verdenius, *Mimesis: Plato's Doctrine of Artistic Imitation and Its Meaning to Us* (Leiden, 1949); B. Schweitzer, *Platon und die bildende Kunst der Griechen* (Tübingen, 1953); and most recently E. Keuls, *Plato and Greek Painting* (Leiden, 1978).
3. U. Wilamowitz-Moellendorf, *Platon* (Berlin, 1920), I, p. 479.
4. R. McKeon, "Literary Criticism and the Concept of Imitation in Antiquity," in R. S. Crane, ed., *Critics and Criticism, Ancient and Modern* (Chicago, 1957), pp. 117–145.

5. For a recent summary of classical theories of imitation (in addition to the studies mentioned above, notes 2 and 4) see G. Sörbom, *Mimesis and Art: Studies in the Origin and Early Development of an Aesthetic Vocabulary* (Uppsala, 1966).

6. For the technical and aesthetic vocabulary (particularly of the visual arts) see the careful and instructive work by J. J. Pollitt, *The Ancient View of Greek Art* (New Haven, 1974).

7. For Aristotle's views on the arts see (in addition to the literature already mentioned) two older studies: S. H. Butcher, *Aristotle's Theory of Poetry and Fine Arts,* with a critical text and a translation of the *Poetics* (London, 1911); A. Rostagni, "Aristotele e Aristotelismo nella storia dell'Estetica antica," reprinted in the author's *Scritti minori,* I, *Estetica* (Turin, 1955), pp. 76–254.

8. This study, which originally appeared in *Neue Heidelberger Jahrbücher* in 1924, is now easily available in Schweitzer's collected articles, *Zur Kunst der Antike* (Tübingen, 1963), I, pp. 11–104. For the concept of artistic creativity in Greek thought, particularly with regard to the painter and sculptor, see also E. Panofsky, *Idea: A Concept in Art Theory* (New York, 1968), chap. 1. Panofsky's study originally appeared in German in 1924, the same year in which Schweitzer's article was published.

9. Schweitzer, *Zur Kunst der Antike,* I, pp. 47 ff.

10. See W. Jaeger, *Paideia: The Ideals of Greek Culture* (New York, 1945), III, pp. 3–45.

11. For the quotation from Galen (as well as for other Greek and Roman sources on the visual arts) see J. J. Pollitt, *The Ancient View of Greek Art* (New Haven, 1974), p. 15.

12. E. Panofsky, "The History of the Theory of Human Proportions as a Reflection of the History of Styles," *Meaning in the Visual Arts* (Garden City, N.Y., 1955), esp. pp. 62 ff.

13. See Pollitt, *The Ancient View of Greek Art,* passim, esp. pp. 74–77. And cf. the extensive discussion by B. Schweitzer, "Xenokrates von Athen; Beiträge zur Geschichte der antiken Kunstforschung und Kunstanschauung" (Halle a.S., 1932), included in *Zur Kunst der Antike,* I, pp. 105–164.

14. Cf. E. R. Dodds, *The Ancient Concept of Progress and Other Essays in Greek Literature and Belief* (Oxford, 1973), with further bibliography.

15. For classical concepts of symmetry see the passages collected by Pollitt, *The Ancient View of Greek Art,* s.v. "symmetria." Interesting is what a great modern mathematician has to say about Greek views of symmetry. See H. Weyl, *Symmetry* (Princeton, 1952).

16. Jaeger, *Paideia* (New York, 1965), I, p. 126.

17. I am here following Pollitt, whose illuminating collection of texts from classical literature (*The Ancient View of Art,* s.v. "akribeia," pp. 117 ff.) brings out clearly the meaning of this concept.

18. J. Burckhardt, "Die Griechen und ihre Künstler," in *Vorträge 1844–1887* (Basel, 1919), pp. 202–214; Schweitzer *Zur Kunst der Antike,* I, pp. 47 ff.; Zilsel, *Die Entstehung des Geniebegriffs* (Tübingen, 1926), pp. 7–105.

19. See Origen, *De principiis,* III. For a good survey of ancient doctrines of imagination see M. W. Bundy, *The Theory of Imagination in Classical and Medieval Thought* (Urbana, Ill., 1927). Bundy explores theories of imagination in general, with no particular focus on the artist's fantasy. Yet the materials he collected help us understand what Antiquity thought of the artist's imagination.

20. H. W. Janson, "The 'Image Made by Chance' in Renaissance Thought," in *16 Studies* (New York, n.d. [1974]), pp. 55–69 (originally M. Meiss, ed., *De artibus opuscula XL: Studies in Honor of Erwin Panofsky* [Princeton, 1961], pp. 254–266).

21. See Horace, *Ars poetica* 361; Plutarch, *De gloria Athenensium* III. 346f—347c. *Ut pictura poesis* became one of the central motifs of humanistic art theory, especially in the Renaissance and the Baroque periods. For these later periods see R. Lee, *Ut pictura poesis: The Humanistic Theory of Painting* (New York, 1967) (originally an article in *Art Bulletin,* 1940).

22. E. R. Dodds, *The Greeks and the Irrational* (Berkeley, 1971; 1st ed., 1951), pp. 64 ff.

23. Zilsel, *Die Entstehung des Geniebegriffs,* pp. 14 ff.

24. Callistratus' *Descriptions,* a rather short text, is frequently published together with Philostratus' *Imagines.* See, e.g., *Philostratus Imagines, Callistratus Descriptions,* with an English translation by A. Fairbanks (Loeb Classical Library, 1931). For the passage quoted see p. 381.

25. Plotinus' aesthetics is surveyed in all major histories of aesthetics. For monographic studies see E. de Keyser, *La signification de l'art dans les Ennéades des Plotin* (Louvain, 1955), and F. Vanni Bourbon di Petrella, *Il problema dell'arte e della bellezza in Plotino* (Florence, 1956). See also Panofsky, *Idea,* pp. 25 ff.

2

The Middle Ages

To formulate the subject matter of this chapter is to beg a question. Did the Middle Ages have an art theory? In that period, as one knows, the "fine arts" were not recognized as such. The concept and term of "art" *(ars)* were even more vague than in Antiquity. To a medieval mind, *ars* meant a body of knowledge, or a system of rules that could be taught. The term *artista* seems to have been coined in the Middle Ages, but it was equally broad in meaning; it could be used to describe an artisan of any kind as well as a student of any of the liberal arts. Such terminological equivocations are particularly significant in a culture that so highly valued systematic grouping and arrangement. The Middle Ages took over from late Antiquity the system of the seven "liberal arts" as a comprehensive classification of human knowledge, subdividing it into the trivium (grammar, rhetoric, dialectic) and the quadrivium (arithmetic, geometry, astronomy, music). In none of these disciplines could the visual arts find an appropriate place, and in historical reality they were in fact relegated to the artisans' guilds, that is, to fields of activity that, in the eyes of the period, were devoid of theoretical knowledge. Moreover, the individual arts were separated from each other and considered in altogether different contexts: the painters were frequently grouped together with the druggists, who

prepared their paints; the sculptors were often associated with either the goldsmiths or with the stonemasons. This general development, lucidly summarized by Kristeller,[1] contributed to obscuring the concept of the fine arts and to making it even less distinct than it had been in Antiquity.

Furthermore, medieval and aesthetic thought was also conditioned by the belief—always present in the background of medieval culture in general—in a chasm between the celestial and the terrestrial, between the internal and the external. Theological thought and monastic attitudes often leaned toward an outright rejection of painting and sculpture, the arts producing "graven images," intimating that they are superfluous, tempting, or even outright devilish. No wonder, then, that in no other period did iconoclastic trends reach such a high degree of articulation as in the Middle Ages.

All this not only characterizes medieval attitudes to the visual arts; it also explains why so much of that period's thought on painting and sculpture is distorted, scattered in the discussion of other subjects, and almost hidden from sight. For a long time scholars indeed agreed that the Middle Ages lacked an aesthetic approach to the visual arts. But a serious study of the ideas current in the times between the decline of the Roman Empire and the beginning of the Renaissance is bound to reveal that the *medium aevum* (middle age) did have modes of its own in viewing and understanding the arts, that it raised new questions and formed new concepts. Admittedly, medieval approaches often radically differ from those of earlier and later periods, particularly with regard to the theory of art. What in the Middle Ages appears as art theory is only *one* part—and probably only a small part—of that period's contribution to our understanding of the problems posed by artistic images. To grasp the full scope of medieval views on visual imagery one has to study ideas scattered in fields that would normally not be counted among the sources of art theory.

The diversity of opinions and the dispersion of texts reflects a complex historical reality. Various social groups held different views on pictures and statues, the attitudes of religious movements changed, and the problem of the image was discussed on different intellectual levels, from the simple artisan to the highly educated scholar. To discover

some order in this seemingly chaotic picture we must remember, first of all, the chasm between the Byzantine East and the Latin West. Though there were mutual influences (mainly exerted by the East on the West), the attitudes to art in the two great medieval cultures remained divergent. What excited the minds in Byzantium never achieved equal significance in the West, and some issues discussed in the West have no counterpart in the East. These two traditions, then, have to be considered separately. We shall begin with the central problem in Byzantine thought of art.

I. ICONOCLASM

Never in European history has the problem of the image been so violently disputed as in one great period of the Byzantine Empire. Here one can quite literally speak of "violence": important social and political movements that shook the very foundations of the eastern Christian empire were focused on the acceptance or rejection of holy images. This question was for a long time the central issue of Byzantine politics, and foreign ambassadors seriously reported home on the fortunes and changes of the dispute. Modern historians have made it amply clear that behind the different attitudes adopted by the parties, in favor of or against images, there were other, more worldly motivations, such as who would be in control of the state or who would decide on the distribution of wealth and resources. But, whatever these motivations may have been, in principle, and at least as it appeared to many contemporaries, the battle was fought over the theological question: What is the statue of an image representing Christ or any other divine figure? It was, then, a conflict in the realm of thought. And in the course of what we have now come to call the "Iconoclastic Controversy" a large literature was produced in which questions were raised and subjects explored that have a direct bearing on our understanding of art and that became an integral part of any theory of painting and sculpture. These specifically art-theoretical questions were raised inadvertently, so to speak, not as questions in their own right; the language and conceptual framework of these discussions were theological rather than aesthetic. Yet it remains true that some problems

that we nowadays inseparably connect with the philosophy of art—as, for instance, What is similarity?—have never been more profoundly discussed than in this strange medieval literature. In a precise sense, as a broad political upheaval, the Iconoclastic Controversy was limited to the eighth and early ninth centuries A.D. Within that period victory and defeat frequently changed sides, now the party attacking images, now the party defending them gaining control. As an intellectual and emotional issue, however, the problem of the image never lost its urgency and consequence since it first appeared in the early Christian period. In the following presentation we shall disregard both the social and the political significance of the ecclesiastical discussion of the icon, and the different periods in which it evolved.[2] We shall only try to follow the argument.

Early Christianity was confronted almost immediately with the need to determine its position with regard to the image, in painting as well as in sculpture. Even in its earliest stages the new religion exhibited conflicting attitudes.

The early Christian attitude best known to us was the rejection of any kind of religious image and its denunciation as an idol. The major source of this position was, of course, the biblical prohibition of "graven images." The scholarly literature[3] that has arisen around the few biblical sentences condemning images (mainly Exodus 20:4–5) has disclosed many variations and inconsistencies in the text and has opened up weighty questions of interpretation. Did the biblical text (itself consisting of different layers) condemn *any* visual representation of any subject? Was it intended to ban only the visual image of God? Or, finally, was it meant only to prohibit the worship of such images? The answers suggested by different scholars are not unequivocal. Another question, often discussed in modern scholarly literature, is: To what extent were those biblical interdictions actual guidelines for historical Jewish society at the period when the early Christian Church was emerging from that society? Many Jewish monuments of that period, lavishly decorated by various visual motifs (including quite a few sarcophagi of rabbis decorated with carved images), would seem to indicate that the attitude of the rabbis was far from uniform and that the biblical prohibitions were not consistently implemented. Analysis of

contemporary texts seems to strengthen the impression that even then the biblical texts were variously interpreted. Nevertheless, there can be little doubt that the biblical prohibition of graven images played an important part in early Christian thought on the visual arts in general and on icons in particular.

Another tradition, profoundly different in character and origin from the biblical heritage but equally hostile to idols, may also have been a factor in molding early Christian thought on the subject. Among the educated classes of Hellenistic and Roman society the belief in idols was considered, and often expressly ridiculed, as a form of primitive superstition, characteristic of the uncouth and illiterate. Horace, in a famous passage of his *Satires* (I. 8. 1), makes a wooden statue of a god say: "Once upon a time I was the trunk of a wild fig-tree, a useless log, when a carpenter, after some doubt as to whether to make me a privy or a Priapus, decided to make me into a god. So I am the greatest deterrent of thieves and birds." Horace's sarcasm does not have the passionate tone of prophetic conviction that inspires a very similar passage in Isaiah (chapter 44), but both suggest that idolatry implies a crude, uncritical clinging to the material and the tangible to guarantee the presence of the spiritual and the divine. Hellenistic and Roman enlightened writers liked to make fun of the absurdity of idol worship and of identifying the idea of a god with the statue purporting to represent him. Thus, Dionysus the Younger of Syracuse, a rhetorician of the Hellenistic school, tells the story of stripping a statue of Zeus of a golden mantle and replacing it by a woolen one: the woolen mantle will be lighter to wear and will keep the god warmer in the winter. And Diogenes Laërtius tells of another rhetorician who, in front of a statue of Athena, asked whether she was the daughter of Zeus, and therefore a goddess. But this statue was made by Phidias, and so she was not a goddess (*The Lives and Opinions of Eminent Philosophers* II. 11. 116). What all these educated authors wished to show (and this idea must have been shared by their public) is the sheer absurdity of the belief that any divine essence can be caught in a tangible piece of matter shaped in a specific, finite form.[4]

There can be little doubt that these opinions, though popular mainly in educated pagan groups, made an impact on early Christian thought.

In fact, most Christian argumentation against images and the belief in idols closely follows the models provided by these pagan authors.

The rejection of images, however, was far from consistent in early Christianity; there were also strong tendencies and traditions supporting the belief in the inherent "truth" of images and in their magic power; if this were not so, one would have to explain how Christian art could have been created at all. In order to understand early Christian acceptance of holy images, let us look, however superficially, at the sources that may have nourished it.

In late Antiquity venerated images could be seen everywhere. The most common examples were certainly the images of emperors, carved in stone, cast in bronze, produced in more perishable materials, in all possible shapes and sizes. These images were not viewed just as "portraits"; in popular belief as well as in legal fiction they were invested with a special kind of power and reality that could not be altogether discarded as fictitious. Modern scholars have often explored the status of these imperial images. Following Kenneth Setton's interesting discussion of the subject, we learn that the emperor's likeness imparted the same degree of dignity to the object bearing it whether it was made of clay or of gold; an insult to that image could not be absolved on the ground that one merely attached no value to clay or to gold. The emperor's image was considered, in some respects, as identical with the emperor himself. A fugitive reaching an imperial effigy was granted ten days' asylum. To say that the emperor's image was only a symbol of the emperor in the modern sense of the term (i.e., an object or form standing for the emperor but having nothing real in common with him) would surely not be true of ancient beliefs. In some sense, then, the emperor's image *is* the emperor.[5]

There may have been another source as well for early Christian belief in images: the cult of relics and the faith in their supernatural power. The relic, that is, any material object that had been in physical contact with a saint, or that was even supposed to be part of his body, was believed to retain something of his supernatural powers. For this reason relics could perform miracles, of which the popular literature of the period reported a great many. Images cannot automatically be included in the same class of objects as relics—except for miraculously

created icons, to which we shall shortly return—but the image was often believed to show something of the relic's close, direct connection with the original, with the holy face that it portrayed. Emotionally, then, if not theologically, the belief in relics could have been a further source of the belief in images. Scholarly explorations of early Christian religion have indeed shown that the belief in relics and sacred images was widespread in the Christian communities of the first centuries of our era. Recently many testimonies to such beliefs and the devotional practices based on them have been collected. Studying this material, one cannot avoid the feeling that, though only in some vague sense, the image was confused with its original. Many people somehow believed that the icon *was* the holy figure that it portrayed.

So far I have outlined the social and cultural background of Christian thought on art. The contradictory tendencies that prevailed in the communities were also expressed in the theological writings of the period. In fact, the conflict between these attitudes must have been felt strongly enough for very many contemporary theological writings to refer, in one way or another, to this question. Although modern scholars have often studied the attitude of early Christianity to images (and perhaps because this was done either by art historians or by theologians), the relationship between the practices of the early communities and the theories formulated by contemporary theologians have not been sufficiently explored. I would venture to say (though I cannot prove it here in detail) that the theologians were much more consistent and determined in their rejection of images than were the laymen. The reason for this may be the disparity between the usually high intellectual level and broad education of the authors of theological treatises and the certainly considerably lower intellectual level of most members of the congregation, who were probably emotionally deeply attached to inherited customs.

The reasons the theologians give for rejecting images (in addition to quoting the prohibitions found in the Old Testament) are mostly such as we already know from pagan literary sources: the images of the gods are, in fact, nothing but pieces of senseless and lifeless matter; they are all man-made; they can be stolen, disfigured, corrupted, and so on. The belief that these images are more than just pieces of stone,

wood, or colored surface is sheer foolishness. In addition to these arguments, almost endlessly repeated, two features are more strongly emphasized in Christian than in pagan thought.

One of them is the great attention given to the dangers inherent in idols. Many authors believe that pagan idols are inhabited by demons. Sometimes it is suggested that the statues of pagan gods are themselves demons. In the words of the early Greek Church Father, Clement of Alexandria (*Exhortation to the Greeks* IV), these statues are "unclean and loathsome spirits" who haunt graves. In the third century, Tertullian (*Apologeticum* 22) suggests that demons destroy the mind "by frenzy, madness, and hideous lusts" and thus provide the fat and blood that is the nourishment of the idols. Even St. Augustine assumes some connection between idols and demons.[6] But the danger inherent in visual imagery is not limited to the statues of pagan gods. The early Church Fathers often write of the morally corrupting influences of images in general. Men have fallen in love with the statues of beautiful nude women, have had intercourse with them, and have finally gone out of their minds. "Craftsmanship is powerful," says Clement of Alexandria, a great and perhaps surprising acknowledgment of the expressive force in art.

The other feature, possibly of even greater consequence for aesthetic thought, is of a completely different nature: the awareness that a true representation of the divine is impossible because the divine and the work of art purporting to portray it are of an altogether different character and belong to different levels of reality. The divine is immaterial; it has no definite, specific forms; it is invisible. The work of art, on the other hand, is by necessity material; it has definite, specific forms; and it is completely rooted in the realm of the visible and tangible, in the field of sensuous experience. To use one of the earliest formulations showing the awareness of this complete contrast between the divine and the image, found in Clement of Alexandria's *Exhortation to the Greeks:* "a statue is really lifeless matter shaped by a craftsman's hand; but in our view the image of god is not an object of sense made from matter perceived by the senses, but a mental object. God, that is, the only true God, is perceived not by the senses but by the mind."[7] Here, then, an abysmal gap is opened up. How can the immaterial and

invisible be revealed and appropriately represented in a material work of art presented to the senses? This was the central question of that great movement we know as the Iconoclastic Controversy.

But in early Christianity there had already emerged the rudiments of a theory of the icon that gave theological justification to the painted and carved image. Theological statements in favor of icons followed actual practice rather than instituting it. As K. Holl, an eminent student of the early Church, has pointed out,[8] these statements diminished the sense of paganism or heresy that surrounded the image in the original Christian communities (in the first two or three centuries A.D.). A certain legitimacy of the sacred image was thus established. Many of the reasons for defending and worshiping sacred images made their appearance in the theology of the period between the reigns of Justinian (527–565) and Leo III (717–740). Icons, it was then said, are "reminders" of him whom they portray; they are "symbols" of what they represent. The theologians of that period were of course not simply idolatrous; they always emphasized the distance between the symbol and what it symbolized.

But, in spite of their good intentions, we here perceive a powerful trend to break down the barriers between the image and its model. In the time between Justinian and Leo III theologians and storytellers often said that a saint's (or even Christ's) spirit "overshadows" his image (they were borrowing the term from Luke 1 : 35 where, in the story of the Annunciation, it is said that the Holy Ghost "overshadows" the Virgin). Such beliefs legitimized the cult of Christian holy images and helped spread them throughout the Byzantine world. But "overshadowing" also suggests—even if only vaguely and unintentionally—an affinity between the image and its origin, between the picture and its model.[9]

We cannot trace here the history of the Iconoclastic Controversy in all its facets. We shall make only a few comments on the ideas that had a direct bearing on the position of the icon and implicitly raise a central question of any philosophy of art. The Iconodules (lit., "worshipers of images") eventually emerged victorious from the long struggle, and they systematically destroyed all the texts composed by the defeated Iconoclasts (lit., "breakers of images"). The victorious party

did such a thorough job that, with a few exceptions, we have to learn the Iconoclasts' views from the summaries of their opponents and from a few scattered quotations found in the polemical treatises of their foes. The major lines of the argument are nevertheless obvious.

The attack on religious images—and implicitly on all artistic imagery—was opened by the Byzantine emperor Leo III sometime between 726 and 730. Leo III was probably of Syrian origin, and modern scholars have considered the possibility that his iconoclastic attitude was largely determined by the cultural and religious traditions in the Near East.[10] In fact, only a few years earlier Khalif Yezid II (720–724) ordered the complete destruction of all cult images surviving in his realm, which bordered on that of the Byzantine Empire. It has also been suggested[11] that Leo III may have been influenced by the well-known iconoclastic attitude of the Jews, who played an important part in the economic and cultural life of the period. Although Leo III actively and violently fought the religion of Islam and frequently forced Jews to convert to Christianity, the impact of both Islam and Judaism cannot be ruled out as sources of his iconoclastic views. However, the full theoretical articulation of Iconoclasm is a specific development of Christianity in the East and is probably unthinkable without the survival of classical trends in the Byzantine world.

What were the arguments in the Iconoclastic Controversy? Disregarding the sequence of their historical unfolding, they may, from our point of view, be summarized in a few specific problems.

Perhaps of the greatest significance was the dispute over what an image is and over the criteria that make an image valid, or "true." The dispute did not start over a purely theoretical question—such as, What is an image?—but rather over specific instances of adoring images of Christ. However, the dispute resulted in a discussion of what an image is and where it should be placed in an encompassing hierarchy of religion. We cannot even be sure that the parties paid much attention to the philosophical formulations as such, divorced from the practical application. Nevertheless, we do find here an important contribution to the philosophy of art, a contribution that has not been sufficiently appreciated by historians of aesthetics.

The Iconoclasts violently denied the very possibility of an appro-

priate or true representation of Christ. For an image to be true, so their argument ran, it must be of the same essence as the model it depicts. But Christ, as we know, is of two natures: corporeal and spiritual, human and divine. The visual arts can represent only the corporeal and human; only these are given to visual experience. Repeating, and further sharpening, the thought of former generations, the Iconoclasts stressed that the spiritual and the divine are altogether beyond the grasp of the visual experience and, therefore, also of the visual arts. Therefore, not only is a portrait of Christ impossible, but any icon of him implies that he has only one nature and therefore comes dangerously close to Monophysite heresy (i.e., the heresy attributing only one nature to Christ).

Analyzing the iconoclastic argument, we necessarily reach the conclusion that a true picture is not a picture at all. Identifying the image with its model—that is, attributing to them a common essence—removes the very basis of the specific character and particular existence of the image qua image. In purely theoretical terms we are faced with a dilemma: either a picture is true, that is, it is identical with its model—and then it is not a picture at all, or the picture does have its own specific character and existence as an icon—but then it has no common essence with its model; it is not true and is, strictly speaking, not an image *of* that model.

Professor Ostrogorsky, in a classical study of Iconoclasm, has suggested that this attitude originates in Oriental approaches and that in its essence it is magical.[12] Whatever the origin and the specific character of this approach, it surely denies the possibility of the image.

What was the reply of the Iconodules, the defenders and worshipers of images, to this aggressive attitude of the Iconoclasts? Did they defend pictures by describing them as mere products for aesthetic contemplation, as objects with no world-shaking theological consequence? Probably the best presentation of the Iconodules' views is found in the three sermons "Against Those Who Depreciate Holy Images" by St. John of Damascus.[13] St. John (ca. 675–749), a native of Syria who spent the latter part of his life in a monastery near Jerusalem, was one of the central figures in the thought of the eastern Church, and his influence was felt for many centuries. His major theological work, *The*

Source of Knowledge, probably served as a model for St. Thomas Aquinas's *Summa theologica,* the most important work of western Scholasticism. St. John was also an ecclesiastical poet; his hymns are considered the climax of hymnology of the eastern Church. The philosophical source of St. John, as that of most other defenders of images, is Plato's thought, especially as developed by later, Christian as well as pagan, commentators.

Iconoclastic thought forced upon every believer an unmitigated either-or: either the image is identical with the model, or it is altogether different from it and they have nothing in common. The later Platonists tried to find a bridge over this gap and discovered it in the Platonic concept of "participation" *(methexis).* This concept became the basis and point of departure of Iconodule theory. Plato used the term "participation" (see mainly *Phaedo* 100d) to describe the relationship between the universal Idea and the sensible particulars. The specific and particular is not identical with the universal (Idea), but it is also not completely divorced from it: rather, the particular "takes part" in the universal. Plato himself had already suggested features of visual experience, especially colors, in this context. The later Neoplatonists, especially after Plotinus, made *methexis* a central category of their thought, particularly with reference to images in the broadest sense of the term. What "participation" precisely is they never made completely clear, but any use of the term intimates that the participating image is neither identical with its model nor completely cut off from it. The image participates, "in some way," in the model, the Iconodules said, and therefore it enables us to get into contact with the original; it makes it possible for us to grasp what the essence of the represented figure is, but it is never identical with the archetype. The Iconodules stressed that though the image participates in the archetype it belongs to the very essence of the picture to be different from its model. "Nobody is that mad," says Theodore of Studion, one of the liveliest defenders of images, "to believe that the shadow and the truth [i.e., the object that casts the shadow] . . . should be of the same substance."[14]

For the Orthodox, as the defenders of images were later called, participation is not a category specific of the painted icon only: rather, it is a universal principle. The whole world is a system of symbols or

images, every single one of them suggesting the invisible behind it, in which it participates. Even Scripture is a simile, or an image, of the Divine. In the Incarnation of Christ matter itself—in the body of Christ as a human being—has been transfigured, man is an image of God, and so forth. Painted icons, then, are nothing but a particular instance of a principle encompassing the whole world. This is the fullest justification of the religious image, and it remained valid in Byzantine, and largely also in western, Christian thought.

Another problem of great consequence in the Iconoclastic Controversy is the *function* that the icon, the real, material, devotional image, can fulfill. For Iconoclasts complete rejection of the icon is a logical and necessary result of their theology. Since a "true" image of the Divine is altogether impossible, the actual icon is misleading, an "idol," and inhabited by demons. Images of the Virgin and the saints are not impossible to the same degree as the image of Christ, but they, too, lead to idolatry. Going back to early Christian sources, the Iconoclasts violently and relentlessly condemned the makers of images. The disparagement of the icon, although in itself based on theological reasons only, also determined the social and religious position of the artist. We shall shortly come back to this question.

For the defenders of images the material icon fulfills a vital function. As in theology, the concept of the image bridges the gap between the human and the divine, so does the painted icon in actual devotional practice. "The homage offered to images passes through them to the persons whom they represent," said some of the early Fathers of the Church,[15] and this idea was repeated by the Iconodules in a vast variety of formulations. As Edwyn Bevan convincingly showed,[16] St. John did not only say that, since the picture of Christ "reminds" the Christians of their Savior, worshiping the image is not idolatry, that it is harmless; in fact, he definitely believed that it was right to worship pictures and images, that this is a positive value. This can only be explained by the belief that there *is* some transfer from the image of the devotion offered it to the prototype, to the figure depicted in the icon. The icon is a real channel from the human to the divine, from the terrestrial to the celestial. This, in turn, leads us back to the theological concept of participation. Only because the image of Christ

participates in the divine prototype can the painted icon perform the function of mediating between the mortal believer and the god.

The belief in the hidden presence of the divine in the material icon was so deeply rooted in medieval, and especially in Byzantine, culture that it produced a vast number of legends attesting to the mysterious life concealed in the picture and proving that the icon is not "lifeless and soulless matter," as the Iconoclasts would have it. We read of countless miracles performed by statues and pictures of Christ, of the Virgin, and even of saints. Sacred images healed the sick, saved those who were in mortal danger, protected the just against the attacks of the wicked. We hear of the icon of Christ that bleeds when attacked by Jews or Saracens, of the Virgin's statue shedding tears or interceding on behalf of sinners. It is well known, of course, that such stories may be found in different religions. Kris and Kurz in their excellent—and too little known—study of the legend of the artist, have shown that the very same legends appear in different cultures and may be said to belong to a universal stock of archetypal beliefs.[17] In Byzantine culture they were a powerful factor, shaping religious and aesthetic attitudes. They were known mainly as popular stories, usually related by less educated believers. But these beliefs also reached into higher ranks; they were also accepted by the educated and the learned. It will suffice to quote again St. John of Damascus. In the first of the sermons mentioned above we read: "Devils have feared the saints and have fled from their shadow. The shadow is an image, and I make an image [of a saint] that I may scare demons."

The magical conception of the image, latent in the attitude of the Iconodules, is made manifest in the belief in miraculously created icons, images that were not shaped by the hands of human artists. Such images—*acheropoietoi,* as they were called—were objects of public and private devotion. Often they were explained as miraculous impressions of the "original," and thus show particularly clearly their origin in the cult of relics. Probably the best-known story of this type is that of Veronica's veil, on which Christ's face was impressed. A famous variation of the same story is the legend of the icon of Edessa: a painter, sent by King Abgar of Edessa to portray Christ, cannot perform his task because of the intense light radiating from his face; Christ takes a

piece of cloth, presses it against his face, and leaves his image on it. This icon was believed to have saved the city of Edessa in a later siege. These legends and beliefs originated, and were popular, in the preiconoclastic period, but during the eighth and ninth centuries the defenders of images made extensive use of them.[18] Here was divine legitimation of the icon as a true image, and therefore as a legitimate mediator between the worlds.

A modern reader acquainting himself with such Byzantine stories cannot fail to see the ambivalent attitude toward the visual arts behind the notion of the "image not made by hands." On the one hand, the miraculous, self-created image is decisive "proof" of the rightness of images in general. On the other hand, however, it calls into question the validity of the regular icon, the one made by human hands. The *acheropoietas* may save the *principle* of the image against iconoclastic arguments, but it also admits that there are two classes of images: the few that were miraculously created and the many regular icons produced by the skill and labor of human artists. The second class of icons is necessarily placed on a lower rung of the hierarchic ladder.

Equally important is what these stories indicate of the artist's standing. If the self-created image is the ultimate justification of the image in general, it is implicitly admitted that the artist in his workshop *cannot* produce a true image, that the painter's work is not fully legitimate in itself. We are not surprised, therefore, that the many Byzantine treaties written in defense of images say practically nothing about the artists who produced them. One could accept an icon, and even worship it, and yet completely disregard the artist.

Among the many authors who participated in the Iconoclastic Controversy there was indeed not a single artist. Considering the social position of the painter in Byzantium, this may not be too astonishing. But it is interesting that among the many learned theologians who took part in this discussion—as we know, a discussion that lasted for more than a century—none seems to have been familiar with the process by which a work of art is shaped, and none of them seems to have visited a workshop in which these very icons that they so passionately defended were produced. A vast amount of literature is devoted to the problem of the icon, yet it tells us very little of the artists and the

workshops. In retrospect, nobody will doubt the great significance of the Iconoclastic Controversy for the evolvement and articulation of philosophical thought on art, but we must remember that this whole controversy was divorced from actual art.

II. THE EARLY MIDDLE AGES: THE WEST

In the western parts of what was once the Roman Empire a different intellectual climate prevailed in the early Middle Ages. Here the image did not become the central problem of aesthetic thought, and what was said about it lacks the profundity and refinement characteristic of the great eastern culture. Western thought pulled in many different directions. But this very fact opened up new vistas and raised questions of which the East, in its single-minded concentration on *one* problem, was not aware.

The historical background of western thought was radically different from that of the East. While in the East, in spite of crises and upheavals, a continuous cultural tradition prevailed, in the West disruptions of continuity and the complete overturning of established institutions were the dominant characteristics of social and cultural developments. Only in the West did the Roman Empire really and visibly break down. Nomadic tribes, carrying with them a culture completely alien to the classical heritage, swept over western and southern Europe. Even though the inheritors of Latin humanities termed the culture of those tribes "barbaric," they could not help observing its characteristics and qualities. Christian missionaries, educated in the Greco-Roman tradition, brought their new religion to the northern countries, and here they found an articulate, highly developed art whose basic values were very different from those they were trained to admire. These missionaries indeed helped to integrate the barbaric and the classical and to form a new art. One wonders: Could early medieval thought on art have remained indifferent to the expressive power of primitive—or barbaric, as contemporaries would probably have said—folk art in Spain, in Germany, or even in the Scandinavian countries? Could it have remained untouched by the refinement and skill of Irish scribes? Some of the specific, original concepts of the theory of art that emerged in

the Middle Ages can, I think, be explained to a large extent by the result of the encounter between classical and nonclassical culture.[19]

The dominant figure in early medieval thought, a figure whose impact is felt throughout the ages, is St. Augustine (354–430). Some scholars have debated the question whether Augustine was the last of the classical or the first of the medieval thinkers.[20] The question is probably incorrectly put; Augustine was both. In the story of his life both periods are combined. Raised in Carthage, then a vital cultural center, he absorbed classical culture and for a decade was a teacher of rhetoric in Africa, Rome, and Milan. Later, after his conversion to Christianity (387), he became the most important founder of western theology. As a disciple of classical culture he was, of course, familiar with ancient aesthetic theories. As a young man, still before becoming a Christian, he wrote a book (now lost) on "The Beautiful and the Fitting," a common topic in schools of rhetoric. Later he composed a book on music. But Augustine was not only a man of high aesthetic culture; he was also personally of a rare sensitivity to the experience of beauty. In his *Confessions* (probably the first autobiography to be written) he speaks of beauty as of that which attracts and fascinates us. "Do we love anything but the beautiful?" he asks (IV. 13). He is enraptured by the experience of visual beauty. "The eyes love fair and varied forms, and bright and soft colors. . . . For this queen of colors, the light, bathing all which we behold, wherever I am through the day, gliding by me in varied forms, soothes me when engaged on other things, and not observing it. And so strongly does it entwine itself, that if it be suddenly withdrawn, it is with longing sought for, and if absent long, saddens the mind" (X. 34).[21]

But, in spite of intense emotional experience, Augustine does not believe that beauty is what attracts us but rather what has definite shape and symmetrical proportions. The concept of symmetry, excluded by Plotinus from aesthetic thought, is here reintroduced in the sense inherited from classical Antiquity. "Symmetry" is not bilateral conformity (i.e., what we today indicate by this term); rather, it denotes "harmony." Surveying heaven and earth, Augustine says, we find what pleases us is beauty, "and in beauty, the shapes; and in the shapes, the proportions; and in the proportions, the numbers" (*De ordine* II.

15. 42). From the innermost habitation glows forth the number *(numerus)*. To Augustine this Platonic concept, the number as the basis of beauty, is so permeated by human emotions that it "smiles kindly" at the explorer. But in spite of such humanization Augustine accepts the fundamentals of the classical theory of beauty.

Augustine also clings to another element of the ancient concept of art. Art cannot be an intuitive action. It must be made according to rules; it must be subject to rational control; and it must display skill. The song of a nightingale is not art, however sweet it may sound. In his treatise on music *(De musica* 1. 1. 4) he says that art is *imitatio cum ratione.*

Augustine's theory of beauty is far from consistent. He is often trapped in the distinction between "exterior" and "interior," a distinction that played such an overwhelming part in the Christian thought of his time. But he did transmit to the medieval world the concept of beauty as harmony and thereby decisively shaped the development of aesthetic thought.

Did St. Augustine formulate his view of the *visual* arts? Although his adherence to the doctrine of symmetry should have been conducive to formulating a theory of painting and sculpture, one does not find one in his writings. Some isolated remarks, however, seem to offer rudiments of a doctrine, and they show surprising insights that go far beyond what was accepted at the time. As we know, neither Antiquity nor the Middle Ages had a system of fine arts. But some scattered remarks of Augustine's seem to indicate a certain hierarchy of the values inherent in the different arts. Music, the art of number and precise proportions, ranks highest; next architecture is praised for its mathematical qualities; painting and sculpture, the arts operating without number and having little rhythm, are the lowest.

Augustine had a deep insight into what we would call the dialectic nature of the work of art. Given to sharp and chiastic formulations, Augustine speaks of the "inevitable falsehood" without which a "true work of art" cannot exist. Even the most correct representation of reality in the theater or in painting is of course something radically different from what it represents. In his *Soliloquies* (II. 10. 18) he ex-

pressed this problem forcefully. "For it is one thing to want to be false, and another to be unable to be true. . . . For a painted man cannot be real, although he endeavors to assume the appearance of a man. . . . And thence is born the strange conclusion. All these things are only partially true, in so far as they are partially false, and can only attain their truth by being for the rest untrue. . . . For on what basis would the Roscius I have mentioned be a true tragic actor, if he did not want to be a false Hector . . . and how would the picture of a horse be a true picture, if the horse in it were not a false horse?" It would seem that Augustine here acknowledges—perhaps more than had ever been done in Antiquity and in the Middle Ages—the autonomy and the specific nature of the work of art.

Augustine was also aware of the different types of aesthetic experience, a problem that is still classified as modern. Works of different arts are perceived in different ways; one looks at a poem otherwise than at a picture. The poem has to be read; what we directly see, the letters, has to be translated into meaning. But when one looks at a picture, everything there to be seen is instantly grasped. In his commentary to the Gospel according to John (24 : 2) we read: "For a picture is looked at in one way, and letters in another. When you see a picture, the matter is ended: you have seen, and you praise. When you see letters, this is not yet the end, because you also have to read."

Early western Christianity did not have a theory of the image apart from the casual remarks of the early Church Fathers (e.g., Tertullian) rejecting any kind of image as pagan. Even Augustine, as we have seen, did not produce a doctrine on this subject. But such a theory was bound to emerge. Caught in the conflict between the original attitude of the Church Fathers condemning sacred images and the deeply rooted popular traditions adhering to image worship, and partly under the influence of the gathering storm of Iconoclasm in Byzantium, Christianity in the Latin West had to come to terms with the problem. It accepted a limited justification of icons. This justification was, however, altogether different from that arrived at in the East; in the West one did not ask whether the images of Christ or the saints were true or false, possible or impossible; rather, there one asked what their use

and function was. What emerged was, therefore, less a philosophical than a practical argumentation, though it necessarily had implications both for philosophical thought and developing art.

One of the earliest, and perhaps the classic, formulation of this theory is found in a letter written by Gregory the Great (ca. 540–604), pope, theologian, active ecclesiastical leader, and a man whose impact on the Church was to be felt for centuries. He expressed his opinion in a letter to a bishop of Marseilles who, apparently having iconoclastic leanings, ordered, or at least tolerated, the breaking of images of saints in his church. The pope censures the bishop, mainly because he thereby alienated his flock; but Gregory does not assume the position of the Iconodules, defending the picture because it is true; he defends the image because it fulfills a useful and important function: the pictures are made for the instruction of the illiterate. The pictures in the church, Gregory says, are there, "not to be adored, but only to instruct the minds of the ignorant." They are there "for the edification of the unlearned. . . . For what the written book conveys to those who read it, that also painting conveys to the uninstructed folk who contemplate it."[22] As we know, this justification of pictures became widely accepted. Walafrid Strabo, a ninth-century author, reiterated that "the picture is a kind of literature for the uneducated man,"[23] and in the Synod of Arras (1025) it was decreed that "illiterate men can contemplate in the lines of a picture what they cannot learn by means of the written word."[24] Durandus, the thirteenth-century codifier of liturgical symbolism, still repeated that pictures are the script of the illiterate.[25]

But what do these statements actually mean? What precisely had medieval authors in mind when they said that the illiterate can learn from pictures what those able to read can learn from the written word? Modern historians and aestheticians, living in a world in which theories of learning and information abound, seem never to have asked this simple question.

Simplifying a complex phenomenon, let us assume that "learning" can have two basic meanings: it can mean either the *acquiring* of knowledge not previously available or the shaping of the overall mental structure of him who learns.

Looking at the great traditions of medieval art in the West, it is difficult to understand how modern scholars can have seriously considered the first meaning of "learning" as applicable in this context. Following the sources just mentioned, some historians have said that one of the main aims of medieval art was the "didactic," but no major feature of this art suggests that paintings and sculptures were meant to offer *new* information to their original public. This is not to say that there were no such tendencies at all. A medieval artist may have tried to make us see a Negro—a type little known in the western Middle Ages—or he may have presented the spectators with detailed images of rare beasts, thereby providing some new, though fantastic, information as to their anatomy. But these tendencies were marginal at best. They are completely overshadowed by the intensely traditional character of the representation of the central themes in medieval art. The meaning of these themes was obviously known to the wide public. The texts on which we today rely in order to explain medieval imagery are mainly narratives of a simple, sometimes even primitive, nature, like those recorded in the *Golden Legend,* a thirteenth-century text comprising stories that had been circulating for centuries in oral form. These stories were in fact available to everybody, literate and illiterate alike; they were told in church, in sermons, and in the marketplace. Only a thorough familiarity with all these stories could have made the pictures intelligible and could have made the illiterate "read" the images. "Learning" from pictures could not have meant, primarily, the acquiring of new information from them.

We are, then, bound to accept the second meaning of "learning." The pictures were meant to serve as a powerful agent in structuring the intellectual and emotional world of men in the early Middle Ages. The repetition of certain themes, inevitably encountered by everybody as they were exhibited in highly visible places, served as a means of intensifying the absorption of the contents represented in them. The representation of these themes—large in size, simple and powerful in their formal composition, often also radiant with color—helped to mold the thought and imagination of the people constantly exposed to them.

Such an interpretation is, in fact, suggested in some of the early medieval texts. Gregory the Great himself, after defending pictures as

the writing of the illiterate, said that "those who cannot read, see and learn from the pictures the model which they should follow." Pictures, then, are a stimulation to a kind of experience that directs one's behavior.

Another way of formulating the educational function of images is to say that they serve as commemorations. This view is often expressed in the so-called *Libri Carolini*,[26] probably edited by the ninth-century scholar Alcuin and by Charlemagne himself. Here we read that "a picture is painted in order to convey to the spectators the true memory of historical events, and to advance their minds from falseness to the fostering of truth" (I. 2). Painters, it is said in another place, "are able in some way to commit events to memory" (III. 23). And Honorius of Autun, writing in the early twelfth century, still believed that one of the principal functions of painting is "to recall to mind the lives of those who have gone before,"[27] obviously referring to the lives of the saints.

Early medieval authors were aware of the picture's power to impress us and to stir our emotions. True, Christian authors of that period often stress that writing is superior to painting. Thus, Rabanus Maurus, the Carolingian encyclopedist (776–856), asserts that "writing is worth more than the idle shape in the picture, and gives the soul more beauty than the false painting, which shows the form of things in unfitting manner." But he knew that one cannot disregard the force inherent in pictures. Even Rabanus Maurus himself addresses his reader by saying: "Even if painting is dearer to you than all art. . . ."[28] Walafrid Strabo, opposing the adoring of images, warns his readers not to neglect "the variety of pictures and paintings."[29] But perhaps most articulate is Durandus, whom we have already mentioned. Summing up the discussion of many centuries, he says: "For painting seems to move the mind more powerfully than writing. It sets events before the eyes while writing recalls them to the memory, as it were, through the hearing, which moves the mind less. This is why, in churches we do not accord so much veneration to books as to pictures and paintings."[30]

In the early Middle Ages, so we are taught in every introductory course, the artists were completely anonymous. Their remaining name-

less is considered a characteristic feature of the period. How does this anonymity fit into the general thought of the time?

As we saw in the previous chapter, in Antiquity the artist's position in society, and the attitudes toward his activity, were ambivalent. On the one hand, some of the ancient artists—such as Phidias and Praxiteles—almost achieved the status of legendary heroes (though as a rule this status was granted to them only centuries after their lifetime), but, on the other hand, the artist's craft and practice were not highly regarded. "We enjoy the work and we despise the master," to quote Plutarch again.[31] In the early Middle Ages, under the influence of Christianity, the intellectual and emotional framework for analyzing the artist's activity was altogether new. Not only was the work of art disputed, as we have seen in our survey of the Iconoclastic Controversy, but the artist's activity and procedures were now approached from a new angle. What called for explanation was the artist's ability to call into being something that did not exist before he shaped it, what we would call his creative act. Indeed, the similarity with God's act of creation was noticed and required analysis and, as such, definition.

One should remember that the problem of creation was a new one in western thought. It is true that it sometimes arose in Greek philosophy (Plato's *Timaeus* is probably the best-known example), but it never became a central problem of classical thought. Moreover, even when it was alluded to, the very concept of creation had a different meaning from its present one. Ancient philosophers assumed that substance, matter *(hyle)*, was uncreated, and as eternal as the gods themselves. Therefore, even in the *Timaeus*, the Platonic god transforms the preexistent chaos into an ordered cosmos rather than creating the world in a modern sense. Christianity, based on the commentaries to the first chapter of the Book of Genesis, introduced an altogether different concept of creation. Here, in a strict sense, "creation" assumed the meaning of producing something out of nothing *(creatio ex nihilo)*. The scholastics, as is well known, accepted much of Aristotle's philosophy, but, in opposition to his view that out of nothing comes nothing *(Metaphysics* 1009a), they maintained the principle of *creatio ex nihilo*. The creator is the absolute and ultimate cause of everything created.

But the power of creation is a property of God only. This theme was discussed, intermittently, throughout the Middle Ages. The most articulate and detailed presentation of the view that only God can create is found in Thomas Aquinas's *Summa theologica* (I, qu. 45, art. 5), but this Christian concept had already emerged quite clearly in the early part of the Middle Ages. "The creature cannot create," said St. Augustine (*De Trinitate* III. 9). What man can do is no more than change the forms of matter that is preexistent and already had some kind of shape. "It is one thing to found and control that which is begotten out of the inmost and highest center of causes, which is the work of God alone, and quite another to perform, according to the faculties granted by Him, some outward operation which produces something at one time or another, in this way or that," said Augustine following the short sentence just quoted. Even in the terms used, a distinction exists between human making and divine creating. The terminology for expressing this distinction was firmly established in the sixth century. Cassiodorus, one of the great figures in transmitting and transforming classical culture in the Middle Ages, clearly stated: "There is a certain difference between things made and things created, if we examine them more closely. For we, who are not able to create, are yet able to make things" (*Expositio psalmorum* 148). Applying Cassiodorus' view to art we should say: the artist is not a creator, but he is a maker.

Based on these testimonies, modern historians tend to believe that the medieval artist was seen by his society as a mere craftsman. In fact, however, the situation was probably more ambivalent than would appear at first glance. Although in the Middle Ages the artist was never seen as a creator, yet he was not always and consistently counted among the simple, everyday makers. Often indeed he was, and even where he was set apart from other craftsmen, the distinctions are vague and fluid. Yet they do indicate some tendencies that are worth notice. Thus, Boethius, in his work on music (I. 34), distinguished between "all art, and also all science" and mere "craft, which is practiced by the hand and toil of the craftsman." The former, we said, is more venerable than the latter. Isidore of Seville, the sixth-century Spanish bishop and encyclopedist, also distinguished between art and craft. "Art is by nature free [from physical effort] and craft consists in

movements of the hands."[32] These distinctions do not suggest a modern concept of art; they refer only to the fact that art is governed by rational rules, while crafts are devoid of such rules (or have fewer of them) and consist mainly in physical effort. Thus, the twelfth-century Spanish scholastic, Dominico Gondissalvi, employs a simple definition: "An artist is one who works in material with a tool according with art."[33] Even at a later stage of the Middle Ages, when a certain social and intellectual upgrading of the artist was taking place, any creativity was still denied him. In the thirteenth century the architect was granted the status and aura of a "schoolman," but Panofsky has called attention to a significant statement by Thomas Aquinas: speaking of the idea of the house in the mind of the architect (and thereby repeating a well-known passage of Aristotle), he expressly defined it as a "quasi-idea."[34]

However, as we shall see in a later section of this chapter, since the twelfth century a certain change of attitude becomes perceptible, and the artist is sometimes granted some vague suggestion of creativity. Alan of Lille, probably the most remarkable of the twelfth-century humanists, spoke of the "wonders of painting" to be found in an allegorical hall. "Oh painting with your wonders! What can have no real existence comes into being and painting, aping reality and diverting itself with a strange art, turns the shadows of things into things and changes every lie to truth" (*Anticlaudianus* I. 119–121). And in the next century, Durandus, whom we have already quoted, even granted the artist a certain degree of freedom. "Various stories of the Old and New Testaments can be portrayed as the painter pleases, for painters and poets have always had the equal privilege of attempting anything" (*Rationale Divinorum Officiorum* I. 3. 22).

In spite of this ambivalence, we cannot speak of the concept of a creative artist in the Middle Ages; it was only in the late Renaissance that the artist's creativity, in the precise and full sense of this term, was discussed as a serious problem.

III. WORKSHOP LITERATURE

In surveying medieval literature on the visual arts one comes across a group of treatises unlike the texts that classical Antiquity has bequeathed to us but also radically differing from the art theory of the

Renaissance and later periods. This unique literature flourished in the
late Middle Ages. The earliest treatises forming part of it were com-
posed in the tenth or the eleventh century, the last in the fifteenth,
one perhaps even later. This literature is sufficiently extensive and ar-
ticulate to enable us to speak of a special type of art theory: it is
completely and in every respect the product of the workshops. In
Antiquity thought on art was essentially found in the writings of the
philosophers, and for them both the work of art and the process of
creating it were marginal subjects. True, Vitruvius, the first-century
architect, wrote a comprehensive book on the figurative arts, but Vi-
truvius discusses architecture on such a broad cultural and scientific
scale that the book cannot properly be compared with medieval work-
shop literature. Renaissance art theory, on the other hand, even when
written by artists (which frequently is not the case), is usually per-
meated by humanistic tendencies; it is of a wide intellectual scope, and
more often than not it is addressed to the general educated reader
rather than to the practicing artist. The medieval treatises I am dis-
cussing in this section cannot boast the philosophical scope and pro-
fundity of either ancient or Renaissance art theory. But they show, in
the problems discussed and in the general outlook, a unique proximity
to the workshop. These treatises constitute a literature composed by
masters of workshops, intended exclusively for artists and craftsmen
working in workshops, and dealing with problems that may be en-
countered in producing the kind of objects now commonly termed
works of art.[35]

This literature consists either of prescriptions for "making" or of
models to be followed. How far these texts actually reflect workshop
practices in each and every detail may be open to discussion, though
it is certain that we can gain a great deal of insight by reading them
carefully. In the whole history of art theory there is no group of writ-
ings so exclusively connected with the workshop.

Perhaps a brief glance at the historical background of this literature
may prove helpful. The dramatic economic and social developments
that began to take place in western Europe in the eleventh century
and reached a climax in the rapid growth of the cities necessarily had
a profound impact on the organization of artistic production. Great

and lavishly decorated cathedrals went up; comprehensive fresco cycles became most frequent; illuminated manuscripts and precious, carefully executed objects found a rapidly expanding market. As the production of many goods grew more complex and differentiated, so did the production of works of art of all kinds. This growing complexity not only demanded a more diversified specialization and an increase in skills; it also forced upon the workshops the need to collect and codify what was known in the different fields of artistic production and to make this knowledge professionally available. Workshops in the early Middle Ages could probably rely on oral teaching only, and traditions could be transmitted by copying the models directly provided by the master. In the later and more dynamic period of growing commerce, of larger commissions, and of many people (including artists) moving from one place to another, the oldtime methods of study were not sufficient; they had to be supplemented by written collections of knowledge.

It should also be remarked that treatises in art theory were not an isolated phenomenon in the period when they emerged and flourished. In the late Middle Ages the collection of knowledge and information in written form was common in many fields. Perhaps the most significant example is the growth and diffusion of encyclopedias. Some historians maintain that encyclopedias are specific to western Europe. We know of no Greek examples, but Roman ones have been preserved (such as Pliny's *Natural History*). In the Middle Ages, Christian encyclopedias were known at least since Isidore of Seville in the sixth century. But from the eleventh century onward encyclopedias—perhaps partly supported by the systematic and classifying tendencies of Scholasticism, which is another product of the same period—abound in number, bulge in size, and are sometimes lavishly illustrated. There is a certain affinity between the encyclopedias and the technical art literature of the period. The technical treatises are, of course, on a much lower intellectual level than the encyclopedias; but they, too, make a certain attempt at completeness, within the framework of the artisan's experience, and they, too, try to provide the necessary knowledge for handy use.

Before discussing the general attitude underlying medieval technical literature on art, let me briefly present some of the typical and most

important treatises that emerged in the workshops of that period. Probably the earliest is the *Heraclius on the Colors and Arts of the Romans.*[36] It consists of three parts, the first two rhymed, the last one, much longer, written in simple prose. Modern research has established that the two rhymed parts are the product of an author who lived in Rome (though he may have come to the city from either southern Italy or western Germany) in the early eleventh century. The third part was added later and probably consists of what originally were two different pieces. Scholars believe that one of these was written in the late twelfth century, the other in the thirteenth century, both in northern France.[37] This way of combining different texts, of so disparate character, into one book, is in itself interesting testimony for the spirit prevailing in the workshops. It reveals a complete disregard for unity of structure and consistency of style; what mattered was obviously only the information contained in the texts that were thus patched together.

Heraclius' introduction sets the tone for medieval technical literature. Addressing himself to an unknown reader, the author says that he has collected and described many subjects "for your use." "If you will try it," he says, "in the testing you will find it true."[38] The modern mind has often pictured the medieval artist as devoid of originality, slavishly copying his models. While in fact he adhered closely to tradition, it is also worth remarking that—even at this early stage— he was to some degree disposed to empirical study and experimentation. The prospective reader—that is, the artist toiling in the workshop—is often encouraged to try out the precepts that Heraclius has collected for his benefit. This experimental attitude is perhaps an early predication on the secular experimentalism that pervaded late medieval culture, especially in the cities. Moreover, it may be seen as a first, hesitant step toward that development that, centuries later, in the Italian Renaissance, made the artist's workshop one of the main laboratories of experimental science.

In other respects, too, Heraclius provided important elements for our understanding of the medieval workshop, of its horizons and limitations. Ancient traditions, however deteriorated and deformed, were

available to the author; he refers to Pliny, and perhaps to Vitruvius,[39] though one rather doubts whether he had actually read these classical texts. A great deal of attention is given to the art of cutting precious stones, and historians have convincingly suggested that the classical study of stones (a whole branch of science in itself) is here strongly reflected.[40] All this would seem to indicate that, to use Panofsky's term, Heraclius' treatise is part of a "Renascence,"[41] one of the medieval revivals of interest in classical Antiquity as a guiding force for the present.

But the author of our treatise was also acquainted with contemporary Byzantine workshop practices. Such an acquaintance is not surprising, since southern Italy had a flourishing Byzantine (Greek) culture, and Byzantine artists were brought over both to Sicily and to southern Italy, and even to different countries in northern Europe; it shows, however, that at least in some workshops artisans were alert to what was going on in some of the distant centers of artistic creation at the time.

Even this brief survey of Heraclius' sources shows the broad range of interests alive in the medieval workshop and of the traditions available to it. Awareness of this range should counteract some popular modern opinions according to which the medieval artist was altogether isolated from the broad cultural currents of his time.

It is equally interesting to see what is missing in this early treatise. Schlosser, in a brief observation in his authoritative work on *Die Kunstliteratur*,[42] points out that Heraclius makes no mention of monumental art. This is remarkable, since in the eleventh century wall painting on a monumental scale was being produced in Rome, and in the late twelfth and early thirteenth centuries (the period in which the last part of the treatise was composed) painting and sculpture on a monumental scale abound in northern France. Heraclius' treatise discusses mainly the preparation of colors for the writing and illuminating of manuscripts; the handling of glass; the cutting of half-precious stones; and the techniques of treating metals, especially gold. Thus, he does not reflect the artistic creation of his time in its entirety but only a certain part of it. And this part seems to be determined not so much

by the medium (painting, sculpture, etc.), but by the size of the works produced, which is small. (But there are also suggestions for the treating of very large objects, like the painting of columns.)[43]

Besides such material lacunae, one is struck by two other omissions, or specific features. One is the overall structure of the treatise. One looks in vain for a principle determining the organization of the assembled material. No general pattern is visible. What obviously mattered both to the author and to his prospective readers was only the individual piece of information, the individual precept. Clearly, the theory of art was not perceived here as any kind of system. A similar lack of systematic arrangement has been noticed in roughly contemporary cookbooks. In order to see this feature in a proper historical perspective, one should should remember that contemporary encyclopedias, and the emerging Scholasticism, placed great emphasis on the systematic arrangement of thought, and on instantly visible, overall patterns of presentation. Perhaps nowhere does the difference in intellectual level between the highly educated schoolmen and the uneducated (i.e., unskilled in formal logic and in the method of literary presentation) craftsmen become so clearly visible as in their attitudes to the overall arrangement of their respective bodies of knowledge.

Another characteristic that may perhaps strike us as an omission is the complete lack of reference to the aim and function of painting, or to the values it may try to embody or to serve. Here we have for the first time the presentation of an attitude we shall encounter in other medieval treatises: it is the narrow workshop attitude. The questions asked are directly related to the specific object the artisan wants to produce. How is it to be produced? What is the practical, matter-of-fact knowledge that will directly, without any roundabout "waste" of education, lead to the desired result? What information and skills will the artisan need in the actual procedures of shaping his object? The western theory of art in the Middle Ages is dominated by this attitude.

Probably the most important, and certainly the most famous, workshop treatise of the western Middle Ages is *The Various Arts (De diversis artibus)* by Theophilus Presbyter.[44] The treatise, which consists of three parts, was composed in the first half of the twelfth century. It was written by a monk, probably of the Benedictine order. The author,

who commanded a rather stylish Latin, called himself by the assumed Greek name Theophilus, but in one of the early manuscripts of the treatise he is also called Rugerus (Roger). One modern scholar has suggested that the first part of *The Various Arts* was composed by a different hand, but this suggestion has been rejected, and it is now generally assumed that Theophilus was the sole author.[45] It is also fairly certain that he lived and worked in an important, flourishing artistic center, and for various reasons, based on suggestions found in the text itself, it seems likely that this center was situated in north-western Germany. Attempts have been made to identify the author of our treatise with a German artist of that region and period, but the results—even though not unlikely—do not contribute much to our understanding of the work.

The Various Arts is an important document of medieval civilization and provides valuable information about medieval technology. Here we find, as the most recent translator has pointed out, what is probably the first direct reference to paper in western Europe, the earliest medieval description of bell founding, and the most complete medieval description of the building of an organ.[46] The range of artistic techniques and\ the author's awareness of their geographic diffusion are impressive. He commends his treatise by promising that the reader will find in it "whatever kinds and blends of various colors Greece possesses: whatever Russia knows of workmanship in enamels or variety of niello; whatever Arabia adorns with repoussé or cast work, or engravings in relief: whatever gold embellishments Italy applies to various vessels or to the carving of gem and ivories: whatever France esteems in her precious variety of windows: whatever skilled Germany praises in subtle work on gold, silver, copper, iron, wood and stone."[47] No wonder that nineteenth-century scholars saw in *The Various Arts* an encyclopedia of Christian art.

As was customary in medieval technical treatises, the short chapters are only loosely connected with each other, and the organization into books is, therefore, only a very general one. The first book deals mainly with painting, the second with glasswork, the third (and largest) with metalwork, but also with fabrication of musical instruments, with the cutting of precious stones, and with bone carving. In discussing each

of these topics, not only are the actual workshop procedures explored, but all external circumstances belonging to the subject are as well. Thus, the book on painting discusses, in addition to the individual colors, the methods of preparing pigments, glues, and varnishes; how to use colors on walls, on manuscripts, and in the decoration of horse saddles; and the working of gold leaf and tinfoil. In the last book one is informed that before embarking on metalwork one must learn what kind of workshop to build, how to make the furnace, the hammers, chisels, crucibles, and so on; the artist working in this field is also required to have some knowledge of the nature of the materials themselves. All this shows how broad Theophilus' range is. His competence as an artisan (and as a teacher) in these media cannot be doubted.

The problem of Theophilus' sources is an interesting one, and what we can learn from analyzing it may go far beyond the individual case of this early twelfth-century master. Theophilus often uses literary formulas, and even actual contents, borrowed from the Church Fathers (Isidore of Seville, Rabanus Maurus) and possibly also from classical authors (Pliny).[48] Though we cannot be sure that he took these forms of expression and pieces of information directly from the venerable authors themselves (he may have got them through some intermediary now lost to us), there can be no doubt that he was an educated man, far above the average of the artisan of his period. It seems at least possible that he also knew Heraclius' treatise and thus had some connection with written workshop theory, as far as it existed in his day. Yet his knowledge is not bookish. In the introduction to the second part of *The Various Arts* he describes himself as a "diligent seeker"[49] and tells us that he has learned from what he has seen and heard. He often, and in detail, refers to his own direct experience. The techniques he proposes to teach he has "examined . . . individually with careful trial and proved them all with hand and eye."[50] Even more than these explicit assertions, the contents of the treatise speak plainly for its author's accomplishments as an artisan and for his thorough familiarity with the techniques. It has correctly been said that the descriptions are so detailed and specific that only somebody who had actually spent a lifetime doing these things could have given such information; it simply could not have been collected from written sources.

(As an example one could mention the observations about the different accidents overtaking workmen who try to gild with impure brass.)[51] We can, then, say that in Theophilus' treatise, whatever his literary sources, we have an authentic reflection of actual workshop exeriences.

Theophilus' treatise, like all workshop manuals, is intended for immediate use. The author never aims at elucidating any theoretical question; his only purpose is to guide the artisan—both in acquiring the knowledge necessary for his own work and in actually applying the techniques he has learned. It goes without saying that Theophilus never explains any principles of learning as such, but his views, implied in much of the material he is presenting, can be extracted from the workshop precepts that make up his work. The method of study (if I am permitted to use such a modern term) is a typical combination of strict adherence to traditional patterns and an experimental spirit. Theophilus obviously does not envisage a situation in which the student may raise questions as to the validity of the general patterns or broad problems of any kind. Topics such as those debated in the Iconoclastic Controversy are completely alien to him, not only because he simply believes that God's house should be adorned, but primarily because the philosophical, theoretical character of the problems is completely beyond his horizon. But also, in a more limited sense, he never questions tradition. Thus, traditional models seem to him to have the unchanging character of laws of nature. For everything he discusses he has certain specific, concrete examples in mind, and these, he believes, should govern representation. A face is to be painted in a certain way only; for the depiction of eyes one uses only certain colors; the highlight should be put in only at a certain spot; and so forth.[52] But, within these narrowly established, constant patterns and models an experimental spirit obtains, which leaves enough room for the artist's enterprise. Thus, the prospective reader is encouraged to use materials found in his own region (though Theophilus tells him about exotic materials, like Arabian gold).[53] He also presents different procedures that lead to the same effect. This is particularly obvious in the third book, which deals mainly with metalwork. The reader can choose the method best suited to his purpose and capabilities. In this combination of orthodox clinging to tradition and innovative experimentation Theophilus rep-

resents the spirit prevailing in the more progressive workshops of the Middle Ages.

Like all medieval workshop manuals, *The Various Arts* is completely composed of practical precepts, presented in a somewhat haphazard arrangement. No consideration is given to any theoretical problem, nor, in fact, to anything that may go beyond what the artisan will need in his actual work. But Theophilus was apparently too educated a man to remain altogether isolated from the great intellectual currents of his dynamic period. Indeed, some of the discussions relating to art that took place in the twelfth century are reflected, however indirectly, in the prologues to the three books of the treatise. One cannot extract a system of aesthetic thought from these prologues, but they are an important testimony to emerging problems and concepts.

The main aim art can serve is the adornment of the church. Referring to King David, Theophilus says that, although he strove for spiritual beauty, "it is certain that he desired the embellishment of the material House of God, which is the place of prayer." Visible beauty is achieved by employing fine materials and by the "variety of all kinds of colors." Another value highly praised is skill and exquisite workmanship. God has given us the "capacity for skill," says Theophilus. The "infinitely rich and various workmanship" is as much of an aesthetic value (to use a modern term) as is the material that makes the ceiling of the church glow like a brocade. In adorning the church with radiant materials and fine workmanship the artisan has given the beholder "cause to praise the Creator in the creature, and proclaim Him wonderful in His works."[54] In the last section of this chapter we shall come back to the broader historical context of these remarks, and Theophilus' significance and proper place in the history of art theory will then become clearer.

Even the expressive function of the work of art is vaguely indicated in the prologue to the third book of *The Various Arts*. The embellished walls and ceiling of the church, in some measure, "show to beholders the paradise of God." Even our emotional response to figural representations (and we should remember that figural representations are not discussed in the treatise itself) is obliquely evoked. When "the faithful soul observes the representation of the Lord's passion expressed in art,

it is stung with compassion." The vivid rendering of the joys of heaven and the torments of hell causes the beholder's soul to be "animated by the hope of its good deeds and . . . shaken with fear by reflection on its sins." One notices that here Theophilus does not want to teach anything; he is not trying to provide information; he merely observes that the work of art affects the beholder's emotional state.

In light of later developments, some of these observations can be seen as early expressions of tendencies destined to become major trends of aesthetic thought. Yet one must note that such philosophical considerations and thoughts, vague and primitive as they are, never invade the treatise itself. What is not directly related to practical workmanship can at this stage perhaps be presented in prologues, together with the author's assertion of his humility, but it is not considered as actually belonging to the subject matter of a workshop manual. The interpenetration of theory and practice, so typical of the Renaissance workshop, still lies in the distant future.

Medieval workshop literature—now largely lost—must have consisted mainly of works such as *The Various Arts.* This type of writing, as we have seen, discussed mainly the technical and material preparations for producing the work of art, the tools employed, and the different stages of shaping the work. It is characteristic of this literature that interest is focused almost exclusively on the *initial* stages of the creative process, such as the preparation of the wall for painting, the parchment for writing and illuminating, and the precious stone for cutting. The more advanced stages of the process are rarely treated, and even in these rare cases no reference is made to the specific scene represented. Technical workshop literature does not deal with subject matter; it chiefly treats such stages in the process of production that are still open as far as subject matter is concerned. On the wall, prepared in the manner Theophilus recommends, the painter could represent a Crucifixion or a Virgin in Glory: *The Various Arts* says exactly nothing about this. Reading this literature, one becomes convinced that in most cases the artists in the workshop must have relied on *specific models* that either were transmitted orally or were directly available in some other form. Such models, whatever their shape, must have constituted a second type of workshop auxiliary.

In the legacy of the medieval workshop we do indeed find a reflection of this second type. As a rule, it is concerned mainly with specific scenes to be represented or with the construction of figures in specific situations (standing, sitting, etc.). Since this type of workshop expedient is oriented toward *specific* themes and works, it is necessarily less uniform in both subject matter and form of representation. The great variety of auxiliary means belonging to this type can perhaps best be described by the general term "model book." Model books can consist of text only, but they can also be made up of drawings accompanied by a few words or, at most, a few sentences. Whatever the form of the model book, its author always has a specific scene, figure, or object in mind, and he is thus much closer to the finished work of art than is the author of the treatise dealing with the initial stages of production. The artisan in the workshop probably used the model book only at more advanced stages of his work, after he had made use of the teachings presented in the workshop manual of the first type. The two types belong together and supplement each other.

We shall here briefly discuss two important model books that fully represent the different types of this kind of literature: one is the so-called *Sketchbook* of Villard de Honnecourt; the other a very late Byzantine text, *The Painter's Guide* by Denis of Fourna, a monk in one of the Greek monasteries on Mount Athos. In spite of its comparatively recent date, the text probably reflects medieval Byzantine workshop practices and attitudes.[55]

The most important surviving example of the medieval model book consisting mainly of drawings is the *Sketchbook* by Villard de Honnecourt.[56] The term "sketchbook" used in English (the French usually call it *album*) is misleading, since in Villard's time one cannot speak of a "sketch" in the sense which the term acquired in the sixteenth century. About Villard we know next to nothing, but from his book we can infer that he was an architect, or *maître d'oeuvre* in one of the thriving centers of Gothic art and architecture, and that he studied the construction and art of such great churches as the cathedrals in Cambrai, Reims, and Laon. Around 1235 he seems to have planned to travel to Hungary, and he apparently made some notes that might be useful to him in the distant land. However, in preparing the manu-

script he must have had a more formal aim in mind than simply composing an aide-mémoire for his own future needs; in the first folio he addresses an anonymous reader or public and asks those who will use his drawings to pray for his soul. Villard's manuscript has come down to us in a fragmentary state, but the part preserved is sufficient to afford us a good insight into the working of his mind and of the workshop tradition to which he belonged.

The materials assembled in Villard's work are not organized according to any distinctive principle. Many of the figures were drawn as he came across the objects represented in them. Some pages are not even by Villard's own hand; as was customary in that time, his pupils copied these pages, probably from another workshop manual, and incorporated them in the master's model book. Yet we find an occasional observation that suggests that he did intend to compose a treatise. A sentence like "Here begins the method of drawing as taught by the art of geometry" would seem to indicate a general plan. The materials collected in Villard's work, though not systematically arranged, can be clustered in a few loose groups: architectural plans and drawings and plans for constructing different tools make up more than one third of the extant manuscript; the rest consists of drawings of individual figures (e.g., apostles), of figural compositions, and of symbolic motifs (e.g., the wheel of fortune). Some of Villard's drawings are recordings of objects that he actually saw, liked, and thought useful to preserve and remember. Sometimes an aesthetic appreciation is implied in his observations: thus, he never saw a tower like the one in Laon, and he liked best the windows of the cathedral in Reims. Some figures reflecting classical sculpture may also involve a certain aesthetic judgement: a standing male nude holding a vase, or a seated male nude wearing a Phrygian cap were probably drawn not for practical purposes only (one wonders what actual purpose they could have served in French Gothic art of the thirteenth century) but perhaps also for their striking beauty. Foliage masks of a definitely classical character may perhaps also reveal the same attitude.[57] One should, however, also remember that this appreciation of the individual classical motif does not mean that Villard conceived of ancient art as an entity of culture or style; rather, he approached it as a treasure house from which individual motifs could

be borrowed while the character of Antiquity as a whole could be disregarded. Representing an elaborate Roman tomb that he saw (as he himself declares), he calls it the "Sepulcher of a Sarrizin." [58]

The drawings in Villard's *Sketchbook* are meant as patterns for imitation (as is amply confirmed in the legends next to the figures). But his most original contribution, and one that is highly characteristic of the western medieval workshop, is what he calls *art de pourtraicture*. [59] By this term he designates a method of drawing—more specifically, of constructing—human figures and faces, and even the bodies and heads of beasts. The most striking feature of the *art de pourtraicture* is its complete detachment from any kind of observation of nature. Nowhere does Villard suggest that the artist look at the human head or figure, or at the beast he is about to represent; never does he ask that the artist measure the figure or that he rely on one of the traditional systems of composition (such as some accepted in Byzantine art) that ultimately go back to actual measurements of nature, even if the artist employing the system was hardly aware of its empirical origins. Even where Villard says that a figure was represented "after nature" *(al vif)*, it is quite obvious that it was constructed with a compass (see his famous drawing of a lion) and in fact lacks any direct observation of nature. In the *art de pourtraicture* abstract geometric diagrams (sometimes of a rather complex nature) are made the basis for constructing figures in different positions, but there is no perceptible affinity between the shape of the geometric diagram and organic figure constructed from it. Thus, a five-pointed star helps to construct the frontal view of a saint's head; the same configuration, if elongated, is the basis for constructing a standing figure. A triangle is the basis for a human profile, also of a horse's head. Since there is no intrinsic affinity between the geometric shape and the figure it helps to construct, the same shape can be employed for different, widely divergent figures. As Panofsky has shown, [60] in the whole history of representing figures in European art there was never a system of proportions as far removed from any relationship to actual nature as Villard's *art de poutraicture*.

"All these figures are extracted from geometry," Villard de Honnecourt says of many of his models. What exactly "geometry" means in this case is not self-evident. Modern historians of aesthetic thought—

mainly Edgar de Bruyne in his great work *Etudes d'estétique medievale*— have suggested[61] that "geometry" may here be a reflection of classical theories of symmetry and that there may thus be a certain speculative aspect to the *art de pourtraicture*. But, whatever may be implied in this concept, Villard makes it perfectly clear what he has in mind: he has constructed his system "pour legièrement ouvrier," that is, "for working easily." The explicit aim, then, is a purely practical one: to facilitate the artist's work.

It may be altogether superfluous to ask whether, and under what conditions, Villard's system made it really easier for the artist to work. To someone not thoroughly familiar with the procedures employed in the Gothic workshop, this method would not appear to be helpful at all. On the contrary, it seems to constitute a highly artificial, overly complex system of construction, and one finds it difficult to imagine how such a system could facilitate a painter's or a sculptor's work. Nevertheless, Villard obviously meant what he said—that his method was aimed at making work more easy to execute—and there can be little doubt that it *did* in fact help artists who were trained in the particular tradition of the thirteenth-century French workshop. As in so many other fields, here, too, technique cannot be divorced from encompassing cultural traditions; only within such a tradition can work be made easier.

Villard's system of construction, original contribution that it is, con-stitutes only *one* part of his book: another part, and a larger one, consists of models plainly offered for imitation. The elaborately and precisely drawn figures are accompanied by legends (such as "Here you will find the images of the Twelve Apostles, sitting" or "This is one of the two women who stood judgment before Solomon . . .") that clearly indicate their aim. Even elaborate compositions (such as the wheel of fortune) are also designed to serve as models for imita-tion. In the Gothic workshop, the imitation of well-defined models and a system of construction fitting the needs and spirit of a specific, highly articulate tradition complement each other. Both the individual models and the method of construction belong to a particular, firmly established, and therefore a "closed" artistic tradition.

Villard's manuscript is just one example, a highly characteristic one,

of a phenomenon that was common in the late medieval workshop. The model book was not only an important resource for artists and their disciples in the workshops; it was also an important channel for the transmission of images and for granting a degree of unity to the products of workshops using the same model books. Thus, it was a significant instrument in establishing artistic usage. Many model books must have been lost in the course of the centuries, but those that have survived form an impressive testimony to a great and powerful tradition.

Villard's work represents the type of model book that was largely composed of drawings, but another type also existed that consisted mainly or exclusively of text. It may be worth our while to look briefly into one example of this type. *The Painter's Guide* of Mount Athos, which I have chosen for this purpose, is a very controversial work.[62] Discovered in the early nineteenth century, this Greek text was first believed to have originated in the preiconoclastic period, and thus seemed to represent an early Byzantine workshop theory. Careful investigations have made it clear that it is of more recent date. In its present formulation it probably does not precede the eighteenth century, but most modern scholars agree that it contains a core of much older workshop practices, some of which genuinely reflect Byzantine teachings. It is true that in *The Painter's Guide* we occasionally even find an Italian Renaissance term,[63] neatly transcribed in Greek letters and slightly changed in meaning, but the contents of the book as a whole have no precise counterpart in the literature of western workshops.

The Painter's Guide, as we now know it, consists of three parts. The first, rather short, deals with technical questions, mainly with the preparation of pigments and glues; in its subject matter it is thus comparable to western treatises, such as *The Various Arts* by Theophilus, though it should be pointed out that only painting techniques are considered. The second part, making up at least three quarters of the whole book, is devoted to religious iconography. In short chapters it deals with the stories of the Old and the New Testaments, including a section on New Testament parables, themes that were dominant in Byzantine art. The stories are discussed according to their sequence in the Bible. In addition to the biblical stories, we find small sections on the Virgin,

the principal saints and their miracles, as well as a section on allegories, partly of pagan origin and character. The third part of the book, again very brief, deals with the location of the pictures in the building of the church and attempts to assign to each theme a special and well-defined spot in the building. Even this brief survey of *The Painter's Guide* shows that the work is arranged according to an iconographic scheme. A structure of this kind is entirely without parallel in the literature of western workshops in the Middle Ages.

The descriptions of religious scenes, which make up the core of the book, are usually brief, consisting of no more than a few lines. These descriptions give some general outline of the composition as well as some indications of the most characteristic features of the scene. Such indications are of an extreme conciseness. The background of a scene may be described by a few isolated words, such as "a cupola," or "mountains and caverns." The same laconic style prevails in what is said about the figures. In describing David killing Goliath the only thing that is said about David is that he is "beardless." From a description of "Christ Healing the Possessed" (the description consisting of three lines) we learn that the Redeemer is there with his apostles and that he is bestowing and blessing; the possessed holds his crutches in one hand, raising the other hand to his ear; from his mouth a demon escapes.

In reading such a fairly typical example one wonders what precisely the book's function was. On the basis of such a text alone, obviously nobody would be able to paint a picture that could, in any possible sense, be attributed to Byzantine art. What did Christ look like? What were the physiognomies of the apostles, and how many of them were present? (Not even their number is indicated in the text.) What were the type, precise posture, and face of the possessed? All these concrete details were, of course, provided by the actual tradition. Simply in asking these questions it becomes obvious that *The Painter's Guide* is not a textbook in the modern sense of the word. It does not, in any sense, propose to replace the workshop or to be a substitute for part of the teaching being carried on there. It is, rather, a codification of accepted images, heavily relying on the fact that everybody using it would be intimately familiar with all the specific details that the text omits. Its

major historical significance probably lies in its testimony to the solid establishment and firm formulation of the patterns, models, and procedures of the workshop. Like Villard de Honnecourt's treatise, *The Painter's Guide*—in spite of their strong contrasts in subject matter and approach—was meant to be used in the workshop only, and only by those artists thoroughly familiar with the respective traditions represented.

Our brief survey of medieval workshop literature has clearly shown how broad was the range of types through which accumulated experience was formulated and taught. It has also indicated, I hope, that in all this variety certain common elements were present, indicating a certain unity of thought and attitude. It may be worth our while to repeat, very briefly, these common features of the whole medieval workshop approach.

Let us remember, first of all, that all these treatises were composed by practicing artists, and the public, the readers for whom they were written, also consisted only of artisans busy in workshops. These treatises, then, form a type of literature that—in every social and professional sense—is an altogether closed system. While the artists were thus addressing their fellow workmen—and this is a second feature worth keeping in mind—they strictly limited the scope of the subject matter they explored; they thought of, and discussed, only the conditions and processes of the production of a work of art. Whether their discussion was focused on the initial stages of the process—the preparations of materials, as explored by Heraclius and Theophilus—or whether they dealt with the more advanced stages—offering a system of construction, like Villard, or providing a series of models for imitation, like Villard and *The Painter's Guide*—they did not discuss anything that has no direct bearing on the production of the work of art. In subject matter, too, the workshop treatises represent a closed type.

This leads us to a last conclusion: the process of producing a work of art was itself conceived as a closed process. Using Panofsky's formulation,[64] we can say that the medieval artist who composed a workshop treatise did not ask with what gifts the artist should be endowed or what he should know in order to be able to represent an unknown subject or to portray a given piece of nature. No broader aspects of

the creative process were ever considered. The only question the medieval artist asked—if we can extrapolate from the treatises—was: How is it done? How is a specific, clearly prescribed subject or figure represented? How is a definitely outlined scene rendered in paint?

IV. AESTHETIC VALUES IN THE LATE MIDDLE AGES

In the preceding section we discussed small groups active in the workshops and engaged in the specific task of producing the objects we now call works of art. But what were the concepts and opinions accepted outside the workshops and current among the broad public in the late Middle Ages? This public is not easily described. The period between the twelfth and the fourteenth or fifteenth centuries was one of great upheavals, of dynamic social transformations, and of cultural and psychological change. Rapidly growing cities were replacing the monasteries as cultural centers, and the urban universities, dominated by Scholasticism, were establishing a new and highly educated elite. But the rapid urbanization was also forming another public, altogether different from the educated groups based on the schools. This other public, living on the fringes of the great cultural centers, consisted mainly of people with a simple, often a rather crude taste. It would be very hard to draw a precise dividing line between these two major types of public, the learned and the ignorant. In a period of dynamic historical processes that continues for centuries, different social and cultural groups cannot be kept neatly apart. The interaction of the two audiences is, indeed, a central feature in the background of the artistic development of the period. It will, however, be useful to keep the two groups in mind when we discuss the aesthetic needs and views of the late Middle Ages.

It is not easy to reconstruct the emotions and thoughts of the people looking at the great cathedrals built in the twelfth and thirteenth centuries or contemplating the many artifacts produced or imported in late medieval cities. However, we can draw on some surviving texts in our attempt to reconstruct the mentality of the medieval public. These texts fall roughly into two major groups. One group consists of occasional descriptions of buildings or objects that the authors have

themselves seen. Such descriptions are scattered in more general texts that, as a rule, have nothing to do with art. Describing the decorations of walls, the texture of fine fabrics, or the shapes of vessels, these statements were by no means intended as contributions toward a theory of art; what they disclose is more than an attitude, a certain receptivity toward aesthetic values. The other group is made up of theoretical statements, mainly in the writings of scholastics. Such statements usually deal with abstract concepts, such as beauty or harmony, and while they may, in certain cases, be applicable to the analysis of works of art, they never refer to actual objects. Both groups of texts, it should be kept in mind, are written by laymen, though by educated ones. Even where they describe workmanship and the nature of materials, they are far removed from the workshop treatise. The artisan in the workshop and the educated observer remain worlds apart.

Any attempt to produce a full catalogue of the values appreciated in the late Middle Ages would of course be foolish. Yet one can try to analyze some of the qualities that were particularly esteemed in that period. Modern interpretations have so deeply impressed upon us the symbolic nature and the didactic goals of medieval art that we are sometimes surprised to find other values of the work of art—values that have little to do with subject matter or with the express purpose of such art. In a well-known study Meyer Schapiro has collected and analyzed many twelfth- and thirteenth-century texts that reflect the impressions made by works of art on the contemporary public, enabling us to speak of an "aesthetic attitude" in that period.[65]

These texts often express the appreciation of sophisticated, complex, and highly skilled workmanship. The spectators often formulate their sheer delight at the decorative effects or the coordination of forms and colors they saw in buildings or art objects. These effects were a witness to masterly skill, but they were not invested with any particular religious or symbolic meaning. In the description of a building the unnamed artist (or architect) is praised for his "varied workmanship." In a church the artist "tastefully and artfully . . . inserted distinct alternating courses of white and black stone and beautified the entire structure of the chapel in an extraordinary manner on the interior and

exterior by an original revetement of black and speckled columns with finely polished bases and sculptured capitals of a wonderful variety."[66]

The same delight at artful variety was experienced by the medieval spectator (this time an English monk toward the end of the twelfth century) when looking at a piece of fine fabric. Reading his description, one is necessarily impressed by the subtle differentiation of colors and hues and by the tone of aesthetic experience. After extolling the beauty of the colors of this fabric the author continues: "The most subtle figures of flowers and little beasts very minute in both workmanship and design, are interwoven in this fabric. For decorative beauty its appearance is varied by contrasted sprinklings of rather uncertain color that proves to be yellow. The charm of this variation comes out most beautifully in the purple cloth, and fresh contrasts are produced by the play of scattered spots. The random infusion of yellow color seems to have been laid down drop by drop; by virtue of this yellow the reddish tonality in the purple is made to shine with more vigor and brilliance."[67]

Intimately interwoven with the appreciation of workmanship is the admiration of skill. While workmanship may include aesthetic effects, principles of decoration, and the general notion of taste, skill is reserved for the sheer mastery of the artisan, his power and discipline in handling the materials and shaping the forms. Skill was always considered a value, and in the preceding chapter we saw that also in Antiquity skill was highly appreciated. Yet it would seem that in Antiquity (as well as in the Renaissance) skill was to a large extent valued as a means to an end. The famous "line of Apelles"—an instance of technical excellence and outstanding accomplishment often quoted in classical literature—had the connotation of creating an illusion (see p. 286). That line may well have been a highlight, as has recently been suggested by Gombrich.[68] But whatever it was, in Greek and Roman literature it clearly was not considered only as a document of sheer manual performance; it tells us something about the texture of the objects represented. In the Renaissance, too, skill was highly evaluated, but it was always seen in the context of creating an illusion or proving a scientific truth. In the Middle Ages—that is, in a culture largely

based on manual work—outstanding dexterity and superb manual skill themselves became central values, highly esteemed in many spheres of production. As far as art is concerned, this becomes particularly clear in the texts stressing that the workmanship surpasses the value of the materials. This is said of objects as different as a chamber with fine windows and a golden chalice. When the material is not precious, as in the case of the oaken sarcophagus of St. Cuthbert, the subtle carving can nevertheless fill the spectator with amazement.[69] In the twelfth century, Hildebert of Le Mans even says of the statues of pagan gods, "What faces have these divinities: They are worshipped rather for their makers' skill than for their godliness."[70] As has been suggested, in the concept of *maiestre certa,* an expression common in the Middle Ages, the praise of the artist's "sureness" of hand may have been linked with the notion of his "fame." In the spiritual world of the Middle Ages the artist was denied the quality of creativity, but his mastery, his manual discipline and accomplishment were appreciated. In a formulation that sounds somewhat ambiguous to modern ears, Thomas Aquinas said that "art does not require the artist to proceed well, but to make a good work."[71] "Proceeding well," for St. Thomas, probably means proceeding according to proper rules, and the rules are already established. The producing of a "good work" is left to the artist's skill.

A modern historian wonders whether the appreciation of superb workmanship and excellence is not, inter alia, an attempt to come to terms with the problems posed by the art of the northern "barbarians," an art in which illusion plays a modest part but that excels in the display of skill. The abbot Suger, to whom we shall shortly return, stressed that in skill and workmanship "the barbarian artists were even more lavish than ours." Perhaps the emphasizing of skill as an independent value is a medieval spectator's attempt to find an aesthetic category for a page of an Irish manuscript or an Ottonian piece of goldsmith's work. It is an attractive hypothesis, though difficult to test. Whatever its origin, the consideration of skill as an aesthetic value is a characteristic feature of medieval thought.

The fascination with precious materials and glittering objects is another well-known feature of medieval aesthetics. Ever since Cham-

bers's evocative work, *The History of Taste,* we have become used to speaking about the medieval attraction to "gold and glitter."[72] In reading medieval literature, especially the descriptions of ecclesiastical buildings and liturgical objects, one is indeed struck by the intensity of feeling and the variety of forms by which the enthrallment with precious substances and shining surfaces is conveyed. In the descriptions of churches authors of the Romanesque and Gothic periods often surpass themselves in superlatives. Thus, the twelfth-century English historian William of Malmesbury relates that Bishop Ernulf rebuilt the church of Rochester "with such splendor that nothing like it could be seen in England for the luminosity of the glass windows, the glistering marble pavement, the multicolored pictures." Another monk of Malmesbury praises an abbot because "He transferred to the inside all the church's splendor; the pomp of beauty glistens throughout the golden ceilings; metallic shell, gemmed fabric, inspiring wonder."[73]

Theophilus, the author of the workshop treatise discussed above, tells his readers that the artist adorns "God's House," the church, not only with a "variety of work," but also with glowing and shining materials. "For the human eye is not able to consider on what work first to fix its gaze; if it beholds the ceilings they glow like brocades; if it considers the walls they are a kind of paradise; if it regards the profusion of light from the windows, it marvels at the inestimable beauty of the glass and the infinitely rich and various workmanship."[74] A French author, possibly a contemporary of Theophilus, described the church in Fécamp, which our workshop master probably never saw, as "The gateway of Heaven and the palace of God himself. . . . It gleams with gold and silver, and is adorned with silken copes."[75]

Perhaps the most famous medieval descriptions of a church resplendent with gold and jewels may be found in the writings of Suger, the twelfth-century abbot of Saint-Denis, the "loyal adviser and friend" of two French kings, and one of the most influential patrons of architecture of his time. His detailed reports of the erection and consecration of the church in Saint-Denis, the first Gothic building, abound in expressions concerning the value of precious stones and gold. The main altar he had "all incased, putting up golden panels on either side and

adding a fourth, even more precious one; so that the whole altar would appear golden all the way round."[76] A precious vase that he offered to the church he had inscribed with the following verses:

> Since we must offer libations to God with gems and gold,
> I, Suger, offer this vase to the Lord.

And another vase, made of porphyry, he had inscribed:

> This stone deserves to be enclosed in gems and gold.
> It was marble, but in these [settings] it is more precious than marble.[77]

Suger also believed that a church built by the Frankish king Dagobert was perhaps designed of modest size because he thought that "a smallish one—reflecting the splendor of gleaming gold and gems to the admiring eyes more keenly and delightfully because they were nearer—would glow with greater radiance than if it were built larger."[78]

It need hardly be stressed that the medieval attitude to "gold and glitter" was not uniform. Important religious and social movements counted gold and precious stones among the sensual temptations and considered them as embodiments of sin. But even in the texts that condemn outright the sinful glitter of gold and jewels we still perceive the sensitivity toward the effects, enrapturing the eyes and mind, of these glowing materials. It will be enough to listen to one brief text. "Beautiful pictures and various sculptures," we read in the statutes of the austere and ascetic Cistercians, "both adorned with gold, beautiful and costly coats, beautiful hangings tinted with different colors and beautiful windows, stained-glass windows tinted with sapphire, copes and chasubles interwoven with gold, golden chalices set with precious stones and gilded letters in books—all this is demanded not by necessity, but by the greed of the eyes."[79] Many similar texts, though rejecting the objects which are a "greed of the eyes," show that their authors were not indifferent to them.[80]

Did all these texts correctly describe the original appearance of the objects and buildings they report? One doubts it. What cannot be doubted, however, is that these texts faithfully reflect both the prevailing taste and the sensitivity to certain effects.

Even within the limited scope of this book it is not superfluous to

ask what the reasons were for this fascination with precious stones and gleaming surfaces. Was it the material, perhaps the monetary value of the gold and the gems that so attracted the medieval mind? Or was it perhaps the dazzling visual experience, the light trance induced by the glimmering surfaces?

The answer is not easily given, and it certainly cannot be uniform. We have many indications that the value attributed to the material itself played an important part in medieval thought. "I confess," says the abbot Suger, ". . . that every costlier or costliest thing should serve, first and foremost, for the administration of the Holy Eucharist. If golden pouring vessels, golden vials, golden little mortars used to serve . . . to collect the blood of goats or calves or the red heifer; how much more must golden vessels, precious stones, and whatever is most valued among all created things, be laid out, with continual reverence and full devotion, for the reception of the blood of Christ."[81] Another author, perhaps a younger contemporary of Suger, demands that the head of a statue of Christ be made of solid gold.[82] Here, then, there is a tendency to accept the material value of gold and of the other precious substances as the reason for their attraction.

But this attitude, so strongly reminiscent of primitive beliefs in the supernatural character of certain materials, was not the single, or even the prevailing one, in the Middle Ages. Medieval literature provides ample evidence for the enchantment with the nonmaterial, purely visual appearances of radiancy and luminosity. Again we may quote Suger. He not only vividly expressed a forceful sensual experience of looking at radiant objects; he was also aware of the slight, unique trance into which the mind may be induced by being exposed to the gleaming of jewels and the brightness of gold. "Thus, when—out of my delight in the beauty of the house of God—the loveliness of the many-colored gems has called me away from external cares, and worthy meditation has induced me to reflect, transferring that which is material to that which is immaterial, on the diversity of the sacred virtues: then it seems to me that I see myself dwelling, as it were, in some strange regions of the universe which neither exist entirely in the slime of the earth nor entirely in the purity of Heaven; and that, by the grace of God, I can be transported from this inferior to that higher world in

an anagogical manner."[83] The *anagogicus mos* (lit., "the upward-leading method") is the ascent from the material to the spiritual world. In medieval thought the term is applied in a variety of contexts. The abbot Suger made the experience of multicolored gems and shining gold the vehicle of this ascent. The glow of gold leads to the spiritual realm. Suger's description of the church he built (a description that shows how captivated he was by the newly discovered effects of stained-glass windows) provides a good example of such an "upward-leading" experience, in which a continuity from the tangible to the symbolic is intimated. One of his inscriptions reads:

> The church shines with its middle part brightened.
> For bright is that which is brightly coupled with the bright,
> And bright is the noble edifice which is pervaded by the new light . . .[84]

The "church" here is the actual material structure Suger had built, but the "new light" is a reference to Christ in his most spiritual form as the new light. And, again intentionally confounding the tangible and the symbolic, he had the doors of his church inscribed with verses, some of which read:

> Bright is the noble work; but by being nobly bright, the work
> Should brighten the minds, so that they may travel, through the true lights,
> To the True Light where Christ is the true door.
> In what manner it be inherent in this world the golden door defines:
> The dull mind rises to truth through that which is material
> And, in seeing this light, is resurrected from its former submersion.[85]

Suger gave these ideas a particularly suggestive expression, but the concepts themselves were common to medieval culture. The images of light and brightness became the bridge between the terrestrial and the celestial. Gold and glitter thus became endowed with theological significance.

The "anagogical method" may point to still another problem: Was the expressive, emotional character of the work of art acknowledged by the educated spectator in the late Middle Ages? Was the artist aware of the emotional impact the work of art might have, and did he aim at achieving it? Expression is an ambiguous concept even today; in

medieval culture it is particularly difficult. Medieval art always carried expressive qualities, such as exalted saintliness or the display of brutal force. But from the twelfth century onward an emotional, highly expressive trend permeated painting and sculpture. The same emotionalism can also be observed in the poetry and drama of the period.[86] Did the attitude to the visual arts, as it prevailed among both intellectuals and uneducated people, reflect this tendency?

The workshop literature, although composed during the period and in the centers of the emotional trend, disregards expressive qualities altogether. Had we only possessed that literature we would never have guessed that the art of the period was characterized by an intensive emotional expressionism. Workshop literature remained completely immersed in the discussion of how to prepare materials and of how to approach the first stages of the artistic process. There is no room here for any consideration of emotions. The gap between the character and scope of the workshop literature and of the actual art of the same period clearly shows that the technical treatises reflect only *one* of the sources from which the artist, toiling in the workshop or in the *chantier,* actually drew. In addition to what the workshop literature provided he must also have relied on other traditions. Going beyond the workshop, we must ask how the general literature of the period, not written for artists and only rarely and sporadically referring to works of art, reflects the expressive trend in art.

I cannot discover any continuous tradition of discussion of emotional aspects in medieval descriptions of works of art, but a surprising sensitivity to expressive effects is occasionally revealed. Most important among such texts is certainly the so-called *Apologia ad Willemum* by Bernard of Clairvaux.[87] Bernard, a central figure in the Cistercian movement in the first half of the twelfth century, was dominated by a severe monastic attitude that led him to violently reject art. He was trying to mortify his senses, perhaps most of all the sense of sight. His early biographers tell us with pride that he spent a whole year in a novice's cell without knowing whether the ceiling was vaulted or flat, and whether the chapel received light from one or from three windows. Similarly, we are told that he rode for a whole day around the shores of the Lake of Geneva without casting a single glance at the

scenery.[88] But in the *Apologia* he reveals himself as a man with an incisive, penetrating eye for motifs and the expressive qualities of images, and with a profound fascination with the art of his time. The *Apologia* is a fierce attack on Romanesque art, perhaps on art in general, but let us listen to what he says: "And further, in the cloisters, under the eyes of the brethren engaged in reading, what business has there that ridiculous monstrosity, that amazing mis-shapen shapeliness and shapely mis-shapeness? [or: that marvellous and deformed beauty, that beautiful deformity?] Those unclean monkeys? Those fierce lions? Those monstrous centaurs? Those semi-human beings? Those spotted tigers? Those fighting warriors? Those huntsmen blowing their horns? Here you behold several bodies beneath one head; there again several heads upon one body. Here you see a quadruped with the tail of a serpent; there a fish with the head of a quadruped. There an animal suggests a horse in front and half a goat behind; here a horned beast exhibits the rear parts of a horse. In fine, on all sides there appears so rich and so amazing a variety of forms that it is more delightful to read the marbles than the manuscripts, and to spend the whole day in admiring these things, piece by piece, rather than in meditating the Law Divine."

In these lines we have an evocatory, highly suggestive description of Romanesque imagery, full of understanding for the expressive spirit of that art. Surely the man who wrote these sentences was not blind; nor was he indifferent to the power of art. To quote Panofsky: "St. Bernard disapproved of art, not because he did not feel its charms but because he felt them too keenly not to consider them dangerous. He banished art, like Plato (only that Plato did it 'regretfully'), because it belonged on the wrong side of a world."[89] St. Bernard's affinity to the tension and chiastic structure of Romanesque art often becomes evident even where he does not speak of paintings or sculptures. It has correctly been said that the paradoxical phrase "that marvellous deformed beauty, that beautiful deformity" has an inherent kinship to the products of Romanesque fantasy.[90]

St. Bernard was a poet, even though he did not write verses, and his poetical nature may explain the evocative power of his literary imagery. But the awareness of an image's emotional appeal was not

restricted to great poets. In the later stages of the Middle Ages wide circles became intensely aware of particularly this aspect of the visual arts. It has been shown by several modern scholars that the emotional impact of the picture became commonplace in the late Middle Ages and that religious movements made conscious use of images in order to evoke piety or compassion through the themes represented (such as the Passion of Christ).[91]

Dante was keenly aware of the expressive qualities of sculptures. He described a carved angel, carrying the divine decree, as weeping. He certainly knew the ancient definition of sculpture as mute poetry, but he is also playing with the theme of real animation when he says of the angel "so vividly graven in the gentle mien that it seemed not an image that is dumb."[92] Dante is also conscious of the expressive character of postures. In a context suggesting a posture he spoke of "the form of the pain." Most interesting is his awareness that a figure carved in inanimate stone can evoke live emotional response. The poet is describing the region of the proud in *Purgatory* (Canto X) where he sees that the sinners are punished by having to support great burdens of stone. The bent, agonizing creatures recall to him a well-known motif of the Gothic art of his time, the crouching corbel figure.

> As to support ceiling or roof is sometimes seen for corbel
> a figure joining knees to breast,
> which of unreality begetteth real discomfort in him who beholds
> it; in such wise saw I these when I gave good heed.
> True it is that more and less were they contracted, according
> as they had more or less upon them, and he who had most
> patience in his bearing, weeping seemed to say: "I can no more."

Here the perception of the statue's expressive qualities is so intense as almost to obscure the distinction between the figure carved in stone and the figure of the real sinner.

V. SCHOLASTICISM

The aesthetic values we have briefly outlined appealed to the medieval public as a whole, especially in the later Middle Ages. Yet most of them—the attraction of gold and glitter, and the emotionalism—may

have made a particularly deep impression upon the uneducated. Primitive people, we are often told, are more easily attracted by gold and glitter than are those who are highly cultivated; the emotionalism, as was known even in the Middle Ages, appealed to ignorant peasants and old women rather than to intellectuals who were used to abstract thinking. The values mentioned may, therefore, represent mainly the taste of the lower classes. What did the intellectuals think of the visual arts? The professional intellectuals of the late Middle Ages were the scholastics. "Scholasticism," originally denoting their social and cultural framework, has become a synonym of an abstract, analytical, and unemotional way of thinking. It may be appropriate to conclude this chapter with a brief outline of the scholastics' view of visual beauty and artistic creation.[93]

Painting and sculpture did not occupy the minds of the scholastics. In the voluminous literature, extending over hundreds of heavy volumes, we do not find a discussion of the visual arts occupying even one page. Perhaps the closest approximation to formulating the essence of the visual arts (and it is still very far from being a real discussion) is a brief statement by St. Thomas Aquinas on the nature of beauty. In this statement St. Thomas does not refer, even if only obliquely, to painting and sculpture; but the features of beauty that he enumerates belong to the realm of visual experience and may thus permit the drawing of conclusions with regard to the visual arts.

Thomas Aquinas (1225–1274) lacked the personal sensitivity to aesthetic or expressive effects that was so characteristic of St. Bernard; his prolific writings nowhere betray a profound emotional experience before a work of art. But St. Thomas's analytic mind, and scholastic's aim of working out a comprehensive, well-ordered conceptual system, lead him also to consider beauty. His occasional remarks on beauty deal mainly with the metaphysical aspects of the problem, such as defining beauty as the splendor of goodness.[94] I shall disregard these aspects and shall concentrate on the few remarks that are pertinent, even if only by implication, to painting.

St. Thomas conceived of beauty as a relation between a subject and an object, between somebody experiencing and something that is experienced. He anticipated philosophical developments of the eighteenth

and nineteenth centuries in describing aesthetic experience as some kind of "disinterested pleasure," as Kant would say. "Only man," he says, "delights in the beauty of sensuous things as such," that is, for their own sake, and not for any ulterior motive (*Summa theologica* I, q. 91 a 3 ad 3). The voice of the stag, he says, in another place (*Summa theol.* II a, II ae q. 141 a. 4 ad 3), is pleasant to both lion and man, but for different reasons: it pleases the lion because it promises him food; it pleases man because it is harmonious.

An object is beautiful not because it is aesthetically experienced; on the contrary, it is aesthetically experienced because it is beautiful. Beauty is thus an objective quality, and like any other objective quality it can be analyzed, and its characteristics can be defined. St. Thomas's fullest definition of beauty is an often quoted text. It reads: "Beauty demands the fulfillment of three conditions: the first is *integrity* or *perfection,* of the thing, for what is defective is, in consequence, ugly; the second is proper *proportion,* or *harmony;* and the third is *clarity*—thus things which have glowing color are said to be beautiful" (*Summa theol.* I, q. 39 a 8). In other places he speaks only of proportion and brightness, but in this, the fullest formulation, he adds integrity. Thomas did not specify any work of art in his definition of beauty (wherever he gives a concrete example, it is the beauty of the human body), but it may be useful in helping us understand the attitude implied toward the values of art. Some scholars maintain that St. Thomas's significance in the history of aesthetic thought is based not so much on his enumeration of the elements of beauty as on his other contributions. It has also been suggested that St. Thomas himself attached little importance to this definition, as it appears only once in his writings. Nevertheless, his brief definition of beauty deserves a closer look, as it may enable us to grasp the scholastic attitude toward beauty as far as it was experienced in the realm of visual shapes.

Among the three features defining beauty, two ("proper proportion" and "clarity") derive from venerable tradition that go all the way back to Antiquity. In the previous chapter we saw that the concepts of proportion and harmony were made the basis of an important theory of art. But in the present context the value of "proportion" consists not only in its being hallowed by a great tradition; the scholastic's

preference for proportion reveals something of his way of thinking, his admiration for quantity, for measurable magnitudes that are susceptible of rational analysis and lend themselves to rational composition. In a proper sense, St. Thomas says (*Summa theologica,* I a, q. 12, a. 1, ad 4), proportion indicates the relation between two equal or different quantities "related to each other in measurable fashion." The emphasis on "proper proportion" *(debita proportio)* is revelatory of the sense of values prevailing in scholastic thought. It indicates, I think, that a system of temperate, restrained forms was regarded as the ideal. Perhaps for this reason St. Thomas speaks of "proper proportion or consonance" *(debita proportio sive consonantia).* "Consonance" (lit., "sounding together") suggest a balanced relationship, in which no form becomes so predominant as to overshadow the other. One cannot help noticing the radical difference between such a system of forms and the tense, twisted shapes conjured up in St. Bernard's writing.

The other concept, *claritas,* is rooted in the Neoplatonic tradition, in the metaphysics of light and splendor that played such an important part in medieval thought.[95] St. Thomas took over this common element, and he specifically combined the splendor with colors.

While proportion and clarity are traditional values, the first element in St. Thomas's definition, "integrity or perfection," was not common in medieval descriptions of beauty; therefore, it calls for an explanation. The meaning of *integritas sive perfectio* is not obvious in St. Thomas's definition. It has been suggested that the meaning of "integrity" is not far removed from that of "proportion"; what is properly proportioned is also complete and perfect. Is "integrity" really nothing more than an additional term introduced without compelling reason? It may be difficult to show in detail the specific function of "integrity," but one can see the direction toward which the concept points. The immediate and direct sense of the term is probably simple: nothing can be beautiful that does not display all the elements that belong to it by its nature. A man is ugly, deformed by the lack of an eye or an arm; by nature he should have these limbs. Another implied sense of totality is perhaps less easily grasped, but it is probably not less important. In scholastic thought totality, completeness, is a fundamental feature, sus-

taining other specifications. What is not complete is in a sense shape-less, devoid of form. The fragment calls the very concept of form into question by making us go beyond what we really perceive.

To fully appreciate the significance of St. Thomas's definition of beauty one should see it within the context of scholastic thought as a whole. Students of medieval culture know that scholastic thinking—and the *Summa* as its classic formulation—had three major require-ments: totality, arrangement according to matching parts, and sufficient interrelation so that the parts do not remain isolated from each other. In a provocative study, Panofsky has explored the significance of these requirements for Gothic architecture.[96] Their relationship to St. Thom-as's definition of beauty are more easily grasped. Totality, or compre-hensive enumeration, corresponds to "integrity"; arrangement by dis-tinct and matching parts is paralleled by "proportion"; and interrelation seems to be mirrored by "clarity" or brightness, in which suffusion is stronger than division. St. Thomas's definition of beauty, brief as it is, could seem to contain in a nutshell the whole of the scholastic way of thinking.

It would be futile to ask what kind of art St. Thomas had in mind. As we have said, in defining beauty he never referred to any work of art. It is striking that he never as much as mentions one of the cathe-drals that were going up under his eyes. Nevertheless, one can consider what kind of style would be most fitting to the spirit prevailing in scholastic thought. The emphasis on completeness, perfection, and proper proportion would seem to suggest a crisp, linear style as that most appropriate to a taste shaped by the scholastic spirit. It is interesting that, in a marginal remark, St. Thomas points out the superiority of line over color. The representation by line is clearer than that by color. An object rendered in outline but without color will be perfectly leg-ible; the same object rendered in color but without outline will look diffused, and the beholder will not be able to identify it. Line, we understand, is the carrier of rationality within the realm of pictorial representation. Without mentioning a particular style St. Thomas, then, indicates a preference for one type of rendering visual reality rather than for another.

NOTES

1. P. O. Kristeller, "The Modern System of the Arts," *Journal of the History of Ideas* 12 (1951): 496–527, and 13 (1952): 17–46; reprinted several times, and here quoted after P. O. Kristeller, *Renaissance Thought* (New York, 1961), II, pp. 163–227.

2. For a general survey of Iconoclasm see E. J. Martin, *A History of the Iconoclastic Controversy* (London, 1930). Different aspects of Iconoclasm are discussed in A. Bryer and J. Herrin, eds., *Iconoclasm: Papers Given at the Ninth Spring Symposium of Byzantine Studies,* University of Birmingham, 1977. A. Grabar, *L'iconoclasme byzantin: dossier archéologique* (Paris, 1957), emphasizes the archaeological material and is particularly interesting in the analysis of coins. Interesting for the theoretical argument are G. Ladner, "Der Bilderstreit und die Kunstlehren der byzantinischen und abendländischen Theologie," *Zeitschrift für Kirchengeschichte* 50 (1931): 1–23, and C. von Schönborn, *L'icône du Christ: fondements théologiques* (Fribourg, 1976).

3. See E. R. Bevan, *Holy Images* (London, 1940), pp. 46 ff., 132 ff. (St. John of Damascus on the Second Commandment). For a recent discussion of the problem cf. J. Gutmann, ed., *The Image and the Word: Confrontations in Judaism, Christianity, and Islam* (Missoula, Mont., 1977).

4. A stimulating exploration of the iconoclastic trend in pagan Antiquity is given by J. Geffcken, "Der Bilderstreit des heidnischen Altertums," *Archiv für Religionswissenschaft* 19 (1916–1919): 286–315.

5. K. M. Setton, *Christian Attitude towards the Emperor in the Fourth Century* (New York, 1941), pp. 196 ff.

6. Augustine, *The City of God* IV. 31 (Modern Library, 1950), pp. 138 ff. For the belief that demons take up their abode in the statues of pagan gods see Origen's views, interestingly discussed by N. H. Baynes, *Byzantine Studies and Other Essays* (London, 1960), pp. 116–143 ("Idolatry and the Early Church"), esp. p. 120.

7. *Exhortation to the Greeks* IV. 45. See *Clement of Alexandria* (Loeb Classical Library, 1968), p. 117.

8. K. Holl, *Gesammelte Aufsätze zur Kirchengeschichte* (Tübingen, 1928), II, pp. 351–387 ("Die Schriften des Epiphanius gegen die Bilderverehrung") and 388–398 ("Der Anteil der Styliten am Aufkommen der Bilderverehrung").

9. For the preiconoclastic period cf. esp. N. H. Baynes, "Icons before Iconoclasm," *Byzantine Studies and Other Essays,* pp. 226–239, and E. Kitzinger, "The Cult of Images before Iconoclasm," *Dumbarton Oaks Papers* 8 (1954): 83–150.

10. L. W. Barnard, *The Greco-Roman and Oriental Background of the Iconoclastic Controversy* (Leiden, 1974).

11. Ibid., pp. 34 ff., 80 ff.

12. G. Ostrogorsky, *Studien zur Geschichte des Bilderstreits* (Breslau, 1929).

13. St. John of Damascus, *De imaginibus oratio* I, II, III. Only a small part of his works has been translated into English (or any other modern language). (The original is in Migne, *Patrologia Graeca,* vol. 94, 1231–1420). Easily accessible, but very brief,

statements on images are in *Saint John of Damascus: Writings,* trans. F. H. Chase, Jr., in *"Fathers of the Church,"* pp. 370 ff. a chapter of his comprehensive theological work, *The Orthodox Faith* (New York, 1958). A good selection of brief passages from St. John's writings is in W. Tatarkiewicz, *History of Aesthetics,* II, *Medieval Aesthetics* (The Hague and Warsaw, 1970), pp. 45 ff. For a sympathetic presentation of the views of St. John of Damascus see E. Bevan, *Holy Images* (London, 1940), pp. 128–144.

14. Theodor of Studion, *Antirrheticus* II. 10. I know of no full translation of his work. The original text is found in Migne, *Patrologia Graeca,* vol. 99, col. 357.

15. Tatarkiewicz, *History,* II, p. 26, no. 19; p. 46, no. 6; (the numbers indicate the passages translated in Tatarkiewicz); Bevan, *Holy Images,* p. 130.

16. Bevan, *Holy Images* (London, 1942), pp. 136 ff.

17. E. Kris and O. Kurz, *Legend, Myth, and Magic in the Image of the Artist: An Historical Experiment* (New Haven, 1970). The original version, *Die Legende vom Künstler,* appeared in Vienna in 1934.

18. For a still indispensable discussion of stories concerning the supernatural origin of Christ icons see E. von Dobschütz, *Christusbilder: Untersuchungen zur christlichen Legende* (Leipzig, 1899).

19. J. von Schlosser, "Magistra Latinitas und Magistra Barbaritas," *Sitzungsberichte der Bayerischen Akademie der Wissenschaften,* phil.-hist. section (1937), pt. 2. Though not a discussion of theory, this study deals with the problems that aesthetic thought of the period must have encountered.

20. From the literature on Augustine's historical position I shall mention only H. Marrou, *Saint Augustin et la fin de la culture antique* (Paris, 1938), and the recent studies by P. Brown on Augustine's background, esp. his *Augustine of Hippo: A Biography* (Berkeley, 1967).

21. The fundamental study of Augustine's aesthetic doctrine is still K. Svoboda, *L'esthétique de Saint Augustine et ses sources* (Brno, 1933). In the following pages Augustine's works are quoted by book and chapter; the references are given in the text. In addition, see O. von Simson, *The Gothic Cathedral* (New York, 1956), pp. 21 ff.

22. *Epistola ad Serenum (Monumenta Germaniae Historica,* Epistolae II, p. 195), quoted after Tatarkiewicz, *History,* II, p. 105, no. 26a. For a broad discussion of aesthetic thought in the western Middle Ages see E. de Bruyne, *Etudes d'esthétique médiévale,* 3 vols. (Bruges, 1946). The visual arts, however, play only a marginal part in this work.

23. W. Strabo, *De rebus ecclesiasticis* (Migne, *Patrologia Latina,* vol. 114, col. 929); Tatarkiewicz, *History,* II, p. 105, no. 28.

24. The full text of the decision adopted by the Synod of Arras is published in G. D. Mansi's collection of ecclesiastical texts, *Sacrorum Conciliorum nova et amplissima collectio* (Paris, 1901) vol. 19, col. 454. I quote after Tatarkiewicz, *History,* II, p. 105, no. 27.

25. *The Symbolism of Churches and Church Ornaments. A Translation of the First Book of Rationale Divinorum Officiorum* by William Durandus (London, 1906), pp. 39 ff.

26. For the *Libri Carolini* in general see de Bruyne, *Etudes,* I, pp. 187 ff.; Tatarkiewicz, *History,* II, pp. 91 ff.

27. Honorius of Autun, *De gemma animae* 1 (Migne, *Patrologia Latina,* vol. 172, col. 586; see Tatarkiewicz, *History,* II, p. 106, no. 31).

28. Tatarkiewicz, *History,* II, p. 102, no. 16 (Migne, *Patrologia Latina,* vol. 122, col. 146).

29. Walafrid Strabo, *De rebus ecclesiasticis,* 8. The chapter in which the sentence quoted occurs is called "De imaginibus et picturis."

30. Durandus, *Symbolism,* p. 42 (I. 3. 4).

31. See above, p. 24.

32. Tatarkiewicz, *History,* II, p. 89, no. 20 (Migne, *Patrologia Latina,* vol. 83, cols. 1–59).

33. Tatarkiewicz, *History,* II, p. 212, no. 18.

34. E. Panofsky, *Idea: A Concept in Art Theory* (New York, 1968), pp. 39 ff.

35. The scholarly discussion of medieval workshop literature is limited. Schlosser's comments (J. von Schlosser, *Die Kunstliteratur* [Vienna, 1924], pp. 20 ff., 77 ff) are brief. Nor is A. Pellizzari, *Trattati intorno le arti figurativi* (Naples, 1915), though still useful, very illuminating. General histories of aesthetic thought in the Middle Ages pay only scant attention to the workshop and its literature.

36. *Heraclius Von den Farben und Künsten der Römer,* Original text translated and edited by A. Ilg (*Quellenschriften für Kunstgeschichte und Kunsttechnik,* IV) (Vienna, 1888).

37. See Schlosser, *Die Kunstliteratur,* pp. 21 ff.; Pellizzari, *Trattati,* pp. 387 ff.; and Ilg's Introduction to his German translation. In addition, see H. Roosen-Runge, *Farbgebung und Technik frühmittelalterlicher Buchmalerei; Studien zu den Traktaten "Mappae Clavicula" und "Heraklius"* (Munich, 1967), I, pp. 147 ff.

38. *Heraclius,* p. 2 (Prohemium).

39. Pliny is frequently mentioned; see, e.g., I. vi (pp. 9 ff.). Vitruvius is not mentioned by name, but Ilg makes it seem likely that Heraclius was acquainted with traditions best formulated in Vitruvius. See Ilg's comments in *Heraclius,* pp. 101 ff. (referring to what Ilg believes to be a "literal copy" of Vitruvius' text), pp. 145 f.

40. See *Heraclius* I. vi (pp. 9 ff., a chapter called "De preciosorum lapidarum incisione"); I. xii (p. 39, a chapter dealing with the cutting of crystals); I. xiv (p. 41, a chapter dealing with the cutting of Roman glass). See also III. ix, x (pp. 61 ff.). For the significance of these remarks cf. Ilg's Introduction.

41. E. Panofsky, *Renaissance and Renascences in Western Art* (Stockholm, 1960), pp. 3 ff.

42. Schlosser, *Die Kunstliteratur,* p. 21; J. Schlosser, *La letteratura artistica* (Florence, 1956), pp. 26 ff.

43. *Heraclius* III. xxv (p. 73).

44. Now available in a good English translation (with the original Latin text on facing pages) by C. R. Dodwell, See Theophilus, *The Various Arts* (London, 1961).

45. For a detailed survey of the views on the date and authorship of Theophilus' treatise see Dodwell's Introduction to his translation, esp. pp. xxxiii ff. (authorship) and xviii ff. (date).

46. For reference to paper (Greek parchment) see I. xxiii (pp. 20 ff); for bell founding, III. lxxxv (pp. 150 ff.); for organ building, III. lxxxi (pp. 142 ff.).

47. Introduction to pt. I, p. 4.

48. See Dodwell's Introduction, pp. xiii, xxxvi.

49. *Curiosus explorator,* translated by Dodwell (p. 37) as "diligent seeker."

50. *The Various Arts,* trans. Dodwell, p. 37 (Introduction to pt. II).

51. Ibid., Pp. 124 ff. (III. lxvi).

52. See *The Various Arts,* trans. Dodwell, I. 3, 13 (pp. 5 ff.) for color of face; I. 6 (p. 7) for color of eyes; I. 5 (pp. 6 f.) for colors to be used in highlights.

53. "do not despise useful and precious things, simply because your native earth has produced them for you of its own accord or unexpectedly" (pt. I, Introduction, p. 3), trans. Dodwell.

54. For the quotations given in this paragraph see the Introduction to pt. III of *The Various Arts,* trans. Dodwell, pp. 61 ff.

55. See A. N. Didron, *Christian Iconography: The History of Christian Art in the Middle Ages* (London, 1851). Under this somewhat imprecise title was the first English translation of *The Painter's Guide* of Mount Athos originally published.

56. The best edition is H. R. Hahnloser, *Villard de Honnecourt, Kritische Gesamtausgabe des Bauhüttenbuchs, Ms. fr. 19093 der Pariser Nationalbibliothek,* 2d ed., rev. and enl. (Graz, 1972).

57. For an analysis of Villard's overall attitude see, in addition to Hahnloser's Introduction, de Bruyne, *Etudes,* III, pp. 251–261.

58. Fol. 6 of Villard's manuscript. For the identification of Roman as "Sarazin" cf. Panofsky, *Renaissance and Renascences,* p. 111.

59. For this concept see the interesting pages in Jean Adhemar, *Influences antiques dans l'art du Moyen Age* (London, 1939), pp. 279 ff. For its possible afterlife see E. Panofsky, *The Codex Huyghens and Leonardo da Vinci's Art Theory* (London, 1940), p. 119.

60. E. Panofsky, "The History of the Theory of Human Proportions as a Reflection of the History of Styles," *Meaning in the Visual Arts* (Garden City, N.Y., 1957), pp. 55–107; for Villard's system see pp. 83 ff.

61. de Bruyne, *Etudes,* III, pp. 254 ff.

62. To give one example: while G. Matthew, *Byzantine Aesthetics* (New York, 1971), p. 9, believes that "it was a cardinal misfortune for the study of European art history" that *The Painter's Guide* for a long time passed as Byzantine. Panofsky, "Theory of Human Proportions," p. 75 ff., maintains that the documentary value of the work has been underestimated in modern literature.

63. Schlosser, *Die Kunstliteratur,* p. 25, calls attention to the fact that the Italian term *naturale,* which as an aesthetic term does not precede the Renaissance, appears, neatly transcribed in Greek characters, in *The Painter's Guide.*

64. Panofsky, *Idea,* p. 50.

65. Meyer Schapiro, "On the Aesthetic Attitude in Romanesque Art," in *Selected Papers,* I, *Romanesque Art* (New York, 1977), pp. 1–27.

66. Quoted after Schapiro, "Aesthetic Attitude," p. 5. The passage occurs in a chronicle of the abbots of St. Trond, near Liège, and is dated about 1169.
67. Quoted after ibid., pp. 11 ff.
68. E. H. Gombrich, *The Heritage of Apelles* (Oxford, 1976), pp. 15 ff.
69. The whole passage, in an exemplary translation, is given in Schapiro, "Aesthetic Attitude," pp. 17–18.
70. See ibid., p. 19. For the full text (which, as far as I know, has not yet been translated) see Migne, *Patrologia Latina,* vol. 171, col. 1409.
71. *Summa theologica* I. ii. 9.57a., ad 1. See Tatarkiewicz, *History,* II, p. 261, no. 21.
72. F. P. Chambers, *The History of Taste* (New York, 1938), p. 8.
73. See Schapiro, "Aesthetic Attitude," p. 14, for both quotations.
74. Theophilus, *The Various Arts,* trans. Dodwell, Introduction to pt. III, p. 63.
75. Quoted after the translation by Tatarkiewicz, *History,* II, p. 176, no. 20.
76. See *Abbot Suger on the Abbey Church of St. Denis and Its Art Treasures,* ed. and trans. E. Panofsky (Princeton, 1946), p. 61 (hereafter cited as *Suger*).
77. *Suger,* p. 79.
78. Ibid., p. 87.
79. This anonymous text is here quoted after Tatarkiewicz, *History,* II, p. 174, no. 13.
80. We should like to quote just one other text, the directives given by the Cistercians in 1138: "We forbid sculptures and paintings in the churches and in any monastery buildings: for when the attention is concentrated on things like this, the usefulness of good meditation and the discipline of religious dignity are often neglected." See Tatarkiewicz, *History,* II, p. 173, no. 11.
81. *Suger,* p. 65.
82. G. Haupt, *Die Farbensymbolik der sakralen Kunst des abendländischen Mittelalters* (Leipzig, 1941).
83. *Suger,* pp. 63 ff.
84. Ibid., p. 51.
85. Ibid., pp. 47 ff.
86. Cf. a classic discussion in J. Huizinga, *The Waning of the Middle Ages* (London, 1924), esp. chaps. 13 and 14. And see also E. Mâle, *L'art religieux en France au fin du Moyen Age* (Paris, 1958).
87. This classic text has been frequently translated and reprinted. Most easily accessible in E. Holt, ed., *A Documentary History of Art* (New York, 1957), I, pp. 19–22.
88. For these and other details see Panofsky's Introduction to his translation of *Suger* (reprinted in Panofsky, *Meaning in the Visual Arts,* pp. 108–145), and Schapiro, "Aesthetic Attitude."
89. Panofsky, Introduction to *Suger,* p. 25.
90. Schapiro, "Aesthetic Attitude," p. 8. Schapiro reminds his readers of modern parallels to such formulations, especially in the writings of Baudelaire.
91. In addition to the studies mentioned above, note 86, see S. Ringbom, *From Icon to Narrative* (Abo, 1965).

92. *Purgatory* X. This is how Dante describes the sculptural rendering of the Annunciation. The following lines are also quoted from the same canto. The translation is by Carlyle et al., The Modern Library, 1944.
93. For a survey of scholastic aesthetics see de Bruyne, *Etudes,* III, pp. 72 ff.
94. *Summa theologica* I. q. 5 a., ad. 1. And see de Bruyne, *Etudes,* III, pp. 282 ff.
95. For the significance of light in medieval thought see the still unsurpassed work by C. Baeumker, "Witelo, Ein Philosoph und Naturforscher des XIII. Jahrunderts," *Vorträge zur Geschichte der Philosophie des Mittelalters* (Münster, 1908), III, pt. 2. And cf. also Simson, *The Gothic Cathedral,* pp. 55 ff.
96. E. Panofsky, *Gothic Architecture and Scholasticism* (Latrobe, 1951; reprint New York, 1957).

3

The Early Renaissance

Among modern historians the period usually called the Renaissance is known as a "problem," that is, it is an issue that stimulates frequent and radical disagreement. The Renaissance has received so many different explanations that a small library of books and articles dealing only with the history of these interpretations has been elicited. Was there a Renaissance period, distinctly different from the ages preceding and following? Was this period not just the last phase—the "waning," as one great historian put it—of the Middle Ages? And had the early stages of that period, say, the fifteenth century and perhaps even earlier, enough elements in common with the last phases, say, the last decades of the sixteenth century, to let us really speak of *one* period? All the possible reasons for and against the existence of a special Renaissance period seem to have been put forward, and seriously explored, by social and economic historians, by students of literature and philosophy, and even by art historians. In some respects, at least, the problem still seems to be open, and scholars in this generation will often still hesitate to take an unqualified stand.[1]

The student of art *theory* has no such hesitations; he knows for sure that the theory of the visual arts—in the precise and full sense of this term—is a product of the Renaissance period. He also knows that this

art theory of the fifteenth and sixteenth centuries distinctly and sharply differs from the ideas on painting and sculpture that were current in the Middle Ages and that it also differs, though not as sharply, from later developments in this field. As the student of art theory is aware of the distinctness of the Renaissance period, so he is also certain of its intrinsic unity. He knows, of course, that the art theory of the early fifteenth century differed in many aspects from that of the late sixteenth, that the emphasis, even within art theory, shifted in the course of time, as we shall see in the following chapters. Yet he also knows that a fundamental attitude survived from the early Quattrocento to the late Cinquecento, that similar questions were asked, and that there was very little change in what authors during these centuries considered to be the ultimate aims of art. There *was,* then, a "Renaissance theory of art." Moreover, this theory is one of the specific features of the period as a whole, and it contributes to the specific character of Renaissance culture in general.

We can even be a little more specific. Renaissance theory of art had a definite home, or mother country. It is of course true that it was not limited to any specific country and that artists and humanists in Germany, the Lowlands, and Spain made significant contributions to it. But it was an Italian phenomenon. Only in Italy did the social, intellectual, and artistic conditions emerge that made feasible the full articulation of a systematic body of thought on the visual arts; only in Italy—"the nurse of the intellect," as she was called by the founder of modern scientific anatomy, the Flemish Andreas Vesalius[2]—did painting and sculpture indeed receive a full theoretical foundation.

The theory, it need hardly be said, did not develop in a historical vacuum. The fifteenth century saw the dramatic efforts of painters and sculptors to extricate themselves from that medieval heritage which lumped them together with craftsmen skilled in the "mechanic arts." We shall have to come back to this process several times. Here let us only mention that literary education and theory played a central part in these historical attempts. Fifteenth-century painters did not want to produce their works for the "ignorants," for the tasteless, uneducated crowd. Most of medieval art, we remember, was meant to appeal to the broadest possible public. In the Renaissance this trend was re-

versed. Artists frequently aimed at a limited audience of learned, so-phisticated spectators. Such spectators, the artists hoped, would grasp the complex subject matter, perceive the subtle ideas concealed—rather than paraded—in a painting, and appreciate the refined formal values. Aiming at an elitist audience was one facet of trying to make the painter and sculptor equal to the scholar and the poet. Learned hu-manists responded enthusiastically. Already Petrarch lovingly cherished a painting by Giotto as well as a "celestial" portrait by Simone Mar-tini.[3] To Boccaccio, Giotto was the redeemer of painting, an art, he says, that was buried for centuries because it aimed at the delight of the ignorant.[4] In the course of the fifteenth century, Italian artists did indeed achieve a unique social position and encyclopedic knowledge. Nobody put this more succinctly than Dürer who, visiting Italy, wrote home to his friend Willibald Pirckheimer: "Here [in Italy] I am a gentleman, at home I am a parasite."[5] For painting and sculpture to achieve parity with the liberal arts, it was also necessary to have a solid theoretical basis. The desire to provide such theoretical foundation was a central motive of Alberti and of his followers.

A Renaissance author or teacher, beginning a course in a certain branch of learning or on any other dignified topic, would frequently start by trying to establish his subject's place within the whole scheme of arts and sciences.[6] Such a procedure, which had been passed on by their medieval forebears, corresponded to the widespread intellectual expectations of readers and students. As has been shown by B. Wein-berg in his monumental *History of Literary Criticism in the Renaissance,* this was also true for the science of poetics, a theoretical tradition that often exercised a profound influence on the theory of painting and sculpture. But was such an approach also true for the theory of the visual arts? After all, poetics was an established discipline of venerable origin that had not been forgotten in the Middle Ages. The theory of the visual arts, on the other hand, was an altogether new field of endeavor. The authors of early Renaissance treatises on painting or sculpture were aware that they were exploring unknown territory, that they were discovering a new continent. Thus, Leone Battista Alberti concluded (ca. 1435) his book *On Painting,* probably the first fully ar-ticulate treatise of Renaissance art theory, with an almost jubilant

expression of pride in being a pioneer. "I was pleased," he says, "to seize the glory of being the first to write of this most subtle art." "If that theory had ever existed," he boasts, "I have lifted it up from unknown depth; if it has not existed before, I have pulled it down from heaven." Now, given the feeling that the theory of the visual arts is altogether new, its methods of presentation are likely to be less traditional than those of the older and more established disciplines. Nevertheless, it may be useful for us to follow the general Renaissance procedure and to briefly survey the conceptual framework within which the new theories must have developed.

Let us start with the term. In Renaissance parlance the term "art"— or *ars, arte, Kunst,* and the other equivalents—still carried the comprehensive and somewhat vague connotation inherited from the Middle Ages and Antiquity: "art" either indicated the ability to purposefully produce objects or natural effects, or it simply denoted an organized body of knowledge. Arts in our sense—I mean here particularly painting and sculpture—were subsumed under these general headings. In theory, at least, they were not set aside from other skills of production or systematic knowledge; nor were they interrelated among themselves, so as to form a special group. To follow Professor Kristeller: "Contrary to widespread opinion, the Renaissance did not formulate a system of the fine arts or a comprehensive theory of aesthetics."[7]

Yet, as we all know, during the Renaissance many important changes came about in the lifestyle of artists. These historical developments had many facets. Here we should like to mention only one of them: the marked trend of lumping together several arts, of forming groups of arts. Surely this tendency was not unopposed. The medieval tradition of separating the arts from each other, and of placing each specific art within a different context, had a powerful effect on the thought of the period. But early in fifteenth-century Florence individual painters, sculptors, and architects were regularly meeting each other and exchanging ideas and experiences. This happened not because they worked in the same enterprise (like the medieval *chantier*) or because they belonged to the same economic or social organization (originally they belonged to quite different guilds) but because they felt that their arts had some common bonds and that they faced similar problems. This

development in actual events could not fail to have an effect on theoretical thought. When Leone Battista Alberti, who should be considered the founder of Renaissance art theory, started writing on the visual arts, he, of course, composed separate treatises on painting, sculpture, and architecture. Yet the first of these works, the epoch-making *Della pittura* (1435), was dedicated to an architect (Brunelleschi), and in the dedicatory epistle Alberti spoke warmly of "our close friend Donato the sculptor and . . . Masaccio" the painter. In his little treatise on sculpture, *De statua,* composed later, Alberti refers back to his book *On Painting,* thus suggesting a special relation between the two arts. In *Della pittura* he had already said that painting and sculpture, though differing in means and aims, were equal in rank. Thus, even in the early fifteenth century the association of the visual arts became, to some degree, a historical reality and found some theoretical formulations.

But this new trend could not easily overcome age-old patterns of thought. What may be called the centrifugal tendencies, aiming at separating the arts from each other, are best known from that particular literary genre, the *paragone,* which was very popular, and was perhaps even some kind of pastime in humanistic circles. In this genre, to which we shall later return in some detail, the different arts, employing traditional techniques of disputation, competed for superiority. Such literary disputations—sometimes composed in a serious spirit, sometimes in a mood of slight mockery—contributed much to the emergence of an aesthetic vocabulary that we still employ in analyses of style. As Panofsky has pointed out,[8] concepts and terms such as "sculptural" and "pictorial," "volume" and "space," "one-view composition" and "multiview composition" are the legacy of the *paragone* literature. But what did a reader, whether an artist or a critic, in the Renaissance period itself learn from that literature? What the *paragone* told him more than anything else is that there is *no* unity of the visual arts, that they do not form a group in themselves. Thus, Leonardo da Vinci, who composed the most famous *paragone* treatise we know, would like to convince his readers that painting is not only superior to all the other arts but that it is more closely linked to poetry and even to music than to sculpture.[9] Leonardo is the most famous, but certainly

not the last, exponent of this attitude. In 1546, to mention just one other example, the Florentine humanist Benedetto Varchi elicited statements from several important contemporary artists, among them Michelangelo, Benvenuto Cellini, and Pontormo, and each of them loyally defended his own profession, usually without remarking that sculpture and painting belong to one group, based on common experiences and having common problems.[10]

In the second half of the sixteenth century the centrifugal tendency subsided (though it did not disappear), and the intrinsic relationships between the visual arts became more manifest. In 1550 Giorgio Vasari, certainly the most influential Renaissance author on the visual arts, published the first edition of his monumental work, *The Lives of the Most Excellent Italian Architects, Painters, and Sculptors.* The title of this work reflects the ambiguity prevailing in sixteenth-century thought concerning our subject. It suggests both the division between these arts (by listing them separately) and their interrelationship (by presenting together, in one work and without further distinctions, the lives of these three types of artist). Maybe Vasari himself was already asking why he lumped together architects, painters, and sculptors. In any case, in the second, much-enlarged edition of this work (which appeared in 1568), he was more explicit about his reasons. To the "Introduction to Painting," which appears in the first edition as well, he added some sentences that should probably be seen as a moment of crystallization. "Seeing that design, the father of our three arts, architecture, sculpture and painting . . ."—so begins this edition. Design, then, is the origin of the three arts, and whatever design may be they have it in common. On the other hand, design refers to something that cannot be found in other, nonvisual arts like poetry and music. Architecture, sculpture, and painting are therefore properly called "arts of design" *(arti del disegno).*

A few years before Vasari used his new concept in a published work, in the second edition of the *Lives,* an actual Academy of Design (Accademia del Disegno) was established in Florence, also upon Vasari's initiative (1563), with the aim of educating painters, sculptors, and architects.[11] The new concept of a close kinship between the visual arts emerges, then, both in historical reality and in the theory of art.

We do not ask here what precisely Vasari and his contempories meant by "design." We shall come back to this rather complex question in a later chapter. We are also aware that speaking of *arti del disegno* does not entail any aesthetic statement, as no specific value is attributed to the three arts by joining them together. Only centuries later do we find the concept of fine arts or beaux arts. When that aesthetic concept made its appearance, it may have been based upon Vasari's term, but it added a new dimension, the dimension of value indicated by such words as "fine" or "beau," to what Vasari had already suggested. By coining the term "arts of design" Vasari (and his sixteenth-century followers) was simply outlining a map of interrelated creative activities and artistic media. Artists working in these media were believed to be faced by similar problems, and they could therefore use a common theory. Renaissance theory of art is a theory of the arts of design.

I. THE IMITATION OF NATURE: A CONCEPT EMERGES

It is a matter of common knowledge that Renaissance literature on the visual arts covers a wide range of subjects—from purely technical questions of how to make colors stick to the wall or how to cast a bronze figure to the intricacies of an astrological psychology of the artist; from a crude presentation of the elements of geometry to profound discussions of symbolism based on humanistic literary sources. It is inevitable that a literature of this breadth should also display a sometimes bewildering variety of opinions and philosophical attitudes. There is, however, one belief that was regarded as a dogma and that was reverently observed by everybody who thought, or wrote, on painting and sculpture: the belief that the visual arts imitate nature. Not a single Renaissance treatise fails to make the point that the imitation of nature is the very aim of painting and sculpture and that the more closely a work of art approaches this aim the better it is. In fact, the belief that art imitates nature can be regarded as a hallmark and distinctive sign of the Renaissance in the development of art theory; wherever we first encounter this belief, we may be sure that the Renaissance has begun.

Few terms are as protean as are "imitation" and, quite particularly, "nature." Later on in this chapter we shall have occasion to look a little more closely at some of the meanings with which the two terms were endowed during the Renaissance. For the present let us assume that the "imitation of nature" is a simple, unequivocal, and self-evident statement, and let us see how it evolved.

The catch phrase that art imitates nature did not originate in the artists' workshops, though this doctrine later dominated the workshops as well as the public; the concept was formulated in the first place by poets and scholars. It is true that the art of the period would make it reasonable for such a concept to emerge. We all know the intense realism that permeated large areas of European sculpture and painting in the thirteenth and fourteenth centuries. Yet what may perhaps be described as the art theory of this early period does not seem to pay attention to this trend. Dante, the great poet of that transitional period, made some scattered remarks about painting and sculpture, but they show that his views were dominated by an altogether different problem: the traditional division between an articulate, fully shaped idea and the crude matter that resists perfect formulation.[12] Petrarch, the poet and scholar, and perhaps the founder of Renaissance humanism, is said to have planned a treatise on art, but we do not know whether by "art" he meant the general ability to produce things according to rules (i.e., the traditional sense of the term) or whether he had something more limited in mind. We do know that he held the work of some contemporary painters in high esteem, dedicating a sonnet to Simone Martini.[13] On the other hand, he mentioned, among the objects that afford us "superficial pleasure," things like "gold, silver, jewels, purple garments, marble dwellings, cultivated fields, painted pictures, horses in graceful drill" (*De rebus familiaribus* III. 18). These scattered remarks reflect an ambivalence in the appreciation of the visual arts that is characteristic of this transitional period. The same ambiguity prevails with respect to interpreting art as an imitation of nature. As far as we know, Petrarch does not explicitly use the phrase that was to become so famous. At the same time, he does compare painting with sculpture, ranking them according to their closeness to

nature. As some kind of beginning to the *paragone* literature he says that "The works of the sculptor are more lifelike than those of the painter" (*De rebus familiaribus* V. 17).

Petrarch's contemporary, Giovanni Boccaccio, the author of the famous *Decameron,* model of vivid, sometimes coarse storytelling, and at the same time a learned humanist, at home in ancient Latin literature, was probably the first Renaissance author to explicitly relate the visual arts to the imitation of nature. In a remarkable story included in the *Decameron* (VI. 5), Giotto, whose ugly physical appearance is wonderfully described, is appraised as a "genius" and is credited with the achievement of radical naturalism. "The genius of Giotto," Boccaccio says, "was of such excellence that there was nothing [produced] by nature, the mother and operator of all things, in the course of the perpetual revolution of the heavens, which he did not depict by means of stylus, pen or brush with such truthfulness that the result seemed not to be not so much similar to one of her works as a work of her own. Wherefore the human sense of sight was often deceived by his works and took for real what was only painted." This radical naturalism is conceived as an achievement of painting, marking the beginning of a new period (the Renaissance), and also as distinguishing Giotto's work from that of former painters which aimed only at superficial decorative effects. "Thus," Boccaccio continues, "he [Giotto] restored to light this art [painting] which for many centuries had been buried under the errors of some who painted in order to please the eyes of the ignorants rather than to satisfy the intelligence of the experts." For all these reasons, Boccaccio concludes, Giotto may be called "one of the lights in the glory of Florence."

The workshops of Italian painters and sculptors were slow in absorbing the new doctrine. An important document of this process is Cennino Cennini's *Libro dell'arte,* the main treatise preceding the emergence of a full humanistic theory of art.[14] Little is known of Cennini's life and work as a painter. Educated in the Giotto tradition, he revered its founder who by now, the early fifteenth century, had become a legendary figure. Employing humanistic formulas, Cennini says that "Giotto had changed the profession of painting from Greek back into Latin, and brought it up to date." Cennini spent the greater part of

his life in Padua, a city that had a tradition of rhetorical studies and later became the center of Averroist philosophy and science.

The composition and literary character of Cennini's treatise are typical of the medieval technical tradition and, in fact, show how lively that tradition still was even in the first decade of the fifteenth century. The *Libro,* written for those "who want to enter this profession" (i.e., painting), consists of individual observations, each cast in the shape of an independent paragraph ("chapter"). Most of these chapters tell the artist how to use certain materials (pigments, glues, metals), how to treat different surfaces (walls, panels, parchment), or give advice on similar matters. This is, of course, the typical, familiar shape of the medieval technical treatise ever since Theophilus' *The Various Arts.* Even the concrete contents of the individual precepts as a rule reflect medieval practices (see, e.g., the observations on gilding). But also in a more general sense the *Libro* often leads us back to the intellectual world of the Middle Ages. Cennini begins by reminding his readers of original sin and of the expulsion from paradise. Hard labor was the wages of sin, and among the different forms of labor there is also an occupation, based on theory, but coupled with skill of hand: "this is an occupation known as painting."

Cennini also orthodoxly believed in the system of exempla, the well-known method of training artists and guiding them in the production of works of art in the medieval workshop. Cennini used established medieval techniques of copying (28); he indicated precisely the specific spots in the face where the artist should apply shadows; and he described how his master, Agnolo Gaddi, used to apply a pink touch to the cheeks of his figures and recommended it as a model for imitation (67). In general, the education of an artist is for him a process of imitating the works of fine artists and of absorbing their style. The apprentice should unwaveringly stick to his master's manner. Let us listen to Cennini himself.

"And if you are in a place where many good artists have been, so much the better for you. But I give you this advice: take care to select the best one every time, and the one who has the greatest reputation. And, as you go on from day to day, it will be against nature if you do not get some grasp of his style and his spirit. For if you undertake to

copy after one master today and another one tomorrow, you will not acquire the style of either one or the other, and you will inevitably, through your enthusiasm, become capricious, because each style will be distracting your mind" (27). Cennini himself spent twelve years, as he proudly tells us (67), working with one master only.

All this points to Cennini's roots in the medieval tradition. But in the late fourteenth century that tradition was not as solid as one would perhaps imagine; the *Libro* itself shows us where it is cracking and breaking up, and this is precisely in the belief that art imitates nature. In addition to following one's master's manner, Cennini knows of another way of cultivating a style: the imitation of nature. "Mind you, the most perfect steerman that you can have, and the best helm, lie in the triumphal gateway of copying from nature. And this outdoes all other models" (27). This rather unusual figure of speech (joining, or confusing, architectural and nautical imagery) is most likely taken over from some humanistic source; it has a definite flavor of rhetoric (and one not fully absorbed by the workshop master), and it is ill-adjusted to Cennini's simple, matter-of-fact style, which usually lacks decorative patterns. Whatever the source, within the theory of painting Cennini's short passage is the first workshop formulation of the idea that the imitation of nature is the basis of the visual arts and a means for developing a good style. It is interesting to note that Cennini did not seem to notice a possible contradiction between following the master's models, on the one hand, and copying nature, on the other.

But, what is nature, in Cennini's view, and how should it be copied? Later in the Renaissance, especially in the sixteenth century, it became fashionable for authors of art theory to engage in lengthy, involved, and not always lucid elaborations about the essence of nature and about the creative powers dwelling in it. Cennini precedes this philosophical wave. To him nature is mainly the individual, tangible object or figure, directly experienced by the artist. To him, therefore, copying nature obviously meant copying the single object or figure. Now, this may seem simple enough in sculpture. Toward the end of the *Libro*, most of which is devoted to painting, Cennini adds: "I will tell you about something else which is very useful and gets you great reputation in drawing, for copying and imitating things from nature: and it

is called casting."[15] He then goes on to give detailed instruction for the casting of faces and even of whole figures. Life casts were, of course, nothing radically new around 1400. In the history of European sculpture life casts have appeared several times,[16] playing a certain role in the process of creating status. The resemblance, authentic and, as it were, guaranteed, between the natural original and the artistic copy in the process of casting from life could not fail to stimulate aesthetic thought. Nevertheless, there is something new in Cennini's use of the technique. It clearly shows that nature is for him the individual face or figure. And it is very interesting that he sees life casting as a means for developing a good style, "to get a reputation in drawing," as he puts it. Cennini considers the individual figure as an exemplum.

How does this approach work in painting where one cannot help translating a three-dimensional reality into a two-dimensional image? Cennini makes this clear in a famous example. In a short chapter entitled "The Way to Copy a Mountain from Nature" (88) we read: "If you wish to acquire a good style for mountains, and to have them look natural, get some large stones, rugged, and not cleaned up; and copy them from nature, applying the lights and the darks as your system requires." This passage contains the major elements of Cennini's approach to the art of painting in a nutshell. In a general sense, it shows how close the author was—consciously or subconsciously—to the theory of microcosm; what is contained in the whole mountain may be found in a single stone. The example also reveals that even when looking at nature Cennini is searching for a specific exemplum (the individual stone) as he would have looked for an exemplum in the artistic heritage had he not turned to nature itself. The appeal to nature, in itself, indicates a profound change in outlook. A medieval artist, when faced with the task of representing a mountain, would probably have looked up a pattern book, or he would have turned to a collection of drawings done after some acknowledged masterpieces and kept in the workshop for precisely such an "emergency." Instead of doing this, Cennini turns to raw nature. He takes a natural exemplum, if we may say so, and he has difficulties in finding a way to cut off a small piece of nature that can serve as an exemplum. This is the first time in art theory that we encounter the model in a modern

sense. All this speaks clearly enough of the crack in the medieval tradition that Cennini's treatise reveals. But, perhaps the most obvious conclusion, almost forced upon the reader of this passage, is, of course, that a "good style" is synonymous with "looking natural." Two generations after Boccaccio's *Decameron* the workshops also started to formulate the gospel of the convincing imitation of nature as the embodiment of artistic value.

II. ALBERTI: THE BIRTH OF A NEW THEORY OF ART

In Cennini's doctrine, as we have seen, "nature" is still unexamined nature, and "imitation" is an unexplored process, an action producing a replica. Though new ideas are emerging, the patterns of thought still remain the old ones. But about a generation later we are confronted with radical change, perhaps with the most profound revolution the theory of art has ever experienced. Historians investigating the operation of hidden tendencies may convince us that this change was not unprepared, but at the time it must have looked like a total break with the immediate past, and to the modern historian it still appears as a moment comparable to the split second when a saturated solution instantly crystallizes. That seemingly abrupt change is almost perfectly embodied in the work of one author; his theoretical purposes are so far unheard of, and the pattern of his treatises is equally new.

Leone Battista Alberti (1404–1472) is a rather unexpected figure to initiate a major transformation in art theory. He did not come from the workshop *(bottega),* and in spite of his close connections with artists he remained a stranger to it. Alberti was the illegitmate son of a wealthy and ambitious Florentine family who were so much involved in rather violent communal politics that they were expelled from Florence. Born in Genoa, he enjoyed the advantages of the finest education then available to an Italian nobleman. He studied at the most renowned universities (especially at Bologna, for decades the famous center of legal studies); he held a post at the papal court in Rome and was the confidant of several popes and rulers. The variety and range of his interests are astonishing. Few figures of that period qualify as well as Alberti as the paragon of the "Renaissance man." Burckhardt

said of him: "he was not versatile, he was universal."[17] In Alberti's multifaceted intellectual world the visual arts formed an important focus: he was significant as an architect, and some of his buildings— the Palazzo Ruccellai and the facade of Santa Maria Novella in Florence, the churches in Rimini and Mantua—are considered to be landmarks in the formation of Renaissance architecture. In painting and sculpture he was much less important, but he practiced both to a certain extent. During the short period that he spent in Florence (after the ban on the Albertis was lifted in 1428), he was in close contact with the most innovating artists; he dedicated his work *On Painting* to Brunelleschi, Donatello, and Masaccio. His theoretical works were certainly his most important contribution to the arts. On each of the three visual arts he composed a special treatise. The first of these was *On Painting,* originally written in Latin in 1435 but subsequently rewritten (and probably circulated in manuscript) in Italian; around the middle of the century he produced an extensive work of architecture, *De re aedificatoria,* patterned after the *De architectura* by Vitruvius; and, finally, he composed a short treatise on sculpture, *De statua,* probably written shortly after 1464.[18] Like his book on architecture, the treatise on sculpture was first published in Latin, but both appeared in Italian versions in the sixteenth century.

All these treatises are composed from a new point of view. As we said above, Alberti did not originate in the workshop, but he also did not write as some of those medieval spectators who were altogether outsiders and who simply enjoyed the end product of the artistic process. Alberti wrote for artists, and he kept this in mind even when he was dealing with subjects that had never been topics of conventional art theory. Thus, before introducing geometry, on the very first page of *Della pittura* Alberti reminds the reader: "But in everything we shall say I earnestly wish it to be borne in mind that I speak in these matters not as a mathematician but as a painter" (I. 1). He attempted to place the visual arts on a new basis, and he wanted the artists to be aware of these new foundations. Alberti's approach has sometimes been called rationalistic. Now, "rationalism" is a term worn out by excessive, and not always responsible, use. But we can say that Alberti considered painting (or sculpture) to be, not a handicraft, acquired by simply

following one's master's example, but an intellectual ability, developed by understanding its elements and rules. This, of course, is also the reason why painting should be considered a liberal art. This idea is emphasized in each of Alberti's treatises. "Arts," he wrote in *De statua,* "are learned first by study of method, then mastered by practice." Rational knowledge is of significance both in the process of shaping a work of art and in the process of educating a young artist. "Let no one doubt," we read at the end of the first book of *Della pittura,* "that the man who does not perfectly understand what he is attempting to do when painting, will never be a good painter. It is useless to draw the bow, unless you have a target to aim the arrow at" (I. 23).

Alberti's rationalism, though important, is not sufficient to define his unique position in the development of art theory. In the medieval workshop philosophical understanding may not have been required, but certainly nobody was encouraged to exercise his abilities without purpose; the artist was clearly required to determine his aim (or have it determined by some authority) before he actually started work. What was new in Alberti's rational approach was that he intended the theory of art to be some kind of logical system and that this approach was employed in the imitation of nature.

The systematic character of the treatise is an original contribution of the Renaissance. We cannot say what the structure of a classical treatise in the figural arts might have been, since no such treatise has survived. But we know that medieval treatises were not intended to have any structure of their own, independent of the artist's actual practice. The observations and rules are assembled more or less at random; either they are presented without any intrinsic order, or they are grouped according to media and materials. Thus, Cennini still combined observations on pigments in one group, observations on parchment in another, and so on. Alberti's point of departure is altogether different. His program for teaching the young artist faithfully reflects his general attitude. Youngsters studying painting should begin with basic elements and go on to more complex tasks. Alberti constructed *Della pittura* according to these principles. The treatise is divided into three books, and in the Latin version (the one Alberti himself published) each book bears its own title: "Basic Principles" *(Rudimentae),*

"Painting" *(Pictura)*, "The Painter" *(Pictor)*. The first book deals with the principles of geometry and optics and how to apply them in painting, especially in perspective. The second book presents a brief history of painting and then describes the most important elements of this art—contour, composition, color, and expressive movements. The third book is devoted mainly to the artist's education and to the steps by which the process of shaping a picture unfolds. Not only the titles but the contents of the books and the transitional sentences connecting them show how consciously and consistently Alberti tried to find its proper noninterchangeable place for each part. The art-theoretical treatise is thus a careful construction. Its composition is neither a hodgepodge of useful observations nor merely a reflection of workship practice. We can say that, by trying to give a systematic and logical structure to the treatise, art theory came into its own.

Even more important is the application of the rational approach to the imitation of nature. The doctrine of the imitation of nature is the focal point of Alberti's conception of art, and all other problems revolve around this central point. In both *Della pittura* and *De statua* he stresses that creating a convincing likeness to nature is the ultimate aim of the painter and sculptor and that the study of nature forms the very basis of creating a work of art. "The function of the painter is to draw with lines and paint in colors on a surface of any given bodies in such a way that at a fixed distance and with a certain determined position of the centric ray, what you see represented appears in relief, and just like those bodies" (III. 52). This is also true for sculpture. The artists, be they painters or sculptors, "all strive, though by different skills, at the same goal, namely that as nearly as possible the work they have undertaken shall appear to the observer to be similar to the real objects of nature" (*De statua* 2). Similarity to nature is not only the final aim of painting; from nature we also learn how to shape a work of art. Never doubt, he says in the book on painting, "the fundamental principle [of this art] will be that all the steps of learning should be sought from nature" (III. 55).

As we have seen, naturalness of appearance was appreciated as a value in painting before Alberti explicitly defined it as such. In Cennini we saw that the imitation of nature is the "triumphal gateway"[19] to

good painting. There is little doubt, in fact, that in postulating the imitation of nature as the aim of the visual arts Alberti was following a trend that was gaining ground both in the workshops and among humanists. Yet he went beyond the connection of the representing arts with a general, somewhat vague notion of the imitation of nature; he required the imitation of nature to be "correct," thereby initiating one of the most important and most characteristic developments in the aesthetic thought of the Renaissance; and he coupled the requirement for the imitation of nature with another, equally significant demand: to represent the beautiful. In the next section we shall deal with what "correct representation" may have meant and with what its impact was. Now let us ask what the demand for beauty meant and how the representation of the beautiful can go together with the representation of nature.

Alberti has left us in no doubt about how serious he was in his demand for beauty in painting. The artist "should be attentive not only to the likeness of things but also, and especially, to beauty, for in painting beauty is as pleasing as it is necessary" (III. 55). This requirement is not left as a general, vague demand; it is directly translated into practical advice. "Before painting a picture," Alberti insists, "one should, above all, consider which manner and arrangement will be the most beautiful."

In his conception of what beauty is Alberti closely follows classical thought; beauty is symmetry, it is the harmonious relationship of the parts of a whole. In his most extensive work on an art form, *De re aedificatoria* (II. 13),[20] he asserts that "beauty is the harmony of all parts in relation to one another." Later on in the same work (IX. 5) he formulates the same idea in somewhat different words. "Beauty is a kind of concord and mutual interplay of the parts of a thing." Employing classical terms with which he must have been familiar from his student days, he continues: "This concord is realized in a particular number, proportion, and arrangement demanded by harmony. . . . This is particularly necessary in building." But it is necessary in painting, too. "First of all," Alberti tells the painter, "take care that all the members are suitable. They are suitable when size, function, kind, color, and other similar things correspond to a single beauty"[21]—in other

words, if they form a harmonious relationship. In his book on architecture (*De re aedificatoria* VI. 2) Alberti employs the term *concinnitas* to describe beauty. *Concinnitas* is a term he took over from Cicero. It is worth remarking that a manuscript copy of Cicero's *Brutus,* a work in which the term occurs, was in Alberti's possession and has survived, with the owner's marginal note that he had finished his work *On Painting.*[22] *Concinnitas,* while evoking certain musical associations, is a formulation of the mathematical concept of beauty as harmony. Perhaps more than other terms it carries the connotations of unity, of combining the different parts into an integrated whole.

The modern reader cannot help asking himself: How can the artist be faithful in his imitation of nature and, at the same time, strive at the representation of harmonious beauty? Alberti—as well as his contemporaries and immediate followers—saw no direct contradiction between these two demands. He did not believe beauty to be alien to nature, an element drawn from an altogether different source, and brought by the artist to the portrayal of reality. It is hidden in nature itself, and the artist's task is to discover that beauty and make it manifest in his work. But the uncovering of it is hard, because beauty is diffused in nature piecemeal. The artist will never find in nature a figure completely beautiful, which he can then simply portray. First he has to find individual members that are beautiful, and then it will be his task to piece them together so as to form a harmonious figure. For this difficult job "excellent parts should all be selected from the most beautiful bodies and every effort should be made to perceive, understand and express beauty. Although this is the most difficult thing of all, because the merits of beauty are not all to be found in one place, but are dispersed here and there" (III. 55). This procedure was legitimized by Antiquity. One story, especially from classical literature, cannot be overlooked by anybody reading Renaissance treatises on art. It is the story of the ancient painter Zeuxis, which the humanists knew from their readings of Cicero and Pliny. When Zeuxis, as the story goes, was asked by the citizens of Croton to produce a cult image of Helen (or Venus), he "did not set about his work trusting rashly in his own talent as all painters do now; but, because he believed that all the things he desired to achieve beauty not only could not be found by

his own intuition, but were not to be discovered even in nature in one body alone, he chose from all the youth of the city five outstandingly beautiful girls, so that he might represent in his painting whatever features of feminine beauty were most praiseworthy in each of them. He acted wisely," Alberti concludes (III. 56).

One should, of course, ask what enables the artist to pick out the beautiful part, the well-shaped, harmonious organ from the sheer infinite mass of ugly and deformed shapes. What guides him when he is scanning the variety of shapes that nature provides? And where does he find the ability to combine the individual fragments so that they form a whole, organic, and harmonious figure? Alberti was not a modern philosopher, and he did not explicitly ask these questions. But he does speak of an "idea of beauties" dwelling in the artist's mind. Erwin Panofsky, in his masterful essay tracing the history of the concept "idea" in art theory, has shown that in Alberti's view the "idea of beauties" is not separated from nature, and by no means does the fact that the artist carries the "idea of beauty" in his mind mean that he need not experience reality.[23] In strong terms Alberti warns the painter not to follow "the habit of those who strive for distinction in painting by the light of their own intelligence without having before them or in their mind any form of beauty taken from nature to follow" (III. 56). Probably referring to medieval habits, Alberti says that those artists will not "learn to paint properly, but simply make habits of their mistakes. The idea of beauty, which the most expert have difficulty in discerning, eludes the ignorant" (III. 56). Whatever the ultimate origin of the artist's "idea of beauty" may be, it cannot come into being unless he studies the objects and figures surrounding him; it cannot replace his direct encounter with nature. Therefore, Alberti can admonish the painter: when you practice, "you should always have before you some fine and remarkable model, which you observe and copy" (III. 59). In other words: you portray nature, but you choose your example so that it will be "fine and remarkable," that is, beautiful.

Alberti, we may conclude, asks of the painter to imitate *examined* nature. The artist cannot accept the object or figure as it may be encountered at random. Verisimilitude itself is not enough; achieving a convincing illusion of the natural body is not sufficient. The object or

figure depicted has to be brought into harmony with pattern of eternal validity (beauty), and the beautiful patterns themselves have to be extracted from nature. The imitation of examined nature is the basis and focal thought of Renaissance theory of art.

Such a theory, of course, departs radically from medieval practices and doctrines. As we said above, an obvious difference is that it replaces the pattern book with the observation of nature. But it differs also in its general character. The medieval approach may be described as unmediated, "closed." The artist seeks the exemplum that can be directly imitated. Alberti's approach may be termed "open"; it aims at developing the artist's skills and understanding so that he will be able to extract the underlying pattern from any given part of nature. Alberti, then, replaces the medieval exempla, the precast models, by "principles," by rational method and absolute values.

III. "CORRECT IMITATION": ART AND SCIENCE

The demand for the correct representation of nature pervaded Renaissance thought. No treatise on art written in the fifteenth and sixteenth centuries fails to mention it. But, perhaps because of its ubiquity, the precise meaning of the concept is often blurred. What did Renaissance authors mean when they required that the artist's work be a true representation of nature?

It is striking that Renaissance literature did not coin special terminology for this concept. We often read of "true imitation" or of the imitation that completely corresponds to the object represented. Leonardo, the champion of correct representation, simply said: "That painting is most praiseworthy which conforms most to the object portrayed."[24] None of these words fully expresses what the required correctness implied. But, while there was no single and precise term, Renaissance artists and critics knew very well what they were talking about. The modern concept "correct" is a proper equivalent of what they had in mind and of the different Italian terms they employed.

If one speaks of a "correct imitation," one assumes by implication that another kind of imitation, one that lacks the property of correctness, is also feasible. A rendering of nature that is not correct can,

nevertheless, produce a convincing illusion. "Correctness," then, is not simply another word for good quality or for the successful creation of an optical illusion.

Rather, it indicates a type of depiction, a specific character of the representation, and this type of representation became, for a certain period, a broadly accepted aim of the artist's endeavors.

"Truth" or "correctness" are not notions that one would normally expect to find in the semantics of the arts; they are at home in the sciences where a statement is either right or wrong, true or false. A scientist ascertaining that his statement is true means both that its contents correspond to the piece of reality about which it is made and that this correspondence can be irrefutably shown, or "proved," as he would say. This is precisely what Renaissance authors, artists, and a large part of the educated public had in mind when they insisted that the artist should imitate nature correctly, when they praised a picture for being a "true imitation" of nature. The work of art as a scientific statement—this is one of the most striking and most original contributions of the Renaissance to aesthetic thought. One cannot imagine such a demand in the Middle Ages, since art was not meant to represent nature. But even in Antiquity, when the convincing illusion of reality achieved in a picture was so highly appreciated, verisimilitude in itself was considered an ultimate value. That a picture can be true in addition to being so convincing that it misleads the spectator was beyond the horizon of even classical aesthetics.

In a seminal essay Erwin Panofsky has traced the background of this original contribution of the Renaissance.[25] In the Middle Ages, he reminds us, the barriers between the different disciplines—and particularly between intellectual activity and manual labor, between what one did with one's mind and with one's hands—were insurmountable. One of the hallmarks of the Renaissance is the breaking down of those barriers. The medical doctor could also be a philosopher and a classical scholar (as was Ficino); the engineer could also be a poet and a diplomat. For this phenomenon Panofsky coined the term "decompartmentalization." While the Middle Ages tried to make the compartments of knowledge and creation as watertight as possible, the Renaissance consistently—and, one should say, with full awareness—

tried to open them up and to fuse them with each other. Decompartmentalization had a most profound influence on the intellectual and artistic world of the Renaissance as a whole, or—to put it differently—it was the outward manifestation of a basic process in Renaissance culture and society. It also bridged the gap—which in the Middle Ages seemed to be an unbridgeable abyss—between theoretical knowledge on the one hand and the direct observation of nature and the practical manipulation of tools on the other. The scientific experiment as a permanent institution was one of the products of this process. (Individual experiments were, of course, undertaken in previous periods as well, but never before do we find a continuous tradition of scientific experiments.)

Within that broad historical process the artist played a central part. The universities in the fifteenth century were mainly centers of conservatism, and their traditional outlook—often closely related to the scholastic method that they still practiced—precluded them from being the place where the old barriers were abolished.[26] Decompartmentalization had to take place mainly outside official institutions of learning, and the artist's workshops proved to be an important ground for the realization of this process.

Since "true imitation" played such a central part in the aesthetic thought of the period, and was regarded as a superior value in art, a bewildering variety of themes and features were associated with it. In reading Renaissance treatises one often wonders whether there is anything on earth that has no legitimate connection with true imitation. But if we consider these different, and sometimes even conflicting, claims, few areas emerge in which the idea of "correct imitation" is regularly applied as well as ways in which it is understood. The first such area I shall call the "material truth" of representation: the artist's attempt to represent, as clearly and as closely as possible, nature "as it really is." "Nature" here includes every object, natural or man-made, encountered in our experience, but the most frequently used and most characteristic specific area is the representation of the human body. A second type of correctness may be termed "formal truth." By this I mean the artist's concern with the *manner* of representation rather than with the objects represented. Renaissance artists strove to turn the

manner of representation into a secure, scientific method, the "truth" of which can be proved. Here, of course, one immediately thinks of perspective. A third area, perhaps less articulate and more problematic, may be called "psychological truth." We shall first outline the development of the two major areas and assess their impact on art theory.

IV. ANATOMY

The demand for "material correctness" encompasses a variety of fields, mainly those belonging to the natural sciences (zoology, botany, etc.), but nowhere did it become as manifest as in the study and representation of the human body. As we know, in the medieval hierarchy of sciences, medicine, dealing with individual, terrestrial, and perishable bodies ranked lower than disciplines that dealt with unchangeable norms (like law), still lower again than those that concerned themselves with eternal truths (philosophy) or revelation (theology). Medical studies were focused on healing, and, therefore, simply knowing how the human body is constructed seemed less important. University studies of the art of healing were largely theoretical and were still based on classical texts, like Galen's, and their later revisions. In the words of Charles Homer Haskins, the American historian of medieval culture: "unfortunately, the scholastic habit of mind and the medieval reverence for the written word put these texts into a position of absolute authority, to be expounded and interpreted literally and dogmatically rather than experimentally in laboratories and clinics."[27] The empirical study of the human body had to begin somewhere else. "Small wonder then," as Panofsky puts it, "that painters rushed in where doctors feared to tread."[28] And, indeed, one of the early, and for a long time quite important, centers for the study of the basic structure of the human body by empirical observation was the artist's workshop. It is difficult, and beyond the scope of the present work, to trace in detail the beginnings of anatomical study by painters and sculptors. In any case, around 1400 a famous Florentine historian, Filippo Villani, tells the story—so strange to a modern mind—of medical students carefully examining the nudes painted by one of Giotto's pupils[29] because they could learn from what they perceived on the wall or panel what

they could not learn in class, namely the structure of the human body. Artists' studies of anatomy must have been, in the early stages, only a matter of simple direct observation, lacking any theoretical foundation. In the same decade in which Filippo Villani wrote his story, Cennino Cennini maintained that "a man has one breast rib less than a woman, on the left side"[30]—obviously, because the Lord had removed one of Adam's ribs to form Eve.

When the new art theory emerged, it displayed a rather limited interest in scientific anatomy. Alberti, the founder of Renaissance art theory, has little to say of anatomy and of material correctness in general. It is true that in *Della pittura* he mentions the "measuring" of members and even praises the knowledge of their interior structure—bones and muscles—though these cannot be seen. He seems to have felt that artists are here dealing with something infringing on their actual job. "But, at this point, I see, there will perhaps be some who will raise as an objection something I said above, namely, that the painter is not concerned with things that are not visible. They would be right to do so, except that, just as for a clothed figure we first have to draw the naked body beneath and then cover it with clothes, so in painting a nude the bones and muscles must be arranged first, and then covered with appropriate flesh and skin in such a way that it is not difficult to perceive the positions of the muscles" (II. 36). This passage may reflect some workshop usage, but it hardly explains why so much effort should be spent on the study of the skeleton. We should, moreover, remember that the context of this discussion is the demand for beauty. The members of the body, Alberti emphasizes, should correspond to each other in shape and proportion so that *beauty* is achieved. Alberti also stresses the importance of decorum: the members should fit the character of the figure; a runner's composition of limbs should differ from a philosopher's.[31] A little later on in the treatise he speaks of the body's movements, and here too it is not only a matter of anatomical correctness; what occupies Alberti's mind is mainly that the movements should clearly reflect emotions.[32] In his last treatise on art, *De statua,* Alberti discusses methods, and presents technical devices, for measuring members; but here, too, it is clear that what he really wants to establish are not so much their correct shape

but their harmonious proportions. At the end of *De statua* we find a list of proportions of the human body, more detailed than anything of this kind that has come down to us from any former period. Again, all these measures and proportions are not meant only to secure the correct representation of nature. Although Alberti derived his list of proportions from measuring many individual bodies, his true aim was "to measure and record in writing, not simply the beauty found in this or that body, but, as far as possible, that perfect beauty distributed by nature, as it were in fixed proportions, among many bodies" (12). It is completely fitting that Alberti here recalls the story of Zeuxis and that artist's procedure in preparing the image of the goddess for the Crotonians.

Alberti's attitude may suggest that the drive for anatomic correctness was not essentially a contribution of the humanists; it was, rather, a legacy of the workshops to the new theory of art.

V. LEONARDO DA VINCI

The acme of artists' striving for material correctness—one might speak of a passion for objective truth—was reached by the end of the fifteenth century. Leonardo's legacy in writings and drawings is the fullest, and certainly a unique, embodiment of this zeal. The universality of Leonardo's interests is a commonplace: if there ever was a *uomo universale,* it was Leonardo. Yet not less striking than the range of his subjects is the unity of his thought; and the specific character that speaks from every part of short notes, partly taken from his readings, others formulating original thoughts and observations, may make it difficult to grasp, at a first glance, a comprehensive doctrine. In spite of the fragmentary state of these notes, however, Leonardo's thought is not a piecemeal combination of different views. We can perceive his intellectual and artistic personality, fully articulate, as cast from *one* mold. Nothing is more characteristic of Leonardo's thought as a whole than his empirical attitude, particularly his making vision the source and touchstone of scientific truth as well as of artistic representation.[33]

Leonardo profoundly and passionately believed in the truth that Panofsky labeled a *symbolum fidei* of Renaissance art theory; the com-

plimentarity—or even unity—of theory and practice. "Those who fall in love with theory without practice," Leonardo says, "are like pilots who board a ship without rudder and compass, who are never certain where they are going" (no. 70).[34] We are reminded of Alberti's dictum that "he who has nowhere to point the arrow draws the bow in vain." "Practice ought always to be built on sound theory" (no. 70), Leonardo concludes. Sometimes he even seems to rank theory above practice. "First study science," he advises the artist, "and then follow the practice that is born of that science" (no. 67). Mathematics, the perfect embodiment of pure theory, is a secure foundation of knowledge. Where mathematical sciences cannot be applied, certainty is unattainable. Even in an anatomical manuscript Leonardo warns the reader: "Let no one read me who is not a mathematician." On one occasion, moreover, he suggests that if one understands the reasons *(ragioni)* of natural processes one no longer needs experience in order to know them. All this applies, of course, also to the artist's job. "The painter who paints only by practice and the use of his eyes but without understanding is like a mirror that imitates without understanding all that is placed in front of him."

But theory, fundamental as it is, does not disparage experience. Experience is the source of all our knowledge. "Wisdom is the daughter of experience"—Leonardo comes back to this guiding principle in a variety of formulations. The sciences "which are not born of experience, mother of all certainty," are "vain and full of errors" (no. 19). Experience is not only the origin of knowledge; it is also the touchstone of truth. "The true sciences are those which become known through the senses, by experience, and which put to silence the tongues of the contentious." Any proof derived from the mind alone (as is the syllogism, which was so much in fashion as an independent mode of thought in Scholasticism) is "dubious talk" *(parlar dubbioso)*. Leonardo admonishes his imaginary reader (or is this perhaps a warning he addresses to himself?) to "flee from the precepts of those thinkers whose views are not confirmed by experience."

But what precisely is "experience"? In Leonardo's view, anything encountered by the senses would deserve that name, but first and foremost he had vision in mind. Visual experience is to him, as we

would now say, the perfect paradigm of experience in general. Seeing something means acquiring secure knowledge, or getting irrefutable proof. So strong was Leonardo's attachment to direct eyesight that some modern scholars believe that he was afraid to make any generalization of abstraction that could not be supported by visual evidence. Ernst Cassirer, in an important book on Renaissance philosophical thought, even maintained that "Leonardo's ideal of science aims at nothing but the perfection of seeing, the *saper vedere.*"[35] Perfect seeing, however, is not merely an undisturbed, but passive, reception of visual stimuli from the outside world; it is the grasping of articulate form and definite shape in everything we see. Seeing, so one must understand Leonardo's thought, is an active process. It is this articulating force of vision that he had in mind when he was praising the eye. The eye, Leonardo says, "is the master of astronomy, it makes cosmography, it advises and corrects all human arts." One is, therefore, not surprised to learn that the "sciences of the eye are the most noble." Sometimes Leonardo is carried away by his fascination with the power of the eye, and his cool tone of detached exposition is replaced by emotional exclamations. He concludes one of his commendations of the eye with the outcry: "O most excellent above all other things created by God, what praises are there to express your nobility? What peoples, what tongues can describe your scope?" (no. 34).

At this point it is interesting to digress briefly to see what Leonardo's reverence for vision may tell us about his intellectual origins and about his place in a specific historical and cultural milieu. The intellectual life of Florence during the period in which Leonardo grew up was dominated by literary humanism in general and by the Neoplatonic movement in particular. These movements, as scholars have often stressed, were indifferent, if not outrightly hostile, to the close observation of material nature and the wealth of optical phenomena. To be sure, Ficino, the central and most influential representative of Renaissance Platonism, was fascinated with the charms of light and the power of the sun, as is amply shown in his free paraphrase of Plato's *Symposium.*[36] But this fascination with light should not mislead us. Ultimately, Ficino believed that the magic power of light will make it possible for us to see "through" what we directly perceive, to go beyond what our bod-

ily eyes reveal to us. Leonardo's attitude is an altogether different one. He takes vision so seriously, not because it helps him to see "through" what he perceives, but rather to see "in," if I may say so. In other words, he reveres vision because it reveals to him the abundance of form in the actual world and in optical phenomena. In fifteenth-century Florence there were a few places in which visual experience was taken as seriously as by Leonardo, and the artists' workshops were the most important among them. Even a brief glance at what was produced in Verroccio's workshop, where Leonardo was a pupil, provides convincing evidence for the strictness and discipline in observing nature practiced there. But in art theory, too, precise observation and the power of vision were held in the highest regard. Alberti had already defined sight as the "shrewdest" sense, the one that enables us "immediately to hit upon what is right and wrong in the contrivance of execution of things."[37] It is probably not mere chance that Alberti's personal emblem was a winged eye. In art theory vision itself became the subject of major explorations. In perspective, as we shall shortly see, the conditions and laws of vision—indicating something of its formative power—were the theme of careful scrutiny.

But vision also held the attention of some scientists of the period. The most famous mathematician and scientist of the fifteenth century, Luca Pacioli—a pupil of Piero della Francesca and Leonardo's teacher and friend—claimed that "On the authority of those who know, sight is the source of knowledge."[38] He therefore even challenged the inherited educational curriculum, the so-called quadrivium, consisting of arithmetic, geometry, astronomy, and music. Either music should be excluded as subordinate to the other three, he said, "or perspective, that is, painting, should be included." Luca Pacioli was, of course, acquainted with the time-honored interpretation of music as a system of abstract proportions, but he himself conceived of music as an art in the modern sense of the term: it cannot exist without a certain type of sensual experience; music must be heard. But, he continues, "If you say that music satisfies hearing, one of the natural senses, then perspective satisfies sight, which is more worthy, since it is the first door of the intellect." This sentence could have been written by Leonardo. Is it surprising that such an attitude eventually produced the concept

of a "science of the eye"? In praising the power of vision, Leonardo was following both the traditions of the artistic workshops and a scientific trend of his time. Both trend and traditions differed from the mainstream of literary humanism and Platonic philosophy.

To return to Leonardo's theory, we should stress again that the "visibilistic" approach should not be understood in a narrow, literal sense. Leonardo was not the naive realist he is sometimes made to appear. He saw in nature more than one would expect from a spectator innocently trusting only his senses. Modern students of his legacy have emphasized that Leonardo "saw mathematical structures in optical phenomena."[39] In briefly discussing his anatomical studies we shall shortly notice that here, too, vision revealed to him, not only contiguous particulars, but also general structures and parallelisms. (That he was also aware of the pitfalls of vision is obvious from his explorations of optical illusions.)[40] Vision, as Leonardo understood it, is an articulation of the shapes inherent—but not always manifest—in nature. In performing this function, vision reveals its profound affinity to painting. In fact, Leonardo did not draw a line between a work of art and a scientific statement. What ultimately appealed so strongly to him in both vision and painting is the immediacy of articulation and the directness and power of communication. What is articulated by vision need not be translated into a different language that, in turn, needs interpretation; rather, it is placed directly before our eyes. "That science is most useful, the results of which are most communicable," says Leonardo (no. 17). But no other medium—no intellectual proof, no logical derivation, no literary formulation—has the directness and distinction of vision and of pictorial representation. Therefore, the scientist should be able to represent his discoveries graphically. It is not enough to have a thorough knowledge of one's field in order to be a good scientist; competent draftsmanship, and even a command of perspective, are also essential requirements. For this very reason the artist possesses one of the qualifications to be a scientist. "Painting presents the works of nature to the senses with more truth and certainty than do words or letters." Leonardo can, therefore, say: "Painting makes its end result communable to all the generations of the world" (no. 17).

The perfect combination of theory and practice, of science and art,

so uniquely characteristic of Leonardo, permeates his whole work, but nowhere is it more fully manifested than in his anatomical studies. These studies, which continued for most of his life, consisted mainly in the dissection of corpses, but also in carefully studying ancient and medieval doctrines of anatomy. Leonardo also met with some of the most advanced anatomists of his age, though the precise nature of these contacts is not always clear (this is particularly true for his meeting with Marcantonio della Torre [1481–1511], the best-known anatomist of the period, a relationship that has become a subject of speculation to which many scholars are attracted).[41] Leonardo deemed these studies so important that he described himself as a *pittore anatomista*, thereby coining one of the most revealing terms in the Renaissance vocabulary of painting.

Leonardo, as is well known, was a most meticulous observer of minute features in nature; his drawings display a wealth and precision of anatomic detail that remained unmatched even in the most advanced artistic workshops of Renaissance Florence, and they are still admired today for the specific information they provide. Leonardo was aware of his concentration on details. To obtain exact and complete knowledge of "some few veins," he tells us, more than ten corpses have to be dissected, "destroying all the various members, and removing even the smallest particles of flesh which surrounded these veins, without causing any effusion of blood other than the imperceptible bleeding of the capillary veins. And as one single body did not suffice for so long a time, it was necessary to proceed by stages with as many bodies as would render my knowledge complete; and this I repeated twice over to discover the differences."[42]

Yet Leonardo's mind, sharp-edged as it was, was not atomistic. He did not dissolve the bodies he studied into an infinite wealth and inexhaustible variety of details. In his anatomical drawings he always tried to present the body's overall structure as clearly as possible. V. P Zubov, a Russian scholar who has written a useful book on Leonardo as a scientist, convincingly emphasized the "synthetic" character of the master's anatomical drawings. These drawings are not recordings of single observations "but generalizations of results obtained from many postmortems."[43] Leonardo's own words lend authority to discovering

a synthetic tendency in his anatomic drawings. Many of his notes pertain to the selection of consecutive aspects of the same object or figure. We can arrive at "true knowledge of the shape of any body," he says, only by seeing it from different angles. In drawing the limbs of man, Leonardo declares: "I will observe the aforesaid rule, making four demonstrations for the four sides of each limb, and for the bones I will make five, cutting them in half and showing the hollow of each of them."[44] The very purpose of anatomical drawings explains why a synthetic character is necessary; the drawings are meant to replace the actual body as an object of study. If you participated in an anatomical demonstration, that is, a real dissection, the reader is told, "whatever your ability, you would not see nor acquire knowledge of more than some few veins," but when you look at the drawing all the details of the whole body are fully presented to you.

In his anatomical drawings Leonardo often went beyond what the artist might need for his work, turning the drawings into almost purely scientific statements. Famous examples (in addition to "the hollow" of the bones, just mentioned) are the drawings representing the anatomy of the heart, the *situs* pictures (i.e., the anatomy of a woman in a state of pregnancy), and the rendering of the embryo in his mother's womb.[45] (Leonardo even used artistic techniques other than drawing to obtain scientific results: he mapped the ventricles of the brain by employing the so-called lost wax-procedure of bronze casting.)[46] In all these drawings, and in the brief texts accompanying them, the drive for objective correctness reaches a climax and overshadows all the other tendencies. One can well understand that from such drawings a direct line leads to Vesalius, whose richly illustrated *Fabrica,* commonly considered the birth certificate of modern anatomical science, appeared in 1543.

Yet most of Leonardo's purely scientific drawings reveal the mind and the hand of a great artist; they are pervaded by strong expressive qualities that turn them into works of art even where they were meant to be scientific statements only. Thus, the contracted posture (anatomically correct) of the fetus and the lights and darks by which it is represented evoke "that age-old feeling, expressed by so many poets, that life is death and death is life."

A modern reader cannot help wondering what this striving for objective correctness could have meant for painting and what difference it made in the theory of art. Can the urge for precision in the rendering of reality be congruous with aesthetic aims? Can the passionate search for "truth" remain within the framework of a theory of painting without exploding that framework? Reading Leonardo's notes with these questions in mind, one is struck by how little he has to say (at least, explicitly) about beauty in art and by how scant was the attention that he paid to most of the central themes of the aesthetic thought of his period. Wherever he refers to beauty—and this happens always in passing—the context is eloquent. Obviously, though he does not say so in as many words, he did not consider beauty an essential component of art in the way that Alberti did. The main context in which Leonardo speaks of beauty is his discussion of contrasts. He was deeply attracted by contrasts, and he sought to discover them in nature and in art. Among other opposites, there is also the contrast between beauty and ugliness. The poet and the painter describe "the beauty and the ugliness of the body" (no. 41). As far as the painter is concerned, the two poles sometimes seem to be of an almost equal importance. Ugliness may even serve a definite purpose: it makes the beautiful, rendered next to it, appear more radiant than it would when seen alone (no. 277).

In few respects does the difference between Alberti and Leonardo become more obvious than in their views about beauty in art, and this difference is related to the striving for correctness. As we remember, Alberti urged the artist to choose from nature the beautiful parts and to render only them, singly or combined, in the work of art. The principle of selection seemed to Alberti to be of universal validity; the artist should always observe it, regardless of what the specific character and subject of his work may be. Leonardo, on the other hand, places little emphasis on the selection of the beautiful in nature. It is symptomatic that the famous story of the ancient artist Zeuxis who painted the perfect image of Helen (or Venus) by selecting and copying the most beautiful parts of the five most beautiful maidens of Croton—a story that no Renaissance author writing on art or aesthetics ever spared his readers—seems never to have been mentioned in the vast

array of Leonardo's writings. From his annotations it would follow that he rejected the principle of selection, though he never explicitly said so. But he did warn the painter not to improve upon the works of nature, for doing this would only lead him to the unnatural and the mannered (no. 433). Leonardo obviously wished the painter to represent *all* there is in nature, without omission or selection. The artist should transform himself into an (understanding) mirror of reality in all its shapes and varieties.

Another difference between Alberti and Leonardo is of no less significance. Alberti believed that he knew what absolute, perfect beauty is—namely, a completely balanced system of proportions. For him there is only *one* type of perfect beauty; it is altogether objective and therefore independent of the spectator's emotions (though it may channel these emotions in certain directions). The same type is, of course, valid for *all* figures. One does not encounter such perfect beauty in direct experience, and Alberti was indeed aware that he was speaking of an "idea of beauty." To be sure, one cannot derive that idea from one's mind alone ("That idea of beauty, which even the most experienced mind can hardly perceive, escapes the inexperienced one").[47] But, though one needs experience to grasp it, it remains an idea, an image of an objective system of proportions.

When Leonardo speaks of beauty, he does not think mainly of objective, measurable shapes but rather of emotional qualities, which are impossible to measure; he speaks of the grace and charm that attract us. There is no yardstick by which to measure beauty, and there is no sure means by which to distinguish it, as Alberti may have thought. The painter not naturally endowed with grace can educate his imagination by looking at beautiful faces. But, in order to pick them out, he should follow public opinion rather than his own taste (or, as we would say, any innate criteria); by following his personal preferences, he will end up painting only faces that are similar to his own (no. 278).

Moreover, Leonardo rejects the very basis of Alberti's theory; in nature there are many sets of proportions, and none of them is inherently superior to any other. In a note that reads as an almost direct criticism of Alberti's theory of beauty, Leonardo reprimands the painter

who studies the measurements and proportions of the nude but disregards variety in nature: "a man may be well proportioned and be fat and short, or tall and thin, or average" (no. 97). Any set of ideal proportions would contradict nature. Among the "praiseworthy and marvellous" properties of nature there is variety; none of nature's works precisely resembles any of its others. "Therefore, you imitator of nature, note and be attentive to the great variations of contour." He then ends this note in addressing the painter: "But, if you wish to make your figures on the basis of one and the same measurement, know that they cannot then be distinguished from one another, which is something never seen in nature" (no. 291).

Many reasons could be proposed to explain the difference between Alberti and Leonardo, the two founding fathers and classical representatives of the theory of painting in the early Renaissance. Alberti had contacts with Platonism, while Leonardo remained indifferent to it; Alberti's sources were mainly philosophical and literary, while Leonardo grew on workshop soil; Alberti, who devoted himself, as he said, to "the cognition of things, the good disciplines, and to the secret arts," was not primarily interested in the empirical sciences and in technology, while Leonardo, who ironically described himself as "an uneducated person" *(omo senza lettere),* was fascinated by what can be learned from experience and from technical experiment.

Whatever the motivations of these two authors and artists, their attitudes mark a clear shift in emphasis in the theory of art. This shift of emphasis coincides with the increasing significance and prominence of the requirement for correct representation. Early in the fifteenth century, Alberti, as we have already remarked, was not aware of the potential conflict between faithful representation of nature and the rendering of beauty. In the two generations that passed between the years when Alberti formulated his concepts and the years when Leonardo wrote down his notes, the conflict between correct representation and the embodiment of beauty must have become manifest. In the artists' workshops and among the groups of scientists people probably realized that if one is striving for correctness of representation, one cannot, at the same time, ask for perfect beauty, or else one has to change one's view of what beauty is.

VI. DÜRER

In the fifteenth and early sixteenth centuries the theory of art was an Italian affair; conditions prevailing in the rest of Europe were not conducive to the prospering of that particular branch of study. Only in the course of the sixteenth century did the new theory begin to spread into other countries, mainly to the Lowlands, Spain, and Germany, and it was thereby often transformed. An early outcome—unique in its character, originality, and significance—of this process is the theoretical thought of the great German artist, Albrecht Dürer (1471–1528).

Dürer's aesthetic thought was triggered by his acquaintance with Italian art theory. In his youth a meeting with "Master Jacobus" (Jacopo Barbari, ca. 1440/50–1516) stuck him both as a revelation and as a painful puzzle. The young apprentice from what must then have been considered a backward province was shown, by a master coming from the great center of Venice, "the secret" of how to draw the figures of a man and a woman "according to measure." Late in his life Dürer still said that he "would rather be shown what he [i.e., Master Jacobus] meant than behold a new kingdom."[48] And when he visited the Netherlands in 1521 and met with the Hapsburgian duchess Margarite, for whose Imperial family Jacopo Barbari had worked, he still asked for "Master Jacob's little book."[49] This episode illustrates the spell that Italian art theory cast on Dürer. Neither of his two trips to Italy (in 1494/95 and in 1505/7), took him to Florence or to another center of contemporary art theory. But both during these journeys and during the years in Germany, spent in the company of humanists who were always attentive to the intellectual news coming from Italy, Dürer was eager to absorb the new gospel of artistic thought that was being preached in Italy at that time and to learn Italians' "secrets." It was his aim, so we learn from the introduction to what he published in his lifetime, to procure for German artists the "true reason of all painting" and thereby to redeem these northern masters from the tyranny of an accepted but unexplored routine practice.[50] In other words, he wanted to infuse into them the spirit of Italian "science of painting." Even if some of the details of Dürer's acquaintance with Alberti, Leonardo,

and possibly other Italian authors still escape us, there can be no doubt that he absorbed the essence of Italian art theory.

Yet Dürer was no mere imitator. Even where he intended to closely follow Italian models, his thought was often original and innovative. In dealing with the central themes of Italian art theory he shifted the emphasis and explored new territory.

During his lifetime he published only two treatises, a *Course in the Art of Measurement with Compass and Ruler* (1525) and a treatise on fortifications (1527). His *Four Books of Human Proportions* appeared in 1528, shortly after his death. Dürer planned to write a comprehensive theoretical treatise on art, "Speise der Malerknaben" ("Food for Painter Youths"), but did not live to complete it. According to a brief outline in his own hand, now in the British Museum, it was meant to consist of six parts: the proportions of man, the proportions of the horse, gestures, lineal perspective, a doctrine of shadows, and a doctrine of color. The parts that Dürer completed deal largely with the human body, and this is so for good reasons. "Seeing that man is the worthiest of all creatures, it follows that, in all pictures, the human figure is most frequently employed as a center of interest."

Dürer approached the task of representing the human figure in much the same way as the Italians approached it: in order to properly portray the human body, one first must know it sufficiently. The artist is thus required to study the natural figure itself. Yet, though Dürer was deeply influenced by the scientific trend in the Italian workshops and copied anatomical drawings by Pollaiuolo and Leonardo, he never became a *pittore anatomista* in the Leonardesque sense. He never had occasion to dissect corpses, and he would probably not have seen this as an attractive goal. The interior structure of the human body, insofar as it cannot be of any value to the painter, does not interest him. His outlook is determined by workshop experience and by the artist's real and immediate requirements. On the other hand, he perfected the means of observing and measuring those parts of the natural world that an artist may actually need, and in this process he achieved a degree of precision unknown before. He employed both the "organic" method of measuring bodies (by dividing them into a number of "heads,"

a method employed by Alberti, the *exempeda*). Alberti, as we remember, divided the human figure into six feet *(pedes),* each foot into ten ounces *(unceolae),* and each ounce into ten "minutes" *(minuta).* Dürer further subdivided each minute into three parts (which he called *Trümlein*) and thus arrived at a unit of less than one millimeter.[51] To be sure, in principle he still stuck to what can be observed in nature and can therefore be represented in a painting. Yet one cannot help wondering what real, practical value such diminutive measurements can still have for the practicing artist. Was not Dürer here following the scientific ideal and, in fact, going beyond the artist's needs?

Dürer's originality, and his major contributions in this realm, do not lie in perfecting the methods of measuring. One of his central innovations is the discovery of the figure's movement as a topic of art theory and the construction of representational patterns for moving bodies. In Italy, too, authors of art-theoretical treatises never forgot that men move in space. Alberti listed the different spatial directions in which one can move (right, left, upward, downward, forward, backward), and Leonardo requested, time and again, that the artist represent body movements so as to infuse life into his figures. Yet the anatomical studies practiced in the artists' workshops in Italy were mainly concerned with the body at rest, normally a standing figure. Dürer, on the other hand, made the moving figure an independent topic of the artist's study. He envisaged the exploration of movement from two points of view: one, the mechanical possibilities of a figure's motions; second, body movements as outer manifestations of states of mind. To the second aspect we shall come back in a later chapter of this book; here we shall only briefly comment on the first one.

In the last of his *Four Books of Human Proportions* Dürer presents his reader with a series of drawings of human figures, alternately male and female, that demonstrate the possible body movements. The artist should know, Dürer adds in a brief text, "whereto they [i.e., the figures] can be bent and turned, how one wants to have it, so far [they] can suffer it."[52] These are schematic drawings, and in them Dürer does not reveal an understanding of the human body as a living, organic whole; nor does he manifest any profound knowledge of anatomy and physiology (as is obvious in any drawing by Leonardo). Dürer's figures,

composed of cubes, are stereometrical bodies governed by the laws of mechanics. So obvious is the artificial character of these figures that art historians have argued that they were done after puppets, or jointed dolls, which were in fact employed in the Italian workshops of that period. By dissecting the whole figure into a few large units (inscribed into such simple stereometrical bodies as cubes, parallelipipedes, and truncated pyramids), Dürer was obviously trying to facilitate the construction of various postures. A few examples of the chief postures demonstrated will make this clear: (1) The trunk bent slightly to the right (of the beholder), the bending is performed in the hip joint; the head is inclined; the left leg is drawn backward. (2) The trunk is bent to the left; the head is raised; the right leg is placed forward. (3) The trunk is tilted forward; the right leg is drawn backward. (4) The trunk is bent backward; the right leg is placed forward. As can be seen from these few examples, Dürer's intention is to provide the artists with a consistent system from which all possible postures can be deduced and constructed.

The systematic, typical character of the postures is further manifested in the manner of their representation. As Panofsky has emphasized, Dürer's figures illustrating the possibilities of movement "remain either parallel or at right angles to the picture plane, so that each figure can conveniently be rotated at 90 degrees."[53] In other words, Dürer omitted the three-quarter view that actually prevails in nature. Instead of this view, with its infinite variety of small gradations, he chose the "basic" but artificial views of pure frontality (front or back) and pure profile (right or left). Such "pure, absolute" views are meant to be building blocks to be employed, and modified, by the artist.

In these studies of movements Dürer obviously does not transcend the realm of the visible. He does not inquire what the skeleton is like, or what the shape and function of muscles or arteries are (and surely he shows no interest in the "inside of the bone"), as Leonardo did. But his approach to visible reality is anything but "realistic." The schematic figures do not pretend to portray any reality as it is visually perceived; they present typical possibilities, if one may say so. They are archetypes of postures and movements. One should also note that in these drawings Dürer does not conceive of movement as being a

flowing continuum in which small, almost imperceptible changes gradually bring about a transformation of the overall shape. Rather, movement is understood as a series of distinct postures, sharply divided from each other.

In Renaissance art literature, as is well known, the theme of human proportions presents the natural context—the locus classicus—for a discussion of beauty. "The Beauty of Human Proportions" was a subject that was not only central to art theory; it was also one around which tension was built up. We have briefly sketched the unfolding of the problem from Alberti's identification of (purified) natural proportions and beauty to Leonardo's awareness of a possible rift between reality and beauty.[54] Where can Dürer be placed in this process?

The idea that man's proportions are the quintessence of beauty Dürer took over from the Italians. In fact, the secret Barbari did not want to disclose to him fully—how to draw figures "according to measure"— was probably not only a method of measuring proportions in nature but also a formula for beauty. This conception he could not learn in the German workshops of his time, and for this reason the Italian doctrine struck him as a revelation. But precisely in his concept of beauty Dürer underwent a development that is unusual and that led to important results in the theory of art.

Originally the young German artist seems to have accepted without question the view that there is only one type of perfect beauty. This view was probably derived from Alberti, and it must have found many followers. Certainly Alberti never fully articulated this view, but it seems to follow from what he discusses. He considers variety an important value of art, yet he never thinks of a possible variety of beauty. What he did investigate was how to arrive at the beauty concealed in nature. In his early work, *On Painting,* he recommended the method hallowed by the ancient Zeuxis story, that is: to select the most beautiful parts of the most beautiful figures; in his late treatise, *De statua,* he suggests another method: since beauty is dispersed in nature, the average proportions of man, to be distilled from many measurements, will coincide with the canon of beauty.[55] But in both cases it seems to follow that the artist will eventually arrive at only one single type of beauty. Dürer, in his early period, apparently held the same views, and

he embodied the beautiful proportions he arrived at in the representation of figures who hold an inherent claim to beauty, like Apollo. It is interesting that in this period the canon of female beauty seems to have been less securely established than that of male figures.

But, in the course of repeated attempts to "extract from nature" a canon of perfect proportions, Dürer gradually came to the conclusion (especially after his return from Italy in 1507) that there are several human types to whom beauty can be attributed. In addition to the perfect Apollo he articulated a "coarse peasant" type, a "long, skinny" type, and so on. Now, the idea of different human types being beautiful was not altogether unheard of. Leonardo also believed that "the beauty of a face" may be equally fine in persons differing from each other (no. 278).[56] Even bodies can have "different beauties of equal attractiveness" (no. 279). Another Italian author, the Neapolitan humanist Pomponius Gauricus (ca. 1482–1528/30), suggested a similar concept. In *De sculptura* (Florence, 1504)[57] he proposes different sets of proportions, according to the age of the figures represented, strongly emphasizing the different proportions of the child (a novelty in the literature of art theory of the period). We cannot be sure that Dürer actually knew any of these texts, but we can say that the idea of different systems of proportions being beautiful was "in the air." However, it seems that only Dürer gave this thought full formation. "But beauty is so put together in men and so uncertain in our judgment about it, that we may perhaps find two men both beautiful and fair to look upon, and yet neither resembles the other, in measure or kind, in any single point or part."[58]

Acknowledging the variety of beauty does not remain a matter of metaphysical belief; it also has practical implications for the artist's education and work. In order to represent different figures the artist must study "different kinds of men." The most striking instances of different kinds of men are the various races. As far as I know, Dürer is the first Renaissance author and artist who considered an application of the theory of proportions to the different racial groups. There are only "two families of mankind," Dürer said, "white and black." They differ from each other in color and body structure, and in general whites are superior in beauty to blacks. But, he adds, "I have seen

amongst them [i.e., blacks] whose whole bodies have been so well built and handsome that I never beheld finer figures, nor can I conceive how they might be bettered, so excellent were their arms and all their limbs."[59]

Since there are, then, different types of beauty, the major requirement is not adherence to a single model but consistency within the particular type represented. "And so in all figures, be they hard or soft, fleshy or thin, one part must not be fat and the other bony. . . . For all things must agree together in symmetry, and not be falsely mingled. Things that agree together in symmetry are considered beautiful."[60]

VII. FORMAL CORRECTNESS: PERSPECTIVE

In defining the notion of "correct representation" we distinguished earlier in this chapter between two of its aspects. What we called "material truth" refers to the measurable correspondence of the representation and the object depicted in it. Since the human figure was considered the chief object of representation, artists believed that a careful and thorough study of the human body itself was an essential condition to performing their job as painters. In the process, they eventually arrived at that level of highly specialized anatomical exploration that is reflected in Leonardo's work. The previous two sections of this chapter were devoted to these studies, their impact on the artists' work, and ideas of beauty. Now we are turning to a different side of "true imitation," one we shall call "formal correctness." Here the question presenting itself to the artist is not: What do I have to know about the human body (or about any other object) in order to portray it correctly? Now the artists ask: What do I have to know, and which rules do I have to follow, in order to secure the correctness of the representation qua representation? In other words: What are the criteria of correct representation regardless of, or in addition to, knowledge of the objects represented? In Renaissance doctrines, "formal correctness" is completely dominated by *one* single concept: perspective.

Perspective representation of space, and of the bodies contained in

it, is one of the best-known achievements of the Renaissance. So large does perspective loom in the contemporary popular view that its impact can be compared only to the enormous revolution in cosmology that originated in the same period. But the attaching of great value to perspective is not a hindsight of later ages; in the fifteenth and sixteenth centuries artists and the public were already expressing their pride in this major accomplishment of their time.

The system of perspective representation makes several implicit assumptions. The artists who developed and employed this system, and the authors who praised them for this, were rarely aware of these implications, but it will be useful for us to spell them out.

The first, most general and simple assumption implied in the perspective system is that painting represents nature *as we see it*. In a specific and precise sense, then, perspective is the branch of study, and the method of pictorial representation, that deals with the shapes that bodies assume in our visual experience. In fact, *perspectiva* is the Latin term for "optics," which is of Greek origin. Throughout the Middle Ages *perspectiva* indeed indicated only a branch of natural science and had no connection with pictorial representation.[61]

From this first, most general assumption we are led to a more specific one, concerning mainly the way we approach the surface on which a picture is painted. Throughout the Middle Ages the picture surface is conceived of as a solid, opaque body, on which the paint is applied and the pattern is drawn.[62] In the Renaissance, with painting following our visual experience in nature, this attitude changes. Ideally the picture surface now loses, as it were, its solid opaqueness, and it is thought of as a transparent surface through which we look at a scene. Dürer transferred this attitude to his interpretation of perspective in general. "Perspective," he says, "is a Latin word which means a view through something."[63] The best-known formulation is provided as early as 1435. Alberti, in his *On Painting*, describes the picture surface as "an open window through which the subject to be painted is seen" (I. 19). In other words, the material surface on which a perspective painting is depicted should be altogether disregarded; ideally, the spectator should believe that he is seeing the scene (the *istoria*, Alberti says in the Latin edition of his work) itself.

A third implication of Renaissance perspective, though not obvious at a first glance, is of great significance, and it probably indicates more than anything else the specific character of Renaissance perspective. Although perspective, as we have observed, is concerned with the shapes bodies assume when they are seen, Renaissance theories of perspective were not founded on any physiological, and even less on psychological, investigation of visual experience; nor did the authors inquire, even in a simple way, what really happens when we see something. Only at a later stage were some empirical and psychological observations taken into account, but they had a very limited effect on art theory. In the fifteenth century a geometric construction seemed to be the perfect model, or "paradigm," of correct perspective representation. Based on assumptions derived from Euclid and his commentators, Renaissance theoreticians of perspective believed that we can construct a simple and perfectly precise model of how the visual rays proceed, and this in turn was considered an adequate model of the process of seeing. Since painting should closely imitate seeing, the same model should be employed in the perspective construction of a picture.

It is not too difficult to see what made the geometrical model so attractive to fifteenth-century artists. From everyday experience we are, of course, familiar with changes in the appearance of objects; the distant body shrinks in size; the object seen in sharp angle seems deformed; and the like. Such intuitive knowledge is normally sufficient to create a convincing pictorial illusion. But Renaissance artists were not content with an intuitively convincing illusion; what they craved was a method by which the correctness of representation could be measured and proved—and this was provided by the geometrical construction.

In fourteenth-century Italian workshops, and slightly later also in the North of Europe, artists were groping their way toward a perspective rendering of space. But, as a scientific system, pictorial perspective was formulated only in the early fifteenth century. We may say, then, that the *theory* of perspective was probably the completion of a historical process rather than its beginning. And, as Panofsky said, it is "a vivid reminder of the historical process" that the invention of a scientific, mathematically based system of perspective "was heralded, not

by the publication of a treatise, but by the painting of a pair of panels."

The man who painted the panels was not a painter. Filipo Brunelleschi (1377?–1446), the architect of the cupola of the Florentine Duomo, a feature so famous that it became a symbol of the city, chose to "publish" his doctrine in such pictorial fashion. The panels are lost, but owing to the painstaking efforts of art historians, they can be reconstructed in detail, a major source for these efforts being a nearly contemporary biography of the famous architect written by Manetti. The first panel represented one of the well-known squares of Florence (the Piazza de' Signori) with its surrounding buildings. The sky of the panel was sawed out, so that if the painting was placed at a precisely defined point and the spectator stood at another fixed point, the skyline of the painting would coincide exactly with that of the real buildings. The method of the other panel was more complex. It represented another square of Florence, the square in front of the Duomo with a view to the Baptistry. In this panel the sky was not sawed out but was covered with burnished reflecting silver. Brunelleschi drilled a hole in the picture, asking the beholder who was standing on a well-defined spot behind the picture to peep through the hole while holding in his other—outstretched—hand a mirror. The painting would thus be reflected in the mirror, and in this way the correctness of the scale, according to which the diminution of the distant buildings was executed, was strikingly shown. The reflection of the sky and the moving clouds on the silver-covered upper part of the painting would have heightened the impression of reality.[64]

The basic principles involved in Brunelleschi's perspective construction were elucidated for the first time by Panofsky many years ago, and we need not discuss them here in detail.[65] Proceeding as an architect accustomed to thinking in terms of ground plane and elevations, he combined the two in a process carefully designed to be provable. But what was so revolutionary about Brunelleschi's panels was not only the technical combination of the two views but the striking empirical demonstration of the correctness of that representational method.

Brunelleschi's invention of focused perspective occurred about 1420. That the time was ripe for such a system to be discovered can be seen

from the speed by which it spread. Masaccio's fresco of the Trinity in Santa Maria Novella in Florence (executed before or in 1428) is one of the earliest paintings in which the architectural background is correctly constructed in focused perspective. It we are to trust Vasari (and often he proves right, after all), Brunelleschi himself taught his friend Masaccio the theory of perspective.

The new doctrine of perspective found its earliest literary formulation in Leone Battista Alberti's *On Painting (Della pittura),* composed some fifteen years after Brunelleschi's pictorial demonstrations. Alberti was probably following Brunelleschi in all essential points, though he was also familiar with the most advanced workshop procedures, which closely approximated Brunelleschi's results. Yet two features, of utmost significance in the historical development of the theory and its impact on Renaissance art, are characteristic of Alberti's rendering of the new doctrine. First, Alberti provided the first explicit scientific foundation of focused perspective; what Brunelleschi implied, Alberti spelled out. Second, Brunelleschi's construction was much too unwieldy to be employed as a routine technique by painters in their workshops. (The two most notable exceptions were Piero della Francesca and Dürer.) Alberti greatly simplified Brunelleschi's model, explained its assumptions, and thus made it acceptable to artists whose knowledge of applied mathematics was limited.

Alberti himself says that he indeed had this particular public in mind. Since the artists did not know Latin, the language of professional scholars, "I did into Tuscan for you," so Alberti addresses Brunelleschi and his artist friends in the introduction to *On Painting.* Historians of science have pointed out[66] that this book is, in fact, the first treatise written in Italian, the spoken language, to treat matters of mathematics and physics in an original way, and it does so with the intention that the knowledge so transmitted be put to practical use. The first book of *On Painting,* the only one of interest in the present context, is partly composed of many quotations, selected for this purpose from the scientific works with which Alberti was familiar from his university education. The sequence of quotations, however, does not follow that accepted in the scholastic tradition; the statements are arranged according to the artist's needs and the practical experience accumulated

in the workshops. From the mathematicians, as he said, he will take only "those things which seem relevant to the subject" (I. 1). He begins with brief definitions of the basic geometrical concepts (point, line, surface), but even these he prefaces with the moving words: "I earnestly wish it to be borne in mind that I speak in these matters not as a mathematician but as a painter. Mathematicians measure the shapes and forms of things in the mind alone. . . . We, on the other hand, who wish to talk of things that are visible, will express ourselves in cruder terms" (I. 1). What he talks about are some basic theories of optics, ancient and medieval. The visual image is produced by straight lines ("visual rays") that connect the eye with the object seen. For our purpose it is of no consequence whether these rays were thought of as emerging from the eye and spreading to the object seen, or emerging from the object and concentrating in the eye. In both cases (both were accepted in theories of vision) the configuration of the rays is conical; it was known as the "visual pyramid." The visual pyramid is by definition "central" and perfectly corresponds to the configuration produced in a photographic camera.

This optical model, or the visual pyramid, can secure the correctness of the painter's representation of reality. The painting, Alberti suggests, should be conceived as a "planar intersection" of the visual pyramid. All the figures, objects, and spatial distances painted on the artist's panel are fully proportional to those found in the actual world that the painting represents. Perspective construction, then, makes it provable that a picture is "correct" in its rendering of space. Not less important is the fact that by employing the system of the visual pyramid Alberti avoids the complex calculations that Brunelleschi seems to have required. Alberti provides a method that is secure, and yet it can be practiced by the ordinary artist. One can understand why it had such tremendous success.

Alberti's text, however, offers us more than this; it gives us an insight into the nature of the general ideas of space underlying the bare mathematical skeleton of perspective construction. Space is not conceived as the immediate surrounding of the individual solid body, its background and foreground, as was the rule in ancient art; nor is it endowed with psychological qualities (such as up and down, right

and left). It is, rather, an infinite, abstract extension, analogous to the abstract conception of scientific space that was emerging in the Renaissance. Within that abstract, infinite extension the figures are placed in accordance with the rules that space dictates. Art theorists were aware of this. In 1505 Pomponius Gauricus says that "The place *[locus]* exists before the body that is brought to it, and, therefore, it must be drawn first."[67] Who does not remember Leonardo's drawing for *The Adoration of the Magi?* In the upper part of that drawing we can see what drawing the space first actually meant in practice.

In Alberti's exposition of the perspective system, it should be noted, no mention is made of beauty. Perhaps the diminishing sizes of objects and figures, though correct in mathematical calculation, may offend the aesthetic sensibility of the eye? May not the angle of vision be too steep for our perception to remain unhurt? Questions of this kind are not raised. *Concinnitas,* symmetry, balanced proportions, concepts so significant in representing the human body, are not even mentioned in the treatments of perspective. Formal correctness was free from any aesthetic burden.

Alberti's formula, though a watershed in the understanding and application of focused perspective, did not instantly abolish older practices that were current in the workshops. This can perhaps best be seen in Ghiberti's *Commentarii.* Lorenzo Ghiberti (1378–1455), the Florentine sculptor who produced the famous doors of the Baptistry, devoted his old age (after 1447) to composing a theoretical treatise. This work, called by the author *Commentarii,* or "Reminiscences," is invaluable as an early testimony to the awakening of the sense of history among Florentine artists. Ghiberti, one of the persons to whom Alberti dedicated his work, *On Painting,* ranges himself among the "modern" and "advanced" artists of the fifteenth century by declaring anatomy and perspective the major disciplines any painter and sculptor should master. But, when we compare Ghiberti's text on perspective with Alberti's lucid and consistent exposition, we cannot escape the feeling that the famous artist, though writing some fifteen years after Alberti, produced a tangled and confused report. His text consists largely of quotations from ancient and medieval authors on optics (Ptolemy, Alhazen, Vitello, Peckham, Bacon), not always fully digested, and cer-

tainly not adjusted to the artist's actual needs. The schematic drawings accompanying the text emphasize rather than alleviate its lack of system. The master who in his door panels produced such perfect perspective representation of architectural space could not give a clear account of his own procedure.[68]

But in the next generation we already notice a more systematic and stricter trend in both perspective representation and theory. Piero della Francesca (1410/20–1492) composed a treatise, *De prospectiva pingendi*,[69] which is probably the acme of scientism in focused perspective. Piero carries mathematical precision to minute details and thus outstrips Alberti's more empirical and intuitive procedures. Piero's treatise is a monument to the "scientism" at work in fifteenth-century art theory. Though not published before the nineteenth century, it was known, quoted, and copied during the Renaissance itself. However, because of the complexity of its geometrical constructions, the immediate value of Piero's treatise for the practicing artist seems somewhat doubtful.

The modern student has no great difficulties in surveying the progress of perspective constructions and the increase in scientific understanding and technical competence among fifteenth-century artists. What he may find more difficult to grasp is the emotional intensity with which these—often rather simple—technical matters were treated by some of the great artists and creative minds of the period. For them, one cannot help feeling, perspective construction was not just a means for the correct graphic representation of spatial relationships. Or perhaps "correctness" itself still possessed a meaning it has lost in our days. How else can we explain that an artist as profound, complex, and subtle as Leonardo da Vinci considered perspective "the rudder and guiding-rope of painting"? Only slightly earlier Paolo Uccello, an artist of great inventive power and artistic seriousness, is reported to have replied to his wife, who asked him to go to bed, with "How sweet is perspective."

The magical attraction of perspective reached its peak around 1500. Dürer, who came from a backward Germany, in 1506 undertook a special trip on horseback from Venice to Bologna (well over a hundred miles) "for the sake of 'art' in secret perspective someone wants to teach me." He returned from Bologna fully informed about the com-

plex geometrical construction set forth in Piero della Francesca's still unpublished treatise, but also with Alberti's simplified form of the visual pyramid. Moreover, he was also acquainted with the geometrical construction of cast shadows, which Leonardo was developing in those very years. Dürer presented the Italian theories of perspective to the North (in final form in Book IV of his treatise on geometry, published in 1525), and he also made original use of what he learned in Italy. However, even he did not add anything essentially new to what was known in Italy.[70]

In the very same years the limitations of linear perspective became apparent. In retrospect we can say that nobody was as crucial in exposing these deficiencies as was Leonardo, though it is likely that this was not his aim. Leonardo carefully studied the traditional models and doctrines of focused perspective. He intended to write a scientific treatise on it (which is hardly surprising for an artist who considered perspective "the rudder and guiding-rope of painting"); and, if we are to trust Luca Paccioli, he gave up this plan only when he learned that Piero della Francesca had already written such a treatise. But, in spite of his reverence for focused perspective, he saw what his contemporaries did not see, or perhaps refused to see, since they were so captivated by the charms of the method: the flaws and imperfections of scientific focused perspective.

Perhaps the most striking flaw that Leonardo discovered in focused perspective as taught and practiced in the fifteenth century is that it does not correspond to the reality of visual experience. Focused perspective is built on the assumption that we see with one eye only (something that actually happens in the photographic camera). "Many times," Leonardo notes, "painters despair of their ability to imitate natural appearance, seeing that their paintings do not have that relief and vividness that things seen in a mirror have." Why should this be so? The reason is, Leonardo says, that we see with *two* eyes. "It is impossible for a painted object to appear in such relief that it approach the reflection in a mirror, although both are on a surface, unless we see it with only one eye" (no. 220). Seeing with two eyes lessens the steepness by which sizes diminish; it moderates perspective intensity. In another note he remarked: "objects in relief near at hand when

looked at with one eye seem like a perfect painting" (no. 486), that is, like a painting constructed according to the rules of focused perspective.

What follows from this observation is of revolutionary consequence: the perspective construction of which science-minded artists were so proud may be correct in mathematical terms, and it may be perfect as a geometrical exercise, but it simply is not applicable to the natural conditions of vision. If this is the case (as indeed it is), one cannot help asking, What does "correctness" mean? Although Leonardo did not push his thought to such an extreme, he certainly shook the foundations of that concept of mathematical perspective that was an ideal adored during a whole century.

Leonardo's essential and best-known contribution to the pictorial rendering of space is the so-called aerial perspective, or "perspective of color." (Incidentally, both terms were coined by Leonardo himself; they do not seem to occur in earlier literature.) The concept of "aerial perspective" is based on the simple observation that the more distant an object is, the paler and less distinct its color becomes. In actual art such atmospheric effects were well known long before Leonardo, both in Italy and in the North of Europe. Fine examples are found in the *Tres grandes heures du Duc de Berry,* especially in the pages on which Hubert and Jan van Eyck are believed to have worked. But the theory of art, particularly the doctrine of perspective, simply ignored the fact that distant objects get paler in color; the rendering of distances was conceived in terms of linear constructions only. The very term "aerial perspective" indicates Leonardo's interpretation of the phenomenon. Layers of air are placed between the eye and the object it sees; the more distant the object, the thicker those layers. Since air was not believed to be completely transparent (Leonardo believed it had a slightly bluish tint), it naturally follows that with increasing distance the color becomes less clear. Leonardo seems to have thought that a mathematical ratio could perhaps be applied to the paling of color. If there is an object "which you wish to show as five times more distant, make it five times bluer" (no. 238).

Zubov, in his study of Leonardo's science, has pointed out[71] that there was also a theoretical tradition of aerial perspective. Medieval

scientists noticed the phenomenon, but they dealt with it in a completely different context: their main aim was to correct these distortions in color for the sake of proper astronomical observations. If Leonardo knew this theory (as seems likely, since he knew many of the sources in which it appears), he did not attempt to eliminate the effect; he simply incorporated it into his theory of painting.

But the paling—or should we say bluing?—of color cannot be as definitely measured and as manifestly demonstrated as the decrease in size. Aerial perspective in itself is not necessarily contradictory to linear perspective, but it emphasizes a different aspect, one that has more to do with our immediate intuitive experience than with a measurable mathematical model.

That Leonardo's drawing from immediate visual experience may imply a contradiction of the very ideals and values that dominated fifteenth-century perspective is revealed in a specific facet of the problem here discussed. In carefully analyzing our actual visual experience Leonardo noticed still another atmospheric effect produced by great distance; the object removed from the eye not only shrinks in size and pales (or gets bluer) in color; it also becomes hazier in outline. The "loss of distinctness of outline," what he called by the technical term *i perdimenti,* is not a concept completely unknown in the theory of art before Leonardo, but only he made it into a principle. "The painter," he says, "should show forms and objects remote from the eye only as stains, and not give them shadows with sharp outlines, but rather with indistinct edges" (no. 468). Now, vague outlines, indistinct edges, misty appearances (like stains)—they all indicate an ideal, an artistic model that sharply contrasts with the one that guided Brunelleschi, Alberti, and Piero della Francesca in their efforts to build up a rational, scientific theory of pictorial perspective. For these earlier artists and writers it was essential that the outlines never get confused, that they always remain measurable and calculable, however distant from the eye and small in size may be the figure or object represented. Leonardo did not accept vague and fuzzy outlines because of any mystical leanings. He was not less rationalistic than Alberti or Piero. It was his faithfulness to our empirical experience that led him to formulate the principle of *i perdimenti.*

But the vagueness and indistinctness of outline, already remarkable as an observation of nature, was turned by Leonardo into an aesthetic principle, what is now known as *sfumato*. The "smoky contour" becomes the cornerstone of an aesthetic attitude in which softness, gentleness, and the toning down of contrasts are the basic values. A picture can be said to have the quality of *sfumato* if the scene and figures represented in it are seen through a thin smokescreen that cancels the glare and slightly obfuscates the borders.)[72] In other words, in a picture so painted the small sizes and forms are no longer strictly definable and calculable. The *sfumato* suggests the beginning of a new period in aesthetic appreciation and art theory.

NOTES

1. The best review of our "problem" is found in W. K. Ferguson, *The Renaissance in Historical Thought: Five Centuries of Interpretation* (Cambridge, Mass., 1948). A more recent discussion, emphasizing the specific problems of art history, is given by E. Panofsky, *Renaissance and Renascences in Western Art* (Stockholm, 1960), esp. chap. 1.
2. L. Edelstein, "Andreas Vesalius, the Humanist," *Bulletin of the History of Medicine* 14 (1943): 547 ff.
3. See T. Mommsen, *Medieval and Renaissance Studies* (Ithaca, N.Y., 1959), pp. 212 ff.
4. Boccaccio, *Decamerone* VI. 5.
5. In a letter written about October 13, 1506. See A. Werner, ed., *The Writings of Albrecht Dürer* (London, 1958), p. 58.
6. B. Weinberg, *A History of Literary Criticism in the Italian Renaissance* (Chicago, 1961; reprint 1974), p. 1.
7. P. O. Kristeller, "The Modern System of the Arts," originally published in *Journal of the History of Ideas* 12, 13 (1951, 1952). Here quoted after P. O. Kristeller, *Renaissance Thought* (New York, 1965), II, pp. 163–227. For the passage quoted see p. 178.
8. E. Panofsky, *Galileo as a Critic of Art* (The Hague, 1954), pp. 1 ff., with further bibliography on the subject of *paragone*.
9. Leonardo da Vinci *Treatise on Painting*, ed. and trans. P. McMahon (Princeton, 1956), pp. 1–44, nos. 1–57.
10. These answers have been reprinted frequently. See P. Barocchi, ed., *Trattati d'arte del Cinquecento* (Bari, 1959), I, pp. 59 ff. For translations of brief passages see E. Holt, ed., *A Documentary of History of Art* (Garden City, N.Y., 1958), II pp. 15 ff., 35ff.
11. See N. Pevsner, *Academies of Art: Past and Present* (Cambridge, England 1940), pp.

42 ff. See also A. Blunt, *Artistic Theory in Italy: 1450–1600* (Oxford, 1940), pp. 57, 137 f.

12. There is no systematic discussion of Dante's views of the visual arts. But see J. von Schlosser, *Die Kunstliteratur* (Vienna, 1924), pp. 67–77; and see also K. Borinski, *Die Antike in Poetik und Kunsttheorie* (Leipzig, 1914), I, pp. 40 ff., 99 ff., 105 ff.

13. Sonnet LVII.

14. Cennino Cennini, *The Craftsman's Handbook: Il libro dell'arte,* trans. D. V. Thompson, Jr. (New York, 1933). The figures in parentheses, given in the following pages, refer to the chapters of Cennini's work.

15. Cennini, *The Craftsman's Handbook,* p. 123.

16. J. von Schlosser, "Porträtplastik in Wachs," *Jahrbuch der kunsthistorischen Sammlungen des allerhöchsten Kaiserhauses* 29 (1910): 173 ff.; see also J. Pohl, *Die Verwendung des Naturabgusses in der italienischen Porträtplastik der Renaissance* (Würzburg, 1938) (with particular emphasis on portrait sculpture).

17. J. Burckhardt, *The Civilization of the Renaissance in Italy* (London and New York, 1951), pp. 85–87.

18. Alberti's work on painting has been translated into English twice. The Italian version, trans. J. Spencer, appeared as *Leone Battista Alberti on Painting* (New Haven, 1966); the Latin version has been translated as *Leone Battista Alberti On Painting and On Sculpture,* edited, with Introduction, translation, and notes, by C. Grayson (London, 1972). Usually we quote Grayson's translation. The numbers in parentheses given in the text refer to the number of the book (roman numeral) and paragraph (arabic numeral). The treatise *De statua* is also quoted in Grayson's translation; the numbers in parentheses refer to the paragraph numbers in that edition. From the literature on Alberti's art theory cf. Blunt, *Artistic Theory in Italy,* chap. 1; Kenneth Clark, "Leone Battista Alberti On Painting," *Proceedings of the British Academy* 30 (1940): 3–40; see also B. Katz, *Leone Battista Alberti and the Humanist Theory of the Arts* (Washington, D.C., 1978).

19. Cennino Cennini, *The Craftsman's Handbook,* chap. XXVIII, p. 15.

20. Alberti's work on architecture (translated into English by James Leoni and published as *The Architecture of Leone Battista Albert in Ten Books . . .* [London, 1755]) is quoted according to book (roman numeral) and chapter (arabic numeral); the references are given in the text. For Alberti's theory of architecture see R. Wittkower, *Architectural Principles in the Age of Humanism* (London, 1952), pt. II pp. 3 ff., 29 ff.

21. Alberti, *On Painting,* ed. Spencer, p. 72.

22. See Janitschek's Introduction to his translation of *Leone Battista Alberti's Kleinere Kunsttheoretische Schriften* (Vienna, 1877), p. iii.

23. E. Panofsky, *Idea: A Concept of Art Theory* (New York, 1968), pp. 53 ff., 57 ff.

24. Leonardo da Vinci, *On Painting,* ed. and trans. McMahon (Princeton, 1956), no. 433 (p. 161).

25. E. Panofsky, "Artist, Scientist, Genius: Notes on the Renaissance-Dämmerung," *The Renaissance: Six Essays* (New York, 1963), pp. 121 ff., esp. pp. 128 ff.

26. For the traditional outlook prevailing in the universities during the Renaissance see, in addition to M. Rashdall, *The Universities of Europe in the Middle Ages,* 3 vols. (London, 1969), esp. vol. II; see also P. O. Kristeller, *Medieval Aspects of Renaissance Learning* (Durham, N.C., 1974).

27. C. H. Haskins, *The Renaissance of the Twelfth Century* (Cambridge, Mass., 1927), p. 324.

28. Panofsky, "Artist, Scientist, Genius," p. 142.

29. J. von Schlosser, *Quellenbuch zur Kunstgeschichte des abendländischen Mittelalters* (Vienna, 1896), p. 371; see also Panofsky, "Artist, Scientist, Genius," p. 142, n. 24.

30. Cennini, *The Craftsman's Handbook,* chap. LXX, p. 49.

31. Alberti, *On Painting,* ed. Spencer, p. 73.

32. Ibid., pp. 77 ff.

33. For Leonardo as a scientist (a subject that has attracted much attention) see the fine study by V. P. Zubov, *Leonardo da Vinci* (Cambridge, Mass., 1968). For the central significance of the eye cf. chap. 4 ("The Eye, the Sovereign of the Senses").

34. Leonardo's notes are quoted *Leonardo da Vinci,* ed. and trans. McMahon, paragraphs numbers are given in the text.

35. See the interesting observations by E. Cassirer, *The Individual and the Cosmos in Renaissance Philosophy* (New York, 1964), pp. 157 ff.

36. Marsilio Ficino's *Commentary* on Plato's *Symposium,* the text and a translation by S. R. Jayne, (Columbia University of Missouri, 1944) *The University of Missouri Studies* 19, no. 1.

37. Alberti, *The Architecture of Leone Battista Alberti in Ten Books,* II, pp. 19 ff.

38. Luca Paccioli, *Divina proportione,* ed. S. Morison (New York, 1932).

39. Cassirer, *The Individual and the Cosmos,* pp. 148, 153 ff.

40. Cf. Zubov, *Leonardo da Vinci,* pp. 134 ff.

41. For a survey of the subject see ibid., pp. 34 ff.

42. E. MacCurdy, *The Notebooks of Leonardo da Vinci* (New York, 1958), p. 166.

43. Zubov, *Leonardo da Vinci,* p. 85.

44. MacCurdy, *The Notebooks,* p. 93. And cf. Zubov, *Leonardo da Vinci,* p. 59.

45. See Panofsky, "Artist, Scientist, Genius," pp. 151 ff.

46. Ibid., pp. 157 ff., with further bibliographical references.

47. *Alberti On Painting,* ed. Spencer, p. 93.

48. Most easily accessible in *The Writings of Albrecht Dürer,* ed. A. Werner (London, 1958), pp. 165 ff. For background and general context see E. Panofsky, *Albrecht Dürer* (Princeton, 1943), I, pp. 242 ff. (the last chapter of the book).

49. *The Writings of Albrecht Dürer,* ed. Werner, p. 121. This is Dürer's entry into his diary, written on June 7, 1521.

50. See, e.g., ibid., pp. 230 ff. (Dürer's dedication of the *Four Books on Human Proportions* to Willibald Pirckheimer), pp. 250 f. (excerpts from the same work).

51. *The Writings of Albrecht Dürer,* ed. Werner, p. 187.

52. For a concise survey of Dürer's theory of movements see Panofsky, *Albrecht Dürer,* I, pp. 267 ff.

53. Ibid., I, p. 267.

54. See above, p. 139 ff.

55. For the selection of the most beautiful parts in nature (what may be termed the Zeuxis model) see *Alberti On Painting,* ed. Spencer, p. 93. For Alberti's other method, arrived at by calculating the average of many measurements, see Leon Battista Alberti, *On Painting and On Sculpture,* ed. Grayson, pp. 133 ff.

56. Quoted in Leonardo da Vinci, *Treatise on Painting* ed. and trans. McMahon. The figures given in parentheses refer to paragraph numbers.

57. Pomponius Gauricus, *De Sculptura,* ed. and trans. A. Chastel and R. Klein (Geneva, 1969), pp. 75 ff., esp. p. 94. This is the most recent and best edition.

58. *The Writings of Albrecht Dürer,* ed. Werner, p. 248.

59. Ibid., p. 247.

60. Ibid., p. 246.

61. Cf. J. White, *The Birth and Rebirth of Pictorial Space* (London, 1957), for a systematic discussion of the developments in the early Renaissance. For an original comprehensive interpretation cf. E. Panofsky, "Die Perspektive als 'Symbolische Form,' " *Vorträge der Bibliothek Warburg 1924–1925* (Leipzig and Berlin, 1927), pp. 258–330.

62. M. Schild-Bunim, *Medieval Space and the Forerunners of Perspective* (New York, 1940).

63. *The Writings of Albrecht Dürer,* ed. Werner, p. 210.

64. White, *The Birth and Rebirth of Pictorial Space,* pp. 113 ff.

65. See E. Panofsky, *Renaissance and Renascences in Western Art* (Stockholm, 1960), p. 123, n. 2, with a history of the problem.

66. See esp. L. Olschki, *Geschichte der neusprachlichen wissenschaftlichen Literatur,* I, *Die Literatur der Technik und angewandten Wissenschaften vom Mittelalter zur Renaissance* (Heidelberg, 1919).

67. Pomponius Gauricus, *De Sculptura,* p. 183.

68. For Ghiberti's handling of perspective, in theory as well as in actual sculpture, see R. Krautheimer, *Lorenzo Ghiberti* (Princeton, 1970), I, pp. 229–253.

69. *Petrus Pictor Burgensis De Prospectiva pingendi,* ed. C. Winterberg (Strasbourg, 1899). Some fragments of Piero's work, in English translation, are now easily available in Holt, ed., *A Documentary History of Art,* I, pp. 256–267.

70. For Dürer's studies of perspective see Panofsky, *Albrecht Dürer,* pp. 247 ff.

71. Zubov, *Leonardo da Vinci,* pp. 134 ff.

72. For the different aspects of *sfumato* cf. M. Barasch, *Light and Color in the Italian Renaissance Theory of Art* (New York, 1978), pp. 73 ff.

4

The Artist and the Medium: Some Facets of the High Renaissance

Around 1500 another transmutation of ideas took place among artists, scholars, and critics. It was not a sudden mutation, and it had nothing of the dramatic quality characteristic of Brunelleschi's display of the perspective panels. The term *revolutio,* which so readily comes to mind in such contexts, cannot be used here. But a reader carefully following the unfolding of aesthetic ideas about the visual arts will not overlook the change in subject matter discussed and in the attitudes displayed. Art historians, investigating the development of painting and sculpture, speak of a "High Renaissance" and try to define in great detail the limits of that short period in which the classical ideal predominated. With the acumen that distinguishes some of them, they ask: Did the period really begin in 1500, or perhaps two or three years later? Did it reach its conclusion in 1527 or in 1520? Some of them, employing refined techniques of stylistic analysis, would even argue that certain works produced in 1518 or 1519 show that the bloom of the classical ideal was already over by this early date. The historian of ideas must resign himself to greater restraint, for the pace of ideas can rarely be as precisely defined as that of a pictorial style. Yet nobody will doubt

that in the aesthetic thought of the first decades of the sixteenth century the emphasis shifted from one group of problems and tasks to another.

The new foci of intellectual fascination that became manifest at the turn of the century are quite difficult to define. One of the reasons for this difficulty is that the authors of that short period often speak in an inherited language and continue to use the concepts that, properly speaking, belong to the former period. The well-known doctrines of perspective and anatomy, the requests for measurable correctness, are repeated and sometimes even elaborated. Yet there is very little in them that has not been taken over from the generations of Alberti and Piero della Francesca. The original contributions of the early sixteenth century lie elsewhere. In bold oversimplification we may venture to say that in the fifteenth century art theory was concerned mainly with the relation between art and nature, between the picture and the piece of reality it portrays. In other words, art was centered on something outside itself. In the thought of the early sixteenth century a certain inversion takes place; art theory is now primarily concerned with the intrinsic problems of art itself. The relation to the piece of nature portrayed becomes a topic of only secondary significance. At the same time, and in intimate connection with this process, art theory becomes more speculative, trying less assiduously to provide the knowledge and to develop the systems that will help the artist in his work. The treatises—now addressed to the educated public rather than to the artists themselves—become a reflection of what the nature of art is.

I. PARAGONE

In the third chapter we had occasion to refer briefly to one of the great subjects of Renaissance art theory: the specific nature of each particular art. Comparing painting and sculpture, and pointing out what distinguishes them, rather than what they have in common, is indeed one of the original contributions of the Renaissance to aesthetic thought in Europe, and its effects have endured to this day. The most common literary from in which such comparisons were carried out is the so-called *paragone* (lit., "comparison"), which in the Renaissance period

was a kind of rhetorical contest in which one art competed with another for superiority.[1]

The origin of the *paragone* as a literary genre, according to Panofsky, lies in the "Greek passion for debate." Debates in Greek literature deal with a variety of subjects, some serious, some rather amusing. The arts in general play a marginal role in these writings, and only in a few instances do the visual arts appear. In Lucian's *Dream,* sculpture wages a battle against "refined culture" *(paideia);* in Dio Chrysostomus' Olympic Oration, Phidias wins an imaginary argument against Homer, and the introduction to Philostratus' *Imagines* begins with a lightly touched juxtaposition (suggested rather than explicitly formulated) of the nature and particular value of painting and sculpture.[2] But we should keep in mind that in this rich literature these are only a few isolated cases.

Little is as characteristic of medieval literature as the contest form of exposition, famous under the name *disputa.* The foundation of medieval moral psychology, Prudentius' *Psychomachy,* is presented in the form of a rhetorical contest between virtues and vices fighting within a soul, and a great deal of later medieval philosophy followed this example. As we know, even theological theory was often subject to similar presentation. Yet, to the best of our knowledge, medieval literature does not provide a single instance in which the visual arts enter a contest of this kind. One can see why this was so: in order for two contestants to compete they must have a common basis; in some way they must belong to the same group, even though they represent the opposite poles of that group. But in the medieval world, painting and sculpture, music and poetry, were altogether separated; they were so distant from each other that nobody seems to have thought seriously about what they might have in common.

In Renaissance *paragone* literature, actually for the first time in the history of this genre, the visual arts played an important part. This in itself indicates the growing aspirations of painters and sculptors and their coming into their own. Renaissance artists and writers who compared the arts seem to have had two separate goals in mind, and in striving for the one they emphasized a different aspect of the comparison than in striving for the other. In comparing the visual arts with old and established disciplines the aim was to raise their status; ac-

cordingly, the common nature of the arts compared is stressed. But in comparing the visual arts among themselves—mainly painting and sculpture—the authors intended to analyze the specific nature of each art, and accordingly the differences are stressed. In historical development the two attitudes often overlapped, but it will be useful for us to treat them separately.

In the Renaissance our story begins with the comparison of painting and poetry.[3] This particular comparison has, of course, an old and famous origin in Horace's dictum *Ut pictura poesis* ("As is painting, so is poetry"). We also remember that Aristotle compares the drama to a painting, the plot representing the drawing and the individual characters standing for the colors.[4] But these particular comparisons seem to have left few traces in the Middle Ages, and the early Italian artists and authors who employed this formula do not refer to Horace or Aristotle. They probably had something else in mind. Throughout the Middle Ages poetry was a dignified literary art, part of the established educational curriculum, an art that had a theory of its own. Could not the comparison of painting, still considered a mere craft, with poetry help confer on the former something of the aura surrounding the latter? It is not surprising that in the comparisons between painting and poetry their similarity is often emphasized and their common nature stressed.

But what is it that painting and poetry have in common? Italian authors focus their thoughts on one single theme: both the painter and the poet have the gift of free imagination. In Renaissance art theory this idea was formulated for the first time in Cennini's *Libro dell'arte.* As we remember, Cennini is still deeply rooted in medieval habits of thought. Only occasionally, mainly in the introduction to his *Libro,* do we find a jumbled mixture of medieval and early humanistic ideas. And here we read that "painting justly deserves to be enthroned next to theory, and to be crowned with poetry."[5] Painting derives this status from having the gift of inventive imagination. The painter, like the poet, has the "freedom to compose a figure, standing, seated, half-man, half-horse, as he pleases, according to his imagination." Cennini, it should be noted, does not elaborate on what distinguishes between the painter and the poet; rather, he emphasizes their common na-

ture—and that nature is inventiveness, imagination, or, as we would say today, creativity. When early Renaissance authors wished to stress that the painter is a creative artist, they often arrayed their statement in the form of comparing him with the poet.

In the course of the Renaissance the kinship of poetry and painting became a commonplace. Often they were called the sister arts, and by the end of the sixteenth century Lomazzo even insisted that they were born together. In Venetian art literature, composed around the middle of the sixteenth century, the common nature of poetry and painting is expressed in a variety of metaphors. Whenever a poet excels in the vividness of his imagery and in a direct and powerful appeal to his reader's senses, he is said to be a painter. Lodovico Dolce, a prolific writer in many fields and probably the most influential author of art theory in Venice, would say that all writers, not only poets, are painters. In his view, "people of small understanding . . . pilot everything towards a single variety of form, and then stricture whoever departs from it."[6] By the same token, every imaginative painter is said to be a poet.

The best-known instance of *paragone* in Renaissance literature is found in Leonardo's notes. Leonardo forcefully asserts the superiority of painting over all the other arts—and does this not speak against the affinity between painting and poetry? Let us remember that the manuscript, compiled by unknown hands from Leonardo's notes on painting, begins with a full-fledged *paragone* in which painting is compared with a variety of other arts. Leonardo, of course, is writing a century after Cennini. In the meantime, painting has achieved an honorable status; it has now become a free art (though one notices in Leonardo's formulations that he is still anxious to stress the point). Nevertheless, it is interesting to examine Leonardo's arguments in light of what we have said before. Painting, he maintains, is superior to all the other arts. Music is a sister art of painting, though only a younger one (no. 39).[7] Painting is even superior to poetry. But this superiority is not based on any difference of aims and demands. Essentially, both painting and poetry have the same goal and the same requirements. "The poet says that his science consists of invention and measure, invention of subject and measure of verses. . . . To this the painter replies that

there are the same requirements in the science of painting; that is, invention and measure, invention concerning the subjects which he must represent and measure concerning the objects painted" (no. 33). The superiority of painting over poetry follows from the superiority of the eye (to which painting appeals) over the ear (to which poetry is directed). The poet's words and verses conjure up only a shadow of what is described; the painter's work places reality itself directly in front of our eyes. Painting is superior, we may then say, because it is fuller, not because it has a different aim.

In Leonardo's comparisons of painting and poetry the old motif of the painter's creative powers also reappears. "If the painter wishes to see beauties which will make him fall in love with them, he is a lord capable of creating them, and if he wishes to see monstrous things that frighten, or those that are grotesque and laughable, or those that arouse real compassion, he is their lord and their creator" (no. 35).

So far we have seen that when Renaissance writers compared painting (standing for visual arts in general) with poetry (representing all literary arts), they stressed their similarity. But what about the comparison of the visual arts among themselves? What are the same authors aiming at when they compare painting with sculpture? In trying to answer these questions we witness a full reversal of intention. When comparing painting and sculpture, Renaissance authors usually focus on the differences between the two arts, on the specific nature of each medium, and on the particular processes required by working in each of them.

The first Renaissance author to deal explicitly with this problem is probably Alberti. In the introduction to *De statua*—we remember, the first treatise on sculpture—Alberti distinguishes three ways of producing a piece of sculpture, each corresponding to a different kind of sculptor: those who work in wax or clay (i.e., soft materials) shape their work both by adding and taking away. These artists, Alberti says, the Greeks called *plastikes* and we call *fictores* (lit., "image makers," "molders"). Here he obviously has modelers in mind. The second group consists of sculptors who work by taking away only. In a bold and imaginative sentence, to the sources of which we shall presently return,

he says that every slab of stone contains (potentially) a figure; by removing the "superfluous" mass of stone, this figure can be brought to light. Artists so working are stone carvers, and these, he says, we call sculptors. A third group, finally, works by adding only. These are the silversmiths who hammer metal sheets and thus produce the image they have in mind. What Alberti says of the silversmiths, that is, those who work by adding only, could be disregarded (it had, in fact, no appreciable influence on Renaissance art theory) were it not for the lines immediately following. "Some might think," Alberti continues, "that painters should be included here because they work by the application of colors. But, if you think about it you will see that they strive to imitate the forms and colors of objects they see before them, not so much by adding or taking away, as by another method peculiar to themselves" (2).[8] But Alberti's protestation was not of much avail. The Renaissance tended to see sculptors as those who work by removing, the painters as those who work by adding.

Alberti did not take his distinctions out of thin air. Borinski has reminded us[9] that a very similar distinction is found in Quintilian, the master of Roman rhetoric. Speaking of how a composition can be perfected, he says that this can be done "by adding, removing, or altering" (*Institutio oratoria* IX. 4. 147). Alberti studied rhetoric (in *On Painting* he even advised the painters to study the rhetoricians), and here we may well have another case of applying classical scholarship to the work of the contemporary artist.

But the Christian allegorical interpretation of the same procedure may have been even more persuasive. To mention just one example: Dionysius Areopagita, a sixth-century mystical Neoplatonist and one of the most influential forces in the spiritual life of the Middle Ages, attempts to explain mystical ascendance (*Mystical Theology,* chapter 2), which to him is the renunciation of everything existing, by comparing it to the carver's procedure. The mystical ascendant is like "him who, in order to produce a true image, removes all obstacles which prevent [us] from seeing the hidden form, and by the mere removal reveals the obscured beauty in its pure splendor." Such ideas were of great influence throughout the Middle Ages and the Renaissance, and Florentine

Neoplatonism was well acquainted with them. Occasionally Ficino describes both man and the world as statues that are carved by the Divine sculptor.[10]

It may well have been the impact of this tradition that made the sixteenth century accept a simplified version of Alberti's still complicated catalogue of artistic procedures. With classical simplicity, disregarding many shades of significance, Michelangelo formulated this view in a letter he wrote to Benedetto Varchi in 1546. "By sculpture," he says, "I mean the sort that is executed by cutting away; the sort that is executed by building up resembles painting."[11]

Michelangelo, then, with his "almost totemistic feeling of the natural-born stone-carver,"[12] simply adds the modelers to the painters. But in developing with mythical intensity the doctrine of the stone carver he comes back to the vision of the figure hidden in the stone slab. One of his most famous sonnets begins:

> The best artist never has a concept
> A single marble block does not contain
> Inside its husk, but to it may attain
> Only if hand follows the intellect. (149)[13]

Presumably, the same idea dominated his technique of actual carving. Vasari relates that the forms of a Michelangelo statue emerged from the stone slab as if there were a model lying in a tub of water that is being slowly drained. Whatever we may think of the precision of this description (Michelangelo's technique was certainly more complex than would appear from Vasari's words), it clearly attests to the life force inherent in the metaphor of the figure hidden in the stone.

Michelangelo was also aware of the allegorical, moral meaning of the process of "removing" that had been crystallized in the venerable tradition of Christian interpretation to which we referred earlier. The noble lady to whom he dedicates a poem is the "carver" governing this psychological art.

> Just as we put, O Lady, by subtraction,
> Into the rough, hard stone
> A living figure, grown
> Largest wherever rock has grown most small,

> Just so, sometimes, good actions
> For the still trembling soul
> Are hidden by its own body's surplus,
> And the husk that is hard and raw and coarse,
> Which you alone can pull
> From off my outer surface;
> In me there is for me no will or force. (150)

Dürer was not a sculptor; he had no experience in carving; his work, rich and diverse as it is, always remained bound to a flat surface. Yet even in his thought, it has been noted, one discovers the traces of the two ways of producing a work of art: removing, or taking away, and positing, or adding. True, in Dürer's doctrine they have become almost metaphysical principles, yet the two actions—metaphorically performed—are still distinguishable. Art, true shapeliness and beauty, Dürer says in a text to which we shall revert, are hidden in nature, in the mass of men. The act of creating is described as one of extracting the true form that only the artist who "can extract the true measure" will really possess.[14]

But the artist's creative process is also understood as a pouring out or, we might say, as an adding. "For a good painter," he says, "is inwardly full of figures and if it were possible that he live forever, he would have from the inner ideas of which Plato writes, always something new to pour out in his works."[15] We do not have to be unduly worried by the reference to Plato. What Dürer had in mind were not abstract "ideas" but rather concrete images that can be transformed into paintings or drawings. What we should like to emphasize here is that the two ways of shaping became so universal that they could serve as metaphysical explanations of how an artist works in general. The simple distinction between the way the sculptor and the painter approach their specific media gave rise to a broad philosophy of art.

It comes as no surprise that painters and sculptors should have devoted so much attention and thought to analyzing how they work, and one can even understand how these procedures came to be endowed with allegorical meanings. But can the character of painting and sculpture themselves be as clearly defined and distinguished from each other as the processes of working in the different media? The attempts

to establish a hierarchy of the arts were based on many considerations, some of them social, others directed more toward the art itself. An illuminating example of the former is Leonardo's well-known description of the sculptor sweating at his hard physical work while the painter pursues his job in comfortable, gentlemanlike circumstances (no. 51). But the *paragone* literature[16] was largely concerned with the nature and intrinsic conditions of what we would today call the media of painting and sculpture. The list of features attributed to either sculpture or painting is long and diversified, but several characteristics keep recurring. In a somewhat schematic way we can present the following distinctions as those which were of particular significance for the aesthetic thought of the centuries to follow.

Multiple Views Versus Single View. It was widely believed that multiplicity of views is a striking characteristic of any piece of sculpture, while a picture always represents only a single view. "Among all the arts based on design," Benvenuto Cellini wrote to Benedetto Varchi in 1546, "sculpture is seven times the greatest, because a statue must have eight show-sides and all should be equally good."[17] He was, of course, expressing the opinion current in the middle of the sixteenth century that a statue has many (to be precise, eight) principal views. But the thought was already familiar to Leonardo, who agreed that a statue has more than just one view (though he limited them to two only, front and back). But he did not think that this represents a particular difficulty and therefore does not give to sculpture any advantage over painting (no. 51). Emphasizing a statue's multiple views reveals how people at the time thought that a statue should be placed (so that it can be seen from different sides). Even more clearly, it reveals how important a part the spectator plays in Renaissance aesthetic thought. To give only one example for the tenacious life inherent in this concept, we shall mention that as late as in 1852 Friedrich Theodor Vischer, one of the great nineteenth-century philosophers of art, said that a single piece of sculpture offers the spectator walking around it "a multitude of works of art."[18]

Aesthetic Self-Sufficiency. Defenders of the superiority of painting often stressed that a statue is more dependent on natural conditions—that is, conditions beyond the artist's control—than a picture. Conditions

of illumination prevailing in nature, for instance, decidedly determine how we perceive a sculpture; light coming from an improper direction may make the statue seem distorted. Contrary to such dependence on nonartistic conditions, painting, according to Leonardo, "carries all its elements within itself" (no. 46). In modern parlance, painting is aesthetically more self-sufficient than sculpture: it is, in a sense, a "purer" art.

Reality Versus Illusion. Sculpture, it was often said, is a more material art than painting. With all material objects it shares three dimensionality; it is a real object placed in actual space. Probably for this reason, "the difference between sculpture and painting is as great as that between the shadow and the object which casts the shadow," to quote Cellini once again. From this very feature Leonardo infers the superiority of painting. In a memorable phrase he says that "the sculptor creates his works so that they appear as they are" (no. 54). But the painter's work is built on illusion: what is in fact flat (the panel on which the picture is painted) appears to be round, to have volume, and to recede in space. Painting is therefore "a matter of greater mental analysis . . . it compels the mind of the painter to transform itself into the very mind of nature, to become an interpreter between nature and art" (no. 55).

The cluster of problems and concepts called *paragone* had a wide diffusion in European literature. The comparison of painting and poetry—always with the intention of promoting the status of painting as a liberal art—could even enter the courts. When Madrid painters were engaged in a suit with the tax office, which considered them as craftsmen and taxed them appropriately, the great Spanish poet Calderón in 1677 wrote an expert opinion in favor of the painters, which is, in fact, a piece of *paragone* literature.[19]

The dispute between painting and sculpture crystallized fully in the sixteenth century. In 1584 all the arguments in favor of either painting or sculpture were already systematically listed in *Il Riposo,* a not very inspiring treatise on the arts by an otherwise unknown cleric, Raffaello Borghini. Yet the questions raised in this dispute continued to occupy the mind not only of painters and sculptors. No less a man than Galileo Galilei, the great physician and astronomer, made an original contri-

bution to the dispute, as Panofsky has shown in a delightful study. It is difficult for us to appreciate properly the powerful impact these distinctions between painting and sculpture made on European thought of later periods. More than three centuries after the Renaissance, when aesthetics had become a full-fledged philosophical discipline and great philosophical systems tried to include the arts, the concepts that had crystallized in the *paragone* disputes formed the solid basis of thin speculation. Thus, the German philosopher Hegel describes the "element of sculpture" as the "sheer existence of matter in space," while painting is a "spiritual" art; and Theodor Vischer, whom we have already mentioned, claims that painting transforms everything into "dematerialized pure appearance."[20] Even the indoctrination of present-day beholders with the notion of "truth to material," a notion that forms the basis of much criticism, still echoes some of the ideas that originally emerged in the *paragone* literature.

II. RISE OF THE CREATIVE ARTIST

It is scarcely an exaggeration to say that no other issue impressed itself more deeply on historical memory, and came to be regarded as more typical of the Renaissance, then the meteoric rise of the artist. Jakob Burckhardt's famous thesis of the discovery of the individual in the Renaissance is best illustrated by the emergence of the artist's individual personality, although Burckhardt himself did not include a discussion of the artist in his epoch-making work. Today, more than a century of painstaking research following Burckhardt's work, we are, of course, aware that much that seemed hard fact in what we call the artist's meteoric rise was, in fact, myth, the projection of modern writers. The historical reality itself was much more prosaic than some romantic historians projecting their visions onto the past would make us believe. Yet, even when we cut down mythological excrescence to historical size, a revolutionary, startling development remains. The artist's position, both as seen by society and as conceived by himself, *was* drastically altered during the Renaissance centuries. Much of this process is reflected in the theory of art, and the ideas expressed in art theory were some of the forces moving the process.

1. SOCIAL CONDITIONS

To relate the story of the artist's rise we must start with the Middle Ages. The low social status and the narrowly limited legal position of the medieval artist have already been discussed, but it may be useful to recall briefly some of the essential facts. Like members of all the other crafts, painters and sculptors were organized in guilds, and these— as was generally the case—took care of the "whole man," enforcing the religious observation of their members, controlling the education of apprentices and the teaching of masters, supervising contracts, and so on. The bylaws of the Painters' Guild in Siena, formulated in 1355, regulates the relationship of master and apprentice in a way becoming to a craft organization of the Middle Ages. In a recent study it has again been shown that the legal requirements for the "masterpiece," the piece of work carried out by the apprentice to prove his competence, were pervaded by a medieval spirit that still applied even to artists. And in an artistically and culturally backward city like Genoa, resident artists in the early sixteenth century were still asking that the immigration of a foreign master be forbidden, so as not to constitute competition.[21]

Nor was the placing of artists and other craftsmen on the same level imposed from the outside only on the artists; they themselves willingly accepted that status. Edgar Zilsel, in his interesting work on the concept of genius, called our attention to the gap between the mentality of poets and of painters in the earliest stages of the Renaissance. Writers considered themselves as conferrers of fame, and they acknowledged that the quest for fame was their own motivation as well. Boccaccio derived poets from the ancient priests who secured immortality to the kinds they served; to these ancient writers, poets and theologians were *quasi una cosa* (one thing, as it were). (See his *Vita* of Dante.) And Petrarch admits, though with some pangs of conscience, that only for the sake of fame did he start writing his epos *Africa* as well as his historical compositions. Petrarch's crowning in Rome as the *poetas laureatus* is a dramatization—in classicizing style—of the desire for fame as the motivation of the literary man.[22]

Painters were more backward in their development. Cennini, writ-

ing a generation or two after Petrarch and Boccaccio, believes that youths entering the profession of painting should not be motivated by "poverty or domestic need"; nor does he even mention fame; what should impel them is "a sense of enthusiasm and exaltation" (2). This may sound familiar, even modern, to a present-day reader who is used to thinking that the artist's individual experience and enthusiasm are what make him work. Yet Zilsel is probably correct in assuming that what we are here reading in Cennini is the expression of the medieval habit of mind requiring that the individual humbly accept the workshop ideal. How else, one could ask, will the same "sense of enthusiasm and exaltation" prevail while the painter embellishes caskets (128 ff.), gilds banners (107), paints shields (29, 91), and displays colors for the benefit of ladies who are indulging in cosmetics (123)? All these activities, one should remember, Cennini accepts without reserve as belonging to the painter's job.

Attempts to radically change the artist's social and legal position pervaded the fifteenth century, and their echo is also often perceived in later periods. The major reason given for raising the artist's status is that the visual arts do not belong to the crafts, the so-called *artes mechanicae,* but that they form an integral part of the liberal arts, that is, the sciences worthy of a gentleman's pursuit. Does not the painter need a thorough knowledge of geometry to accomplish correct perspective rendering? Do not both painters and sculptors show their knowledge of anatomy? And do they not all need a familiarity with classical literature and history so as to be able to properly understand heroic and elevated subject matter? In other words: the artists claimed a higher status, not because of any specifically artistic values (we would today speak of creativity, psychological experience, etc.), but because art is a science. The artist claimed a doctor's hat, and this is also why he claimed the doctor's social status.

It would, I think, be a gross oversimplification to assume, as some sociologists do, that fifteenth-century artists based their work on science *in order* to achieve for themselves the social status that was reserved for scientists. We cannot inquire here into the ultimate reasons for the turning of art toward science (that would probably be a philosopher's task), but we can say that, once art was based on perspec-

tive, correct anatomic rendering, and the like, this became a basis for claiming a new position for the artist.

In their struggle for recognition, artists and their champions often also relied on Antiquity. Hallowed Antiquity was believed to provide a model for the high regard in which the visual arts should be held. Alberti, in the second part of *On Painting,* devoted a lengthy passage to the venerable age of the visual arts and the high esteem that they enjoyed in the classical world. The legendary ancient sage Trismegistus, we here read, "believes that sculpture and painting were born at the same time as religion" (II. 27), that is, they have existed since time immemorial. Alberti also adduces in detail what Pliny and Vitruvius, the classical literary sources regarded as norms in his time, had to say about the honors bestowed upon painters and sculptors in the heydays of Greece and Rome. Twenty years after Alberti, the architect Filarete, in his curious *Treatise on Architecture* (Florence, 1464), talks of Roman emperors who were not ashamed to paint, while "today it is considered a shame." At the end of the fifteenth century Giovanni Santi, Raphael's father, reminded his "mean century," which despised painting, that in Antiquity it was forbidden to instruct slaves in the art.[23] And according to Condivi, Michelangelo's servant and secretary, Michelangelo himself wished to admit to the study of art "only noblemen, not plebeians," because this "was the custom of the ancients." The Antiquity projected by all these artists and writers was altogether utopian, more like a humanist's dreamland than historical Antiquity. In the first chapter of this book we saw in how low an esteem the artist was, in fact, held in Greek and Roman society. But in the fifteenth century the utopian image conjured up by the humanists played an important part in the continual debate about the artist's social position.

But what happened in reality? In some cases, particularly in Florence, it is possible to follow the process in some detail. In 1378 the painters of Florence had already been granted the privilege of forming an independent branch within the Doctors' and Apothecaries' Guild, to which they belonged. This privilege was granted because their work was "important for the state."[24] Giotto, a painter, was made superintendent of all artistic work connected with the Cathedral of Florence. Yet such developments, remarkable in themselves, did not amount to

setting the artists free from the bonds of the medieval guild system (as, e.g., the poets were). An open clash between the artists' aspirations and organizational patterns of the medieval craftsmen's system was therefore unavoidable. Perhaps the best-known instance of such a clash was Brunelleschi's refusal to pay his dues to the Arte de Maestri di Pietra e Legnami, the guild to which all building workers belonged. Upon request of the guild he was duly thrown into prison on August 20, 1434, and was freed only eleven days later upon intervention of the Cathedral authorities;[25] he was at the time executing his unique work for the dome of the Cathedral of Florence. But Brunelleschi's outspoken demonstration of personal independence and protest against inherited social fetters did not change the artists' situation overnight. It was only in 1571 that, in Florence, the claim of the guild to control the artists' work and behavior was officially abandoned, though it had practically ceased to be felt generations earlier.[26]

One of the most explicit expressions of the slowly changing positions of the artist in society are the biographies, and later the autobiographies, of painters and sculptors. We have seen that Boccaccio devoted a story to a painter, Giotto, in his *Decameron,* and described his behavior and even physical appearance. By 1400 the painters' prestige had grown sufficiently to cause some of them to be included among the citizens of which a city could be proud. Filippo Villani, an early chronicler of Florence, reckons some painters among the dignified Florentines who are honored by having their life story recorded. In the middle of the fifteenth century a humanist living in Naples, Bartolomeo Fazio, composed a collection of the life stories of famous men (*De viris illustribus,* 1457), and together with the biographies of princes and military heroes, he also told the stories of some painters. To Bartolomeo Fazio we owe the first biography of Jan van Eyck, "the foremost painter of our time."[27]

But, in spite of such gradual advances in the artist's social and legal position, the opinions held by the common folk changed only very slowly. If we are to trust Vasari, near the end of the fifteenth century Michelangelo's father was still objecting to the profession chosen by his son, because he could not tell a *scultore* from a *scarpellino,* a sculptor from a stonemason. In another place Vasari tells of a fifteenth-century

painter who, "like most of the excellent artists of his time, also painted chests, while today everybody would be ashamed of it." Vasari, writing in the middle of the sixteenth century, could look back upon a dramatic development in the artist's position in society.

Another expression of the changes taking place, especially of artists' growing self-esteem, is formed in their autobiographies. Though these are few in number, they are significant testimonies. The earliest is probably found in Ghiberti's *Commentarii*.[28] In the second book of the *Commentarii,* surely the most important of the three making up the work, Ghiberti attempts to give a history of his artistic ancestors, as it were, to prepare the reader for his concluding account of his own works. Though a sculptor's autobiography, the first of its kind, manifestly a proud announcement of individual independence, we still perceive in Ghiberti's text the echo of workshop ideals. "I, O most excellent reader," Ghiberti asserts, "did not have to obey [a desire for] money, but gave myself to the study of art, which since my childhood I have always pursued with great zeal and devotion."

Was the portrait a means of manifesting, and buttressing, the artist's new position? It need hardly be said that the portrait as a pictorial genre arose out of conditions much broader in scope than the artist's aspirations and struggles for his position. But it is worth considering Zilsel's theory that with the emergence of portrait art the painter and the sculptor performed a task that was strikingly similar to that performed by the poets.[29] The poet bestowed fame and immortality upon the hero and ruler whom he eulogized, and now in a similar way the painter aggrandized, and preserved "for eternity," the image of the hero and ruler. As the poet derived his prestige from this function, could not the painter too derive his from portrayal? Leonardo counts among the virtues and values of painting the fact that the painter preserves images of famous men for posterity. In the sixteenth century, Pietro Aretino advises artists to portray only famous men, obviously in the belief that the prestige of those represented will be reflected on the painter. Francesco Bocchi, in 1571, explored in detail the social relationship between artists and the people whose portraits they produce: the higher placed the subject, the more elevated the artist's own position.[30]

2. THE ARTIST'S NATURE

What we have sketched so far of the Renaissance artist pertains to his struggle for social status and legal rights, for recognition in society. But the transformation of his status in society is only one side of the historical process we are trying to describe; the other side is the artist's image, as it crystallized in the culture of the period, and his self-perception. What kind of a figure was the artist? What did one think of his character, his habits, and his relation to his work?

In the process out of which the new image of the artist emerged, two consecutive periods can be discerned. For a certain relatively short period of time the two overlapped, and in the works or views of some artists and authors the characteristics of the earlier and the later stages seem to be fused. Yet, when looked at from a proper distance, they clearly emerge as being dominated by different trends and as focusing on different problems.

The first stage occupies most of the fifteenth century. It is the period in which the artist tried to justify his claim that painting is a science and that he therefore deserved the doctor's status and the honors that go with it. As we have seen, fifteenth-century artists were, in fact, busy studying some sorts of science and applying the results in their works. The native abilities and properties of character most highly valued at that time were diligent study, careful deliberation and rational balancing of compositional patterns, and the power of intellectual penetration. "Perfection of art," Alberti, the most important spokesman of this period, says, "will be found with diligence, application, and study." When he describes the process by which the painter creates a work of the most elevated and dramatic kind, an *istoria,* a tone of cool restraint prevails. "When we are about to paint an *istoria,*" we read near the end of *On Painting,* the artist should make careful drawings, and then he should call in his friends and ask them to give advice concerning the composition. Alberti emphasizes the need for deliberation and careful preparation. "We will endeavor to have every thing so well worked out beforehand, that there will be nothing in the picture whose collocation we do not know perfectly" (III. 61). In ac-

tually applying the paint the artist will combine "the necessary dili-
gence combined with speed," but Alberti warns the painter to avoid a
situation in which "eagerness to complete makes us rush the job" (III.
61). This process of slowly, deliberately figuring out the work leaves
no room for what later generations have understood by inspiration.
Inspiration, rapture, an urge to self-expression—these psychological
qualities do not enter the process of "constructing" a painting, as one
would erect a building. Nothing of Plato's *mania* survives here; the
painter is a rational "maker."

Other qualities, mainly of a social nature, are also valued, and artists
are urged to promote them. They are primarily intended to show that
painters and sculptors are gentlemen. Thus, Alberti requires that the
painter be "as learned as possible in the liberal arts." But he also
requires that the artist "should be a good man." Manners seem to
have been more important than character. Therefore, to quote Alberti
again, the artist "ought to acquire good habits—principally humanity
and affability." In other words, the artist's personal behavior should
conform to the norms of the class into which he wants to be accepted.
A specific "artistic behavior"—that cliché that has gained such wide
popularity in our day—is altogether absent.

Sometime around 1500 the image of the artist gradually began to
change. Obviously, no specific dates can be given for this process, but
as we read the sixteenth-century literature, especially in Italy, we can-
not help noticing that the emphasis on the artist's scientific compe-
tence and achievements diminishes; other qualities are stressed, quali-
ties that we would nowadays subsume under the general heading of
"creativity." One also hears less of the artist's good manners and social
grace; instead, there slowly emerges the outlines of a somewhat eccen-
tric figure, characterized mainly by its nature and temperament, which
in modern times has come to be typical of the artist. Together with
this gradual change of opinion, biographies of painters and sculptors
abound, reaching a climax in Vasari's famous work. Autobiographies of
artists also become more frequent, and in the late sixteenth century
the delightful autobiography of Benvenuto Cellini, a classic of its genre,
was written. The life stories of painters and sculptors now resembled

more closely the biographies of poets; the emphasis on workshop practices and routine reality was drastically reduced, and the biographies became portraits of personalities.

Perhaps the most striking expression of the new concept is the repeated protestation that one has to be born as an artist to be able to achieve eminence; training itself, even the most exquisite, will not do it. As the century progressed and the climate changed, we also hear less and less about artistic training in general. Leonardo, who did more than anybody else to firmly establish the image of the artist as a scientist, had already insisted that painting "cannot be taught to those not endowed by nature." Moreover, in a brief statement that almost reverses everything he had said before, Leonardo declared that painting is more sublime than the sciences because works of art are inimitable. In teaching mathematics, Leonardo somewhat optimistically asserts, "the disciple absorbs as much as the teacher reads to him," but painting "cannot be taught to those who are not naturally fitted for it" (no. 18). In sixteenth-century Venetian art literature, the critic Pietro Aretino, irascibly attacking the humanists who were weighing down literature and art with their erudition and learned norms of judgment, became a passionate champion of the inborn artistic genius. "Art," he said, "is the gift of bountiful nature, and it is given to us in the cradle." Another Venetian author, Lodovico Dolce—who dedicated to Pietro Aretino a rhymed translation of Horace's *Ars poetica*—in 1557 composed a treatise on painting that he called the *Aretino*. In his treatise he strongly advocated the same idea. "The painter is born that way," he says, and approvingly quotes Ariosto:

> Poets are rare, and painters prove the same—
> Painters who really deserve this name.[31]

Of Titian he says later in the same work that nature itself made him into a painter.[32] Propelled by nature, he therefore could not follow "that arid and labored line" of his teacher. Here a motif is suggested that is hardly conceivable a century earlier: an artist's individuality clashing with the accepted technical procedures of the workshops. The idea of the born artist continued to occupy a central place in aesthetic thought. In 1590 Giovanni Paolo Lomazzo, in a work that shall occupy

our attention later on, said that those who are not born painters can never achieve excellence in this art, that is, "if they are not blessed with creative gifts and the concepts of art from the cradle." [33]

Reading these statements, which could easily be increased in number, one wonders what artists and authors of the fifteenth century thought. Surely at the time of Alberti and Piero della Francesca no one believed that just anyone, given the proper training, would be able to create the great works of art of which the period was so proud. Yet, when writing about art, the artist's inborn gifts are not mentioned. Between the fifteenth and the sixteenth century the image of what an artist is and needs changed radically.

Sixteenth-century painters and sculptors, writers and readers, attracted by the new image of the artist, quickly focused their attention on two questions: What is the artist's nature? What is the fountainhead of his creative powers? Fifteenth-century art theory, so completely centered on different problems, could not provide the new generations with the conceptual frame of reference for exploring these unknown fields; a guide had to be found in other traditions of thought.

One of the major approaches to an exploration of the artist's nature, and the first explanation of his personality, was the theory of the melancholic temperament. The concept of "melancholy," as we know from several excellent investigations, goes back to Greek science and medicine. [34] The Greeks classified the infinite variety of human characters into four major classes or types, which they called the temperaments. The four temperaments—sanguine, choleric, phlegmatic, and melancholic—are explained by the mixture of the four humors, or fluid substances in the body. Based on a philosophy that conceived of man as a psychophysic creature, they believed that the predominance of one of the fluids gave rise to a type of character. The melancholic is a person in whom black bile prevails; the choleric is one in which yellow bile is preponderant; the sanguine has a domination of blood; the phlegmatic, of phlegm. Early in history the temperaments were also linked to certain abilities and gifts, so that the theory of temperaments also became an occupational pathology.

In ancient Greece melancholy was of an ambiguous nature; if the black bile, the preponderance of which produces melancholy, was not

properly tempered, the melancholic would suffer from different forms
of insanity, but if that fluid was properly tempered it would create a
predisposition to genius. Aristotle seems to have been the first to pos-
tulate a connection between the melancholic humor and outstanding
talent in the arts and sciences. His famous *Problemata* (XXX. 1) begins
with the question: "Why is it that all those who have become eminent
in philosophy or politics or poetry or the arts are clearly melancholics,
and some of them to such an extent as to be affected by the diseases
caused by black bile?" He then goes on to explore the interrelationship
between melancholy and genius. The Aristotelian concept was never
completely forgotten, but in the Middle Ages it was largely repressed.
In fifteenth-century Florence it was revived and became a major intel-
lectual force. Marsilio Ficino, the founder of the Florentine Platonic
Academy, emphasized these "divine gifts" of the melancholic, though
he never forgot the dangers; he combined the intellectual and artistic
gifts of the melancholic with the Platonic concept of divine *mania*. To
many Renaissance thinkers the conclusion seemed inescapable: only the
melancholic could experience Plato's creative enthusiasm.

In the Middle Ages a close and fundamental connection was believed
to exist between the temperaments and the planets. This theory, per-
haps formulated for the first time by an Arab writer of the ninth
century, Abu-Masar, assumed that the sanguine temperament "be-
longed" to Jupiter; the choleric, to Mars; and the phlegmatic, to Ve-
nus. The melancholic was born under the sign of Saturn, and to Saturn
were attributed all the ambivalences of the melancholic temperament;
Saturn is the sinister and brooding figure among the mythologized
stars. Ficino claimed that all men of genius, who are necessarily melan-
cholics, are children of Saturn. In his work propounding this theory,
De vita triplici, written between 1482 and 1489, he discussed only the
temperaments and achievements of scholars and poets, but even with-
out intending to he provided a conceptual pattern for investigating the
character of painters and sculptors as well.

After about 1500, when a veritable vogue of admiration for melan-
choly and the melancholic swept the centers of educated Europe, it
was indeed fashionable to characterize painters and sculptors, as well
as poets and philosophers, as "melancholics" or as born under Saturn.

It also became common practice to discover in artists those inclinations and qualities of character and behavior that were usually associated with melancholy—sensitivity, gloominess, seclusion, and eccentricity. Melanchthon, the erudite theologian of the Lutheran Reformation, pictured Albrecht Dürer as a *melancholicus.* The learned ambassador of Ferrara to Rome described Raphael (while the artist was still alive) as "inclined to melancholy like all men of such exceptional genius." The sixteenth-century Venetian painter and author of an art-theoretical treatise, Paolo Pino, pays tribute to the general vogue of melancholism (if I may call it that) by giving artists well-meant advice as to how to overcome the depressed moods necessarily linked to the temperament of outstanding people. That a sixteenth-century scholar, the Spanish precursor of modern psychology, Luis Vives, expresses doubt as to whether one can really know a psychic problem ("There is nothing more recondite, obscure, and unknown to all than the human mind," he said in words that are as true today as they were four centuries ago) does, of course, not indicate a lessening in influence of the belief in the qualities of the saturnine temperament; Vives never questioned these specifically.[35] In Vasari's great work the artist's melancholy nature is, of course, a commonplace. Even artists who are today almost forgotten are characterized as melancholics. The giant figure of the melancholic who cast his shadow on the aesthetic thought of the whole sixteenth century is, of course, Michelangelo, to whom we shall shortly return. In the late sixteenth century, Romano Alberti, who later became the first secretary of the Academia di San Luca in Rome, the first full-fledged academy of art, even tried to find a modern psychological reason for artistic melancholy: since painters and sculptors have to "retain visions fixed in their mind," they necessarily become "detached from reality" (today we would probably use the term "introvert"); their being detached from the world turns them into melancholics, but melancholics, Romano Alberti assures us, comprise "almost all gifted and sagacious persons."[36]

We can say, then, that artists belong to a certain temperamental type. But the saturnine type encompasses a much broader group than painters and sculptors; as we know, philosophers, poets, and other men of genius were also believed to be melancholics. On the other hand,

Renaissance scholars did not believe that the melancholic temperament works automatically. They would only admit that the fact of belonging to the saturnine temperament creates an *inclination* toward art (or the other occupations demanding excellence). To say of somebody that he is a melancholic can mean only that he has the *predisposition* to be an artist (or poet or philosopher), not that he *is* one. What, then, makes somebody so inclined and predisposed into an actual artist?

3. THE GIFT OF CREATIVITY

The Renaissance did not have a term for creativity, but this is what the authors of the period had in mind when they attempted to answer our question. To put it in a very simple way: what turns a melancholic into a painter is his ability to produce a work of art that has not existed before. In the fifteenth and early sixteenth centuries, even the most advanced thinkers and artists shrank from saying of anything man-made that it had been "created." The powerful impact of medieval beliefs that "a creature cannot create" (to use St. Augustine's words)[37] could not easily be overcome. In the second chapter of this book we saw that Thomas Aquinas specifically emphasized that what an artist produces is only a "quasi-creation";[38] what seems to us a creation is, in fact, no more than a change in the ephemeral form in which a piece of matter is cast. The inherited idea that only God can create was very much alive during the early Renaissance. As Panofsky has shown,[39] even Leonardo—as independent as was possible in his time from medieval theological concepts—avoided the term *creare* when speaking of the artist, even though he designated the painter as "master and god" of a world of images, friendly or frightful, which he shapes in his work. But, as we have said before, this avoidance of the term should not mislead us; in the High Renaissance and the late Renaissance people had a rather clear concept of the idea of artistic creation.

It was a concept that began to emerge only around 1500. The fifteenth century was familiar with the notion of *invenzione* (invention) that, to modern ears, may have a similar ring to "creation." But what was then meant by *invenzione* is very different from what is now meant by "creating." By *invenzione* one did not mean inventing something that

did not exist before, a *creatio ex nihilo,* to remind us of the medieval definition of "true" creation. Fifteenth-century authors understood by *invenzione* mainly the subject matter of a work of art; this subject matter had to be found or, rather, selected from the body of inherited literary and historical themes. *Invenzione* may also mean—and this is stretching the concept as much as possible—the novelty and inventiveness of details, or even of entire allegorical figures who, in the manner accepted at the time, would make the meaning of the theme more intelligible.[40] But this, of course, is not identical with the medieval or modern meaning of "creation," namely, to originate the work, to make it come into being out of nothing. Leone Battista Alberti introduced the notion of *invenzione* into art theory, and it is worth remembering that he does not speak of it with reference to art in general but only with reference to a particular type of picture—the *istoria,* the depiction of heroic and elevated subject matter. "Invention is such," he says, "that even by itself and without pictorial representation it can give pleasure" (III. 53). What could better illustrate the distance between Alberti's *invenzione* and the modern concept of creation than his confounding the work of art with its theme? Of course, nobody has seen the telling example Alberti adduces, the legendary painting, *The Calumny,* by Apelles (depicting the conviction and punishment of an innocent victim belatedly vindicated by Repentance and Truth). Alberti knew it from Lucian's literary description (see *On Painting* III. 53), translated from the Greek shortly before he wrote *On Painting.* What Alberti seems to have regarded as the main "invention" were the allegorical figures in the picture, perhaps particularly the figure of "a young girl, shamefaced and bashful, named Truth." If such is the meaning of "invention," one is not surprised that in this very context Alberti advises the painter to "associate with poets and orators" (III. 53).

Two generations after Alberti the perspective changed. In acquainting ourselves with the new ideas, let us begin with Dürer. The great German painter and draftsman was a fervent missionary of the (Italian) gospel that painting is a science and that a picture must be "correct." As we have seen, he himself made original contributions to anatomic measurements and constructions and to the practical employment of

the perspective system; moreover, he explicitly rejected any "invented measure" (or proportion) *(erdichtete Mass)*. Yet the same Dürer was also aware of an altogether immeasurable "marvelous gift" of the painter of "Making something in his heart" that had never been seen by anybody, and that had never been in anybody's mind before. It seems to him "strange" that "a man may sketch something with his pen on half a sheet of paper, or cut it into a tiny piece of wood with his little iron, and it turns out to be better and more artistic than another's big work at which he has labored for a whole year."[41] Artistic quality is, then, independent of size and of the time spent in preparing a work of art. The subject matter, too, seems to become less decisive than used to be thought. "Strange" or "unusual" indeed it must have appeared to artists or writers, after the century-long indoctrination with the belief that there is only one "true" manner of representation and that the value of a work of art is determined by its "correctness" and its beauty—both equally measurable—to come to the perplexing conclusion at which Dürer arrived in the first quarter of the sixteenth century: "For it is a great art that in crude, rustic things can show real power of art . . . and this gift is wondrous. For often God gives to one man the intellectual power *[Verstand]* to make something good, the equal of whom will not be found in his time; and perhaps long before him there has been none and after him another will not come soon."[42]

The creative nature of the artist is underscored by comparing him to the principal creator, God. Since the early or mid-sixteenth century, painters and sculptors are with increasing frequency called divine. In the Middle Ages the adjective *divus* was, of course, strictly reserved for saints. But the urban, secular society of the Renaissance in Italy, as Burckhardt has clearly shown, did not particularly hesitate to employ this hallowed term for rulers or celebrities of the day. The term also entered the eulogies of poets. Thus, Boccaccio asserts that Dante, were it not for his enemies, would have been a "god on earth."[43] What Boccaccio probably meant was that Dante would have been recognized and universally venerated, but he does not make any specific references to the poet's ability to create. The term "divine," slowly losing its

purely religious connotation, could even be used to characterize paint-
ing. Alberti opens his epistle to Brunelleschi, which serves as a pro-
logue to his book *On Painting,* with the words (not always correctly
translated): "I used to marvel and at the same time to grieve that so
many excellent and divine arts and sciences . . ." (*che tante optime et
divine arti e scientie . . .* in the Italian). Later in the treatise (in the
second book) he describes how the artist seeing the public adoring his
works "will feel himself considered another god" *(un altro Iddio).* Does
this mean that the artist will feel adored, revered like a supreme being,
or do we here have a (perhaps veiled) reference to the artist's power
to create? However that may be, in the fifteenth century the designa-
tion "divine" was not yet conferred upon an individual artist, living or
dead.

However, this is exactly what happened in the early and mid-six-
teenth century. Even in this period the precise meaning of the term is
not always obvious. It can express general, exalted praise, some kind
of exclamation of admiration that, though based on the artist's work,
is not necessarily restricted to it. But, more often than not, it specifi-
cally refers to the artist's power to produce—or, as we would say
today, largely in the wake of the ideas expressed in the literature here
considered—to create.

Pietro Aretino, the Venetian critic whom we have already men-
tioned, addresses a letter to the "divine Michelangelo," assuring him
that he is a "divine person," not, however, without specifically refer-
ring to the artist's "superhuman pencil."[44] In a letter to Titian the
same Aretino speaks of the painter's "superhuman brush."[45] (One should
mention in passing that there are few details that could show more
clearly the intellectual distance between the Middle Ages and the six-
teenth century than the attribution of a "superhuman" nature to an
object that is normally a craftsman's regular tool—like a brush or a
pencil.) Paolo Pino, in his *Dialogue on Painting* (1548), calls Titian and
Michelangelo "mortal gods."[46] Were it possible to unite them, Pino
says, one would have the "god of painting," which can here mean
nothing but the creator of the perfect work. A few years later Lodov-
ico Dolce published his *Dialogue on Painting,* called the *Aretino* (1557),

which certainly is the most important Venetian treatise on the subject. In the very long title of this book Dolce speaks of "the virtue and the works of the divine Titian."

The climax of the literary vogue of comparing the artist with God is reached in Vasari's great work (first edition, 1550; second, revised edition, 1568), to which we shall shortly revert. Vasari uses the adjective "divine" extensively; he obviously no longer hesitates to avail himself of this comparison, which a century earlier would have sounded so blasphemous. By it he expresses his general admiration for the artist's marvelous nature (in a very broad sense) and, more specifically, denotes the painter's and sculptor's creative ability. Thus, Leonardo has a "divine and wonderful" intellect that enables him to depict a pasture "so naturally and carefully" that even a divine *ingegno* could not make it better. Raphael is a "mortal god" because of his many fits, among them his graceful *umanità* (humanness). But the comparison of the artist with God also had a more specific meaning, referring mainly to the work of art. A *cartone* by Michelangelo is a "more divine than human thing," and his *Moses* is "not a human, but a divine thing" *(cosa)*.

III. MICHELANGELO

Sixteenth-century ideas concerning "the artist"—the sense of his uniqueness, his melancholic temperament, and his innate creative powers—found perfect embodiment in the image of one particular artist, Michelangelo. What may be called the Michelangelo myth was reflected, in turn, in the theory of art and was of consequence to many of its later developments.

Michelangelo indeed holds a unique position in Renaissance culture. No other artist made an impact, on art and thought alike, comparable to his. During his lifetime, Vasari says, Michelangelo enjoyed a *gloria* that others hardly achieve after their death. Even if we disregard his impact on art itself and concentrate only on sixteenth-century aesthetic thought, we cannot help being constantly confronted with his overwhelming influence. His poems, and what were by different writers considered to be his views on art, were frequently quoted, and they

often served to buttress whatever argument a specific author wanted to reinforce by recourse to an established authority. But did Michelangelo have a theory of art? Modern scholarship is divided on this issue. Some scholars suppose that Michelangelo's writings on art, in spite of their fragmentary formulation, are sufficiently coherent to permit us to speak of a theory, even though that theory becomes visible only in very general outlines. Other scholars maintain that what we assume to be the outlines of Michelangelo's theory are actually commonplaces in sixteenth-century intellectual life, devoid of the imprint of his unique personality and incapable of explaining his art.[47] We do not presume here to suggest a solution to this problem. But, whatever opinion one holds on this specific question, one cannot understand the art theory of the High or the late Renaissance without taking Michelangelo's thought into account. Whether he was original or not, one cannot get around him.

Whatever we can claim to know of Michelangelo's views on art is derived from three different groups of sources. The first consists of his sonnets. These are not always concerned with art, and they are neither detached nor systematic enough to fit the notion of a theory. But they suggestively reveal Michelangelo's intellectual and emotional world. (His letters do not yield much of interest; they deal with simple business and with matters of daily routine.) A second group of sources are his biographies, written by his friends, mainly during his life. Vasari's *vita* of Michelangelo appeared in the first edition of the *Vite* (1550), and in a much-amplified version in the second edition (1568), only a few years after the master's death in 1564. Another biography, written by Michelangelo's pupil, Ascanio Condivi (1555),[48] is said to have been dictated, to a considerable degree, by the master himself. Both biographies contain a good number of thoughts and theoretical reflections. We will probably never be able to distinguish sharply between what is really Michelangelo's own thought in them and the various authors' opinions attributed to the great artist. Moreover, the theoretical observations included in these biographies are not presented in any systematic fashion, and in this respect, too, they are not a theory. The third source, finally, is a treatise in dialogue form by the Portuguese painter Francisco de Hollanda, *Tractato di pintura antigua* (1548), in which Mi-

chelangelo is the principal interlocutor. Francisco de Hollanda would have the reader believe that he recorded genuine discussions with Michelangelo and that in these talks the great artist systematically expounded a coherent theory. If accepted, Hollanda's work would be the major source for Michelangelo's concepts of art. Unfortunately, most modern scholars have doubted the authenticity of Hollanda's records, and some have suggested that the *Tractato* is a typical Renaissance product, in which a famous figure is made to endorse the author's views. Even if a few scholars accept Hollanda as a reliable source, the prevailing opinion prevents us from basing our report on his treatise. There may be other sources, only indirectly related to Michelangelo. Among them, following Schlosser and other scholars, we should perhaps reckon a lengthy treatise by Vincenzio Danti (1530–1576), a Perugian sculptor, who was a follower, though not a pupil, of Michelangelo. Danti's *Il primo libro delle perfette proporzioni* (Florence, 1567)[49] was the first of fifteen books that he planned but the only one he completed. Danti purports to express, and probably indeed reflects, some of Michelangelo's ideas, though only in a general way. Obviously, Danti's text, though suggestive of Michelangelo's concepts, cannot be considered an authentic source. Under these circumstances, one asks, can we speak of Michelangelo's art theory? Did he have a theory at all?

What precisely Michelangelo thought about art is arguable (particularly since most of our sources are open to doubt), but the fact that he believed in the need of a theory, in the broadest sense of the term, cannot be doubted. Condivi, whom modern scholars usually consider the most reliable witness, tells us that Michelangelo intended to write an "ingenious theory based on his long experience." Condivi admits that he cannot define the scope of that theory. But "I know," he says, "that Michelangelo, when he read Dürer, found him very weak." That Michelangelo should have read Dürer is in itself an indication of how seriously he took art theory. But what could it have been that so disappointed him in Dürer's work? Condivi has some suggestions. Dürer, he believes, was concerned mainly with "the measures and variations of bodies, according to age and sex," but "of what is most important, of human action and movement, he says nothing."[50] We may infer,

then, that what attracted Michelangelo most was what he called "human action and movement," not necessarily something that is self-evident.

Michelangelo was, of course, affected by the traditions in which he grew up. He was concerned with perspective, as is attested by Condivi and Vasari. He practiced anatomical studies in the traditional manner accepted in his time; in his youth he is said to have dissected bodies. Even around 1550 (when Michelangelo was about seventy-five years old) his friend, the surgeon Realdo Colombo, sent him the beautiful corpse of a Negro, and in this corpse the master showed Condivi some "rare and hidden things." But, though he was rooted in tradition, "correctness"—whether of space or of anatomical structure—did not have to him the almost mythical meaning it had for Alberti and Leonardo. All our sources agree that Michelangelo was not primarily interested either in scientific proof or in creating a convincing illusion of a particular piece of reality. He made only a few portraits, and those were notoriously free from strict likeness to the sitter; and according to Francisco de Hollanda his scorn for the Flemish painters was based on their sticking to external exactness.[51] Even if we make allowance for Hollanda's personal interests, which are expressed here, what he says accords with what we know from other sources to be Michelangelo's views. But, if the traditional ideals of art theory were only of marginal value, what were the centers of Michelangelo's interests in the intellectual comprehension of art?

In Michelangelo's long life (1475–1564), creative from youth until his last days, intellectual contemplation also began early and lasted long. The building blocks of his art theory—his poems and his talks as recorded by his pupils and friends—cover a span of over two generations, and these were generations of great social and religious upheaval, of profound and dramatic changes in the intellectual and emotional climate. Michelangelo's thought could not fail to be shaped, at least to some extent, by the powerful trends that dominated minds in his time. We are not surprised, then, to see that the topics central to Michelangelo's thought also changed in the course of time. Although naturally no precise dates can be given, it would seem that up to around 1530—that is, roughly corresponding to what is called the

High Renaissance—there was one question around which Michelangelo's thought revolved, other themes becoming predominant later.

Beauty was the great theme of Michelangelo's thought in that first period. Condivi tells us that the artist "loved not only human beauty but universally every beautiful thing," and Michelangelo, in his many poems praising the power of beauty, also specifically relates it to the arts.

> As a trustworthy guide in my vocation,
> When I was born I had a gift of beauty,
> In both the arts my lantern and my mirror. (162)

"Beauty" is, of course, a household word in Renaissance theory of art. We remember that in Alberti's treatise *On Painting* it is beauty that endows the work of art with lasting value. There are, however, profound differences between the concept of beauty traditional in fifteenth-century art theory and Michelangelo's understanding of it. For Alberti, as we have seen, beauty is conceived as harmony, as a balanced system of clearly outlined, proportionate shapes. In Alberti's own words, it is "a kind of concord and mutual interplay of the parts of a thing" *(De re aedificatoria* IX. 5). In talking of beauty, Alberti actually employs the concepts and terms customary in the expositions of mathematical symmetry. Beauty, he says, is a "concord . . . realized in a particular number, proportion, and arrangement demanded by harmony."

Michelangelo's conception of beauty is altogether different. Beauty is not a measurable system, the parts and internal relationships of which we can mathematically analyze. It is the immeasurable splendor of a supernatural perfection. Beauty is the reflection of the Good (to speak in Platonian terms) or of the Divine (to use the Christian medieval formulation).

> He who made everything made every part,
> And then from everything He chose the fairest,
> To let us here look at His very greatest,
> And now has done so with His sacred art. (9)

The effect of beauty on the spectator is different both from what the fifteenth century assumed it to be and from what is accepted in

modern thought. Aestheticians nowadays say that the perception of beauty—often called the aesthetic experience—is a quiet contemplation, leaving the spectator without any desire to go beyond the experience he is having. In Michelangelo's view beauty has the opposite effect: experiencing beauty makes one long for the ultimate origin; it awakens our desire to go beyond the experience itself. This is a motif that constantly recurs in Michelangelo's sonnets. It will be sufficient to quote from just one:

> While toward the beauty that I saw at first
> I bring my soul, which sees it through my eyes,
> The inward image grows, and this withdraws,
> Almost abject, and wholly in disgrace. (42)

In the late fifteenth century these views were current in the Platonic Academy in Florence. As is well known, the Platonic Academy, and the trends of thought articulated there, powerfully affected Michelangelo's spiritual and emotional world. Even a casual glance at one of the central works of the Platonic Academy, Ficino's *Symposium* [52] (the Renaissance paraphrase and interpretation of Plato's *Symposium*), will show the tribute Michelangelo paid to it by emulating its ideas, and frequently even its literary formulations. Ficino often defines "beauty" as something spiritual that transcends sensual experience and that makes us long for the origin of what we perceive. Beauty, he says, "consists of a certain charm" (I. 3); it is a "radiation of the divine Light" (II. 7); and among our senses the eye alone is capable of grasping it (II. 9). The essence of beauty, Ficino never tires of emphasizing, does not consist of anything pertaining to the body; beauty may reside in bodies and may shine forth in them, but in itself it is bodiless (V. 3). There is a descending hierarchy of beauties; from the absolute beauty of God, through the beauty of the angels, to the beauty of the soul, and finally ending with the beauty of the body. The more we ascend, the more beauty is without form; the closer to earth, the richer in shapes beauty becomes. "Do you wish to behold the beauty of God?" Ficino asks somewhat rhetorically. "Then suspend the variety of shapes, confine the form to absolute simplicity, and forthwith God's image will be present to you" (VI. 17). But, withdrawing from the "multitude of

forms," as Ficino knows, leaves us with nothing to hold on to; what is left after we have divested ourselves of the variety of specific forms is a mystical experience of shapelessness, surely nothing an artist can use in his work. It may be of some importance to remember that Neoplatonism, in spite of its profound influence on Renaissance art, did not provide a theory of art that could be employed by the artist.[53]

As we know, Michelangelo was deeply influenced by Neoplatonism, especially in his theory of beauty. In the beauty of the work of art, as well as in that of the human face, he sees a stimulus to go beyond sensual shapes and form of actual experience. Whatever beauty we perceive awakens the desire to strive for the source. Michelangelo wrote in 1526:

> Nor can I now behold in mortal things
> Thy light eternal without strong desire. (149)

Love, the desire to find the shapeless origin of all shapes—this is the essence of beauty. Such spirituality is, of course, in sharp contrast to Alberti's *bellezza*.

But where does the visual image of beauty, especially as embodied in the work of art, come from? In attempting to answer this question, the difference between fifteenth-century art theory and Michelangelo's becomes almost tangible. The early Rennaissance believed that beautiful form comes from nature. Certainly, nature does not present them handily; the artist must pick them out from a bewildering variety of shapes that are all less than perfect. Looking back on fifteenth-century thought from the vantage point of the High and the late Renaissance, one cannot help asking: What is it that enables the artist to distinguish the perfect from the defective, the refined from the crude? Fifteenth-century artists and humanists were not fully aware of these questions. True, it was vaguely assumed that the artist was carrying some kind of "idea" in his mind. But the precise status and function of this idea, and its relation to what the artist observed in nature, was never fully explored; it was not even clearly presented as a problem demanding investigation. Alberti's warning to artists not to waste their time and effort by attempting to draw from their own resources alone, without having recourse to the study of nature, culminates in the memorable

sentence: "The idea of beauty, which the most expert have difficulty in discerning, eludes the ignorant" (III. 56). This sentence has rightly been considered a summing-up of early Renaissance thought on what is now called the creative artist. But, even after having carefully read that sentence, one still does not know how "the idea of beauty" is related to "experience." Does the "idea" lie dormant in the artist's mind and "experience" only awakens it? Or does experience teach the artist, infuse the idea in his mind? There is no answer to these questions in Alberti's writings, nor in those of his immediate followers. In other words, the art theory of the fifteenth century did not really inquire into the origin of the work of art. The artist's creativity was not a central, not even an articulate, problem.

Whether one attributes to Michelangelo a full-fledged theory or not, the question of where the work of art originates is to him both articulate and central. The notion pervading Michelangelo's thought—as expressed in poems or in other forms—is that the image in the artist's mind is the ultimate origin of the work of art, that from this image flows the form the artist impresses upon the raw material, colors or stones, of which the work of art consists. When Michelangelo says, in the poem already quoted,

> The best artist never has a concept
> a Single marble block does not contain
> Inside its husk (149)

he is, in fact, defining the "concept" dwelling in the artist's mind as the fountainhead of the shapes into which the marble slab will eventually be carved. In another poem, written somewhat later (ca. 1544–1547), and interesting also for the information it provides about the master's technical procedures, Michelangelo outlines the stages of the creative process. It begins with the artist having in his mind a *concetto* of the form and posture of a human figure. The next step ("the first born" of this conception, as Michelangelo says in a remarkable combination of biblical imagery and workshop terms) is a "simple clay model." Only at the end comes the work in the "rugged live stone" in which the statue is then completed.

The image in the artist's mind—that image that serves as a model

for his work—Michelangelo usually refers to as *concetto*. Even the smith, he says in one of his poems, shapes his beautiful handiwork according to a *buon concetto*. Now, *concetto* is an almost perfect synonym for "idea." In fact, Benedetto Varchi, the Florentine humanist, acknowledged the identity of the two terms. He wrote an extensive commentary on the sonnet by Michelangelo, which we have already quoted several times ("The best artist never has a concept. A single marble block does not contain inside its husk."), that was explicitly approved by Michelangelo himself. In this commentary Varchi maintains that "our poet's *concetto* denotes that which . . . is called in Greek *idea*, in Latin *examplar* and known to us as 'model': that is, that the form or image . . . that we have within our imagination, of everything that we intend to will or to make or to say; which [form or image], although spiritual, . . . is for that reason the efficient cause of everything that can be said or made." Panofsky, in the last chapter of his masterly study, *Idea*, has shown that Michelangelo's use of the term *concetto* instead of "idea" (which would perhaps more readily come to mind) is not just a matter of chance or personal idiosyncrasy.[54] Precisely because Michelangelo is familiar with Platonic thought he avoids using the term "Idea," which would be the authentic Platonic term. "Idea," in its genuine Platonic sense, suggests the unbridgeable gap between the "Idea," and any attempt to realize it in matter. The term *concetto,* borrowed from the Aristotelian tradition, carries the connotation of a transition from the image in the soul to the work in stone or color.

What interests us in this piece of terminological selection is not so much the artist's acquaintance with trends of thought as his emphasizing that artistic creation is feasible. Deeply imbued with Platonic thought as he was, he diverged from Platonism at the point where the great philosophical school seemed to make popular artistic creation—that is, an adequate transition from the picture in the imagination to the picture on the wall—impossible.

The concept of *concetto* may indicate still another difference between Florentine Neoplatonism and Michelangelo. Some modern authors—perhaps influenced by Neoplatonic thought—have interpreted Michelangelo's complaints, particularly frequent in his old age, about the futility of art, to mean that the actual work, shaped in concrete material,

will always remain pale compared with the artist's mental image. This romantic interpretation, however, has little support in what Michelangelo himself said. It is true that Plotinus—and his Renaissance interpreter, Ficino—believed that the statue the artist carves in stone is always inferior to the idea in his mind. But this dichotomy is not typical of Michelangelo's thought. Late in his life, under the powerful impact of the religious and ascetic moods of the Counter-Reformation, Michelangelo spoke of the vanity of all art. In a poem written in 1555 he confesses his sorrow and remorse for having "let the vanities of the world" rob him of the time "for the contemplation of God." Even at this late period, however, when he questions the value of art in general, he does not suggest that the work of art is inadequate to the *image* in the artist's mind. In his historical image and in his thought Michelangelo embodies the idea of the creative artist.

NOTES

1. See above, pp. 112 ff.
2. See Lucian, *Somnium*, 7 ff. For Dio Chrysostomus and Philostratus, see above Chap. I, pp. 26 ff., 31 ff.
3. For this much-discussed topic and its impact on Renaissance theory of art cf. R. Lee, *Ut pictura poesis: The Humanistic Theory of Painting* (New York, 1967) (originally an article in *Art Bulletin,* 1940).
4. *Poetics* 1450a. 14 ff. See S. H. Butcher, *Aristotle's Theory of Poetry and Fine Arts* (New York, 1951), pp. 27 ff.
5. Cennino Cennini, *The Crafsman's Handbook: Il Libro dell'arte,* trans. D. V. Thompson (New York, 1933), chap. 1, p. 1. The figures in parentheses refer to the chapters of *The Craftman's Handbook.*
6. M. Roskill, *Dolce's "Aretino" and Venetian Art Theory of the Cinquecento* (New York, 1968), p. 89. For the art theory in Venice and Lombardy see the next chapter.
7. The numbers in parentheses refer to Leonardo da Vinci, *Treatise on Painting,* ed. and trans. P. McMahon (Princeton, 1956). The numbers are those of paragraphs.
8. Roman and arabic numerals in parentheses following quotations from Alberti refer to book and numbers, respectively, paragraph, in Leone Battista Alberti, *On Painting and Sculpture,* edited, with Introduction, translations, and notes, by C. Grayson (London, 1972). References to Alberti's work on architecture are similarly numbered according to book (roman numeral) and chapter (arabic numeral).
9. K. Borinski, *Die Antike in Poetik und Kunsttheorie* (Leipzig, 1914), I, pp. 169 ff.

10. Ficino translated some of Dionysius Areopagita's writings and wrote a commentary on them. For the general background, and the diffusion of such ideas in the Platonic Academy of Florence, see A. Chastel, *Marsile Ficin et l'art* (Geneva and Lille, 1954).

11. For the full text of Michelangelo's letter in an English translation see E. Holt, ed., *A Documentary History of Art* (Garden City, N.Y., II, 1958), pp. 15 ff. For the original version see P. Barocchi, ed., *Trattati d'arte del Cinquecento* (Bari, 1959), I, p. 82.

12. E. Panofsky, *Studies in Iconology: Humanistic Themes in the Art of the Renaissance* (New York, 1939), pp. 178 ff.

13. Numbers in parentheses after quotations from Michelangelo's poems refer to the numbers of the poem in *Michelangelo: Complete Poems and Selected Letters*, trans. Creighton Gilbert (New York, 1963).

14. *The Writings of Albrecht Dürer*, trans. and ed. W. M. Conway (New York, 1958), 247. I have slightly changed Conway's translation.

15. Ibid. p. 177.

16. For the *paragone* literature in the early Renaissance see above, pp. 112 ff. In addition to the studies mentioned there cf. also A. Blunt, *Artistic Theory in Italy 1450–1600* (Oxford, 1940), pp. 50 ff.; L. Mendelsohn, *Paragoni: Benedetto Varchi's "Due Lezzioni" and Cinquecento Art Theory* (Ann Arbor, Mich., 1982); and B. Cohen, *"Paragone:* Sculpture versus Painting, Kaineus and the Kleophrades Painter," *Ancient Greek Art and Iconography,* ed. W. Moon (Madison, Wis., 1983), pp. 171–192.

17. For an English translation of this letter see Holt, ed., *A Documentary History of Art,* II, pp. 35 ff. For the original text see Barocchi, *Trattati d'arte,* I, pp. 80–81.

18. F. T. Vischer, *Aesthetik oder die Wissenschaft des Schönen,* 3 vols. (Reutlingen and Leipzig, 1846–1857). The passage quoted is in vol. IIIa, pp. 447 ff.

19. E. R. Curtius, *European Literature and the Latin Middle Ages* (New York, 1953), pp. 559–570.

20. Cf. Raffaello Borghini, *Il Riposo* (Florence, 1584; reprint Olms, 1969), pp. 456 ff.; for Galilei see E. Panofsky, *Galilei as a Critic of the Arts* (The Hague, 1954); G. F. W. Hegel, *Vorlesungen über die Aesthetik* (*Werke,* ed. 1832–1887, vols. XI, XII), pt. III, sec. 22; Vischer, *Aesthetik,* nos. 538 ff. (vol. IIIa, pp. 151 ff.).

21. Important collection of material is found in E. Zilsel, *Die Entstehung des Geniebegriffs* (Leipzig, 1926), pp. 144 ff. For the requirements for a "masterpiece" see W. Cahn, *Masterpieces, Chapters on the History of an Idea* (Princeton, 1979), chap. 1, and see in general R. and M. Wittkower, *Born under Saturn* (New York, 1963).

22. Zilsel, *Entstehung des Geniebegriffs,* pp. 111 ff., 123 ff.

23. Ibid., pp. 146 ff.

24. See A. Doren, *Entwicklung und Organisation der florentiner Zünfte* (Leipzig, 1897), pp. 51 ff. See also M. Meiss, *Painting in Florence and Siena after the Black Death* (Princeton, 1951), pp. 63 ff.

25. For this frequently discussed cause célèbre see R. and M. Wittkower, *Born under Saturn,* pp. 9 ff.

26. Ibid., p. 11.
27. For Villani see J. von Schlosser, *Präludien* (Berlin, 1927), pp. 261 f. For Bartolomeo Fazio see E. Panofsky, *Early Netherlandish Painting: Its Origin and Character* (Cambridge, Mass., 1953), pp. 2 ff., 361 ff.
28. For Ghiberti's *Commentarii,* an early and conspicuous case of an artist's autobiography, see J. von Schlosser, Lorenzo Ghibertis *Denkwürdigkeiten: I Commentarii* (Berlin, 1912). For the biographies of artists see also Zilsel, *Entstehung des Geniebegriffs,* pp. 159–178.
29. Zilsel, *Entstehung des Geniebegriffs,* p. 148.
30. See M. Barasch, "Character and Physiognomy: Bocchi on Donatello's St. George: A Renaissance Text on Expression in Art," *Journal of the History of Ideas* 26 (1975):413 ff.
31. Roskill, *Dolce's "Aretino" and Venetian Art Theory,* p. 161.
32. Ibid., p. 185.
33. See below, pp. 288 ff.
34. R. Klibansky, E. Panofsky, and F. Saxl, *Saturn and Melancholy* (London, 1964), pp. 362 ff. (for Dürer), 232 (for Raphael).
35. For a survey of Vives' psychology (though without reference to art) see G. Zilboorg, *A History of Medical Psychology* (New York, 1969), pp 180 ff.
36. Romano Alberti, *Trattato della nobilità della pittura* (Pavia, 1604); reprinted in Barocchi, ed., *Trattati,* (Bari, 1962), III, pp. 197–23. For the passage quoted see p. 209.
37. *De Trinitate* III. 9.
38. See above, p. 69.
39. E. Panofsky, "Artist, Scientist, Genius. Notes on the 'Renaissance-Dämmerung,' " *The Renaissance: Six Essays* (New York, 1962), pp. 173 ff. and n. 52.
40. Lee, *Ut pictura poesis* pp. 16 ff.
41. *Writings of Albrecht Dürer,* trans. and ed. Conway, p. 244. I have slightly changed Conway's translation.
42. Ibid.
43. See Zilsel, *Entstehung des Geniebegriffs,* p. 276 ff.
44. In a letter of November 1545. See R. Clements and L. Levant, *Renaissance Letters* (New York, 1976), pp. 118 ff.
45. Useful for the study of Pietro Aretino's views of painting is S. Ortolani, "Le origini della critica d'arte a Venezia," *L'arte* 24 (1923); 3 ff.
46. Pino's *Dialogo* is now easily accessible in Barocchi, ed., *Trattati,* pp. 95–139; for the passage quoted see p. 127.
47. For the first view cf. R. J. Clements, *Michelangelo's Theory of Art* (New York, 1961); for the other view cf. C. Gilbert's review of Clements' book in *Art Bulletin* (1962). Needless to say, the enormous literature on Michelangelo contains much that is of interest for the study of art theory.
48. Ascanio Condivi, *Life of Michelangelo,* trans. C. Holroyd (London, 1903).
49. For Danti's art theory see the next chapter, pp. 228 ff.
50. Condivi, *Life of Michelangelo,* p. 69.

51. For Michelangelo's scorn of Flemish naturalism, as reported by Francisco de Hollanda, see D. Summers, *Michelangelo and the Language of Art* (Princeton, 1981), pp. 216 ff.
52. Roman and arabic numerals in parentheses refer to book and chapter numbers, respectively, in this work. Translations are mine. There is a full English translation of Ficino's *Commentary*. See Marsilio Ficino's *Commentary on Plato's Symposium;* the text and translation are by S. R. Jayne (Columbia, Miss., 1944), published in *The University of Missouri Studies,* 19, no. 1.
53. N. A. Robb, *Neoplatonism of the Italian Renaissance* (London, 1935), esp. pp. 212–238 ("Neoplatonism and the Arts"). See also the interesting discussion of Michelangelo's Neoplatonism in K. Borinski, *Die Rätsel Michelangelos* (Munich, 1908).
54. E. Panofsky, *Idea: A Concept in Art Theory* (New York, 1968), pp. 115–121.

5

The Late Renaissance

I. NEW AUTHORS AND NEW READERS

The historian will never cease to meditate on the variable pace at which Renaissance theory of art unfolded and on the surprises it offers the student who follows its path. In the first decades of the sixteenth century, theoretical reflections on painting and sculpture reached a climax in the unique expression of great artists and bore the impact of an incomparable personality. But how much do they have in common? How far can they be seen as parts of *one* theoretical tradition? Can we really describe them as parts of a single doctrine? It is difficult to answer these questions definitively. Yet we will probably not be wrong in assuming that their influence on the artistic tradition of their day was rather limited; only in later periods was their full significance revealed. In the High Renaissance, at that moment of unique artistic creativity, art theory played a rather minor role. But by the middle of the sixteenth century a veritable outburst of theoretical reflection is evident. The two generations between the late forties of the sixteenth century and the first years of the seventeenth century witnessed an extraordinary flourishing of art theory, probably unparalleled in any other period. The sheer bulk of theoretical literature produced in these generations is astonishing, and the treatises differ in tendency and lit-

erary character, in purpose and in philsophical sources. It is sometimes difficult to find one's way in this jumble of ideas and theories, and the concepts are rarely neatly defined and separated. Yet we will try to show that this bewildering variety is held together by some hidden bonds, that there is a unity in the aesthetic reflection of the period. A few themes governed the overflowing contemplation of art.

But it is not only the sudden increase in the number of treatises that is characteristic of the period. In contents also art theory comes into its own; it grows into a separate discipline, a specific literary genre, with its own tradition. This development was not an isolated affair. In the second half of the sixteenth century literary theory and criticism also swiftly grew and expanded. The reception of Aristotle's *Poetics* and the attempts to formulate a systematic theory of literature led to many great syntheses, notably in Girolamo Pracastoro's *Naugerius sive de poetica dialogus* (ca. 1540) and Francesco Robortello's *In librum Aristotelis De arte poetica explicationes* (1548). The most detailed systematization of literary concepts, Caesar Scaliger's *Poetices libri septem,* a volume of more than 800 pages, appeared in 1561. In the theater we find a similar development. Sperone Speroni, the author of a tragedy, a genre revived under classical influence, defended his work in two lengthy theoretical treatises, explaining how he was following (and where deviating from) Aristotle's *Poetics.*[1]

The relation between art theory and actual artistic creation will always fascinate us, and never was the complexity of this relationship more sharply revealed than during this period. Only one generation before the unprecedented flourishing of art theory, painting and sculpture had reached the peaks of the High Renaissance; the great masters—Leonardo and Raphael, Correggio and Michelangelo—created their famous works, and those were immediately acclaimed as a hitherto unattained climax of achievement. Is the art theory that began to be constituted immediately after that great generation only a reflection of past glory? Is it only an analysis of the accomplishments that the first half of the sixteenth century bequeathed to its second half? Is it true, as Hegel once put it, that Minerva's owl begins its flight only with dusk? Be that as it may, artists and authors in the latter half of the sixteenth century were intensely aware of the debt they owed to the

recent past, and they often described themselves as heirs to whom a great treasure has been entrusted. The summit reached by the great masters cannot be surpassed; we often read: "our task" is to keep their legacy alive. Vasari, to whom we shall shortly return, is the best-known spokesman of this attitude, but here I shall adduce another author. Vincenzio Danti, a sculptor and writer who will also appear in the following pages, opened his treatise on proportions (1567) by stating that Michelangelo surpassed every ancient and modern artist; everybody wishing to excel in the "arts of design" should follow "with ardour" Michalangelo's manner.[2] Mannerism—that multifaceted movement in late-sixteenth-century art, the name of which is sometimes also made a period term—is permeated by the idea of an inherited style, a cultural phenomenon, determined by established artistic models and norms rather than by the study of nature and science. The awareness of being heirs and guardians certainly induces stocktaking, analysis, and theoretical reflections on the past.

Yet it would be mistaken to assume that art theory in the age of Mannerism was only eclectic, merely a passive reflection of famous works of art universally admired as models. Actually, some of the most innovative and far-reaching departures in the history of art theory originated in the late sixteenth century, and some of the problems that were to occupy much of modern aesthetic thought were then first outlined. To be sure, most of the authors were convinced that they were remaining true to tradition and faithfully guarding the inherited treasures of art as well as of thought; in fact, however, they were radically transforming the character and purposes of art theory. Art theory was never altogether uniform—after what has been recounted in the preceding chapters this truism hardly needs to be emphasized—but for a long time, throughout the medieval and early Renaissance periods, it was dominated by the artist's outlook and needs. Practicing artists were the principal authors of art treatises, and artists in their workshops were seen as the reader to whom their writings were addressed. The explicit purpose of art theory was to guide and assist painters and sculptors in their labors. The historian, having the advantage of hindsight, knows that the Renaissance contributed much to the disintegration of that uniform character, but for more than a century

this was an invisible process. Throughout the fifteenth century, art theory seems to be directed to the artist only. When Alberti, primarily a humanist and literary man, proposed revolutionary ideas about the artist's work and education, he was still addressing the presentation of these ideas, mainly the treatise *On Painting,* to practicing artists, and he obviously had their education and their workshop procedures in mind. Systematic presentations of projective geometry—the treatises on perspective—were addressed to painters and were meant to be used by them in the workshops. Even Leonardo's art theory, scientific as it is, originated in the workshop and leads back to it.

In the second half of the sixteenth century, this time-honored character of art theory was transmuted. The part played by artists and workshop experience is still significant, but now for the first time writers without any workshop experience composed many of the treatises. Lodovico Dolce and Andrea Gilio, Benedetto Varchi and Raffaello Borghini, Francesco Bocchi and Gregorio Comanini (authors who will loom large in the present chapter) were erudite humanists and clerics; they worked in chancelleries and libraries or were dignitaries of the Church, but they never held a brush or a chisel in their hands. They often spoke of the artist's skill and knowhow, and they admired his virtuosity, but their viewpoint was that of outsiders, of spectators and critics, rather than of creative artists.

The new type of author is only one facet of the comprehensive reality emerging in the sixteenth century. Its corollary is a new type of reader. For the first time since Antiquity art theory was now being addressed to the general public, to the educated reader capable of appreciating the refinements of culture and art, rather than to the artist himself. The traditional workshop treatise did not altogether disappear, but even where an artist wrote for artists, he now set forth ideas, and he included materials that could be of no immediate use in the workshop. (A good example is Armenini's treatise, for which see below, pp. 236 ff.) By the end of the century the authors are fully aware that they are writing for a new public. The readers they have in mind are "gentlemen" *(gentilhuomini),* and these, as Vincenzo Borghini expressly states, though they do not actually practice the arts, are able to form a judgment.[3]

The new authors were not overly modest. They did not see themselves as mere "interpreters." Carving out for themselves a specific domain, they jealously guarded its peculiar character and its autonomy. Vincenzo Borghini, who was a friend and adviser of artists in the late sixteenth century, once imperiously addressed the Academy of Design in Florence, violently condemning artists who encroached upon the critic's territory by their speculations about the relative merits of painting and sculpture. This, in his view, is the critic's domain. "You should know," he preached to the assembled painters and sculptors, "that in every art there is a difference between operating in that art, and speaking or treating of it."[4] The artist should practice his art; treating the theoretical problems of art is the function of "philosophers and rhetoricians."

No wonder that the literature composed by such authors for such a public differs in content from what had traditionally been the subject matter of art theory. The educated public was not interested in the same things the practicing artist was. Panofsky assumed that late-sixteenth-century theory of art was centered on the question: "How is artistic representation . . . at all possible?"[5] Even if one finds this formulation a little too restricted (it is clearly influenced by the Neo-Kantian philosophy that was so significant in the 1920s in Germany), one cannot deny the paramount consequence of the philosophical trend in Mannerist theory of art. But besides the treating of philosophical questions, there are also other forms in which broader ideas, definitely beyond the confines of the workshop, come into play.

In this chapter we shall not only explore the treatises that are mainly philosophical in nature (such as Federico Zuccari's *Idea*); we shall also encounter other contexts in which broad ideas, definitely beyond the confines of the workshop, made a lasting impact on the interpretation of art. Even the literary patterns are diversified. Vasari's *Lives* is the most famous example of sixteenth-century writing about art that is addressed to the public at large rather than to artists. Another literary form characteristic of the sixteenth century is the composition in which an artist explains his work (usually cycles of paintings) to the spectators. Giacomo Zucchi's *Discorso sopra li Dei de' gentili e loro imprese*[6] and Vasari's *Ragionamenti*[7] are good examples of this genre. Sometimes the

dividing line of a text written for artists from one written for the public is obscured. Cesare Ripa's *Iconologia*[8] is a perfect example of such overlapping of different intentions.

The abundance of theoretical speculation does not necessarily imply the rational character of a prevailing mental attitude in a culture. In recent decades there has been a great deal of scholarly argument about Mannerism, that is, the style of late-sixteenth-century art, and the bewildering variety of movements that come under this heading. Historians probing late-sixteenth-century painting and sculpture cannot fail to devote attention to the intellectual trends and emotional character of that period. In modern investigations perhaps too much has been made of the supposed "irrationality" of the decades after 1550; this late Renaissance period has often been pictured as a mirror image of some of our own contemporary trends, and contemporary "anxieties" (to use a term frequently employed in writings on Mannerism) have been projected onto what happened some four centuries ago. However, after making allowance for such distortions of historical reality, there can be little doubt that late-sixteenth-century thought lacks the naive belief so characteristic of the fifteenth century that everything in nature is susceptible to precise measurement, that a proper representation is one that follows accepted rules, and, therefore, that the "correctness" of artistic representation can be proved by recourse to projective geometry (perspective) and anatomical dissection. Sixteenth-century authors continue to employ literary formulations inherited from fifteenth-century humanists and artists, and this fact is apt to obscure the new ideas and the new attitude that emerged in the later period. But a careful reader of Manneristic literature cannot fail to notice that the themes and thoughts that originated at this time imply the admission of irrational factors in the creation of the work of art. By the end of the century, this trend reached its peak in the great importance accorded to the artist's nature (which cannot be deduced from rational premises) and in the violent rejection of any "rules," particularly those based on mathematics.

But generalities such as "recognizing the irrational," fashionable as they are now, indicate vague, almost intangible, directions of thought; they cannot do justice to the wealth of specific materials and the di-

versification of trends that distinguish the art theory of the late sixteenth century. A well-informed reader will not hesitate to describe Manneristic theory of art as more complex—that is, composed of more elements—than the aesthetic speculation of any other period prior to the nineteenth century. A striking feature of Manneristic thought on painting and sculpture is the existence of regional traditions. Three such traditions stand out clearly: Florence and Rome form one variegated and multifaceted school of art theory; another tradition is formed by the writings composed in Venice, or directly influenced by Venetian thought; a third school is composed by writings in northern Italy, especially Lombardy. Together these traditions form the body of sixteenth-century art theory; what they have in common by far outweighs what is peculiar to each of them. Yet their differences cannot be overlooked; they rival the variety of intellectual sources from which each of the schools drew; even more important, they reflect the peculiar artistic problem with which creative artists and the public were concerned in the different regions of Italy. In this chapter we shall attempt to present, as far as this is possible, the art theory of the second half of the sixteenth century as it crystallized in the regional schools.

II. FLORENCE AND ROME

1. VASARI

No other author has shaped the study of painting and sculpture to such an extent as Giorgio Vasari. In making such a sweeping statement we do not run the risk of exaggeration—so obvious is Vasari's impact and so largely does he figure in the interpretation of the visual arts. Vasari's famous literary work, *The Lives (Le vite de più eccelenti architetti, pittori et scultori Italiani),* is not only a mine of factual information (reliable or fantastic) about artists in the centuries of the Renaissance; it also provided later generations with concepts that are still employed today. We are indebted to him even for the term "Renaissance" *(rinascita)* as the designation of his period. What is more important, his image of the artist remained for centuries the unchallenged model, accepted by public and artists alike; he molded the view, so powerful to our own day, of how the artist's personality is reflected in the works

he creates, and how his temperament can be read from his brush strokes and chisel marks. True, in all these respects Vasari was not entirely a pioneer; others preceded him, and he freely drew from their writings. Yet he became the main spokesman of that trend of thought which flowed through the Florentine tradition from Boccaccio to Ficino and Michelangelo.[9] It may, therefore, be appropriate to start our presentation of Florentine art theory with an examination of Vasari's work, even though chronologically he cannot be placed at the very beginning of our story.

Close to the end of the *Lives,* in an autobiographical chapter, Vasari relates how he came to write his book. One evening, in Cardinal Farnese's house, the conversation turned to the paintings of illustrious men collected by Paolo Giovio, bishop of Nocera and a learned and witty litterateur. The bishop himself spoke of the need for a literary account of the famous artists from Cimabue "to the present time." Everybody agreed that Giovio himself should write the book. Vasari, also present at the occasion, suggested that the bishop have "someone of the profession" to help him over technical details, and—after some hesitation—agreed to serve in this capacity. Later, however, Paolo Giovio gave up the idea of writing such an account and insisted that Vasari take over. "My account," the learned bishop said, "would more resemble a treatise such as that of Pliny."[10] It is not difficult to guess what he had in mind when he evoked this classical source, at the time universally revered as the perfect model of a systematic art theory. Giovio's treatise, we may safely assume, would have been a learned compilation, its material arranged according to some doctrinaire principle, rather than a narrative account. Vasari wrote an altogether different book. But, before we look into it more closely, it may be wise to pause for a moment to consider what the conditions under which it was conceived may tell us. Obviously, Vasari's book did not grow out of the workshop; rather, it originated in the palace of a high dignitary of the Church who was an enlightened patron of learning and the arts. In the company of guests in the cardinal's house, Vasari was probably the only artist. Yet the story also shows that the account proposed there was not considered as a completely literary affair, altogether divorced from the practicing artist. "Someone of the profes-

sion" was deemed necessary to tell the story of Renaissance painting, and though the suggestion was made by a painter, it was immediately accepted by the company of laymen in the cardinal's house. In other words, art was dealt with by humanists and writers, but there was an awareness that it also required an understanding of the métier.

We do not know the precise date of the dinner party (it was probably in 1546), but we know that Vasari's book was for some time in the making and that it was apparently eagerly awaited. Even before it was published it had made an impact on contemporary art theory. In 1548 Paolo Pino, a Venetian painter and author, referred to Vasari's work, then not yet published.[11] The first edition of the *Lives* appeared in 1550. Characteristic of it is a certain detachment from the contemporary scene: Vasari dealt only with artists who were dead or who for some other reason had completed their work (as, e.g., Rovezzano, who was by then blind). Only one exception to this rule was made—for Vasari's hero, Michelangelo (though Michelangelo was by then seventy-five years of age). In 1568, eighteen years later, Vasari published a second, much-enlarged edition of his work. To a certain extent, he changed the perspective: in the second edition he deals with many living and still creating artists; he is more involved in contemporary thoughts and moods and thus more clearly mirrors the processes taking place in his own days. All these changes may have obscured the clear architecture of the first edition, as Schlosser believes, but it is this amplitude that made the second edition so famous, a book read throughout the four centuries that have passed since it appeared.

The *Lives* is not a theoretical book; it tells a story. But a theoretical attitude is implied in what Vasari related. It has to be extracted, but whoever takes the trouble to do so is richly rewarded.

Vasari was uniquely qualified to write this book.[12] He was a well-known artist. Some of his great cycles of paintings—frescoes in the Scala Regia in the Vatican and the allegorical frescoes in the Palazzo Vecchio in Florence—display the contorted nudes, the virtuosity of the depiction, and express the combination of anxiety and sweetness that came to be regarded as hallmarks of Mannerism. As an architect he helped to crystallize—in such buildings as the Uffizi in Florence— the late Renaissance style in Tuscany. In the introductions to the dif-

ferent parts of his book he speaks with supreme competence of the artistic techniques, not only of painting and architecture, but also of sculpture, an art he never practiced. He did not approach the workshop experience from the outside. Vasari's education, however, differed from that of an artisan. Early in life he came into close contact with some of the leading Florentine humanists. Among his teachers was Pierio Valeriano, a classical scholar and Florentine historian, the author of the first dictionary of traditional enigmatic symbols, the large tome of the *Hieroglyphica*. What Vasari learned from Pierio Valeriano as well as from his other teachers did not turn him into a bookish humanist, but it gave him a perspective that was normally not easily available to a practicing artist. His interest in iconography—as shown in his *Ragionamenti,* an explanation of the intricate allegories he painted in the *studiolo* of Francesco de' Medici—may well have been influenced by the legacy of his teachers.

For whom did Vasari write? The second edition of his work was prefaced with a letter "To the Artists of Design."[13] This is not surprising in view of a well-known tradition of art theory; we remember that Alberti had placed a dedicatory epistle to a group of artists at the beginning of his *On Painting.* Yet from Vasari's book itself it emerges that he did not write for the traditional reader of art theory. He writes *of* artists, not *for* them. The example of many great artists may be "of no small advantage to those who study the arts," but he wants to write "for the more perfect satisfaction of many friends, devoted lovers of art, though not within our ranks," that is, not painters themselves. The "amici . . . dell'arte" are the readers he had in mind; he wants to "gratify all others [than artists] who have taste for, and pleasure in," the arts.

Vasari may be considered as the founder of an historical approach to the study of art, though he was preceded by earlier pioneers, such as Ghiberti. It would be anachronistic to expect of Vasari what one would request of any modern historian: a careful examination of sources and a critical scrutinizing of details. Vasari likes gossip and is ready to believe it when it helps to build an image. Yet continued stress on his inadequacy as a historian (the argument of some modern scholars) will

obscure one of the most significant developments in thought on art that the Renaissance has bequeathed to us.

At first glance, Vasari's historical attitude seems full of contradictions. On the one hand, he describes the unfolding of Renaissance art in time and space. Artists working in the same years and in the same region are brought into relation with each other and are lumped together into schools (though he does not seem to have used that term). He has a keen sense for historical continuity; he often asks what a generation has learned from its predecessors and where it deviated from them. All this would seem to add up to a regular historical account. On the other hand, he is not content with just telling a story. Nothing would be more alien to him than the modern historian's reticence in judgment, what we now call the value-free attitude. He unashamedly admits that he wants "to exalt, to celebrate, and to honor" the artists of his period and to keep alive the memory "of the great artists." Based on belief in a "perfect rule of art" *(perfetta regola dell'arte),*[14] he measures each work of art (and artist) by this absolute yardstick, to pronounce on them as more or less successfully attempting to reach perfection. History and criticism are inextricably interwoven in his views.

Another seeming conflict is that between the individual and his period. Biography, it need not be stressed, was not invented by Vasari. Renaissance culture was intimately familiar with this literary form from the biographies of Roman emperors and Christian saints. But Vasari knew biography also from sources closer to his time and to his heart— the life stories of famous men, or even specifically of artists, as recounted by Filippo Villani. For Vasari, biography is not just a literary form, a manner of presentation. The artist's character often explains broad historical developments. Art forms are the "invention" of individual artists (Duccio invented the black-and-white floor mosaic); characteristics of style are often explained by an artist's specific inclination (slender gracefulness of figures is derived from Parri Spinello's admiration of *bravura*). Clearly, an artist's individual character is not a negligible accident, and biography is not simply a neutral pattern of telling a story.

On the other hand, Vasari's historical concepts are of a comprehen-

sive nature. Focused on whole ages, they seem to leave no room for the individual. Following a model dear to the hearts of Renaissance humanists, Vasari believes that art ran its course through history in three major stages: the glory of Antiquity, the decay of the Middle Ages, and the "revival" characteristic of "our own times." Even Renaissance art itself developed in three comprehensive periods: the very beginnings called by Vasari "the first lights," the fifteenth century, and finally the great period of the High Renaissance (in which he includes his own time). Surely, no earlier author, and few later ones, had a finer sense for an artist's individuality than did Vasari. Some of them he has transmitted to posterity in so classic a form that they have become almost proverbial—the juxtaposition of Michelangelo's *terribilità* and Raphael's grace is a well-known example. Yet acknowledging the artist's individual character by no means obscures the collective character of the age to which the different artists belong. Though Vasari's literary form was biography (with the exception of a few introductions), modern scholars have rightly observed that he was "more concerned with the history of style than with the history of artists." Subsuming the artist under the period makes it possible for Vasari to do historical justice to painters and sculptors of different stages.

The first epoch *(età)* extends from the mid-thirteenth to the end of the fourteenth century. It is an age one can describe as the time of "the first lights" *(i primi lumi)*. Imitation of nature became the major aim of art. We have already encountered the humanists' opinion that Giotto, the outstanding painter of this period, "brought the art of painting back from its grave" (Boccaccio) or "retranslated the art of painting from Greek into Latin and [thereby] made it modern" (Filippo Villani). This tradition of Florentine humanism is Vasari's principal source. He admires Giotto. The "gratitude which the masters in painting owe to nature" is actually due to Giotto—so Vasari opens his life of Giotto. Considering the "character of the times" in which Giotto lived, his works will appear "not only merely beautiful . . . but miraculous." But Giotto was far from reaching the "perfect rule of art." Nobody should believe, Vasari says, that "I am so dull and poor in judgment" as not to see that the works of Giotto and his contemporaries, when compared with the works of artists of a later stage, "do not deserve

extraordinary or even mediocre praise." Giotto was a pioneer, "and a beginning, however, small, is worthy of no small praise"[15]

After the stage of pioneering came the *età* of solidification, which extended through the fifteenth century. In that period, Vasari says, artistic production was "ameliorated." We know in what this improvement consisted: richer invention, more correct drawing, more careful finish. "Care was taken," we read, "that all should proceed according to rule . . . drawing acquired force and correctness." Vasari does not use that famous coinage of later days, "the spirit of the age," but he clearly defines the collective qualities that characterize an age. The second *età* is determined by the drive for scientifically measurable "truth" in painting and sculpture. But again Vasari is not a detached observer; he is also a critic. He knows the limitations of the age, and these one can perceive only when one sees a certain period within the whole process leading to ultimate perfection, that is, when one considers a certain epoch as a step in the ascent toward the "perfect rule of art." In this context the second *età,* for all its correctness and amelioration, is characterized by a certain dryness. Study, when diligently employed to obtain finish, "gives dryness to the manner." Take, for instance, Uccello, an almost perfect embodiment of the ideals and values of the second *età.* To Vasari's eyes, Uccello's work was that of an "original and inventive genius," but he wasted his talents and efforts on perspective. "For although these studies [i.e., perspective] are meritorious and good in their own way, yet he who is addicted to them beyond measure . . . exhausts his intellect, and weakens the force of his conception, in so much that he frequently diminishes the fertility and readiness of his resources, which he renders ineffectual and sterile." Piero della Francesca, too, could have been a great artist had he not wasted his life and efforts on science. The works of fifteenth-century artists, though correct, produce "an effect that is displeasing to the eye."

Only the third stage, the *età moderna,* which began with Leonardo da Vinci and lasted to Vasari's own days, overcame dryness. To the power and boldness of drawing and exactitude of representation Leonardo added a "most divine grace," imparting to his figures, "not only beauty, but life and movement." These specific qualities characterize

the third period, the culmination of the whole Renaissance. Giorgione endowed his paintings with "force and animation" and softness; Raphael gave his figures "perfect grace"; Correggio painted his figures, especially the hair, with "feathery softness"; and many other artists of that last stage worked with "much facility." The artists of this stage achieved ultimate perfection. They lead us to a discussion of more theoretical issues.

Before starting to discuss these qualities we should briefly summarize what is implied in Vasari's historical approach. His description of how Renaissance art evolved is more than just an account of events and a collection of life stories; it embodies a theory of art and of art criticism. Every artist and work of art must be understood in two different contexts and judged by two different standards. The one context is historical, and the standard of judgment is relative: What did the artist mean in his time? And what is his achievement if measured by what was possible in his period? The other context and standard of judgment are absolute: What is the value of each artist and work of art when judged by the unchangeable "perfect rule of art"? One can see that the historian Vasari cannot be divorced from the philosopher, the critic, and the theoretician.[16]

If Vasari had a theory of art, it is not openly presented. As we have already said, it can be extricated from the stories he tells and from the few general observations interwoven in the stories. But Vasari's theory, though so well hidden, constitutes an important turning point in the history of aesthetic thought on painting and sculpture. We shall here concentrate on two central features: Vasari's vision of the system of arts and his notion of "grace."

In the third chapter we referred to Vasari's concept of the "arts of design" *(arti del disegno)*, a notion that for the first time articulates a system including all the visual arts and setting them apart from other creative activities. There is no need to restate here that in Renaissance Italy—and perhaps particularly so in Florence—the three sister arts were often united in actual life. The painter was frequently also an architect, and of many artists it is difficult to say whether they were painters or sculptors. But while this was so in historical reality, Vasari seems to be one of the first authors to make this relation explicit, to

cast it into a conceptual pattern, and to transmit it to the aesthetic thought of the centuries to come. The corollary of the new concept was the trend of thought expressed in the *paragone* literature. While in the discussions known as *paragone* the specific character of each individual art, and what distinguishes it from the others, was emphasized, the notion of *arti del disegno* stresses what the visual arts have in common. Vasari, a veritable son of his age, was acquainted with, and obviously accepted, the hierarchic grading of the arts underlying the concept of *paragone*. Architecture, he believes, is the noblest among the visual arts, and painting is superior to sculpture (a view not surprising in an artist who was both a painter and an architect). But his contribution to art theory lies in the other concept, the *arti del disegno*. He points to the kinship of the three visual arts by looking for their common origin.

In the second edition of the *Lives* Vasari enlarged the introduction on painting by adding two fairly long paragraphs that he placed at the beginning of that introduction. The first sentence of the "Introduction on Painting," as it now stands, begins: "Since Design, the father of our three arts, Architecture, Sculpture, and Painting . . ."[17] Later he comes back to the same image of Design being the father of all the three visual arts. They are interrelated because—at least, in part—they flow from the same source.

The idea intimated by Vasari must have been very much in the air in the late sixties and in the seventies of the sixteenth century. One year before the second edition of the *Lives* appeared, Vincenzio Danti, a sculptor and thinker on art, published his *Trattato delle perfette proporzioni* (to which we shall shortly return), and in it he states a very similar view. "Those arts of Design," says Danti, "form a kind which embraces the three most noble arts: architecture, painting, and sculpture, each of which is only a variety of this one kind."[18] Danti's *Trattato* appeared in 1567, a year before Vasari's second edition, but both were composed in the very same years. Karl Frey, a very thorough scholar and editor of the first part of the *Lives,* suggested that Vasari added the two passages following the advice of Vincenzio Borghini,[19] another litterateur and art lover. A few years later Gabriele Paleotti, a learned cardinal and another "lover of art," claimed that *disegno* is what

forms the principle of all the arts producing images (published in 1582).[20] In a vague and general sense the idea seems to go back to Michelangelo. Whether Francisco de Hollanda faithfully reports the master's views or not, the idea seems to have had currency in Michelangelo's circle. One remembers that both Vasari and Danti were particularly close to the Michelangelo tradition and saw themselves as some kind of apostles of the great master. Vasari, then, did not coin the famous phrase out of the blue. But his formulation, however it may have been indebted to tradition, became the best known and most influential. The concept of *arti del disegno* will remain connected with his name.

But what precisely is "design"? Vasari's formulation is far from plain. He was a vivid writer; his prose is picturesque. But he did not care too much about explaining or about using abstract terms consistently. When we try to extract what he actually may have meant by "design" in his fluent and elegant sentences, two different explanations suggest themselves. (We cannot even be sure that Vasari was aware that two altogether different modes of thought were providing a basis for these separate interpretations.)

One is spiritual and speculative. 'Design, the father of our three arts . . . derives a general judgement from many things: a form or idea of all the things in nature. . . .'' To put it as simply as possible (even at the cost of missing some of the subtler intricacies of the notion), design is a sort of mental image of the figures and objects to be represented. Panofsky, in his study, *Idea,* has called attention to Vasari's diverging from the philosophers in employing the term "idea."[21] In the philosophers' view—especially those of the Florentine Neoplatonists—the "Idea" is inborn to man; it mentally preexists and predates encounter with the outside world and is independent of any observation. In artistic terms, it could thus be regarded as a competitor to the observation of nature. But in Vasari's thought, "idea" or *disegno* is derived from experience, distilled from many observations. It thus bears a certain similarity to Dürer's "accumulated secret treasure in one's heart."[22]

But whatever the psychological origin of *disegno,* it is conceived, at least in certain contexts, as an immaterial image dwelling in the mind. Artists keep this image before their spiritual eye when they are painting or carving. In the *vita* of Luca della Robbia, Vasari, speaking of the

"arts of design," assures the reader that "whoever has the clear idea of what he desires to produce in his mind . . . will ever march confidently and with readiness towards the perfection of the work which he proposes to execute."[23] "Idea" and *disegno,* one notices, are here used interchangeably. If we accept this interpretation of *disegno,* the "arts of design" can only mean the arts that flow from the images in the makers' minds.

But in Vasari's thought *disegno* also has a different meaning, one that is closer to what we now understand by this term: a linear configuration indicating the structure of what is represented and the production of which requires skill, dexterity, and training. Often he has an actual outline in mind when he speaks of "design." Sometimes he probably means a sketch, the initial formulation of an idea. Any work "of painting and sculpture, or any other work of similar kind" will be more forceful as a sketch *(disegno)* than as a completed, finished work. As a linear construction design has a particular value. Michelangelo, seeing a picture by Titian, regretted "that the Venetians did not study drawing *[disegno]* more." Had Titian done so, he would have surpassed all other artists. Drawing the lesson from this remark, Vasari adds that "whoever has not practiced design extensively can never attain perfection." Design could, then, also mean an object, a drawing on paper. The Mantuan painter Marcello made numerous little pictures "from the designs . . . of Michelangelo."[24]

Disegno was one of the central concepts of late-sixteenth-century art theory, and at the end of this chapter we shall analyze it in its wider contexts. Here we shall only remark that, if we accept the second definition of *disegno,* the *arti del disegno* will mean the arts built upon a basic linear structure, or the arts in which the sketch is the first stage in the process of production.

The notion of *arti del disegno* articulated thoughts and opinions current in many circles in the second half of the sixteenth century. In the crystallized form that it received in the *Lives,* it had a profound impact upon the classification of the arts, and its influence is still felt in our own age. However, Vasari's major contribution to the theory of art does not so much consist in the formulation of this notion, nor in the coining of theoretical concepts in general; rather, it was the emphasis

he placed on certain values that makes him so important in the history of aesthetics. Values are rarely formally defined. In Vasari's views they appear under different names, and frequently different aspects of the same value are stressed. Yet, in spite of all this, the values he admired emerge clearly; their novelty in the framework of art theory is obvious; and they can thus be discussed with some confidence.

The central aesthetic value in Vasari's views is what he sometimes calls "grace" (*grazia*). It is a protean and elusive quality, ever changing and hard to grasp. In presenting it, one should always be aware of the danger of making Vasari appear more systematic and philosophical than he really was. Yet so important and novel is this quality that the attempt must be made to treat it as explicitly as possible.

Vasari speaks of *grazia* particularly when he is discussing the art of the third *età*. The style of this period is "more free and graceful" than that of the former period; it is characterized by "delicacy, refinement and supreme grace." Leonardo da Vinci was endowed with a "most divine grace." Raphael, a "most graceful" artist, imparted to the faces he painted "perfect grace and truth"; his self-portrait is "infinitely pleasing and graceful"; as a person he was "no less excellent than graceful," and "grace and softness . . . were peculiar to Raphael." Parmigianino was also "exceedingly graceful." He imparted to his figures "a certain beauty and sweetness, with a singular grace of attitude which was entirely peculiar of himself." He "contributed to art a grace so attractive, that his works must ever be held in esteem."[25] These are just a few quotations, and they could easily be increased. What, then, is "grace" in Vasari's views?

The history of grace in aesthetic thought abounds in turns and changes; it may be worth our while to pause for a moment in our presentation of Vasari's views and to consider, at least in outline, the past history of this concept.

In ancient criticism "grace" was a household word. "The grace of his [Apelles'] genius remained quite unrivalled," Pliny assures his readers (*Naturalis historia* XXXV. 79). Apelles' contemporaries, among them the greatest painters of the time, "failed in grace [*venustas*], called *charis* [χαρισ] in Greek"; this quality was "distinctively his own." Grace, then, is not simply excellence; it is a specific property, a quality of a

definite character. In rhetoric the quality of "grace"—mainly in the orator's presentation—was considered a supreme value. Teachers of rhetoric were fully aware that *venustas* was a trait diverging from rigidly established rules. "Such graces and charms [that] rhetorical figures afford . . . depart in some degree from the right line, and exhibit the merit of deviation from common practice"—so Quintilian taught (*Institutio Oratoria* (II. 13. ii) his students and the many centuries who religiously studied him.

In the course of time, however, the distinction between grace and beauty lost its sharpness. Alberti employs *grazia* simply as a synonym for "beauty." "From the comparison of surfaces arises that elegant harmony and grace in bodies which they call beauty" (*On Painting* II. 39).[26] Harmony, we remember, is the perfect relationship of measurable shapes, and therefore grace cannot be regarded as a quality deviating from the rules, or from the "right line," as Quintilian put it. But Neoplatonism prepared the way for interpreting grace as a quality distinct from beauty. In Ficino's terminology, beauty and grace are not yet kept apart, but beauty itself is understood as an incentive to the spectator, an intangible quality for which no formula can be found; in other words, *bellezza* is closer in character to grace than to what was traditionally regarded as beauty. Some believe, Ficino says, "that beauty consists in a certain arrangement of parts. . . . We do not agree with this."[27] Pico della Mirandola discovers a *qualità* "which appears in, and transfigures, all that is beautiful . . . for this quality there is no more appropriate name than grace." Beauty is the property of bodies, whereas grace is a spiritual quality. Since "it does not stem from the body, one must of necessity ascribe it to the soul."[28] The Neoplatonists, then, paved the way for the notion of grace as we know it from later periods.

The full articulation of *grazia,* however, was achieved outside the realm of philosophy; it was mainly in opinions on social manners and behavior that this notion is most developed. Baldassare Castiglione, an official in the courts of Milan and Urbino and an arbiter of Renaissance standards of elegance, discussed it in his *Book of the Courtier* (1527). Castiglione knows the difference between beauty and grace. A face can be "very agreeable and pleasant to all, although the features of it are

not very delicate . . . and yet it is full of grace" (*Courtier* I. 19). Such is the character of Renaissance culture that the author of a book on the courtier's manner is influenced by Neoplatonic thought. "Beauty," he says, using a metaphor characteristic of Neoplatonism, is like "a stream of divine goodness flowing onto all things like the light of the sun" (V. 52). But he is more specific about our subject. *Grazia* is a unique gift of nature; it is added to beauty or other good qualities, but it is not identical with them. "I wish," Castiglione describes his ideal figure, "the Courtier . . . endowed by nature not only with talent and with beauty of countenance and person, but with that certain grace which we call an 'air' " (I. 14). Being a gift of nature, grace cannot be learned or otherwise acquired. If one tries hard to achieve it, it will forever remain beyond one's reach. It is a social ease that conceals the laborious efforts it takes to acquire polite manners. It is a "nonchalance of movement and action." To be graceful one has to avoid affectation "as though it were some very rough and dangerous reef." To express what he means by grace in behavior Castiglione coins a new term. "To pronounce a new word," as he says, the courtier should "practice in all things a certain *sprezzatura* [nonchalance], so as to conceal all art and make whatever is done or said appear to be without effort and almost without any thought about it" (I. 26).[29]

Of the grace of women, who are particularly endowed with this mysterious quality, we learn from another author. Angelo Firenzuola, a churchman and brilliant translator of Apuleius' *Golden Ass* (considered by Renaissance humanists a perfect model of elegant Latin style) and himself a model of a refined Italian style, composed a *Dialogue . . . of the Beauty of Women,* which is an important document in the history of sixteenth-century taste. "Grace," we read in that churchman's *Dialogue,* "is nothing else than a luster produced in some occult way by a particular union of some limbs and features." Luster, of course, cannot be measured and, therefore, is not subject to any quantification. Moreover, it results in an "occult way," again emphasizing that it does not follow any rules. It can therefore not be learned from books. And this luster, Firenzuola continues, "strikes our eye with such intensity, and so great satisfaction to our heart and joy to our mind, that forthwith it is this grace which delights us more even than beauty." Following

the Renaissance habit of explaining concepts by looking for their etymology, Firenzuoa says that this specific quality is called "grace" because it is "granted" *(e chiamasi grazia perciocch'elle fu grata).*[30]

Literary criticism, too, could not withstand the charm of "grace." Suffice it to mention Pietro Bembo. In his youthful work, the immensely influential *Asolani* (1505), Bembo explains that beauty is nothing other than a certain grace born of harmony and proportion. Grace is a quality of the soul; as the body is beautiful in its measurable proportions, the soul is endowed with grace in its virtues. In Bembo's later Latin *Book on Imitation (De imitatione libellus)* he extols negligence as a source of grace. "Just as an unpainted face can be graceful in a woman, so, too, negligence can sometimes impart grace to a writer."[31]

We shall conclude this brief sketch of the history of grace in Renaissance thought with a text that brings us closer to our proper subject, the little *Book of Beauty and Grace (Libro della beltà e grazia)* by the poet, historian, humanist, and theoretician of the arts, Benedetto Varchi.[32] We have already mentioned Varchi, and in the course of this chapter we shall have occasion to come back to his many-sided work. The *Libro* was published (posthumously) only in 1590, but Varchi composed it much earlier, probably shortly after 1543. This brief text, not more than twelve pages in a modern edition, is probably the finest reflection of Florentine ideas on grace in the mid-sixteenth century. In no other text is *grazia* so clearly distinguished from *bellezza*. Grace, Varchi says, can exist without beauty, but there can be no real beauty without grace. As most humanists did, Varchi accepts the definition of beauty as an objective, measurable harmony. Beauty is nothing more than "proper proportion and the correspondence of all members." Grace, on the other hand, is a stimulus, a charm: it is "what delights and moves us." Grace, Varchi assures his readers, cannot result from measure and proportion; it does not flow from bodies or "brute nature"; it emanates only from the soul. Varchi, explicitly referring to Plato and Plotinus, anticipates Romanticism in describing grace as the "beauty of the soul." As such, it can dwell in a "body which is not perfectly proportioned, and which, as is vulgarly said, is not beautiful." Here, then, a little more than a century after Alberti's *On Painting*, grace is fully recognized as a quality altogether independent of beauty.

Let us now return to Vasari. He was no philosopher, and he was ill at ease in handling abstract concepts. It is not surprising that he never defined "grace" in theoretical terms. Yet he was the first author to consistently apply this concept to the visual arts (mainly to painting), and thus to transform it into a term in the discussion of aesthetic values. Though he never specifically defined what "grace" is, we know quite well what it means in his work. Not only did he accept the connotations of *grazia* as current in sixteenth-century thought; he also described it, intuitively and vividly, in metaphors and synesthetic comparisons. Two metaphors occur most frequently, and both refer to senses other than vision: grace is regularly related to softness and sweetness. These metaphors are particularly frequent in the third part of the *Lives*. In the second *età* of the Renaissance, as we remember, art achieved correctness and scientific verifiability, but these achievements did not lead to grace; on the contrary, they produced "an effect that was displeasing to the eye."[33] In the third period we find the soft and sweet grace. Thus, to give but a few examples, Raphael's disposition was one of "gracious sweetness." Figures painted (in Agostino Chigi's palace) by artists other than Raphael are not altogether satisfactory, "since they want that grace and softness which were peculiar to Raphael." The *Mona Lisa*'s smile—a common example of grace—is sweet. Leonardo introduced grace into painting, and Giorgione possessed some of his works, "which were painted with extraordinary softness." Correggio's "charming manner" was exquisite in "softness of carnations," and he finished his pictures with grace. In other words, grace is what strikes us as "soft" and "sweet."

If "correctness" follows from the observation of rules and of science, grace depends on what is called "judgment." Again we must return to Vasari's introduction to the third part of the *Lives*. "In proportion," the works created in the second *età*, "there was still wanting that rectitude of judgment which, without measurement, should give to every figure, in its due relation, a grace exceeding measurement. In drawing . . . the arm was made round and the leg straight, there was yet not that judicious treatment of muscles, nor that graceful facility."[34]

Judgment (*giudizio*) was another term frequently employed in Re-

naissance criticism. Judgment was not considered, as Robert Klein has shown,[35] as a matter of pure intellect; the act of judging hovers between the intellect and the senses. It cannot be quanitified, and it is not "provable." But one can always judge—clearly and distinctly—whether a work of art or a person has grace. The spectator's immediate intuitive reaction is not the less positive for not being subject to scientific proof. Judgment, or the spectator's eye, is the final arbiter of the quality of a work, and Vasari explicitly acknowledges its superiority over objective measurement. "After all, the eye must give the final judgment," he says in his introduction on sculpture, "for, even though an object be most carefully measured, if the eye remain offended it will not cease on that account to censure it." And again: "although measurement . . . may make the work well proportioned and beautiful, the eye nevertheless must decide."[36]

The spectator's eye intuitively judging the work of art by perceiving its *grazia* reminds us of the classical concept of *eurhythmia*. Greek and Roman authors, often referring to the "optical refinements," define *eurhythmia* as "a pleasing appearance and a suitable aspect" (Vitruvius, *De architectura* I. 2) or as "that which appears comfortable and eurhythmic to the sense of sight." We can thus say that what *eurhythmia* is in classical aesthetics *grazia* and *giudizio* are in Renaissance theory of art.

But *giudizio* is not only the spectator's part. In sixteenth-century criticism it was a commonplace that the artist needs judgment. Already Leonardo, at the very beginning of the century, extols *giudizio* as a property of the painter (*Treatise on Painting* no. 439).[37] At this stage the connotations of the artist's *giudizio* are still somewhat vague and fluctuating. But two generations later the meaning of the concept becomes clearer, the significance of the property more obvious. Without having judgment the artist cannot create his work. "Proper proportions," Raffaello Borghini boldly asserts in his *Il Riposo* (1584), cannot be taught; "it is necessary that the artist have a natural judgment."[38] The most popular formulation is that the artist has the compass in his eyes. "Modern painters and sculptors," Lomazzo reports Michelangelo as saying, "ought to have proportions and measures right in their eyes" (*Trattato* VI. 18).[39] Vincenzio Danti, to whom we shall shortly revert,

claims for Michelangelo the discovery of the authentic proportions of the human body. What made it possible for the great artist to achieve that goal were not only the dissections he performed, and his anatomical studies in general, but, not less than these, his "intellectual vision." The ultimate goal of the artist's striving should be to replace the "material compass," the one he can hold in his hand, by the "compass of judgment." The most far-reaching formulation is found in Vasari, who reports Michelangelo as saying that "it is necessary to keep one's compass in one's eyes and not in the hand, for the hands execute, and the eye judges."[40]

The very formulation of judgment as a critical concept, and the significance granted to what is described by this term shows that the absolute validity of rules and the supreme value of scientific representation were no longer taken for granted. In the final section of this chapter (a section that deals with the generation following Vasari's) we shall come back to the consequences implied in these intimations. Vasari himself did not yet altogeter reject rational rules and correct representation as yardsticks by which to measure the value of a work of art. But the doubts alone cast on rules and "truth" of depiction were enough to give rise to another value, the admiration for refined skill, studied carelessness, or what Vasari called "facility."

"Facility" *(facilità)* is one of the many synonyms for virtuosity that were employed in the late sixteenth century. Awe before the artist's virtuosity, the feeling of wonder evoked by his miraculous skill, may be found in different cultures and periods. Kris and Kurz, in their study of the myth of the artist, have outlined the universal scope of this theme.[41] They convincingly maintain that in the Western world admiration for the artist's virtuosity has historically focused on two themes: the one is his ability to portray a piece of nature so faithfully that our sense of vision is deceived, and we take the artifact as the natural object; the other is the artist's capacity of producing his complex and intricate work easily and rapidly, without any effort, and, so to speak, instantaneously. The rapidity by which a painting or a piece of sculpture is shaped attests to the artist's facility in producing it. All great artists are endowed with this rare gift of facility. Giotto drew, "with one turn of the hand," a circle so perfect that it was "a marvel

to behold."[42] But Giotto was of course a lonely figure in his time. In the second *età* artists were careful and thorough in their work, but facility of execution was not among their virtues. In Vasari's view, the slowness with which fifteenth-century artists produced their works is closely interrelated with the "dryness" characteristic of their style.[43] Careful correctness cannot produce grace.

In the third *età*, characterized by the grace of style, facility and quickness of execution are a common property. The facility of this period is not simply the result of accumulated experience; it follows from the nature of the artist. Everything that is easy for your *ingegno* should be judged as good—this is the essence of what Vasari wrote to Benedetto Varchi in 1547, before the first version of the *Lives* appeared in print. It would not be difficult to collect from the *Lives* many passages extolling the facility of the great masters. As a single example we shall mention one of the lesser-known biographies. The painters Polidoro da Caravaggio and Maturino, treated by Vasari in one chapter,[44] achieved "the most perfect facility" in imitating the manner of antique art; they displayed an "admirable facility" in executing their own works. No other artists demonstrated such "perfect facility, and such remarkable promptitude" as they did. Everybody is "dazzled and confounded" by the skill and grace exhibited in their work. "Happy was the union of nature and art" in the "grace and excellence of his [Polidoro's] pictures." And when Vasari wants to extol his own gifts, he tells us that he produced his paintings "not only with the greatest possible rapidity, but also with incredible facility and without effort." A monumental picture he painted in only six days. All these works also had the character of *grazia*.

In sum, the connection between grace and ease is a constant feature in Vasari's thought.

In making facility a condition for the appearance of grace Vasari was not contributing an altogether novel idea. Here again he took over opinions and beliefs current in sixteenth-century society and applied them to the criticism of art. In the ducal courts, and in the "polite society" of the times, it was widely believed that facility is an indication, or even the source, of grace. The courtier, Baldassare Castiglione keeps stressing, should never appear studied and laborious. Whatever

he is doing, he should perform as if he did it with ease. "Therefore we may call that art true art which does not seem to be art; nor must one be more careful of anything than of concealing, because if it is discovered, this robs a man of all credit and causes him to be held in slight esteem" (I. 26). Castiglione, the lawgiver of social manners, himself draws from ancient literature on art. Protogenes, so Castiglione echoes his classical sources, did not know when to take his hands off his painting. It has been "proverbial with certain most excellent painters of antiquity that excessive care is harmful" (I. 28). That harm Castiglione describes as "affectation"—Vasari may have used the term "dryness."

The consequences of shifting the emphasis from correctness to grace, from careful preparation to facility turned out to be far-reaching. Vasari himself is still far from being aware of all the implications of his views. He often stresses the care that he, and other masters approved by him, lavished on the works they created. But the views of grace and facility paved the way for appreciating the sketch, the improvised shape, and ultimately contributed to breaking down the structure of an objective art, and its theory.

2. VINCENZIO DANTI

Only one year before the second edition of Vasari's *Lives* came on the market, the sculptor Vincenzio Danti, a Perugian by birth and a Florentine by choice and vocation, published a slim volume with a long, cumbersome title, *Il primo libro del trattato delle perfette proporzioni di tutte le cose che imitare e ritrarre si possono con l'arte del disegno.*[45] Danti planned a comprehensive work in fifteen books, which, had it been written, would have been the most important document of Mannerist theory of art. At first sight, Vasari and Danti seem to form a perfect contrast: while Vasari vividly tells a story, and his general concepts are implied rather than explicitly stated, Danti attempts to erect a comprehensive and systematic structure, in its abstract formulations sometimes reminding the reader of scholastic modes of thought. It has been maintained by Paola Barocchi, the modern editor of the *Primo libro,* that Danti's was an isolated case.[46] Yet even if this is so, Vasari and Danti have more in common than meets the eye. Few texts as sharply illu-

minate the crisis and transformation of late-sixteenth-century art theory as does Danti's fragment of his proposed monumental work.

A glance at Danti's personal background may show to what extent he represents a living tradition, but it may also reveal some of the origins of the crisis he documents. He came of a family renowned for its scientific and artistic interests.[47] His grandfather, Piervincenzo Rinaldi, was an architect and a poet and is reputed to have translated Sacrobosco's *Sphaera* (a thirteenth-century astrological compendium based on Arabic sources) into Italian as early as 1498. His son Giulio followed his father's profession, but he was also a skillful bronze caster. Danti's brother Ignazio was one of the famous mathematicians and astronomers of the time. He translated Euclid's *Optics* and wrote a mathematical commentary to Vignola's *Prospettiva prattica;* the astronomical instruments he constructed were still in use in the seventeenth century. Ignazio Danti also painted geographical maps for Pope Gregory XIII and was a member of the Academia del Disegno. The admiration of classical art was a family tradition, and as a result of the family's efforts, and of Vincenzio himself, an ancient statue of a praying boy was brought to Florence. Such a background was unusual for an artist even in the late sixteenth century. Vincenzio Danti was both a scientist and an artist. In his *Trattato* he tells us how, in the course of his anatomical studies, he dissected eighty-three corpses,[48] an unusually high figure for those days. Some chapters reveal that he was also a careful observer of inanimate and organic nature—witness what he has to say about the nature of stones and vegetation. The refined style of his text and the many allusions to classical literature, especially to Aristotle's *Poetics,* disclose the learned humanist.[49] But, above all, Danti was a practicing artist, a sculptor of importance in Manneristic art. "With glowing zeal," he asserts, he studied the excellent works of art, ancient as well as modern. The core of Danti's artistic program—both as executed in marble and as formulated in sentences—is his devotion to Michelangelo. He never was the great master's direct pupil, but his declared aim was to imitate the style *(maniera)* of the "divine Michelangelo."[50] As Schlosser saw it, even Danti's treatise originated in the Michelangelo cult.[51] Condivi, the biographer of the old Michelangelo, relates that the master intended to compose an anatomical treatise for artists,

mainly because he considered Dürer's theory of human proportions—which was widely read in Italy—inadequate. He was particularly desirous of treating the body in movement, but old age prevented him from writing the book. The outline of Danti's planned treatise almost exactly fits Michelangelo's intentions. The main subject of the treatise is bodies in movement, and Michelangelo is quoted on practically every page. Moreover, Danti seeks to derive from Michelangelo's figures the "true rules" for representing bodies in movement.

For whom did Danti write? Had he completed his ambitious project (a veritable encyclopedia of all the themes of art theory), his monumental treatise would probably have been addressed, to a large extent, to practicing artists. The projected work is outlined at the end of the first book;[52] it was to have consisted of fifteen books. Books II–VII were to be devoted to the anatomy of man (and accompanied by drawings); book VIII, to the shapes of particular limbs; book IX would have discussed the reasons determining those shapes; book X would have dealt with postures and movements; book XI, with the expression of emotions in art; books XII and XIII were to take up the specific problems of *istoria,* landscape, animal pictures (i.e., the specific genres of art); books XIV and XV, finally, were to be dedicated to architecture, especially as derived from the proportions of the human body. However, this comprehensive program—the broadest known of its kind in the sixteenth century—does not tell us much of what precisely would have been Danti's point of view in analyzing all these fields. Almost all the subjects mentioned could have been applied in the workshops and discussed by the critic who had never himself produced a work of art. But, as we know, only the first of the fifteen books was written. Danti's treatise, as it now stands, is addressed only to a very limited degree to the painter or sculptor in the workshop. True, occasionally we come across annotations of value for our understanding of the workshop procedures of the late sixteenth century. Witness the remarks—so far as I know, the first of their kind—about the little wooden figures suspended from the workshop ceiling that enable the painter to study foreshortening. But such details are isolated. In general, the more intellectual, theoretical trend prevails. One is tempted to believe that the

public to whom the first *libro* is meant to appeal is composed of general educated readers, critics of art, or those humanists for whom art was more of a value than a workshop reality.

That Vincenzio Danti made *imitatio,* that commonplace term, the central concept of his theory would hardly deserve mention. Yet he took an important step in further defining that notion and in distinguishing the different shades of its meaning. In so doing Danti was not an original thinker; he was simply the mouthpiece of new trends of thought that came to dominate the art theory of the late sixteenth century.

No term was more banal in Renaissance aesthetics than "imitation." Perhaps precisely because of its frequent use it had worn thin, and its meaning had become pale and ambiguous. In broadest outline, in the Renaissance imitation was considered in two principal contexts: imitation of objects and imitation of manners. In bold oversimplification one can argue that ever since the days of Petrarch and Boccaccio declaring their wish to imitate the ancients, they obviously have the classical *style* in mind, the manner in which the ancients wrote.[53] In the theory of painting and sculpture, on the other hand, the physical, natural object constitutes the focus of imitation. Cennini speaks of "imitation" and "copy" in this sense.[54] During the fifteenth century the concepts of painters and sculptors became even more focused on objects than before. "True imitation"—as the correct representation was usually termed—is either the representation of the objects or figures as they really are (anatomy) or as they appear to our sense of sight (perspective). In any case, imitation is not understood as the following of a style. In the fifteenth century, the idea of the artist divorcing himself from any attachment to an inherited style had an important historical basis; to forgo all reliance on artistic models in favor of the direct, that is, independent imitation of nature was precisely the distinctive mark of the artist's emancipation from his low social and intellectual status of the Middle Ages. Of course, even in the Renaissance the idea of imitating a style was not altogether unknown. But an art based on the scientifically correct representation of nature almost by necessity led to outright rejection of the imitation of

styles. A painter who imitates the work of other artists instead of Nature herself, so Leonardo's famous dictum reads, becomes Nature's grandchild when he could have been her son.[55]

In the humanist movement of the same period the other interpretation of "imitation" gained the upper hand and, in fact, became the central feature of the humanists' program. A writer's or scholar's direct encounter with reality, and his exploration of it outside the inherited cultural frameworks, were not accorded crucial importance. The invention of individual motifs also did not count for very much. A single fable that goes beyond the traditional subject matter of Antiquity is sufficient. Pietro Bembo declared that even Virgil did not himself invent the fable of Aristaeus but took it from the Greeks and that Pindar invented only two new fables.[56] The guiding role of the classical authors consists in their establishing models of style. In the debate about the imitation of Cicero, a famous topic in fifteenth-century humanism, the argument was whether modern writers should imitate only Cicero, that exemplary model of pure Latin, or other authors as well. Everybody agreed that imitation refers to style.

It would lead us too far to attempt to trace the gradual assimilation of classical art in Renaissance painting and sculpture. That it began as the reception of subject matter and individual motifs and models from Roman Antiquity is well known from such excellent studies as Krautheimer's chapter on Ghiberti and Antiquity and from Janson's study of Donatello and the Antique.[57] If we focus our attention on *theoretical* statements, the situation seems curiously ambivalent. On the one hand, a vague idea of classical (Roman) art hovered before Renaissance artists' minds from the beginning of the period. As a theoretical concept, however, creation *all'antica,* that is, the imitation of classical *style,* becomes fully conscious only in the Cinquecento. A close reading of Vincenzio Danti's treatise convinces us that in bringing this principle to full awareness the literary theory of humanism played a significant role.

Danti's statement is one of the early, fully explicit definitions of *imitation* as the assimilation of a style. He did not reject the artist's immediate encounter with nature; he dissected corpses, as we know, and he asserts that, to properly depict something, we must compre-

hend the reasons behind the things *(la ragioni dell essere delle cose).* Yet all this is overshadowed by interpreting *imitazione* as a manner of doing. The core of Danti's program of art—the imitation of Michelangelo's *maniera*—depends on this interpretation of "imitation."

But even when we limit our interpretation of imitation to that of style, we can still distinguish two types. Danti calls them *ritrarre* (lit., "portraying") and *imitare* (imitating). We read: "by *ritrarre* I understand the representation of a thing exactly as it is seen by others, and by *imitare* I mean that a thing should be represented not as it is seen by others, in its incompleteness, but as it should be in its perfection."[58] The distinction between two types of representation, one strictly adhering to a model, the other idealizing it, is, of course, as old as is Renaissance theory of art, and would not of itself warrant any renewed discussion. In Danti's treatment of this time-honored topic, however, there are some amplifications that afford a model lesson to those intending to follow the intricate paths of art theory. The late sixteenth century took up the question of *imitazione* with a vigor that strikes the historian as unexpected. Could something new still be said about that *symbolum fidei* of Renaissance aesthetics, worn out by excessive use and often thoughtless application? But writers and artists in the last decades of the Cinquecento did, indeed, unveil new facets in that hackneyed notion. One of the more original contributions is that by Gregorio Comanini, a little-known clergyman from Mantua and a friend of the famous poet Torquato Tasso. In 1591 he published a little treatise, *The Figino, or the Aim of Painting (Il Figino, ovvero del fine della pittura).*[59] Comanini knew his texts. From Plato's *Sophist* (235d–236a) he derived a distinction between two types of imitation: there is an imitation of the things that actually exist (called, following Plato, *eikastic* imitation) and one of the things that do not exist (called *fantastic* imitation). The first represents things "shaped by nature"; the second "depicts his [the artist's] own fancy."[60] Imagination, then, becomes a source of imitation, but it can lead to fanciful images.

How common such ideas must have been one learns from another treatise by a clergyman, Giovanni Andrea Gilio's *Dialogue . . . About the Errors and Abuses of the Painters of Istorie,* published as early as 1564. Gilio rejects "caprice" in imitation and preaches a return to the "original

purity" of art.[61] "Original purity" is a rather ambiguous formulation; since Gilio certainly does not want to go back to the "correct repre- sentation" of the fifteenth century, his term may foretell the appear- ance of an anti-Mannerist trend in art as well as in aesthetic thought. Whatever he may have precisely meant by this and other notions, they suggest that in the mid-sixteenth century "imitation" was already being reconsidered as a central theoretical problem.

Danti's distinction between *ritrarre* and *imitare* marks still another stage in this historical process. The very coining of special terms re- veals as in a flash, how much the old distinction between the two types of representation has become a fully crystallized theoretical prob- lem. But it also indicates that art theory is now drawing from new sources. Danti derived the distinction between the two types of imi- tation, not only from the time-honored juxtaposition known in art theory since Alberti, but also from a literary source that was beginning to exert its influence, Artistotle's *Poetics*. Without going into the intri- cate history of how this classical text was transmitted, we can say that Aristotle's *Poetics* was "discovered" in the late fifteenth century (Angelo Poliziano had a manuscript copy of it), but it was made available to Renaissance scholars only in Pazzi's translation (1536) and Robortello's extensive commentary, which appeared in 1548. These dates mark the beginning of Aristotelianism in Italian literary criticism.[62]

In his *Poetics* (1451a ff.) Aristotle juxtaposes, as is well known, the poet and the historian and the specific nature of their crafts: "it is not the function of the poet to relate what has happened, but what may happen—what is possible according to the law of probability or ne- cessity"; the historian's task, on the other hand, is to relate what has actually happened. Aristotle is at pains not to make the contrast be- tween poet and historian a matter of form. "The work of Herodotus might be put into verse, and it would still be a species of history, with meter no less than without it." The true difference is in their aims: "poetry tends to express the universal, history the particular."

It is not difficult to see that, to artists and art lovers, the "universal" and the "particular" could easily be transformed into an idealizing and a naturalistic representation. Yet, while Aristotle's distinction became well known and was often quoted and commented on in mid-century

literary criticism, it did not as yet affect theories of painting and sculpture. Danti seems to have been the first artist who transferred this distinction—taken either directly from the *Poetics* or from Robortello's commentary—to the visual arts, and he further developed it by relating it to the two types of artistic imitation. "For between *imitare* and *ritrarre,*" Danti says, "there is the same distinction as between poetry and history." We should remember that the historian's craft was never even hinted at in art theory, and poetry was mentioned as a paradigm of the artist's ability to invent, not as a norm of style. But now Danti, a sculptor and theoretician of the visual arts, asserts: "History describes things as they are seen . . . and this is appropriate for history, to relate things exactly as they are seen and felt. And poetry expresses them not only as they are seen and felt but as they should be in their full perfection. . . . Similarly, *imitare* and *ritrarre* have the same goal."[63]

Few features reveal so clearly the transformation of art theory from a workshop doctrine into a "humanistic" discipline as Danti's borrowings from Aristotle's *Poetics* and their transformation into central categories of theoretical thinking in art.

The growing significance of the Aristotelian current in the theory of the visual arts is characteristic of the late sixteenth century. Since we will encounter it again in the course of this chapter, it may be well to remember that since its beginning Renaissance theory of painting and sculpture had been, more or less, under the spell of Platonism. Although, to quote Kristeller again, "Renaissance Platonism . . . was not as persistently anti-Aristotelian as we might expect,"[64] it still emphasized different aspects and produced a different atmosphere than did Aristotelianism.

Danti's most important concept of Aristotelian character is *attezza*.[65] This word is not easily translatable by a single term. Its ultimate origin is Aristotle's *entelecheia,* which, competent scholars believe, was the philosopher's own coinage. In Greek philosophy, *entelecheia* means a "state of completion or perfection, the attaining of a body's or object's final aim," and later it was also translated as "actuality." The concept had a long history that may have had some meaning for a Renaissance author. In Roman literature *aptum* becomes a theoretical term, especially in rhetoric, meaning: fitting, suitable, appropriate. Alberti, refer-

ring to Cicero (*De oratore* III. 45. 46), employs it in his theory of architecture. But the concept was also known in the Middle Ages. Dante, summarizing scholastic views in his *Convivium* (IV, chapter 25), asserts that the soul, acting within the body, will function properly when the body is well arranged and fitting its purpose. Vincenzio Danti's immediate source for *attezza* may have been Renaissance literary criticism, but the term as such does not seem to occur in Italian literary theory and is probably his own coinage. But, from wherever Dante took his concept, he adjusted it to the special problems of the visual arts. *Attezza* has the same meaning as Aristotle's *entelecheia,* but the scope of its application is different. A work of art can be properly executed only when the matter in which it is shaped has attained its perfection. If the stone in which a statue is carved is porous *(spugnosa),* that is, has not attained its *attezza,* which is to be hard, the work will fail. The same also applies to *what* we represent, and therefore the artist must know the "purpose of nature" in each object or figure. *Attezza* has an eminently aesthetic meaning. "Perfect proportions," Danti says, "are nothing more than the perfection in the composition of a thing to that full extent*[attezza]* necessary in order to attain its goal."[66] A little later he says that *attezza* "generates a beautiful proportion." In sum, then, beauty is fulfillment, the complete realization of a desired, or potential, form. The Aristotelian concept of *attezza* here reminds us of the old Neoplatonic image of realizing an Idea.

3. ARMENINI

To be sure, intellectualism dominated Tusco-Roman art theory, yet it would be mistaken to presume that this tradition consisted of nothing but abstract spectulations. It had, in fact, many facets, and an aspect differing from the main trend is represented by Armenini.

Armenini (1540–1609) can be counted among Roman authors only with some hesitation. Faenza, near Bologna, where he was born, is situated midway between Tuscany and northern Italy. He sometimes betrays his Venetian leanings in his critique of the painters in Florence and Rome: they excel in *disegno* but are weak in *colore.* For this reason Panofsky counts him among the sixteenth-century authors who protested against the Florentine fanaticism for *disegno.* But Armenini's

formative experience as a painter was his training in Rome (1550–1556) and the great impression that Tuscan artists made on him during his stay in the Eternal City. He was a diligent reader of Vasari's *Vite,* but he did not take over Vasari's hierarchy of artists; though he admired Michelangelo, his true ideal is Raphael, and he extols the merits and achievements of Raphael's followers, Polidoro da Caravaggio and Perino del Varga.[67]

In 1586 Armenini published his treatise, *De veri precetti della pittura,* just before he entered a monastery where he spent the rest of his life. As one vividly perceives when reading this treatise, Armenini felt that he was witness to the decline of a great era. He speaks of the *malignità de' tempi*[68]: the great masters have died; ignorance prevails; the monumental achievements of the recent past are endangered. This feeling lies behind his attempt to write a comprehensive system of painting that would preserve for future generations the great "truth" of High Renaissance art. Nobody before him, so he believes, has done this. His voice comes from the workshop, and it is saturated with the experience of creating actual works of art. But let us not forget: this is the workshop of the second half of the sixteenth century, and it is almost worlds apart from the medieval or early Renaissance workshop. The very title of Armenini's treatise suggests a program typical of the late sixteenth century. He is not content with transmitting the experience gradually accumulated from artists' successes and failures; what he wants to formulate are the *true* rules.

The doubts his generation had cast on the validity of rules in general—a subject to which we shall return at the end of this chapter—have not escaped his attention. There are those, he says in the *proemio* to his treatise, who maintain that painting "is so difficult that it cannot be taught by the written word except in certain confused, feeble, and poor principles, and they add that it [painting] is a virtue and grace poured from heaven into human bodies which cannot be acquired by other means." What worries Armenini is not the view that art cannot be taught *in writing* but that it cannot be taught *at all*. A "virtue and grace poured from heaven" cannot be acquired by rational study, and if we accept this view, the very basis of "rules" is undermined. But Armenini spurns these prophets of an innate artistic genius that cannot

be acquired by learning. "How stupid are those," he says in rather frank language, "who have got into their heads the idea that this [i.e., painting] is one of those speculative or occult sciences which are only revealed and comprehensible to the deepest and most acute minds." Rules that can be learned also by those who are not among "the deepest and most acute minds" are "the unchangeable foundation of art."[69]

The rules Armenini presents, however, are not of the kind we remember from the fifteenth century. Their contents are different, and so are their ultimate aims. In the extensive index to *De veri precetti della pittura,* compiled by Armenini himself and printed in the first edition, there is only one brief mention of "anatomy" (in the text itself we read that a knowledge of anatomy is "useful" to the painter of nudes); and for perspective, that paradigm of scientific rules in the fifteenth century, there is no entry at all. It is not "correctness" that his rules are meant to secure, and he has no interest in the artists preceding Leonardo who were so devoted to scientific rules—and this in spite of the fact that he shows a curiosity for rare techniques: the ancient mosaics he saw in Rome are *mirabile.*[70]

De veri precetti provides interesting, authentic information about workshop auxiliaries, such as the little figurines in different postures, made of wood, terra-cotta, or other materials,[71] which served for purposes of study, especially of foreshortening, and as models. But such observations, some of which we know from Danti's treatises, are only marginal. Armenini's principal aim is a different one. The first thing that meets the eye when reading *De veri precetti* is that he wants to educate the artist. In this respect, as in others, he represents the "afterlife" of an old tradition: his treatise is addressed to artists. Only when keeping in mind the public for which he writes can we understand why he deplores the difficulties young artists encounter when they wish to learn the "secrets" of coloring. To help artists overcome such difficulties he writes his book. His principal aim, however, is to educate artists to the *buona,* or *bella, maniera.* It is not competence he wants to teach his readers but a good style.

One way to reach this goal is to know he different media, what each of them offers and what it precludes. He devotes much attention

to media, which so far, though very well known to every artist and spectator and frequently mentioned in historical literature, have not been treated in art theory. One example will make this sufficiently clear: What is the difference, our author asks, in coloring between fresco and panel painting?[72] Questions such as this must have been talked about almost daily in the workshops, yet Renaissance art theory ignored them.

Another method in the artist's education is the study of the great masters' *modi*. Armenini's concept of *modo*—similar to that commonplace term, *maniera*, but not quite identical with it—combines an artist's technical procedures with the overall expressive character of his work. There is a *modo* of preparing the canvas for painting[73] and a *modo* for "easily drawing from nature."[74] But there is also a *modo* of Michelangelo, which is "difficult," and one of Raphael, which is gracious. That Armenini uses the same word for what we would today designate by different terms is not just a semantic deficiency. It indicates the unity of the two aspects. What a young artist should learn from the great masters' *modi* is both their actual procedures (e.g., what their steps were in preparing a picture) and the aesthetic quality of their work; in modern parlance, their style. From classical art, too, we learn the *modo*. He lists most of the ancient sculptures that had come to be considered as canonical in his time—the *Laocoön*, the *Torso Belvedere*, and so on. What Michelangelo and other modern artists derived from those classical pieces was their *modo*, in both senses of the term. Armenini wants to educate artists by making them assimilate great models of style.

Armenini's observations on *disegno* are an important testimony to the rapid changes in the workshops' outlook and the public's taste. After paying some lip service to the fashionable intellectual conception of *disegno* as the image in the artist's mind, he deals with "drawing" in a more practical way: as a medium and as a material object. "Drawings," we are informed, are made in different materials and techniques.[75] He distinguishes four types of drawing, and they should be practiced by the young artist in the sequence indicated. The first type consists of the simple outline. The second is an ink drawing, in which the contours are done in sharp lines and the shades in slight washes.

The third type is an ink drawing on colored paper: the paper provides a medium tone; lights are placed in white strokes; and the deep shadows are depicted by dark washes. The fourth type is a drawing in charcoal or red chalk: these soft materials enable the artist to draw quickly and make it possible to combine deep, dramatic contrasts with gradual, delicate transitions. Looking back from the viewpoint of, say, 1900, we have to admit that not much change took place in the course of the centuries that elapsed since *De veri precetti.*

Armenini also discerns between different manners of drawing. Dürer's drawings, though representing all the *minutezze,* are pleasant to look at.[76] Leonardo's small drawings are superior to anything else in "science and wisdom."[77] Sketches, catching a figure's general posture,[78] are most frequently mentioned in connection with Italian artists, but prints are predominantly a "German invention."[79] Armenini also records that drawings, mainly by Michelangelo, were traded in Rome in his days. What all these observations attest to is that drawing had come of age as an accepted medium of art.

Armenini's most original, but least noted, contribution is his discussion of what would now be called art forms. These explorations fill the third book of *De veri precetti.* The idea that each art form has a different character is, of course, not new. That paintings representing an *istoria* should have a special character was generally accepted since the very beginnings of Renaissance theory of art. As we remember, Alberti expressed this view, and we would be hard pressed to find a single author between 1435 (when Alberti wrote his *Della pittura*) and Armenini's own days who would not repeat that an *istoria* should be rendered in a heroic manner. But what of the other art forms? Here Armenini takes an important step. He devotes separate chapters to the character of painting in palaces, to the decoration of libraries, and deals extensively with painted facades. But most important for the history of art theory is his treatment of portrait painting.[80] That a portrait is a painting of a lower rank than an *istoria* was an axiom in Renaissance theory of art: Danti, as we have just seen, even uses "portraying" *(ritrarre)* to indicate a representation lower than the more noble *imitare.* Vasari required for portraits strict resemblance; other authors preferred

an idealization of the sitter's imperfect features. Armenini does not assign the portrait a rank in the hierarchy of art forms. He comes close to saying—though he never so states explicitly—that a portrait should be neither an extremely realistic image of the sitter (some kind of snapshot) nor an idealization of his appearance that tends toward anonymity. A portrait should represent the sitter's personality. As usual, Armenini's treatment is not abstract; his chapter is filled with vivid and perspicuous memories of painted portraits, some of which are still well known. Among his great examples are Raphael's portraits of Pope Leo X and Pope Clement. The most important portrait painter, Armenini says, is Titian. He speaks particularly of Titian's portrait, *Paul III with His Nephews* (the picture is now in Naples) and of his portrait of Charles V (but it is not clear which of the king's pictures he had in mind).[81] From the context in which these portraits are analyzed we learn that, in Armenini's view, such works cannot be considered merely as poor relatives of the heroic *istoria*. The portrait is a specific art form, with its own character and values, a distinct and dignified field of artistic creation.

In all this, one may safely assume, Armenini was not being original and inventive; he was probably only articulating what must have been felt intuitively by both artists and the public. But the very fact of putting such feelings and intuitions into words (even if the sentences are often not conclusive) proves that in the late sixteenth century another domain of painting, and of art theory, became fully established and recognized.

III. VENICE

Vasari records Michelangelo as saying that Titian's "manner of coloring greatly pleased" him, but "it was a pity that the Venetians did not study drawing more." The Venetians, then, were conceived of as a distinct school or tradition. A few years earlier, Paolo Pino, himself a painter, wrote his *Dialogue on Painting,* the first art treatise on painting to be composed in Venice. At the beginning of the dialogue, Fabio, who later turns out to be a Florentine, says to his interlocutor: "You

speak as a Venetian."[82] A decade or two later, the expression "Florentine drawing and Venetian coloring" became a commonplace, inescapable in almost any Renaissance text dealing with the art of its time.

Anyone even slightly familiar with the history of Renaissance art is acquainted with these opinions, and there is no need for us to adduce further examples. Nor do we have to decide whether they are correct or inaccurate. True or false, in the Cinquecento it was assumed that there was a distinct Venetian character in all artistic matters. When an educated sixteenth-century Italian used the adjective "Venetian" he knew what he meant, and his audience understood him without difficulty.

In art theory it is hard to draw a clear line of demarcation between Venetian and Florentine traditions. The impact of Florentine thought is felt in everything Venetians wrote on art. In fact, such was the power of Florentine aesthetics that Renaissance theory of art, both in Italy and outside it, is altogether inconceivable without the conceptual framework established in Florence. But, as I hope to show, in art theory not less than in other fields it is possible to distinguish features that are specifically Venetian, though this may often be more a matter of where the emphasis is placed than of distinctly different theory. Venetian art theory, with one exception, to be explained later, concentrates on painting and neglects sculpture, an indication of how close it was to the art of Venice. The literary forms and the spirit of the writing are different: while in Florence the rigorous systematic treatise prevails (even Leonardo's scattered notes were eventually meant to be composed into a well-ordered *libro*), in Venice the literary form of the dialogue, a looser and much more casual form, was preferred. As the literary shape, so also the "tone": Venetians like to tell anecdotes or to make polite or ironic allusions; Florentine authors are usually very much in earnest. But two external features are particularly prominent: Venetian art theory began at least two generations later than that of Florence. In Venice we find no counterpart to Cennini or Alberti and Piero della Francesca. The first texts that can be counted as art theory, though with some hesitation, were composed long after the classic achievements of Florentine theory had become famous throughout Eu-

rope. Venetian art-theoretical writing proper begins only in the middle of the sixteenth century.

Another feature, not less striking than the chronological, is the public that the authors had in mind. Perhaps more than anywhere else in Italy, Venetian art theory is addressed to the spectator, the educated public, rather than to artists. Even when the authors are themselves painters—as, for instance, Paolo Pino and Cristoforo Sorte—the content of their treatises is theoretical, removed from the workshop and transmitting little of its atmosphere. Most Venetian authors never practiced any art at all, and their aim is to explain art to the public rather than to guide the artist in his work.

1. PRELUDE

Two texts, differing in character, form an unusual prelude to the blossoming of Venetian art theory. In our context, both are to some extent problematic. One, Pomponius Gauricus' *De sculptura,* can doubtfully be called authentically Venetian; the other, the famous *Hypnerotomachia Polifili,* can be defined only with considerable hesitation as art theory. Yet they both belong to the beginning of Venetian thought on the visual arts, and they may illuminate the positions and problems of the next generation, which produced art theory in the more usual sense.

Different as these two works are, they share an extremely broad scope: geographical and cultural in the case of Gauricus, literary and intellectual in the *Hypnerotomachia.* They both show that Venetian art theory began marginally, whether the margins were geographical or cultural. We have nothing here comparable to the solid Florentine tradition, unfolding from the workshop to the humanists, and always written by Florentines, for artists in Florence, and to a large extent dealing with Florentine monuments.

In the almost universal scope of his interests Pomponius Gauricus can serve as a model embodiment of the so-called Renaissance man.[83] He was a poet, a humanistic scholar, a professor of philology at the University of Naples; he knew Greek rather well (something quite rare in his time even among the erudite); and, at the same time, he was also a sculptor of more than amateurish competence. This multifaceted

personality was born in Gaurico, near Salerno in southern Italy, around 1482. His background was one of learning. His father was a well-known grammarian, and one of his brothers, Lucas, was a mathematician, famous in his time for dealing with that branch of science which was of the greatest significance for painting, namely perspective. Lucas edited the *Perspectiva communis* by John Peckham, a late medieval book on optics still studied in the sixteenth century. As a young man Pomponius Gauricus came to Venice and studied at the University of Padua from 1501 or 1502 until 1507. Some of his fellow students were to become famous scholars and writers: Girolamo Fracastoro, a humanist and physician; Ramusio, the future editor of *Navigatione e viaggi;* and Pierio Valeriano, whom we have already met as Vasari's teacher. Among Gauricus' teachers were such famous humanists as Pietro Pomponazzi, then a professor of philosophy at the University of Padua. But Gauricus was not devoted to bookish studies alone. He owned, as is attested by the so-called *Anonimo Morelliano* (a list of Venetian collections composed by M. Michiel in the early sixteenth century), many pieces of ancient sculpture, as well as works by modern painters, among them a panel by Van Eyck. He was also a collector of manuscripts; the famous Joshua Roll, now one of the most precious treasures of the Vatican Library, was in his possession. In addition to this, he had a small workshop where he worked on bronzes. His contacts with contemporary artists must have been close, and he mentions some of them, including Mantegna.

As a young man of about twenty-two, and while still studying in Padua, he published in Florence a Latin work, *De sculptura* (1504). Both the thought and the style of this work reflect Gauricus' exceptional position. He uses much Greek (which he must have learned in southern Italy, where a modest tradition of Greek learning still persisted), often without any real justification, giving the impression that he is showing off his erudition. His allusions to ancient literary sources are numerous, exceeding what was accepted in art theory of his time. Yet his treatise is not merely another laudatory epistle of art composed by a humanist who knows sculpture only from what he has read in old books. Gauricus knows the carver's, especially the bronze caster's, trade, and all the ornate Greek terminology cannot conceal his genuine fa-

miliarity with the workshop, a familiarity that could have been gained only from direct experience.[84]

In both style and content *De sculptura* is a strange mixture of commonplaces and unusual topics. The terminology, too, is often arbitrary, and most likely invented by the author himself. The treatise is composed in the form of a dialogue, and the two figures appearing in it are not imaginary. One is the philologist Regius, a commentator of Quintilian, on whose interpretations of that venerable text Gauricus often relied; the other, Leoninus Tomeus, was the first commentator of Aristotle's Greek text in the earliest printed edition. That Gauricus should have selected these two scholars as the interlocutors in his dialogue is not surprising in view of his erudite leanings. But that he should have made these two bookish humanists, who never had anything to do with producing a work of art, discourse in some very technical aspects of sculpture is more than we would expect.

That their discourse frequently deals with commonplace topics, such as perspective and proportions, need hardly be emphasized. It may, however, be worth noting that in the chapter devoted to proportions, or *symmetria* as Gauricus calls it (chapter II), the Platonic tinge of the views expressed is stronger than is usual in similar treatises of the period. Our author also makes detailed and precise references to Plato's *Timaeus*.[85] But we are more interested in the new subjects to be found in Gauricus' treatise. The very fact that large parts of the work are of a purely technical nature, mainly pertaining to bronze casting, is striking. It is astonishing to observe the two venerable humanists— so well versed in the subtleties of Greek and Latin grammar and in the intricacies of editing ancient texts—exploring the shapes and functions of furnaces and giving such earnest attention to the quantity of sand that should be added to the plaster.[86] Some parts of *De sculptura* are indeed so purely technical that they are unique in the art theory of the early sixteenth century. Were it not for the refined Latin style and the many Greek terms disclosing literary erudition, parts of the treatise could have been taken from medieval precept books. In concentrating on bronze casting, the author may be reflecting a local Venetian tradition. As we remember from previous chapters, sculpture was divided into two major categories, carving and modeling. Carving in

stone was generally considered the more noble form, and this view was certainly prevalent in Florence. An artist who "adds," instead of "taking away," Michelangelo said, does not deserve to be called a sculptor.[87] In the Venetian domain the situation was different. Monumental stone sculpture was almost nonexistent, but since Donatello introduced the art of bronze casting to Padua in the mid-fifteenth century, this technique continued to be in use in the region. Perhaps in concentrating on bronze casting, Gauricus shows us that he is not borrowing his art theory from books. The brief chapter VII (hardly more than a page) on the different "species" of sculpture is revealing both for what it includes and for what it omits. The kinds ("species") of sculpture are arranged, in a somewhat jumbled manner, according to the materials in which the works are executed, or according to the techniques of execution. Thus we have modeling, sketching (*protoplastice,* in the author's Greek terminology), carving in ivory, cutting, and other types of sculpture. Carving in stone is omitted. If there were any need to show that Pomponius Gauricus' classification is not taken from books, the omission of work in marble, the most frequently quoted sculptural art, would be sufficient. Other details also attest to the origin of *De sculptura* in actual workshop experience. Chapter VI. 15 is misleadingly called "Chemike," an expression that, with its alchemist connotations, was probably coined by Gauricus himself. It deals in great detail with the implements, materials, and procedures of bronze casting.

But the most interesting original feature in *De sculptura* is a long discussion of physiognomics (chapter III). The study of physiognomics—that is, of the manifestation of character and emotion in the human face—did not, of course, begin with Gauricus. Interest in this field was always alive in the figurative arts, especially in the Renaissance. Art theory, too, did not altogether disregard it. Alberti, and particularly Leonardo,[88] occasionally made remarks pertinent to the subject, Leonardo's perhaps connected with his caricatures. Dürer, in his *Four Books of Human Proportion,* offered a brief treatment of abnormal physiognomics. But before the sixteenth century no separate theoretical discussion was devoted to the subject; Gauricus' is the first, and it precedes by two generations the full flowering artistic and theoretical

interest in physiognomics. One cannot help wondering what precisely made Gauricus include a long chapter on physiognomics in a book on sculpture and how the treatment of this subject relates to the other topics discussed in this work.

Physiognomics itself, without any relation to art, has a long history; beginning with Aristotle's *Physiognomica,* through late antique commentaries (Ptolemon, Adamantius) to the late medieval Latin treatise, *Secreta secretorum,* this slightly occult science enjoyed a continuing tradition. In the Renaissance it received much attention. A treatise on the subject, now lost, is attributed to Ficino. In the early sixteenth century Venice seems to have been a center of physiognomic studies. Pomponius Gauricus must have derived his knowledge of physiognomics from this learned tradition rather than from workshops. This is made even more likely by the fact that Pomponius' brother, Lucas Gauricus, much later (in 1551) published a learned compilation of physiognomic texts and specifically mentioned that his brother, at the age of eighteen, wrote a "book on sculpture and physiognomics."[89]

The structure of Gauricus' chapter on physiognomics does indeed closely follow the composition of the classical treatises on this "science." The different parts of the face are treated in separate paragraphs, under special headings. Even the sequence of these features (eyes, eyelids and nostrils, nose, forehead, mouth, etc.) is the one most frequently found in the ancient treatises. They all provide clues to a person's "soul." Aristotle, as well as the other physiognomists, is frequently quoted. It is also remarkable that in this chapter not a single concrete reference is made to the workshop. It is an altogether learned, literary chapter.

Little can so clearly show the unique position of Pomponius Gauricus as well as of Venetian art theory in general as this juxtaposition of strikingly technical passages and a learned discussion of a subject not yet integrated into the theory of art.

2. HYPNEROTOMACHIA POLIPHILI

Like the numbering of Gauricus among the Venetians, the inclusion of the other work belonging to our prelude, the *Hypnerotomachia Poliphili,* in a discussion of art theory, demands an explanation. Its author, Fran-

cesco Colonna,[90] was a Dominican monk, born in 1433 in Treviso, who died in Venice in 1527. The work appeared anonymously, but the author's name is indicated by a cryptogram, and Francesco Colonna's authorship now seems to be generally accepted. In one place the work is dated 1467, but some scholars believe that the author kept working on it till the date of publication, 1499. The *Hypnerotomachia,* in many respects, is a remarkable book. Composed in a strange combination of Latin and the Venetian *volgare,* it is considered an important document by linguists. Some of Colonna's coinages are of interest for the art historian. Let us remark only that the term "arabesque," now so commonly used, probably appeared here for the first time.[91] The book is also noteworthy for its sumptuous shape (it was printed by Aldus, the great Venetian publisher) and for its exquisite woodcuts.

The *Hypnerotomachia Poliphili* follows the medieval tradition of the allegorical novel, known to us from many examples, including the *Roman de la Rose* and Boccaccio's *Amorosa visione* (the latter seems to have been of particular significance for our author). Its intricate, complex plot, combining the world of dreams and fictional reality, is not for us to explore. At first sight, it would seem, such an allegorical love story cannot be counted among art-theoretical treatises. The author does not want to instruct artists; nor does he even "explain" art in the categories so well known in the fifteenth century; nowhere are perspective and anatomy mentioned. Nothing could be more remote from this allegorical tale than the artist's workshop. Indeed, the value of the *Hypnerotomachia* for the art historian lies in its reflecting an atmosphere rather than in providing a "theory." But the student of art theory may also find that it sheds light on the background of certain topics. The almost religious veneration of Antiquity is one example. By the end of the fifteenth century this was, of course, not exclusively characteristic of Francesco Colonna. Yet the *Hypnerotomachia Poliphili* reveals some special facets in the Renaissance attitude toward Antiquity, and these foreshadow important future developments.

Antiquity, "hoary, venerable Antiquity," as our author puts it, appears in the guise of a beautiful and tempting nymph, Polia. Antiquity is not only a vague generality, a utopian ideal one sees in an attainable distance, or the mere concept of a style. The author devotes a great

deal of attention to actual remains; he closely observes fragments of ancient sculpture and architecture. To be sure, many of these remains are described, and reconstructed, in a way that reveals that they are the author's inventions. But some of the pieces he describes are not the product of his fancy; they have been identified by modern scholars as ancient works of art that could be seen in contemporary Venice (such as the *putti* relief, then in the Venetian Church of the Miracles). The obelisks he describes are another case in point. Borinski believes that Francesco Colonna's major significance lies precisely in his accurate descriptions of works of art.[92] However literary and imaginative he was, he must be counted among the earliest Italian antiquarians. He is also one of the earliest authors to express an almost romantic melancholy on the subject of ruins. "Look a while at this noble relic of things great in the eyes of posterity," says Polia to her lover when they come across the ruins of an ancient temple, "and see how it now lies in ruins and has become a heap of fragments of rough and jumbled stones."

Another characteristic is Colonna's propensity to discover hidden "meanings" in the figures, motifs, and compositions of ancient art. His antiquarianism differs from that of later centuries. He does not simply delineate, with the utmost care and precision, the vestiges of the past. The objects he describes are charged with mysterious messages. Ancient art presents endless riddles and hidden truths that can be solved and deciphered. The fine woodcuts illustrating the original edition of the *Hypnerotomachia Poliphili* are meant to aid in the decoding of these secrets. The *Hypnerotomachia,* then, is also an early document of that absorbing fascination with emblems that became a major cultural force in the sixteenth and seventeenth centuries.

3. THE SYSTEM OF PAINTING

The *Hypnerotomachia Poliphili* and Gauricus' *De sculptura,* published within only three years of each other, are merely a prologue. The efflorescence of Venetian art theory began later; it burst forth suddenly, it would seem, and within a single decade it was practically concluded. This period of intensive production begins with Paolo Pino's *Dialogue on Painting* (1548), the work of a mediocre artist, who was, however,

intimately acquainted with the painting of his city. Only one year later
a Venetian physician and litterateur who had spent a long time in
Rome, Michelangelo Biondo, published his *Della nobilissima pittura* (1549)[93]
The text, not very clear in structure, is a compilation of passages culled
from a great many authors, and its main value lies in its being a faithful
mirror of what was being read at the time. In the same year a Flor-
entine author, Antonio Francesco Doni, published in Venice a short
treatise with the cumbersome title, *Disegno partito in più ragionamenti ne'*
quali si tratta della pittura.[94] Its author, who had left a monastic order
and become what we would now call a journalist, is remarkable for
his satirical vein; he appended to his treatise some parts of his corre-
spondence, thus further demonstrating its unsystematic character. In
1557 the masterpiece of Venetian art theory appeared, Lodovico Dolce's
Dialogo della pittura intitolato L'Aretino.[95] Its author, a prolific writer on
a variety of subjects, had no direct artistic experience, and what he
presents is the layman's and spectator's outlook. Almost a generation
later appeared Christoforo Sorte's short *Osservazioni della pittura* (1580).[96]
In this work Sorte, a painter of some significance, provides a kind of
epilogue to Venetian art theory.

Although compressed into such a short period of time, Venetian
theoretical writings are far from uniform. The Florentine tradition that,
as we have seen, had developed organically, was governed by one main
trend—intellectualism. Venetian art theory lacks a single dominant trait.
In this unique city, open to the Byzantine East and the Italian south,
to northern Europe as well as to Tuscany, a more cosmopolitan at-
mosphere prevailed, and almost inevitably it is reflected in its art the-
ory. Some of the authors who shaped Venetian theory were not of the
city by either birth or education; some who were spent part of their
lives in other places. In spite of all this, we are entitled to speak of a
Venetian theory of art.

The cultural background of that theory was also full of contrasts.
Venice was a center of humanistic scholarship in a very precise sense.
Here the first editions of ancient authors, especially of Greek classics,
were edited and published. In the early sixteenth century Venice was
perhaps the capital of Europe in respect to the emendation of texts.

In philology and antiquarian studies it overshadowed Florence, as Florence overshadowed Venice in respect to the bold flight of ideas.

But the editors of manuscripts and collators of texts were not the only types of intellectual to dominate the scene. The frivolous Pietro Aretino (1492–1556), though himself a Tuscan by birth, is not less typical of Venetian culture than Aldus, the careful and learned publisher of the antique heritage. Few escaped Aretino's biting tongue. The main objects of his satirical criticism were the frequent attempts of artists in his time to follow the lead of venerated masters, to imitate their style. In literature he ridiculed the "Petrarchists," the followers of the laureate poet's pure and elevated manner. In a letter written in 1537 he relates his mock dream of ascending Mount Parnassus. He gets caught in an avalanche of people hurtling down from the immemorial mountain: they are the poets who imitated the time-hallowed styles and are now about to drown in a sea of ink.[97] The same attitude characterizes his approach to painting. What he praises is the immediate experience of nature, a vivid representation of what one really sees: in brief, originality. He is less interested in the sublime ideas that may have inspired a work; it is the painting's sensual qualities that attract him. Thus, he savors the subleties of Titian's color or the feeling of texture that painters can transmit. In the twentieth century Pietro Aretino would probably have been called a critic rather than a philosopher of aesthetics or a theorist. Indeed, he was probably the first layman-critic who judged a work of art just because it appealed to him and evoked his response, without caring for either the correctness of the representation or the profundity of the thought suggested in it.

It is against this multifaceted cultural background that we should see Venetian art theory as it emerged during the decade between 1548 and 1557.

In literary presentation, too, Venetian art theory differs from its Tuscan counterpart. Since Alberti imposed his strict university education on art writing, the typical Florentine treatise had been manifestly systematic. And even though Vasari tells stories full of piquant details, he still organizes his work in rigorous structure; it is divided into three stages *(età)*, all neatly distinguished from each other, and it is prefaced

by dry technical accounts of the three separate arts discussed in it. In Venice a system of art theory is not altogether absent, but it is hidden from sight. The literary form preferred here is that of the free dialogue, where the main theories are presented in a casual manner. Venetian authors certainly do not forget to make learned references to classical authors, but they obviously strive to impart to their writings a tone of light conversation. The setting of these fictional dialogues is also sometimes slightly frivolous. Paolo Pino opens his *Dialogue on Painting* by inviting his interlocutor into a company of beautiful women and concludes it with a bow to irresistible feminine charm. Lodovico Dolce, by the very fact of making Pietro Aretino the main speaker of his dialogue and calling the whole work the *Aretino*, suggests an atmosphere of slight sarcasm and sensuality. In his defense of the artist who is called upon to correct nature, the illustrative example chosen is again a woman. Apelles and Praxiteles could render their celebrated images of Aphrodite after Phryne, the most beautiful of courtesans; but nowadays, Dolce laments, no such beauty can be found in a single woman. This lightness of tone is all the more remarkable because Lodovico Dolce was neither an art critic, like Pietro Aretino, nor any kind of courtier for whom fluent and easy conversation was a cherished aim. Dolce, a prolific writer, dealt with a great variety of erudite subjects, including an interesting discussion of color symbolism (which has, however, nothing to do with art). In adopting the conversational tone in the *Aretino*, was he adopting himself to what was considered appropriate in Venice to a treatise on painting?

But, colloquial as the literary tone may be, Venetian art theory is not altogether devoid of a conceptual structure. It is hidden, but it can be made manifest. The theory of painting, as we can define it from Pino's and Dolce's texts, consists of three parts: *disegno, invenzione,* and *colorito.* The division of art theory into three parts was well known since Alberti divided his doctrine on painting into the three parts he called "Basic Principles," "Painting," and "The Painter." Though Pino and Dolce apparently follow Alberti in the tripartite division, the character of the individual parts is altogether different. They omit Alberti's first part, the "Basic Principles." What Alberti discussed there and believed to be essential to his theory of painting—the mathematical

foundations of correct perspective and the geometrical definitions of point, line, and surface—are in Venice rejected out of hand. In the introduction to his *Dialogue* Pino refers to Alberti's *On Painting* ("a treatise in Latin," as the Venetian painter does not forget to point out), which "deals more with mathematics than with painting, although he promises the opposite."[98] Alberti's third part dealt with the painter's education. Here again the difference is obvious. While Pino and Dolce occasionally make some remarks on the young artist's training, nowhere do they devote a special discussion to this subject. One can easily understand the reason for this difference. Alberti wrote, at least partly, for painters; he wished to shape the new artist's education and considered the curriculum of his studies of major importance. The Venetians, on the other hand, write mainly for the general public; the details of the painter's education therefore have at most only marginal importance. What they want to do is to explain what the art of painting is, and this is what would principally interest the general reader.

The division of "painting" into three "parts" (*disegno, invenzione, colorire*) is common in sixteenth-century Venice, but their sequence is not inviolable. Dolce's order, for instance, is invention, design, and coloring. Whatever the particular sequence, the meaning of each individual part is the same in all Venetian treatises. Since Pino is most explicit in his presentation, we shall follow his lead.

Disegno is the most complex and the most tangled of the three parts. Florentine influence is of course strongest in the interpretation of *disegno*. Pino subdivides *disegno* into four components: judgment, circumscription, practice, and composition.[99] These components are heterogeneous, and their combination in one group contributes to the vagueness of the concept as a whole. Judgment, as we have already said,[100] cannot be taken in any sense as part of painting in a well-defined technical sense. In Venice, not less than in Florence, it suggests a general trait of the artist's personality, a faculty that applies to the same degree to "drawing" as it does to the other parts of painting. It need not even be limited to painting. "Men of judgment," Dolce says, are "like a piece of poetry to be of moderate length."[101]

If *giudizio* is so broad in scope because it refers to a quality of the artist's personality, the last category of *disegno* (composition), is com-

prehensive because it constitutes the combination of all the other categories, as Pino himself declares. What he had in mind is probably the general disposition of the completed work of art. We are thus left with two specific categories, circumscription and practice. In *circonscrizzione* Pino clearly followed Alberti, who defines this term as the outlining of the object or figure represented (*On Painting* II. 30). Dolce understands design in the same sense, though he adds something that evokes the character of the line. "Design," Aretino is made to say, "is the form imparted by the painter to the things he sets about imitating." [102] Thus far he repeats Alberti's definition of the term as the outlining of the object or figure to be represented. But he departs from Alberti in important respects. When Pino speaks of "circumscription with the brush" *(circonscrizzione con pennello),* [103] he probably refers to Venetian painters' habit of drawing with the brush, a practice unknown in Florence. An even more radical deviation from Alberti's views is Pino's association of "outlining the figures" with "adding to them the whites and the darks [shadows] of things, as you would require of a sketch." For Alberti the principle of outlining (i.e., of describing the "boundary of things") is so abstract that it is divorced from any practical application. Pino turns this abstract principle into a real drawing by adding the whites and shadows. Moreover, in Alberti's view "outlining" is, so to speak, a timeless principle, ever present in any completed picture. For Pino it is a hastily done drawing and is thus a document of a specific stage in creating the work of art, a "sketch," as he says. [104]

Practica is also one of those changeable terms so favored in the sixteenth century. As we shall see in the next section, it could have a broad range of meanings. In Venice, however, it is mainly employed to designate the study and exercise by which the artist acquires manual skill. Dolce uses "practice" and "experience" as synonyms. [105] It is curious that practice and skill are not considered as conditions for painting in general but are grouped with the specific requirements of *disegno.*

"Invention" *(invenzione)* was a popular concept in sixteenth-century theory of art. Nobody opening a late Renaissance treatise can escape a discussion of *invenzione*. In the sixteenth century, writers primarily meant

by this term the subject matter of the work of art that the artist drew from literary sources, whether from the Scriptures, classical literature, or history. Alberti wishes to be "learned in the liberal arts," though he still places more emphasis on the need of "a good knowledge of geometry" (*On Painting* III. 53). It will be of advantage to the painters, he says, "if they take pleasure in poets and orators"; from them, we must conclude from the context, the artists will learn invention: "Literary men are full of information about many subjects." Anticipating theories that became common only in the late sixteenth century, he says, "invention is such that even by itself and without pictorial representation it can give pleasure." The inevitable examples of classical subject matter (such as *The Calumny* of Apelles) and the allegorical figures that the Renaissance derived from, or projected onto, Antiquity, are then advanced.

In Venice, too, *invenzione* primarily means subject matter. The "invention," Lodovico Dolce summarily declares, "is the fable or history which the artist chooses."[106] For Pino "invention" more specifically means "the finding of poetry or history," which is one of the artist's tasks.[107] But Dolce is more liberal: "invention" can also be presented to the artist "by others." It is, he says, the "material for the work he [the artist] has to do." All this, then, suggests that "invention" means subject matter in a purely literary sense. Modern formalistic aesthetics could maintain that it does not belong to painting as such.

Yet such a view, if understood literally, would be mistaken, at least as far as Renaissance thought is concerned. Form and content were not conceived as separate airtight compartments. In Venetian art literature *invenzione* is a curiously ambiguous term. A careful reading of the texts shows that "invention" refers not to the literary subject matter from which the actual work of art, in the sense of what we see in it, may be safely separated without suffering essential damage. Instead, *invenzione* constitutes a bridge between the literary and the visual, between the unrepresentable and what is actually represented. It is particularly closely connected with the emotional character of the figure of work, with what we are now in the habit of calling expression. By *invenzione* the authors frequently allude to the painter's adaptation of his shapes to fit the story he is depicting. "Subject matter," Dolce

explains, "simply supplies the painter with his material. From his intellect, over and above the elements of disposition and propriety, there come the poses, the variety, and again (so to speak) the dynamism of his figures." [108] Both together form *invenzione;* "Invention originates from two quarters, the subject matter and the painter's intellect." There is, then, a specifically *pictorial* side to invention that goes beyond the merely literary subject matter. Therefore, Dolce warns, "the painter should avoid being slipshod in any of these areas which come under invention." He should bear in mind that the "target of his representation is the spectator's eye." Note: the spectator's eye, not the reader's ear or mind. Dolce is aware that all this invention "links up with the matter of design." Pino was also perfectly aware that "invention" has formal visual aspects. Under *invenzione,* he says, comes the proper distinction of the objects represented; and, he specifically adds, the good accommodation of the subject matter to the actions and characters of the figures.

This concept of invention can be amply illustrated; one or two examples will suffice for our purpose. One of the best-known and most-often-told stories in Renaissance theory of art is that of the ancient painter Timanthes who depicted the sacrifice of Iphigenia. Having to represent "On the faces of the bystanders every aspect of grief, he [the painter] did not trust his ability to make the grief on the face of the sorrowing father greater still." Therefore, the legendary artist "arranged for the father to cover his face . . . with the edge of his mantle." Alberti had already told the story (*On Painting* II. 42), but Dolce concludes his account with the remark that the particular pictorial device of covering the father's face "was a very fine example of true invention." [109] The formal motif, then, is not less invention than is the story itself. Precisely because invention bridges the gap between literary contents and pictorial representation, it is closely related to decorum, to the principle of making the visual appearance of a figure suited to its contents or character. It is a good invention, to quote Dolce once more, that Raphael, in his rendering of the fall of the manna, imparted to the figures collecting the food an air of eagerness, while "he has given Moses a solemn expression." [110]

Invention is also (somewhat vaguely) considered a stage in the pro-

cess of shaping a work of art. Dolce would not like the painter "to be satisfied with a single invention when it comes to his trying out in preliminary sketches the imaginative ideas inspired in his mind by the subject matter." Raphael, "a man so rich in inventiveness," worked out "four or six" different groupings, and from them he then chose the final form.[111]

So much was invention considered an essential part of the painter's or sculptor's work (beyond being merely subject matter) that one can identify an artist by his inventions. The lascivious embraces of men and women in compositions engraved by Marcantonio were the "invention of Giulio Romano rather than of Raphael."[112]

To summarize, "invention" has two aspects: subject matter and the artistic rendering of it. Though the literary aspect of *invenzione* was always present in the writers' minds, they never really forgot that invention is also a part of the painter's and sculptor's translation of that subject matter into visual shapes.

Views on *colore,* the third "part" of the "art of painting," constitute the most original contribution that Venice made to Renaissance theory of art. In its sensitivity to subtle color effects, Venetian art literature remains without parallel in the Renaissance.[113] This sensitivity, and the many observations of hues and tones as presented in the treatises of theoreticians, is closely related to the art produced in the city during the sixteenth century. All the treatises extol Titian's, "our own" (Dolce), coloring, and often other Venetian painters, such as Giorgione and Bellini, are extensively discussed. Yet Venetian theory of color has more than local significance. Perceptions and thoughts present in a vague form in other schools are here fully articulated.

All Venetian authors are fascinated by color, but only Pino tries to erect a full theoretical structure for exploring this medium that has so often proved elusive. He optimistically subdivides color into three neat categories: *proprietà, prontezza,* and *lume.*[114] As we shall immediately see, in spite of his good intentions, the clean division is not always successful, and the categories overlap. Nevertheless, it seems best to follow Pino's theory in a brief survey of color conceptions in Venetian art theory.

Proprietà is the application of decorum to color. By using the proper

hues or combination of tones the painter reveals the figure's character (age, sex, group, etc.) and the material nature of the object represented (i.e., texture). Though color thus "shows," Pino never implies that *isolated* colors have a definite meaning. This was the attitude of many authors who wrote on color symbolism (without any relation to painting). Pino, on the contrary, stresses the ambiguity of each tone, and never deals with a single color only. It is the composition of colors and tones that constitutes the *proprietà*.

Prontezza, in itself, is not restricted to color. The term is also used to denote expressive, dramatic movements, such as bold foreshortenings, and it may also indicate the painter's "sureness of hand, and the grace granted to him by nature."[115] It thus has a very broad scope; it is related to the artist's nature and is therefore intimately connected with *giudizio*. That Pino placed *prontezza* in the division of color suggests that the artist's unique nature can be revealed in his coloring not less than in his line and composition. The painter's brush strokes are, then, recognized as something transcending those workshop habits which can be acquired through training. They reflect the artist's temperament and his "sureness of hand," as *facilità* did in Floretine concepts. Titian sometimes painted with his fingers rather than with brushes, thereby imitating God, who created Adam with his own hands: Marco Boschini telling this story in the seventeenth century gives us an idea of what was meant by *prontezza*.

The last category of "color" *(lume)* contains the most original of Venetian contributions to art theory. Ever since Alberti it had been indistinctly felt that a certain connection exists between color and light. But that light should be made a part of color is a sign of the Venetian inclination to fuse the two. The basic attitude underlying fifteenth-century Florentine thought, an attitude drawn from scientific sources (mainly Aristotle) and consistently applied in actual painting, was that every object is colored by nature. What light does is nothing more than to reveal—to a larger or lesser degree—the object that is colored before any ray of light strikes it. Light is what makes things visible, but it adds nothing to them. In painting the major function of light is to bestow volume on the figures and objects represented, to make them appear round, and to let them "emerge" from the flat canvas or wall on which they are depicted. A first break in this sepa-

ration between light and color is Leonardo's *sfumato*. But the process of removing the barriers between *lume* and *colore* was completed in Venice where artists and critics stopped treating them as separate qualities.

This process had wide-ranging consequences in many fields of aesthetic appreciation. In the opinion of Venetians the illusion of volume that the artist imparts to a painted body was not as highly esteemed as in Florence. Instead, the richness of tones, what later became known as values, is promoted to the rank of a central aesthetic criterion. The brilliance of pure, unbroken colors was seen in Florence as beautiful; in Venice it is the half tone, some kind of coloristic dusk, that is most highly appreciated. Drawing on the synesthetic vocabulary so widely accepted in the late Renaissance, this twilight kind of tint was called "soft coloring." The authors, in repeatedly extolling this soft coloring, were fully aware that it was an achievement of their own period. Dolce opens the *Aretino* with a comparison of fifteenth- and sixteenth-century painting. Bellini, he says, was "a good and careful master"; every figure in his pictures "stands up well" (what he probably means is that each figure is clearly separated from the others). But Bellini was outdone by Giorgione, and Giorgione by Titian. It was Titian who devised a "system of coloring so very soft *[una maniera di colorito morbidissimo]* that it goes in step with nature." Softness, that is, complete integration of light and color, is a dominating aesthetic ideal. "The blending of colors," Dolce says later is his dialogue, "needs to be diffused and unified in such a way that nothing, such as contour lines, offends gaze." Crisp contours, the pride of Florentine art theory, "should be avoided (since nature does not produce them)."[116] Blackness, in other words, the deep shadow that creates the full illusion of volume and roundness, Dolce says, is "a term I use for harsh and unintegrated shadows." Soft coloring is the supreme aesthetic value, superior to rational structure, and it may even negate that structure. The Venetian system of painting, especially as developed by Pino, is summarized in Table 5.1.

4. BEGINNINGS OF CRITICISM

Our presentation of Venetian thought on painting is bound to be inadequate. A brief exposition of a rich and complex body of thought necessarily focuses on what can be described in a few sentences, and

TABLE 5.1.

The Venetian System of Painting

Disegno and giudizio	*Invenzione*	*Colore*
circumscription	(both subject matter and formal motifs,	*proprietà*
practice	but the distinction is not explicitly de-	*prontezza*
composition	fined	*lume*

abstract ideas are particularly suited to such a purpose. However, the major value of Venetian art literature does not lie in logical structure and the neat division of concepts but in the urban tone, in the great sensitivity to pictorial effects, and in the many evocative descriptions of paintings and of natural sites. A systematic presentation cannot do justice to these qualities. Yet these particular characteristics are combined in another theme, of remarkable significance in sixteenth-century Venice, that should not be overlooked: the thoughts and observations that form the beginning of a layman's criticism of art.

That the artist should seek to impress the beholder is, of course, nothing new. This desire is part of the quest for fame that forms such an important feature of Renaissance culture in general. It is also not surprising that this attitude should be reflected in art theory. "The painter's work," Alberti assures his readers toward the end of *On Painting* (III. 62), "is intended to please the public. So he will not despise the public's criticism and judgment. . . ." Leonardo, too, advises the painter to listen carefully to what spectators say. "If we know that man can truly judge works of nature, how much more should we be ready to admit that they can judge our errors."[117] Yet in the Florentine tradition such remarks remained of marginal significance for the general understanding of art. Pleasing the public does not cast any doubt on the objective standards of valuation, primarily correctness. The question was, as Leonardo so lucidly put it, to see whether the spectator has discovered an "error" that the painter himself had overlooked. Should this indeed happen, one would have to fall back on the scientific yardsticks by which the "truth" of the representation could be measured.

In Venice the prevailing attitude is different. The question never is whether the spectator finds an "error" in the painting he is looking at but—to put it in its crudest form—whether he likes it and finds it pleasing. In a statement that is extremely bold for its time, Dolce asserts that "painting was invented primarily to give pleasure."[118] He thus anticipated Poussin who, a full century later, maintained that the "aim" of painting is "délectation."[119] Dolce's statement deserves our attention not only in its anticipation of modern thought. The context in which it appears clearly shows that it was considered as expressing a specifically Venetian attitude. Aretino's interlocutor, the Florentine Fabio, praises foreshortening as the ultimate proof of an artist's skill and ability. Foreshortening is among the major achievements of Michelangelo and other Florentine artists. But Dolce warns: "The artist should not limit his pursuit of praise to one element alone," such as foreshortening. "He should endeavor to excel in all elements of painting, more especially in those which afford greater pleasure." An artist's fame depends on his pleasing his public, not on showing his virtuosity: "if the artist fails to please, he remains unnoticed and devoid of fame." Therefore, foreshortenings should be used occasionally but "so that one's pleasure is not disturbed."[120]

In asking the artist to please his public, Renaissance scholars and writers were not indicating a belief that the taste of the crowd should be preferred. They remained as elitist as ever. The philosophers—so Dolce repeats well-known views—expressed their hidden wisdom in allegorical language so as not to throw pearls before swine, and the same is true in art. There is a kind of painting, one is given to understand, that is addressed to the sophisticated spectator. The pleasure in question, we hear Aretino declaring in Dolce's *Dialogue,* "is not, in my books, the one which gives sustenance to the masses." What precisely is it that gives pleasure to the educated spectator? Dolce has no abstract answer, but he refers to a well-known experience. A good poem one wants to read again, and a good picture is "one which increases [the pleasure], the more the eye of any sort of man undergoes a renewed exposure."[121] In other words, one intuitively grasps what is good and one wants to see it again.

A practical example of the new criticism is the comparison between

Michelangelo and Raphael, a common theme in Renaissance writings on art and one that pervades Dolce's treatise as well as those of other Venetian authors. "For the sake of amusement," Dolce writes in a well-known letter to Gasparo Bellini, "we discuss among ourselves painters of our time." Surely Dolce admires Michelangelo, but Raphael pleases him "a great deal more." Raphael has "grace" and makes "a good impression." Michelangelo is "awesome," yet Raphael (who could also produce awesome figures) "felt no great love for this mode, like a man who had directed his every bent towards giving pleasure (regarding this as the painter's foremost resource) and in seeking a reputation for delicacy rather than for awesomeness simultaneously acquired another reputation, which went under the name of attractiveness."[122]

The juxtaposition of Michelangelo and Raphael is remarkable for several reasons. To one of them, the establishing of a typology of artists, we shall come back in the next section. Here we should only like to emphasize that, in weighing the merits and limitations of each artist, there seems to be no doubt as to the competence of the layman's judgment. Raphael is preferred, not because he is more correct or because he meets, to a higher degree than Michelangelo, objective standards of quality, but—ultimately—because he is more pleasing to the spectator. As we have said before, we are here confronted with the beginnings of an art criticism based on the educated layman's taste.

IV. NORTHERN ITALY

North Italian authors were latecomers to the Renaissance theory. Their treatises were composed only in the eighties and nineties of the sixteenth century, that is, about a generation after Florence and Venice had already completed their central contributions to this new field of study. What separates the mid- from the late sixteenth century, however, is not merely the passing of a few decades; rather, it is the emergence of a completely different intellectual atmosphere. By the last two decades of the Cinquecento the repercussions of the Reformation and the Counter-Reformation had already affected all areas of life and culture. But the specific character of north Italian art theory resulted not only from its late flowering; strong local traditions en-

dowed the culture of the region with a quality of its own. Every region of Italy, it has been said, had its particular "Renaissance of Antiquity."[123] In northern Italy antiquarianism, in a precise sense of that term, was one of the prominent forms. Here the study of numismatics and epigraphy and the investigation of ancient remains were more solidly established than anywhere else in Italy, and these pursuits were carried out in a consistent and systematic spirit, perhaps in part a residue of Scholasticism, which seems to have survived more forcefully in the north than in the great Italian centers of humanism. Antiquarians did not write history; they composed systematic surveys of their findings, arranging the material according to classes of objects, and never making chronology the major principle of composition. Both the survival of scholastic tradition and antiquarian habits of thought encouraged a systematic attitude.

All this could not fail to have a profound impact on the theoretical reflections of artists and critics. It is characteristic that the major work of art literature in Florence, Vasari's *Lives,* was a history; the major text of north Italian art theory, Lomazzo's *Trattato,* is a systematic survey. It divides the doctrine of painting into separate "parts" without ever raising the question of what comes earlier and what later and without devoting as much as one single thought to the unfolding of art in stages.

1. THE ICONOGRAPHIC MANUAL COMES INTO BEING

A systematic theory of art has many facets, one of which is the doctrine of symbols. That a picture should be "read," that its message can be made out by translating the encoded meaning of figures and objects into comprehensible terms, was not a new idea in the sixteenth century, nor was it an exclusive trait of north Italian thought. The fashion for hieroglyphic writing that swayed Italian humanists in the fifteenth century was based on the assumption that it was a visual language.[124] The shapes of ancient works, though visually perceived, must be interpreted, since their meaning—at least is some cases—differs from what meets the eye. The Florentine philosopher Marsilio Ficino, as we remember, declared that the ancient (Egyptian) sages encoded their secret wisdom in mysterious images.[125] His public, both in Florence and

in the other centers of humanistic learning, were all too ready to believe that the sages employed this method so that only the wise and enlightened among the modern would be able to unriddle such images, and in their readings they gave their fancy a free hand. However fantastic the individual interpretations were, they deepened the awareness that images often have to be deciphered.

This notion was accepted by humanistic circles everywhere, but in the sixteenth century it nowhere found a more ample development than in northern Italy and in the transalpine countries. Scholars tried to establish keys for making such interpretations. In 1555 the Bolognese humanist Achille Bocchi published his *Symbolicarum libri V*, which suggests attempts at interpreting what was conceived as ancient symbolism. Earlier in this chapter we had occasion to mention another north Italian author, Pierio Valeriano, whose monumental *Hieroglyphica*, aiming at the same goal, presented a system of explaining Egyptian as well as Greek "riddles." These two books, though perhaps the most famous of their time, were not isolated phenomena; they were but the tip of the iceberg. An extensive literature was flourishing devoted to the same purpose, the literature of emblem books. An emblem, as one knowns, consists of an image (in the printed books, usually a woodcut), a laconic inscription, and a short explanatory poem.[126] Though emblem literature derived much inspiration from the tradition of hieroglyphics, the first full-fledged emblem book was composed in the sixteenth century by the Bolognese scholar, poet, and jurisconsult Andrea Alciati and was published in Augsburg in 1531.[127] Its descendants, Panofsky said, "proliferated like crab grass in all north Italy" as well as in the transalpine countries, but the trend remained insignificant in central Italy. The effects of emblem books on the art and thought of the period were manifold but lie outside our present context. One particular consequence, however, cannot be overlooked: emblem books educated readers and spectators not to be content with what they saw in a picture but to go beyond what met the eye and search for what the image meant.

Even closer to the artist's work than emblem books was another type of literature, mythography. What does a classical god look like? What were the deeds, meanings, and the appearance of mythological

heroes? "Why," to quote one of the earliest sixteenth-century mythog-
raphers, the German Georg Pictor (*Mythical Theology*, Freidburg, 1532),
"has Jupiter no ears? Why does he hold a scepter in his left hand,
thunderbolts in his right?" No words need be wasted to explain how
precious answers to such questions must have been to the Renaissance
artist. How could he possibly disregard them when he so frequently
found himself depicting those very gods and heroes? But mythography,
we should keep in mind, was not read by artists only. For a culture so
much under the spell of ancient myth, a description of the gods and
heroes almost inevitably allured any educated reader, promising him,
as it were, the revelation of closely guarded mysteries.

Mythography, though drawing from ancient and even medieval sources,
was a new field. "The professional mythographer," Don Cameron Al-
len said, "is a Renaissance creation, and the manuals he wrote were
closely consulted by artists, men of letters, and all educated men."[128]
It is not surprising, then, that mythography, a new and fashionable
branch of literature useful to so many, and different, groups of readers,
shaped the sixteenth-century imagery of the pagan gods. And, in so
doing, it fulfilled yet another function: it became a mediator between
the artist and his public; it enabled the artist to live up to his specta-
tor's expectations; and it enabled the spectator to withstand what he
saw in the picture.

Mythography, originating in Antiquity, subsisted—subterraneously,
as it were—even in the Middle Ages. For the Renaissance it began
with Boccaccio's great work, *Genealogy of the Gods*,[129] but it reached its
heyday only in the mid-sixteenth century. The great mythographers of
the sixteenth century belonged—by birth, education, and cultural
bonds—to northern Italy. The most learned among them was the an-
tiquarian, poet, and student of ancient religion, Lilio Gregorio Giraldi
(1479–1552).[130] He was born in Ferrara, and, after having traveled
throughout Italy, returned to his native city where, toward the end of
his life, he wrote his great mythographical work. Giraldi's monumental
History of the Gods (Historia de diis gentium), published in Basle in 1558,
and in the Lyon edition of 1596, containing 468 folio columns) became
the *summa* and ultimate authority of what was known (and accepted)
in his time about the pagan gods. In general, he avoids the symbolical

or allegorical readings that were so much to contemporary taste, and by which he himself was enchanted in his youth. What he wants to do in the *History of the Gods* is to relate and describe. This scientific approach prevails even where he deals with such problematic figures as demons, tutelary gods, and vampires (Book XV), though it should be noted that sometimes he repeats the allegorical interpretations of other authors. To present correct descriptions he, of course, draws from ancient literary sources and sometimes also from such Renaissance authors as the Florentine poet Poliziano and Leone Battista Alberti. It is of particular interest, however, that works of art also occasionally figure among his sources. Moreover, as Giraldi himself says in the dedicatory epistle prefacing his *History of the Gods,* he was provoked into composing his monumental work by the many "errors" he encountered in reading modern poets and viewing the works of painters. (Note: no doubt now arises as to the interrelationship of poetry and painting, an issue hotly debated in the preceding century.) With the historian's advantage of hindsight we can now clearly see that Giraldi's work is an early and very learned version of the iconographic manual for painters, that is, of a text assuring the "correct" visual representation of mythological figures.

Another north Italian mythographer, Natale Conti, whose *Mythology* was published in Venice in 1551, was more remote from the artist's work.[131] His interpretation of the figures of classical mythology is mainly allegorical, and the visual aspect of figures and scenes plays a smaller part. His impact on art and aesthetic thought was in fact more modest.

The climax of sixteenth-century mythography was reached by Vincenzio Cartari (ca. 1520–ca. 1570).[132] Little is known of him except that he was born in Reggio Emilia, and, like Giraldi, he was a protégé of the duke of Ferrara. Cartari's literary production, including his major work, *Delle imagini degli Dei de gli antichi* (Venice, 1556), was composed in vernacular Italian. Dispensing with the Latin of the other mythographers, which could be read by the erudite only, Cartari thus reached a much wider public than his learned predecessors, and his work enjoyed a popularity that was not accorded to the other mythographical treatises. Between 1556, when the book was first published, to the end of the seventeenth century, it went through thirteen Italian

and five French editions and was translated into both German and English. Starting with the second edition, the work was profusely il-lustrated, and the number of illustrations grew continuously. The edi-tion of 1571 had 85 engravings; the late-seventeenth-century editions have more than 160 woodcuts. The increase in illustrations shows, we believe, how strongly readers perceived the *visual* depiction to be es-sential to the meaning of the book, as well as how much the work appealed to painters and sculptors. Moreover, Cartari's first publisher, Marcolini of Venice, said in the preface to his edition that many au-thors had written about the gods, but before Cartari none had de-scribed their statues or pictorial representations. Hence, the learned publisher concludes, the volume should not only please the ordinary reader but should also be of great service to painters, sculptors, and poets. In a later edition (Venice, 1615) another preface, written by Pignoria, praises man's superiority over all the other creatures on earth; this superiority is shown by man's ability to make his head and hands work together to produce "figures." A glance at Cartari's book bears out this emphasis on the maker of images and on the "figure": each chapter of *Delle imagini* is dominated by an image (an engraving or a woodcut), which, in turn, is based on a classical text or a monument of ancient art. These images are not illustrations in a modern sense, some kind of ornament to the text; they are an integral part of the statements made in the book. Cartari does not want to invent, or to discover, layers of meanings that nobody has ever noticed. What he does comes very close to the iconographer's job: he attempts to recon-struct the god's "true" image by explaining works of ancient art (known to him either from descriptions or from direct observations) by using literary texts, and sometimes he tries to make sense of ancient texts by looking at classical statues and coins. No wonder that his impact on the art and art literature of the late sixteenth century was greater than that of the other mythographers.

Mythographical traditions had a long and richly varied afterlife. For us one result is of particular significance—Cesare Ripa's *Iconologia*.[133] Born around 1560 in Perugia, Cesare Ripa made a living as a cook and caterer to various cardinals in Rome. He was, then, not a professional scholar, and indeed he relied more often on what we would call sec-

ondary sources (emblem books, sixteenth-century mythographical trea-
tises) than on the original texts of Antiquity. Perhaps precisely for this
reason he mirrors, more clearly than any other author, the images and
concepts current among many patrons and spectators of his time.

The *Iconologia* is both broader in scope and more limited in purpose
than emblematics or mythography. Ripa does not combine pictures and
poems; nor does he limit his work to describing the ancient gods. He
lists personifications of ideas and abstract notions, arranged in alpha-
betical order, and he pictures in words, as it were, their appearance
and attributes. The *Iconologia* is thus a dictionary of personifications.
But, though Ripa is not concerned with mythology, the thought of his
time requires that the personifications described bear the stamp of
ancient authority. "The images made to signify something different
from what the eye can see," Ripa instructs his readers in the intro-
duction to his volume, "have no briefer nor more general rule than
the imitation of the records found in the books, the coins, and the
marbles of the artful Greeks and Latins, or of earlier people who in-
vented this artifice."[134] In spite of pledging his allegiance to Antiquity,
Ripa, as has been shown by Erna Mandowsky and Gombrich, was
profoundly influenced by medieval thought and imagery.[135] Ripa's per-
sonifications of moral concepts, so central in medieval culture, have
little to do with the heroes who populated Olympus. Note also that
among the classical sources referred to monuments (coins and marble)
play a central part.

Ripa's work must have fulfilled a widely felt need. Today we may
find it difficult to understand how a dictionary of personifications,
never very exciting in style or subject matter, could have proved such
a success, but it remains a fact that for two centuries editions of the
Iconologia followed each other at short intervals, that the book was
translated into most European languages, and that the various editors
kept elaborating Ripa's descriptions and adding new ones. To whom
was all this information addressed? Who was to use the book? The
artist, he who actually shapes the image, was clearly meant to be Ces-
are Ripa's main reader. Indeed, for almost two centuries a copy of the
Iconologia could be found in every workshop; it became a bible for
painters and sculptors. Yet artists alone were not numerous enough to

account for the many editions. The general educated reader would also use Ripa's work and, looking at works of art, would then be able to grasp the subtleties of their symbolic allusions. Ripa was aware that he addressed both groups of readers. He wants to treat, so he states in the introduction , the manner in which symbolic images are "formed" and "explained."

Is the *Iconologia* art theory? No simple answer can be given. Such an excellent and erudite scholar as J. von Schlosser omitted Ripa from his magisterial work, *Die Kunstliteratur,* probably on the assumption that the iconographic handbook constitutes a tradition altogether different from that usually known as art theory. We should keep in mind, however, that in the sixteenth century art theory branched out into different directions, achieving a range that remained unrivaled in any other period. Within this broad scope, the codification of symbols and personifications became a doctrine the artist needed and the spectator used. The iconographic manual may therefore be seen as an established type of art theory. What Ripa wrote was, in fact, generally accepted as essential for the artist's as well as the spectator's education.

That late-sixteenth-century critics who were not themselves mythographers fully accepted the value and importance of mythography for art is not surprising. The demand for iconographic "truth" has always been intrinsic in Renaissance art theory. Alberti asks the artist who paints *istorie*—which he conceived only as mythological scenes—to learn from books, or from his erudite friends, the details of the original fable; this would enable him to represent the figures correctly. "It is not suitable for Venus or Minerva to be dressed in a military cloak, and it would be improper for you to dress Jupiter or Mars in woman's clothes" (*On Painting* II. 38). More than a century later, "historical" or mythological "truth" became a central criterion for judging the value of a work of art. Seznec, in his well-known work, *The Survival of the Pagan Gods,* has called attention to sixteenth-century discussions of this subject.[136] Raffaelo Borghini[137] adduces Horace's dictum that painters, like poets, are free to exercise their imagination, but he is quick to criticize any abuse of this license. A painter deserves blame for the liberties he takes with his fable. Representing the right attributes enhances the value of a painting or a statue; depicting improper ones

detracts from it. The criterion of "correctness," as can be expected of a humanistic author, is the legacy of the ancients. Michelangelo represented the Night correctly: the owl and the crescent moon on the forehead are the attributes the ancients gave to the Night. But Titian is censured for not following in detail Ovid's description when he painted Adonis trying to escape from the arms of Venus, and this deviation from the text disparages the painting's value. *Cose disconvenevoli* (unbecoming things), as Borghini says, can determine our appreciation of a picture. Is it ignorance, one of the interlocutors in *Il Riposo* wonders, that made Ammanati carve pine garlands on a statue of Neptune? Pines belong to Cybele and Bacchus, not to Neptune. Our author here goes so far as to distinguish between *pino* and *arbore picea,* "a species of pine very similar to fir."

In this pedantry over iconographic detail Borghini was not alone at the time. Lomazzo, to whom we shall shortly revert, makes mythographical knowledge a condition and important "part" of artistic creation. "If the painter wishes to give a perfect representation of Jupiter," he writes, "he must first of all know what Jupiter is." Jupiter's "form" consists, among other features, of "thunderbolts, eagle, scepter, costume."[138] In the next section we shall have occasion to investigate Lomazzo's concept of form; for the moment it may be sufficient to say that to Lomazzo and to some of his contemporaries, consciously adopted mythography is the kind of knowledge that no artist can afford to neglect.

Cesare Ripa probably wrote mainly for the artist, though he never disregarded the general educated reader; the mythographers wrote mainly for the learned, but they rarely lost sight of the artist and his work. Together they reflect an intellectual atmosphere that could not fail to have a profound impact on art as well as on art theory.

2. LOMAZZO: THE SYSTEM

The transformation of art theory into a "system" was a cherished goal of artists and humanists ever since the beginnings of the Renaissance. The medieval treatise, intended to be a direct, and rather limited, aid to the practicing craftsman, did not aim at such a goal. Its contents and structure changed with the changing needs of the artist and of the

models available to his workshop. Humanistic thought did not accept such total subordination of the treatise to the workshop. The authors of art theory, no longer content with simply providing aids to working artists, aspired to speculate about the components of painting and sculpture, to educate the painter, and to explain the finished work of art to the public. But, in order to make art theory relatively independent of the workshop, one had to show that the new field had a distinct structure of its own. The desire to achieve this goal motivated the repeated attempts to cast art theory into a comprehensive and rational pattern.

Alberti, as we remember, divided his treatise *On Painting* into three books, each dealing with a different domain yet together forming a unified whole. In the sixteenth century this trend increased in intensity. We have just seen how common it became for the Venetians to speak of a doctrine of painting consisting of three parts (design, invention, color). Vincenzio Danti outlined his ambitious plan for a theory of art dealing with eight different subjects; had the book been completed, it would have been the ultimate art system consisting of distinct, yet closely interlocked, parts. But the Venetians' casual tone and colloquial language may have induced a certain suspicion as to the logical strictness of their thought; though their tripartite division of the "art of painting" became widely accepted, it never acquired the rigor of an overall doctrine. Danti's great project remained a fragment, only frustrating those readers who craved a proper system of art theory. Toward the end of the sixteenth century, however, the old dream came true: Lomazzo composed what, at the time, must have appeared as the final classification and orderly arrangement of the elements of painting, and he showed that they were all regulated by the same rational principles.

Giovanni Paolo Lomazzo (1538–1600), a Milanese painter trained in the Leonardo tradition that was still lingering on in that northern city, was a competent, though not an exciting, artist. He was intimately familiar with the art, aesthetic thought, and art criticism of his time. At the age of thirty-three he went blind, and since he could not go on painting, he directed all his efforts toward composing that systematic theory of art which, as he so well knew, his time was waiting for. We

do not know the circumstances under which his literary work was composed; unlike Vasari, Lomazzo, who was not a storyteller, also did not tell the story of his own work.

A curious blend of painter, *dilettante,* and antiquary, he was a prolific writer. His literary legacy includes a volume of poetry, *Rime* (Milan, 1591), and a would-be scholarly work, *Della forme delle Muse cavata degli antichi autori Greci e Latini, opera utilissima a pittori e scultori* (Milan, 1591), in which he draws on the mythographic tradition and applies it to the contemporary artist's job. His most important achievement, however, is the presentation of a system of art.

Fourteen years after he lost his sight Lomazzo published a monumental treatise on painting, *Trattato dell'arte della pittura* (Milan, 1584), which in the original edition contained 700 pages. It is the *summa* of late Renaissance theory of art, a book Schlosser called the "bible of Mannerism." Six years later, in 1590, Lomazzo published a shorter but more imaginative version of his theory in a slim volume bearing the intriguing title *Idea dell'Tempio della Pittura (Idea of a Temple of Painting).*

Lomazzo's art theory reached many readers. Only one year after the first edition of the *Trattato* appeared, a second edition seems to have been published. Still in the sixteenth century a translation of the *Trattato* appeared in Oxford, "englished by Richard Haydock, student of Physick" (1598). A treatise by the English miniature painter Richard Hilliard is so closely related to the *Trattato* that it has been considered a paraphrase of Lomazzo's text. In 1641 a French translation of Book I of the *Trattato,* [139] done by Ilaire Pader, was published in Toulouse.

A modern student cannot help wondering what may have accounted for the extensive diffusion of Lomazzo's theory. His style can hardly have been the cause. Though he occasionally writes with some imagination, his prose is usually repetitive and is sometimes obscure. True, his visual memory is remarkable. He described the paintings and styles of different artists that, while he was writing, he could have seen, in his own words, only "with the eyes of my mind." [140] But this, too, cannot have been a sufficient reason for his success as a writer; vivid descriptions of paintings and styles were not lacking in his time. There must have been something else that struck a chord that evoked such a wide response. It is not hard to understand, we believe, what this

something was: here was finally the longed-for, articulate, complete system of painting—and Lomazzo constructed a system perfectly fitting the intellectual and emotional atmosphere prevailing among the public he addressed. His claim to providing a system rests, to begin with, on what he believes to be a complete enumeration of the constituents, or "parts," of paintings. The art of producing images consists of seven parts, and to each of them a book of the *Trattato* is devoted; in his *Idea* they appear in a more complex, yet not less manifest, form. Many of the "parts" are commonplaces, but some are new and call for explanation . This explicit, seven-part pattern is sometimes overlapped by another division. The latter is implied rather than spelled out, but it keeps surfacing: the division between theory and practice. We shall immediately return to the details of the two classifications, but to prevent possible confusion it may be useful to insert here a brief observation on the meaning of "theory" and "practice" in Renaissance terminology.

"Painting," we read at the beginning of the *Trattato* (I. 2), "is divided into theory and practice. Theory gives the general precepts which everybody must observe who wishes to excel and become famous in this art. Practice gives rules of prudence and judgment, instructing how to implement what has been said and imagined in general." This would seem a fairly traditional statement in a Renaissance treatise on art, and this is surely also how Lomazzo meant it. Ever since Alberti art theory was concerned with the relationship between theory and practice. We remember how consistently the superiority of theory was maintained. A painter working without theory is, in Alberti's view, like somebody drawing a bow without having a target to aim at (*On Painting* I. 23). Leonardo compares theory to the captain, practice to the soldiers. A practitioner lacking in theoretical knowledge is like a pilot without rudder and compass.[141] In his treatment of theory and practice Lomazzo thus seems to continue faithfully in that central Renaissance tradition—but only seemingly so, because at least one of the two concepts radically changes its meaning. When Alberti or Leonardo speak of practice, they mean—quite simply—the work the artist actually performs in his workshop, the manual activity, such as outlining the composition on the canvas or wall, the application of paint, and so on.

What Lomazzo calls "practice" is something different. "Practice," it turns out, is not less theoretical than "theory." Lomazzo presents two types of theory. One is concerned with elements of a general and abstract nature (proportion, color, light); the other is closer to rules directing the painter's implementation of the general categories. The first is called "theory," the second "practice." But both are—and were so understood in the late Renaissance—art theory.[142] While Lomazzo speaks the language of his venerable predecessors, he in fact transforms the meaning of their concepts.

Now let us turn to the explicit division of painting into seven parts. "Painting," the first sentence of the *Trattato* reads, "is the art which stimulates the nature of things by means of proportionate lines and colors." Consequently, Book I of the *Trattato* is devoted to proportion.

To begin a system of painting with a discussion of proportions may, at a first glance, seem strange. Renaissance treatises on art usually begin with a general notion, such as *disegno* (which may include proportions but does not consist only of them). Proportions are necessarily proportions of something specific, of a man, a building, or any other measurable object. After some brief introductory remarks Lomazzo does indeed proceed to present specific sets of proportions—of men and women, of the horse (a favorite subject of the Renaissance, which occupied the minds of such artists as Leonardo and Dürer), and of the different architectural orders. This concentration on the particular intimates the overall character of Lomazzo's thought. He is rarely concerned with abstract concepts. In the forefront of his mind is how to implement the general element in depicting a particular subject and in creating a specific work of art. Certainly, he is influenced by the philosophical atmosphere of his time. As Panofsky has shown, a long chapter in the *Idea*—dealing with Beauty in a Platonic vein—is nothing but a paraphrase (and often outright quotation) from Ficino's commentary to Plato's *Symposium*.[143] But in the main version of Lomazzo's theory of painting, as presented in the *Trattato,* the specific proportions of men, horses, and buildings completely overshadow the question of what proportion as a general concept, detached from the particular, may mean. Lomazzo's was not a philosopher's mind. We should also remember that in that particular tradition of art theory that remained in

close contact with the workshop, "proportion" often stands for design. Armenini, for example, speaks of *quantità proporzionata*[144] where, in a more philosophically oriented treatise, we would expect *disegno*. In Lomazzo's language, too, "proportion" is often the painter's equivalent for the more philosophical *disegno*. It is "impossible to shape any object," that is, to outline it, if it has no measurable proportions (*Trattato* I. 4). Beginning the treatise with a circumstantial presentation of specific sets of proportions is, therefore, an indication of Lomazzo's place among the different schools of sixteenth-century theory of art.

Most of Book I is devoted to a description of actual proportions and instructions on their measurements. The unit by which proportions are reckoned is either a "head" *(testa),* extending from the top of the head to the point of the chin (I. 7), or a "face" *(faccia),* measuring from the top of the forehead to the chin (*Idea* 35). (Unfortunately, Lomazzo is not consistent in using these terms, and thus causes some confusion.) In the Renaissance workshop this was, of course, common knowledge, and would not have stirred any particular curiosity. What is interesting, however, is the attempt to codify the proportions of *different* types of figures. The graceful, Apollolike youth, preferred by Raphael, is nine "heads" tall (*Trattato* I. 8; *Idea* 35). It is perfectly rendered in Raphael's *St. George Killing the Dragon* (probably the picture now in the National Gallery in Washington, D.C.). A figure ten heads tall is mightier, more muscular; it is the figure appropriate for Jupiter, and it also fits kings, who "tower" above their subjects (*Trattato* VI. 3). The figure eight heads tall is vigorous and masculine (I. 9), and one that measures only seven heads is heavy, robust, and has knotted, muscular limbs (I. 10).

In codifying the proportions of different types of men a great historical process is completed; the end of the Renaissance comes to negate its beginning. The first Renaissance author to formulate a theory of human proportions was, as we remember, Leone Battista Alberti. He established only *one* set of proportions, and this set was the canon of beauty. Like the legendary artist who produced the image of the Venus of Croton, Alberti arrived at his model by collecting the beauties diffused in nature. His model is an average of many measurements, a "mean" figure, as he says (*De statua* 12). Since this abstract model is

the embodiment of beauty, Alberti rejects any variety. But even in the early sixteenth century doubt was cast on the belief in a single set of beautiful proportions. Dürer conceived of different types of proportions and even coined the term "characteristic beauty." Lomazzo knew Dürer,[145] and he may well have been inspired by him, but he was certainly expressing a broader feeling: the ideal of *one* classical beauty was now shattered. The quest for expression and appropriateness now became stronger than the wish to present beauty. There are, Lomazzo says, "fat, slender, peasant-like, delicate, large, and small bodies." Obviously, they cannot be shaped after the same set of proportions. The artist is to "give to everyone his own particular proportions" (I. 9). "One clearly understands," Lomazzo continues, "that not every proportion can serve everybody, because they [the proportions] are different among themselves as the bodies are different among themselves by nature" (I. 10).

But mastery of proportions, be it ever so precise and perfect, is not sufficient for a proper representation of human figures. Canons of proportion perceive of the human body as motionless, but living creatures are always in movement. The coordinated actions of the limbs, resulting in a common, overall movement, endow our body with that mysterious ability to manifest emotions and states of mind. This movement Lomazzo calls *moto*. *Moto,* he claims, is "the spirit and life of art," but it is also that part of painting that is "most difficult to attain" (II. 2). Book II of the *Trattato,* devoted to *moto,* treats one of the oldest subjects in the study of art; it is also one of Lomazzo's most original contributions.

In principle, *moto* includes all kinds of body movement—purely physical locomotion (walking, running) as well as gestures motivated by "movements of the soul." But Lomazzo focuses on expressive movement to the exclusion of almost any other kind. He is well aware of what he is doing. Movement, as he defines it, "is only a certain [distinct] expression *[expressione]* and an external sign in the body [of man] of the things he experiences internally. By this [movement of the body] one discerns the intrinsic movements of man better than [by means of] words. . . . The few artists who understand this, achieve that one sees in their paintings those wonderful hidden works of na-

ture, moved by that virtue of movement which remains concealed in our heart, sending to the outside its branches according to which the organs [of the human body] move" (II. 2).

To trace the history of this theme we would have to go back to Aristotle, and this book is not the place to do this. But a brief look at that *fons et origo* of Renaissance art theory, Alberti's *On Painting*, may give us a sense of the development from early to late Renaissance thought. Alberti requires that the painter carefully observe all movements. "These he may well learn from nature, even though it is difficult to imitate the many movements of the soul." The humanist is surprised how troublesome it is to depict emotions clearly and distinctly. "Who, unless he has tried," Alberti asks, "would believe it was such a difficult thing, when you want to represent laughing faces, to avoid their appearing tearful rather than happy?" (II. 42). But, though he knows that here there is a problem of "making," of shaping a form that would bear a distinct expression, he fails to instruct the artist in this task. The little he has to say about expressive movements is concerned with purely aesthetic requirements, such as balance and symmetry.

In Leonardo's thought movement occupies a more central place than in Alberti's; his observations are also more differentiated and precise. The Leonardo tradition in Milan is, in fact, the major source of Lomazzo's doctrine of *moto*. Leonardo is more often quoted in Book II of the *Trattato* than in any other book, and than any other artist. For Leonardo, the very nobility of painting results from its being concerned with movement. "Painting is proved to be philosophy because it treats of the motion of bodies."[146] The movements of the figure depicted should be appropriate to his mental attitude. "If the figures do not perform lifelike actions, and express the concepts of their minds with their limbs, those figures are twice dead," reads one of Leonardo's best-known statements.[147]

But how, if at all, can the artist be trained to represent bodily movements according to "mental states"? What can equip him to master this most difficult task? Leonardo has a single piece of advise: look at nature; observe closely how people respond when provoked, how they behave when in emotional tension. For two figures (the despairing

and the angry) he has more specific instructions,[148] which read like descriptions found in an old model book, and clearly contradict actual experience. But in general he recommends only the observation of nature. This observation, it should be emphasized, is in itself open-ended. Leonardo provides no classification of emotions or movements to which the painter's attention should be directed; in no way does he give "rules."

Lomazzo is of one mind with Leonardo as to the significance of movement in art, but when it comes to the question of how to train the artist to properly represent these movements, he diverges from his ancestor. The difference between the two painter-theorists—one at the very beginning, the other at the end of the sixteenth century—reveals, as in a flash, how radically aesthetic thought was transformed in the Cinquecento. Lomazzo does not preach the gospel of observing nature; he barely pays lip service to this sacrosanct dogma of Renaissance thought. True, both agree that movements can be scientifically explained, but their actual explanations diverge. The function that anatomy performed in Leonardo's thought is assumed by astrology in Lomazzo's doctrine; a person's nature is mirrored in the way he moves. What is more important in our context is Lomazzo's attempt to derive practical guidelines for the artist's task from astrological knowledge. When one knows how a figure moves according to his nature, one will be able to portray him properly. Thus, "the movement of melancholy is dangling, heavy, and restrained, because melancholy is composed of the element of earth which, itself tending downwards, is heavy and compact." The movements of a figure dominated by fire are "violent, impetuous, arrogant, audacious, and ferocious" (II. 5). A major part of Book II is devoted to assembling the different emotions in a few groups (nine altogether) and to describing the movements of each of them separately. Two examples will give us a sense of Lomazzo's approach. "Melancholy, diffidence, malevolence, avarice, slowness, envy, redness, and anxiety" form one group (II. 9). "Fortitude, faithfulness, devotion, majesty, and steadfastness" form another (II. 10).

It may be difficult to tell how a painter could have used Lomazzo's descriptions in practice. Comparisons such as "heavy and compact" or "audacious and ferocious" may be vivid descriptions, but they are cer-

tainly vague as visual models. Sometimes the descriptions are made more useful for the artist by references to well-known works of art; movements of strength and severity can be learned from Christ's figure in Michelangelo's *Last Judgment* (II. 10); movements of suffering and pain can be seen in the *Laocoön* (II. 16). Frequently, one assumes, the verbal descriptions may have evoked an imagery familiar to the artist from his workshop models. Whatever the applicability of Lomazzo's descriptions, what remains beyond doubt is that he abandons Leonardo's advice: just go and observe nature. Lomazzo formulates "rules," and he articulates "types." The age of the Academy looms on the horizon.

This propensity for distinguishing "types" permeates Lomazzo's whole work. It can also be found, though less explicitly, in his treatment of color (III). Light (IV) he subdivides into several types: direct and indirect, natural and artificial, terrestrial and celestial. Even the book "Perspective" (V) suggests some different types of the representation of space. In the last two books of the *Trattato*, however, "Practice" and "Form," it becomes particularly manifest. The theory presented in "Practice" (almost 250 pages in the original edition, more than one third of the whole *Trattato*) apparently grew out of the feeling that traditional art theory had so much developed its own, autonomous character, it had been so much transformed into philosophy or science, that it had become altogether remote from what the artist actually did in his workshop. There is, Lomazzo says, "mathematical" or "philosophical speculation" on art, on the one hand, and "experience," on the other (VI. 1). The theory of practice, we suggest, is intended to mediate between "speculation" and "experience," between scientific or literary theory and the artist's actual job. "Practice" is sometimes also called "composition." In Book VI Lomazzo warns his readers that he will do nothing but discuss "the composing in practice of what is expected of the painter" (VI. 2).

To do this he has to review, from the aspect of implementation, what has already been said in the preceding books. How does one put into practice proportion and *moto,* light, color, and perspective? However, Book VI does more than just scan the elements of the painter's work from the practical point of view. Lomazzo intends to distinguish

the "kinds and their species" *(genere e sue specie)* of the painter's prac-
tice. It is not by accident that he employs Aristotelian-scholastic ter-
minology. The choice of terms indicates his adherence to the ideal of
a comprehensive, articulate system, which was so closely associated
with this philosophical school.

In the book on practice Lomazzo emphasizes two clusters of prob-
lems. This grouping alone is an original contribution to art theory. It
should be carefully studied both because of its intrinsic intellectual
significance and because of its impact on subsequent ages.

One genus of "Practice" has to do with the relation of the work of
art to its environment. The question is: What kind of a painting is
fitting for a certain place? That a painting should fit its physical envi-
ronment was not a new requirement in the late sixteenth century;
perhaps it never completely disappeared from the minds of painters
and patrons. From Cennini to Armenini increasing attention was de-
voted to this subject, and as time went by, observations on it became
more specific and precise. But they remained scattered fragments.
Lomazzo, so far as we know, is the first author to discuss the adjusting
of a painting to its physical surroundings as a subject in its own right.
This, he stresses, is one of the "regole universale della pittura" (VI.
20). And, since the subject is so central, Lomazzo tries to make of it a
system in itself.

Every type of building, or other artifact that may provide a frame
for a work of art, has its own character; it evokes articulate emotional
reactions. Palaces differ from subterranean churches, gardens from church
facades. To this character the painting's matter should be adapted. In
a cemetery the artist will paint *istorie lugubrie* (VI. 21); in decorating a
fountain one will depict "tavole delli amori, e delle varie transforma-
zioni delle Dee e delle Ninfe" (VI. 22); and if you have to adorn a
fireplace you should depict scenes having something to do with fire,
such as Prometheus, the Burning Bush, or the Column of Fire (VI.
23). Decorum becomes an overall principle and dominates both the
subject matter and the placing of a work of art.

Lomazzo has little to say about *how* the different scenes should be
represented. Was he altogether neutral concerning the form in which
such widely differing scenes should suitably be cast? Did he want the

artist to enjoy complete freedom in the handling of his subject? Or did he, on the contrary, take it for granted that every painter and patron would be so familiar with the appearance of traditional scenes in art that no words need be wasted in describing them? An occasional observation may suggest that he was aware of a connection between subject matter and style. Paintings in temples should be done in the *maniera* Raphael employed in the "Stanza della segnatura" (VI. 22); the movements of figures connected with fire (and painted on fireplaces) should be "impetuous, tumultuous, violent," as already mentioned (I. 23). These remarks, though they remain scattered and vague, may have been a stage in the evolving of what, two generations later, Poussin called "modes." [149]

Another central genus of "Practice," the presentation of which takes up a large part of Book VI, deals with the subject matter of the work itself. This is not another iconographic manual. Iconographic literature, whether in the form of handbooks such as Ripa's *Iconologia* or explanations such as Vasari's *Raggionamenti* or Giacomo Zucchi's *Discorso sopra li Dei de' Gentili,* always focuses as precisely as possible on a specific scene or an individual figure. Each specific scene must be made unmistakably clear. To adduce an example dear to the eye of so many Renaissance painters and *litterati:* a Pluto abducting Proserpina should be clearly distinguishable from a Lapith abducting Deianira. What Lomazzo does is the very opposite. He lumps together different scenes that have a certain common quality, and so he forms types, as we would say. A few examples will easily show what he aimed at. How, for example, does one compose a battle scene? Regardless of who the combatants were, for which cause and in which period they fought, the landscape in which the battle takes place, the formation of the troops, and the like will be similar. It is this common structure with which "Practice" is concerned. In his prescriptions for battle scenes Lomazzo may well have drawn from the Leonardo tradition; he may even have had access to some of Leonardo's notes. "Paint first the smoke of the artillery mixed in the air with the dust raised by the horses of the combatants," Leonardo [150] advises the painter in a manner that could have served as a model for Lomazzo. But what is an isolated observation in Leonardo's notes, restricted to a single theme,

becomes in Lomazzo's system a universal principle. Take, for instance, his advice for a subject altogether absent from any former treatises of art theory—naval battles. When representing a naval battle—legendary or historic, ancient or modern—the painter should not omit the defeated pleading for mercy, their hands crossed on their chests; nor should the boats, with corpses cast into the water, be missing (VI. 29). The chapter on the depiction of rape (VI. 30) is, if anything, even clearer. The man committing the rape has "primarily to show force and insolence, accompanied by a certain desire . . . but in the raped [woman] one should express weeping, dread, pain, fright, imploring." Such guidelines are cogent regardless of which particular rape is represented, Proserpina's, Deianira's, or that of the Sabine women. Here as in all other chapters Lomazzo lists a perplexing wealth and variety of individual motifs. Still, what counts is not the individual scene or the specific motif; they are all subordinated to the comprehensive type. We are here tempted to speak of a pictorial syntax.

Lomazzo did not invent the themes he described; his lists mirror the subject matter of late-sixteenth-century painting, and they thus have a documentary value that deserves close study. The student of art theory cannot help asking which particular criterion determines the assigning of an individual scene to a specific type. As usual, Lomazzo's formulations are not always consistent; sometimes they are even confusing. Yet what emerges from a careful reading of this long book is that the *emotional* coloring of the scene is the ultimate criterion for its ascription to a type. Lomazzo does not present us with an iconographic theory but with a system of expressive types.

The chapter titles in themselves are enough to demonstrate that this is indeed so. A chapter entitled "Different Love Affairs" (31) follows the one on rape. "Cheerfulness and Laughter" are dealt with together (32); "Sadness and Affliction" form another chapter (34), as do "Fright, Scare, and Terror" (37) and "Astonishment" (39). To be sure, this list of emotional states is interspersed with some scenes of a more narrative character, such as "Shipwrecks" (38), "Games and Plays" (40), and "Offerings and Privations" (41). But even these carry articulate emotional connotations and fit well into the general expressive framework.

In sum, "Practice" consists mainly of a discussion of types—both of relations between paintings and their environment, and of the emotional content of the paintings themselves. The doctrine of types, as we have said, bridges the gap between pure theory and pure praxis. Lomazzo was laying a cornerstone for the building of academic theory.

The seventh, and last, book in Lomazzo's system, "Form," is the most puzzling. "In the sequence [of the system] form is the last part of painting," we are told in *Idea* (25). "But with regard to the theory and practice of art it is the first and most important." Nothing could seem more obvious. Yet what Lomazzo understands by "form" is far from obvious. What can we make, for instance, of the assertion that after the decline of Rome artists were "deprived of the cognition of form"; their works were of small value, since "knowing the external form of everything is not only useful, it is mandatory in painting" (*Trattato* VII. 1). A modern student, indoctrinated with the belief that form is completely represented by what we see, may ask what "external form" can mean. Is there any form that is *not* external, in the sense that it is not grasped in visual experience? That Lomazzo makes this statement in a discussion of the painter's practical work makes our question even more bewildering than it would have been in any case.

To acquaint ourselves with the scope of Lomazzo's notion of form it may be useful to review briefly its "species," as they are listed, neatly separated from each other, in *Idea* (25). Innocently enough, the list starts with "anatomy," conceived in the sense traditional in workshops (the skeleton, muscles, limbs, etc.). But the next "species," "contemplative form," is perplexing. What Lomazzo means by this term—which has no precedent in Italian art theory—is the images of angels, of the heavenly host, of the Virgin, and of the saints. Contemplative form, we are told, can be learned only from Scripture. As is well known to every attentive reader, Scripture gives few and very vague descriptions of the appearance of such personages. What Lomazzo probably had in mind were their conventional representations as he knew them from the art of his time. The "sign form" *(la significante),* the species that comes next, consists of another part of inherited culture imagery: it includes "the shape of the world," astronomical symbols, the zodiac, and the planets. The fourth species, "visible form,"

transplants us into an altogether different domain: it comprises what we perceive in regular visual experience, unaided by prior knowledge. Lomazzo here mentions the forms of men, women, quadrupeds, reptiles, and similar creatures. (A modern reader may consider "visible form" tautological terminology—What form appearing in painting is invisible?) "Imaginable form" *(l'immaginabile)* brings us back to cultural imagery. It includes the shapes of pagan gods and of "other products of the imagination, such as Pans, Fauns, and Nymphs." The "manufacturing form" *(fabbricativa)* shows Lomazzo's awareness of historical and ethnographic documentation. It refers to buildings, armor, and musical instruments, as they were shaped in different ages and among different nations. The images of devils, furies, Lucifer, and other demons constitute the "spirit form" *(la specie spirituale)*. The last species, best translated as "omen form" *(detta accidentale)*, comprises "thunderbolts, rays, lights, comets, omens, marvels, and similar objects which are seen as accidents, and of which one reads in histories."

All these species, says Lomazzo, come together in painting, molding a "universal representation of things divine, celestial, and terrestrial." The artist cannot master them without "careful study of Scripture, mathematics, poetry, hieroglyphics, history, architecture, anatomy, and many other sciences."

What, then, is "form"? This we can perhaps better learn from the *Trattato* than from the *Idea;* the earlier work shows us more clearly where the emphasis is placed. Of the thirty-two chapters forming Book VII (over 180 pages), only two short chapters (23 and 24) deal with the human body. The subject matter of all the other chapters we would now, without any hesitation, classify as iconography. When speaking of form, Lomazzo actually has a universal iconography in mind. "Form" is a term indicating the pictorial conventions employed in the sixteenth century to represent the traditional literary themes.[151]

Even from this brief and necessarily schematic review of Lomazzo's doctrine, we can draw some conclusions. The ambition to be all-inclusive, to formulate a theory covering all important elements of the "art," is the most obvious characteristic of his teaching. He manifestly aims at a *whole* theory, a *summa*.

To do this he first enumerates all the "parts" of painting. In addi-

tion, he also combines (or places one next to the other) the different traditions that sustained the Renaissance painter's workshop. He draws from the scientific traditions (anatomy, perspective); he discusses the problems of media and gives the technical traditions (light, color) their place; and, finally, he considers the iconographic traditions, making them actually the backbone of the artist's work.

Lomazzo's system of painting completely fits the world image, as late-sixteenth-century humanists perceived it. The four elements, the seven planets, and the four temperaments, assumed to govern the structure and course of things and man, also determine the structure of the "art of painting."

The articulation of types is probably the most characteristic, and most influential, feature of Lomazzo's theory. None reflects more clearly the changes that took place in Renaissance theory of art. Direct observation of nature, undetermined by any preconceived notions, is no longer the artist's most important task. Sometimes the reader has the impression that Lomazzo's set of types, or *regole,* as he sometimes calls them, are almost supposed to replace the artist's immediate encounter with reality. Even if this is not so, the artist is certainly not encouraged to look at nature with an innocent eye. The artist trained in Lomazzo's spirit knows in advance what he is looking for when observing nature, and the doctrine provides him with an encompassing pattern into which his individual observations are placed.

3. LOMAZZO: A DOCTRINE OF STYLES

The tendency toward discriminating and classifying groups of related features and listing them in a comprehensive and well-ordered scheme had yet another outcome—a system of artistic styles. Lomazzo is conspicuous in the history of art theory for admitting into aesthetic thought the notion of a variety of styles that, different as they may be from each other in character, may still be equally good. He also offered artists and readers of his time a theoretical foundation for this plurality. Lomazzo's doctrine marks an important stage in the process that eventually resulted in the modern notion of an artist's personal style.

People looking at pictures must always have noticed that the works of one outstanding artist have certain qualities in common that are not

found in the works of other artists and that these qualities make it possible for us to recognize the master's hand or spirit, or what we would now call his style. But when it came to the formulation of a theory, most periods disregarded these observations. Whenever the question surfaced as to what these qualities might be, the answers remained vague and ambiguous. "Uniqueness" was a term frequently employed when one wished to praise an individual work of art or an artist's manner. But "uniqueness" need not necessarily refer to character; it can also be understood as praise of skill and sheer mastery. Some of the classical stories, well known to every Renaissance humanist and painter, show how ambiguous such descriptions or notions were. In a famous story Pliny relates (*Naturalis historia* XXXV. 65) that Zeuxis painted grapes at which doves tried to pick, and Parrhasios painted a curtain that Zeuxis attempted to pull away. The competition between the two artists does not seem to be a juxtaposition of different styles; it is, rather, a competition of excellence in the same style, illusionism. Another anecdote told by Pliny (*Nat. hist.* XXXV. 81–83) may at first sight seem to carry some inarticulate connotations of personal style, but again it turns out to be a story about skill and marvelous achievement. Apelles, the story runs, visited the home of Protogenes and drew a fine line on the panel he found in the room. Protogenes, coming home, immediately recognized Apelles' hand and drew a finer line. But Apelles, on a further visit to his rival's house, drew a still finer line. Both artists, it would seem, painted in the same fine, linear style, and both appreciated the same kind of skill and virtuosity.

Early Renaissance art theory altogether disregarded the variety of personal styles, an attitude that parallels the refusal to admit various forms of beauty. The tacit assumption was that there is only *one* good style—one *perfetta regola dell'arte,* as Vasari later called it—and that this one style should be the sole model for all artists. But, as the belief in a single canon of beauty was shaken in the sixteenth century, so was the dogma that there is only one good style. In the mid-century critics and writers became more acutely aware that the great artists of their own time created in different styles. The juxtaposition of Raphael's *grazia* and Michelangelo's *terribilità* became a fashionable topic recurring in many writings on art, and many Venetian authors tried to describe

the individual character of Titian's style. These observations did not lead immediately to conceptual generalizations. Vasari, to mention just one outstanding example, often has penetrating insights into the personal styles of the artists whose life stories he tells, yet his system of styles is that of periods: *buona maniera antica* is the style of venerated Antiquity; *maniera tedesca* is that of the barbaric Middle Ages; the Byzantinize style of the early Italian schools is the *maniera greca;* and the *buona maniera moderna* is the style of his own period. No corresponding system of personal styles is to be found in Vasari's work. Some twenty years after the second edition of the *Lives,* Lomazzo presented his theory, and here for the first time a variety of styles were classified not according to periods but to artists, or rather artistic archetypes.

This doctrine was one of the last achievements of the sixteenth century. It was long in the making, but its final formulation can be dated with precision. All the ideas are present in Lomazzo's *Trattato* (1584), and in its concise and final form the doctrine is formulated in his *Idea* (1590).

Lomazzo's *Idea* appears as the description of an imaginary building, a temple that makes visible in its architectural structure the art of painting. The literary device is age-old. One finds descriptions of allegorical buildings in the literature of Antiquity as well as of later periods. Lomazzo had several models available. Schlosser suggested a fourteenth-century didactic poem, entitled *Intelligenzia,* as the immediate prototype; the most recent editor has proposed Giulio Delmino's *Idea del teatro.*[152] But the allegorical temple was so common a topos in Renaissance literature[153] that the identity of the direct model is not very important. The importance of Lomazzo's theory is that it does not remain in the sphere of abstract allegories. He describes a celestial edifice that is supported by seven columns and having seven "regents." The "regents" or columns of this temple are seven well-known Renaissance painters: Michelangelo, Gaudenzio Ferrari (a Lombard painter who worked in the first half of the sixteenth century), Polidoro da Caravaggio (Lomazzo's teacher), Leonardo, Raphael, Mantegna, and Titian. All the seven parts of painting are present in the works of each of these artists, but in variations characteristic for every specific type. Moreover, in the work of each of the seven painters one "part of the

painting" is more prominent than the others, and this artist becomes the embodiment of that particular "part" or element of the art. Thus, light can best be observed in Leonardo's paintings, perspective in Mantegna's, color in Titian's, and so forth (*Idea* 9). The ultimate source of the whole edifice is astrological cosmology. Indeed, each of the seven artists, that is, "regents" or columns, also represents a planet. Following the ramifications of astrological theory in the late sixteenth century, to each of the artists also corresponds a particular metal, animal, ancient sage, and so on. Robert Klein has compiled a detailed diagram of all these correspondences, which is presented in Table 5.2 in abbreviated form.

That Lomazzo should have assigned to astrology such a vital function in his grouping of artists should not surprise us. The theory of astrological types was the core of sixteenth-century psychology. As usual, Lomazzo did not revolt against accepted wisdom; he only tried to codify its application to art. In fact, however, he was more original than he himself believed, and he raised questions in aesthetic thought that are still with us.

By relating artists to planets Lomazzo attempted to describe their "nature." He created a psychology of art. The artist's nature was a fashionable subject at the time. Artists cannot be produced by training, critics emphasized; "a painter really needs to be born that way, just as much as the poet does," to quote Dolce.[154] What these writers had in mind was what we would now call the artist's creativity. Lomazzo,

TABLE 5.2.

The Colums of Lomazzo's "Temple of Painting"

Artist ("Regent")	Planet	Animal	Part of Painting
Michelangelo	Saturn	Dragon	Proportion
Gaudenzio Ferrari	Jupiter	Eagle	*Moto*
Polidoro	Mars	Horse	Form?
Leonardo	Sun	Lion	Light
Raphael	Venus	Man	Composition?
Mantegna	Mercury	Serpent	Perspective
Titian	Moon	Bull	Color

though naturally subscribing to this view, aimed at something completely different in his psychology of artists. To be endowed with the gift of creativity in no way indicates what *kind* of artist one is. Both Michelangelo and Raphael were "born" as artists, but this fact does not explain their different styles. What Lomazzo sets out to do is to describe and interpret the *particular* character of different artistic types. He does not want to explore what makes the artist an artist but what makes one artist different from the other, even if circumstances and training are similar.

Lomazzo does not invent a special doctrine to explain the painter's nature. The categories he employs in his psychology of the artist do not differ from those that were employed for classifying all human beings. He simply applies the current doctrine of human nature to artists. There are hosts of saturnine people who do not paint or carve, as did Michelangelo, and there are countless people who "belong" to Venus without creating pictures, as did Raphael. What Michelangelo and Raphael have in common with all the other people classed with Saturn or Venus is not their being artists but their general disposition, character, or what we would now call their personality.[155]

But the classification of artists according to astrological types acquires a more than merely biographical significance if we assume, as Lomazzo did, that an artist's nature is mirrored in his work. This assumption, too, was not altogether unheard of. Renaissance humanists could learn from such a venerated source as Pliny that the unfinished works of certain painters were even more highly regarded than their finished ones, because these sketches showed "the workings of the artist's mind." Vague as this statement may sound, it reinforced a feeling not unknown among sixteenth-century critics in different fields. In 1512 Pico della Mirandola, the nephew of the famous fifteenth-century humanist of the same name, maintained that writers have an inborn instinct in selecting the particular model they should imitate.[156] A few years later, in 1528, Erasmus of Rotterdam, concluding the debate on the imitation of Cicero's style, which was a cause célèbre in literary circles of the time, spoke out against the slavish imitation of a single ideal model. He did so on the basis of human diversity. As you cannot offer the same food to guests of different tastes, Erasmus said,

so you cannot ask of different authors to write in the same style.[157] Every reader will find an author whose style fits the reader's desire. That painters, too, have specific styles according to their nature was also felt in the mid-sixteenth century. In the *Aretino,* Dolce maintains that the "diversity [that] exists in the complexions and humors means a diversity in the modes which issue from them."[158]

In his psychology of the artist, as in the other parts of his theory, Lomazzo does not claim to say anything new; he wants to summarize and systematically expound what is commonly believed. But the modern reader, carefully rethinking Lomazzo's procedures, cannot help asking: How can we classify styles according to artists' personalities? What does Lomazzo know of the painters whose manners he analyzes? There is little doubt that in reality he was familiar with what most artists and writers of his time knew—the life stories of the seven masters, the legends told about them, their "inventions," and so on. But in his theory he completely and consistently abandons any biographical approach and disregards any anecdotal material (much to the regret of some modern readers). Unlike Vasari, Lomazzo does not attempt to present a well-rounded portrait of the artist's personality. He admits only the basis for classifying artists, and that is their work. The artist's "personality," his "type," is reconstructed from what we can read from his work. The primary object of Lomazzo's analysis is the work of art; his image of the artist is derived from what one sees in his pictures. Leonardo is a "solar" painter; he belongs to the sun because the expressive qualities of his style and the "part" prominent in his work (light) are characteristic of the psychological type belonging to the sun. General psychology provides the categories for classifying artistic styles.

As the artist's nature is not a matter of his choice, so he cannot choose his style deliberately. Michelangelo could not help creating in a saturnine manner, and everybody in the sixteenth century took this for granted, while Raphael's graceful manner unalterably flowed from his nature. An artist's style is the unavoidable and unalterable result of his nature. As one cannot change one's style, one should not try to imitate another (alien) one, be it ever so good. A young artist, looking for a master with whom to study, should be careful to find one who

belongs to the same type as the student himself. Although Lomazzo's doctrine is firmly rooted in sixteenth-century thought, there is something modern about his making an artist's style the result of his personality.

That the artist's nature unavoidably imparts itself to his work is indeed the strongest and most specific expression of the belief in his creativity. Ultimately, the painting or sculpture arises neither from an artistic tradition nor from social patronage; Lomazzo, in fact, discussed neither of these. The real and final origin of the work of art is the artist himself.

But this doctrine also raises a question of far-reaching consequence. If an artist's style is indeed not a matter of his choice, what can be the effectiveness of the "rules" he is taught and of the models he is provided with? A rule and a model are necessarily supraindividual, general. Lomazzo himself, we have just seen, accepted this axiom of early Renaissance aesthetics. But how can an artist properly acquire the general "true manner" and be educated to follow good norms if he is so inextricably confined to his particular nature? Does not an unbridgeable gap open up here between the variety of artists' natures and the universality of the *one* good style? Lomazzo seems to have been as unaware of this concealed contradiction as Alberti, in his time, was unaware of the conflict between claiming to be faithful to nature and, at the same time, to produce perfectly beautiful figures. In the centuries that followed, however, the contradiction between the artist's individual psychology and the aesthetician's idea of a normative style came into the open, becoming a focal problem of any thought on art. By raising this question, even though unintentionally, Lomazzo marks the end of Renaissance thought on art.

V. REBELLING AGAINST THE RULES: THE LAST PHASE OF RENAISSANCE ART THEORY

1. POETICS AND PHILOSOPHY

The High Renaissance did not recognize the rivalry between genius and rule. Creation and the imitation of former models, so the artists and critics of that period believed, overlap, or even inseparably merge

into each other. In the course of the sixteenth century, however, the latent conflict between these two poles gradually became manifest. The final stage of Renaissance theory of art, lasting only a few years at the turn of the century, was dominated by an altogether unconcealed clash between the belief in the artist's spontaneous creativity, on the one hand, and institutionalized traditions and prescribed procedures, on the other. If the late sixteenth century did indeed undergo a profound intellectual and psychological crisis, as some modern historians would have us believe, the clash between creativity and tradition must be considered one of its obvious manifestations. As far as art is concerned, nothing reveals the intrinsic dialectics of this process more clearly than the fact that the most explicit and violent rejection of rules and authority was pronounced in the recently established Academy of Art, an institution formed to teach rules and preserve tradition.

The conflict between spontaneous creativity and traditional models and rules was not limited to painters and sculptors. At the very time that some writers on the visual arts were so violently denying authority and rules, the theory of literature was undergoing a similar handling. It is probably impossible—and useless—to determine which domain, the theory of painting or of poetry, preceded the other in casting doubt on rules and questioning authority; they are both manifestations of the same process. But it may be useful to glance briefly at the questions raised by literary critics and to hear what they had to say on this common subject.

In 1586, two years after Lomazzo's *Trattato* was issued in print, the Italian philosopher and man of letters Francesco Patrizi (1529–1597) started producing a series of volumes on the art of poetry.[159] The first volume of Patrizi's *Della poetica* was published late in his life, but, as he himself attests, he began working on his poetics much earlier, in 1555. In his general philosophy Patrizi attempted to develop a systematic explanation of the physical universe without drawing on, and in contrast to, the dominant Aristotelian tradition. The same holds true also for his theory of poetry. Aristotle's *Poetics,* that scripture of literary criticism and a work that also exerted a profound influence on the theory of the visual arts, is attacked and its theses are systematically refuted. So consistent was Patrizi's negation of Aristotelian *Poetics* that

his own theory has aptly been called "negative poetics." For the traditional commentators of Aristotle's *Poetics* he has harsh words: "with a hesitant foot [they] have gone turning about in circles around precepts which were few, and not sufficient, and frequently false, and not a few of them inappropriate and excessive." In the intellectual atmosphere of the late sixteenth century these were daring words indeed. However, Patrizi aimed even further. Though explicitly his criticism is focused on Aristotle's *Poetics,* he not only intends to undermine that particular tradition of literary criticism; he also wants to demolish *all* authority in understanding matters of artistic creation and in judging works of art. Renaissance humanists used to present their own contributions, sometimes of great originality, to the philosophy of poetry, disguised under the cloak of classical authors. The ancient sages were asked to lend sanction to what the sixteenth-century writers had to say. Patrizi rejects the very principle. There are no authorities that cannot be questioned; even Plato's wisdom is not absolute. Patrizi boldly stresses his own originality and independence of authorities. He wants to lead his readers out of the "blind labyrinth" (*cieco labirinto*) of his time by showing them what the elements of poetry really are, beyond what "authorities" may have to say to them.

What makes words into a poem? And what causes the poem's effect on an audience? Patrizi asks these questions, but he knows that what lies behind these manifestations is ultimately an irreducible quality. He calls it *mirabile,* that at which we wonder and marvel. The poet partakes of this quality. Remembering Plato's differentiation of makers into God, nature, and the artificer, he inquires into which of these categories the poet fits and answers: all and none. The poet is not God, but he has something of the divine; he is not nature, but nature makes him poetize; he is not an artificer, but he does many things by art. Hence, the very way in which the poet creates is "marvelous." He is not only a *facitore del mirabile* (maker of marvels); he is also a *mirabile facitore* (marvelous maker). Patrizi's text is long and elaborate; nevertheless, it is not perfectly clear what he means by "marvel." One conclusion is certain, however: marvel comes from divine furor, and it excludes any rationally calculable rules.

At the same time, Giordano Bruno, the famous Italian philosopher

(1548–1600), definitely formulated the rejection of rules in matters of poetry and art. His version of the world, while deeply rooted in Renaissance beliefs, has a distinctly modern quality.[160] That "beauty is of many kinds" he frequently repeats (e.g., *De vinculis in genere* III.643), and these kinds "differ one from another." He was also aware that "the essence of beauty, like the essence of pleasure and [the] good, is undefinable and indescribable" (III. 663). Such thoughts may show how far removed his intellectual world was from that of the early Renaissance, that is, from the period in which the best thinkers believed that a single and concrete ideal of perfect beauty could be crystallized and that it could form the basis of all artistic creation. But his views about rules for artists are even more radically different from those accepted earlier. Bruno draws the final conclusion from what is now often called the irrational nature of the artist's work. Calling himself an "academic of no academy" (*academico di nulla academia*), he does not seek to compose a treatise for poets and artists, formulating rules to guide them in their work. Such a treatise would be altogether useless, if not outright misleading.

Only one year before the appearance of Patrizi's first volume on poetics, Bruno's *De gli eroici furori* (1585) was published in England. In its literary form, a series of dialogues, it bears—probably more than any other work of its author—the distinctive imprint of its time. In the dialogues, the recital and interpretation of a series of poems by Bruno and others, and the explanation of a number of symbolic mottoes and devices—all imitating emblem literature—occupy a large place, interrupting as well as enlivening the presentation of the chief ideas. In the last decades of the sixteenth century one could hardly find a literary form more obviously related to humanistic erudition and more expressive of the veneration of tradition than the one employed by Giordano Bruno. Yet his views are revolutionary. Originality, not adherence to tradition, is the poet's central achievement. His task is to create something that has never before existed. Altogether reversing medieval ideas, Bruno believes the poet (and, in a broader sense, every kind of artist) to be a creator of something out of nothing. But rules, everybody will agree, are the crystallization of former experiences. If every poetic creation is by definition new, original, without prior models,

how can rules be formed? Rules, Giordano Bruno therefore concludes, are good only for those who are more capable of "imitating" than of inventing (note the derogatory connotation of "imitating"). Probably referring to Aristotle, he even adds that rules were laid down by one who was not a poet at all.

In the place of impersonal rules Bruno sets the artist's personality. At the beginning of the first dialogue he asserts that "Poetry does not grow from rules, but rules are derived from poetry." It is not surprising, therefore, that "there are as many kinds of true rules as there are kinds of true poets." Homer, for example, "was not a poet who depended upon rules, but was the cause of rules."[161]

Giordano Bruno rejects rules, not only as guides to the artist in his work, but also as criteria for judging the completed painting or sculpture. His contempt for professors and professional critics is profound. The latter particularly are "stupid pedants" *(pedantacci)* who for some reason fancy themselves to be "the only ones into whom Saturn has implanted the power of judgment." Speaking of these guardians of rules, Bruno's language often becomes extremely unacademic. These institutional judges, who pretend to establish fixed, transpersonal rules and judge by them, are "worms" and "blockheads."

2. ZUCCARI: THE THEORY OF DISEGNO

As literary critics questioned the validity of "rules" in the domain of poetry, so did theorists of the visual arts in the realm of painting and sculpture. The most explicit spokesman of this trend in art theory was Federico Zuccari (1542–1609). Though he denied rules and authority altogether, it would be mistaken to picture Zuccari in the image of the modern rebel revolting against all institutions, social as well as artistic. In fact, the opposite was the case. Zuccari was a renowned painter, an upper-class gentleman, a favorite of many rulers in Europe, the guest of the prince of Savoy, of King Philip II of Spain, and of many other nobles. During the crucial years of the formation of the Roman Academy he also appeared as the embodiment of the academic ideal. In an interesting article, Walter Friedländer compared Zuccari with his contemporary, the great painter Caravaggio. The latter, famous for his unruly temperament, unconventional behavior, and supposedly ple-

beian tastes, is the first "bohemian"; Zuccari, adroit, at ease in society, and very much part of the establishment, is the first "academician." This social conformist was the spokesman of the most radical aesthetic theory advanced prior to the nineteenth century.[162]

He presented his theory within an official and highly regarded institution. After trying for some fifteen years to reform the Academia del Disegno in Rome, he finally succeeded in doing so with the help of Cardinal Federico Borromeo. On November 14, 1593, the Academy was inaugurated by a solemn service in the church, and Federico Zuccari was subsequently elected president *(principe)*. The primary aim of the new institution was educational (in the next chapter we shall have occasion to discuss its contribution). Every day an hour after lunch, and an entire session once a fortnight, was to be devoted to theoretical debates. Zuccari was a regular speaker. The minutes of these lectures, kept by the first secretary of the Academy, Zuccari's nephew Romano Alberti, provide ample evidence that Zuccari's theory was fully developed by the end of the Cinquecento. It received its authentic literary form only slightly later, in Zuccari's *L'idea de' pittori, scultori, et architetti* (Turin, 1607).[163] The notes by Romano Alberti and the *Idea* are the sources for the following pages.

The core of Zuccari's doctrine is his theory of design. Speaking in an Academy of Design, it seemed appropriate that he should start his course with a definition of *disegno*. The *principe* was a conservative academician indeed. Addressing his students, he said that after they attended mass they would have occasion to listen to the theoretical deliberations offered at the Academy. (It may be worth mentioning that advice as to how artists should behave was not unknown in earlier Renaissance art literature; Leone Battista Alberti had already devoted many thoughts to this respectable subject. Yet so far as we know, no author before Zuccari required would-be artists to attend mass.) In his first lecture Zuccari outlined his views about how youngsters starting their studies at the Academy should be educated. There is an "Alphabet of Design," Zuccari said in his first lecture, held on November 14, 1593, and the beginner must first master its "letters." Here, too, a brief glance at the past may be instructive. That the "art of painting" is composed of elementary "parts," and that the young artist must first

acquire a mastery of these, was not new in Zuccari's days. Yet views of what precisely those elements were had radically changed in the course of time. For Leone Battista Alberti, in 1435, the building blocks of painting are geometrical figures (the point, the line, and the surface) and stereometrical bodies. For Zuccari, speaking a century and a half later, the ABC of painting is more naturalistic: the letters are the shapes of individual limbs of the human body, such as eyes, noses, mouths, ears, heads, hands, as well as the parts of other real creatures or objects. This difference indicates a problem that goes beyond the individual elements themselves. In the early Renaissance there seemed to exist a natural transition from the individual geometric shape to the perspective structure of space (perspective itself also being a geometrical projection) and from there to the constructing of the work of art as a whole. But how does one combine the individual limbs of the human body—these eyes, hands, and feet—into a whole? There seems to be no obvious transition from the part to the whole. What, then, is here the principle of composing the work of art? Zuccari's answer is given in his theory of design.

To understand the sources and background of his views of *disegno* we should keep in mind that Zuccari's theory was formed in an explicit debate with former schools of art theory. He discusses such classics as Alberti, but also many authors much closer to his own day, such as Vasari. In his lecture of January 2, 1594, he quoted at length from Lomazzo's *Trattato* and *Idea,* the latter of which had appeared only a few years earlier.[164] The *principe* was up to date in his reading. His main argument against inherited art theory was concerned with a central category in Renaissance aesthetics, the category of "rule" *(regola).* Zuccari altogether rejects rules in painting, and the more strongly they are based on mathematics—that is, the more they strive to attain scientific objectivity—the more he uncompromisingly rejects them. Let us listen to his own words.[165] "But I do say—and I know I speak the truth—that the art of painting does not derive its principles from the mathematical sciences, indeed it need not even refer to them in order to learn any rules or manners of procedure, or even to be able to discuss them by way of speculation; for painting is not their daughter, but the daughter of nature and design" *(Idea* II. 6). And, as if to dispel

any possible doubt as to what he has in mind, Zuccari gives an example. "Dürer, albeit a capable painter," tried "to shape human bodies by mathematical rules," but he did so "after his own whim." The belief that it is possible "to teach artists to work by such rules" would thus be "vanity and outright madness." Following them, an artist will never produce a good work. Therefore, Zuccari suggests, even Dürer may have done his work (which, he admits, "was not negligible") just "as a joke, a pastime, and to give diversion to those minds that are inclined to contemplation rather than to action." In this violent rejection of rules Zuccari belongs to the same broad intellectual trend as Patrizi and Bruno. But, by referring specifically to "mathematical" rules, he indicates a dimension peculiar to the visual arts and Renaissance theory of painting.

Zuccari's attitude, though prepared by the doubts of two generations, is something new. In this chapter we have seen how the significance of mathematical foundations of painting gradually shrank throughout the sixteenth century. In 1548 Paolo Pino had criticized Alberti's *On Painting* for being more about mathematics than about painting. The Michelangelo cult in the second half of the century contributed much to making genius and inspiration overshadow training and acquired method. Yet nobody before Zuccari explicitly and completely rejected rules or discarded scientific truth as a value of painting.

The reason for this total rejection of rules is that they keep the artist's mind in bondage and imprison his imagination and creative power. And the more precise the rules are—as are those based on mathematical calculation—the more rigidly they confine the artist's spirit. "But the [artist's] intellect must be not only clear but also free, his spirit unfettered and not thus restrained in mechanical servitude to such rules."[166] A little later in the same chapter Zuccari explains that, "instead of increasing practical skill, spirit, and liveliness, this kind of thing [i.e., rules] would take them all away: the mind would debase itself, the judgment extinguish itself, and all grace, all spirit and savor, would be taken away from art." Doing away with rules restores creativity to the artist's unfettered mind. Only after we have excluded rules can we understand *disegno* and what it does in the process of artistic creation.

What precisely Zuccari meant by *disegno* is not easily said. His formulations scintillate. But perhaps because he felt this, he wants to start his work by explaining the term. "Before we treat of any subject it is necessary to explain its name, as the prince of philosophers, Aristotle, taught us," Zuccari assures his readers; "otherwise we shall have to travel an unknown road without a guide, or enter the labyrinth of Daedalus without a thread."[167] He concludes the *Idea* by showing how an analysis of the term unveils the hidden relationship between *disegno* and the divine. Some of these deliberations must strike us as strange in the context of a professional school. One cannot help wondering, for instance, how students of painting and sculpture may have received Zuccari's ostentatiously erudite discussion of the eminently practical question of how many letters should make the holy name of God. Reflecting the Holy Trinity, God's name should have only three letters. True, in most languages, ancient, Oriental, and modern, it consists of four, "but our Italian tongue names God in a word that has but three letters, namely *Dio.*" The number three in the divine name corresponds to the three syllables of *disegno.* Furthermore, the division of this term into its three syllables *(di-segn-o)* reveals that the first and last syllables form the name of God *(Di-o),* and the middle syllable, circumscribed by the divine name, signifies "design" *(segn).* The very structure of the word *disegno* thus proclaims the essence of design with miraculous tongue. *Disegno* bears the divine stamp; it is "the true sign of God within us" *(vero segno di Dio in noi).*[168]

The sign of God is of a unique nature. *Disegno,* Zuccari says early in the *Idea* (I. 3), "is not matter, not body, nor affection, nor substance: it is a form, idea, order, rule, boundary, or the object of the mind." Yet, in spite of all these qualities it is not only spiritual; on the contrary, the concept of *disegno* covers the whole span from an image in the mind to a drawing on paper. In order to grasp that range, the reader is told: "one should remember that there exist two kinds of operations: external ones like drawing, outlining, shaping, carving, building; and internal ones like reasoning and desiring."

That *disegno* extends from the internal to the external, from the image in mind to the drawing on paper, is not Zuccari's invention. In 1549 Francesco Doni, a Florentine humanist who published a book

entitled *Disegno* in Venice, had defined the work of art as "the work of the hand, originating from the design of the mind" *(disegno della mente)*.[169] Vasari, as we saw earlier in this chapter, held similar views. And Raffaello Borghini, in his *Il Riposo* (1584), takes "design to be nothing else but a demonstration made visible by means of lines of that which was first in man's soul."[170] Zuccari crystallized these views by coining the terms *disegno interno* and *disegno esterno.* The articulation of terms only brought into the open what had been growing in a less articulate form for half a century.

A modern reader is naturally inclined to understand "internal design" as a psychological category. What else can it be but an evoking of what is distilled from many visual experiences, something similar to what Dürer meant by "the accumulated, secret treasure in one's heart": But Zuccari thought differently. He went beyond the reach of psychology. *Disegno interno* exists in God, in the angels, and in man. Mediated by this hierarchic chain, *disegno interno* in man is an "example and shadow of the divine one" *(tipo et ombre de quel divino),* and therefore we can call it the "spark of divinity" *(scintilla della divinità).*

The *disegno interno* that God implanted in us is both a faculty and an image dwelling in our mind. On the one hand, it is the "moving cause, generating the arts"; it is the "very cause of art."[171] On the other, it is the image present in the artist's mind. As an image present in the mind it is not even confined to artists. Internal design is a means of cognition, and as such—this is what emerges from Zuccari's text—it is a property common to all men. *Disegno interno* is a "concept formed in our mind, that enables us explicitly and clearly to recognize anything, whatever it may be, and to operate practically in conformance with the thing intended."[172] The *principe* declares that only because he is addressing painters, sculptors, and architects does he use the term *disegno.* It is not difficult to understand why *disegno interno* is altogether independent of its execution in any artistic medium.[173]

As ambiguous as the *disegno interno* is, so is its corollary, the *disegno esterno.* Is "external design" a drawing on paper, or is it a completed work of art? Zuccari aims at something else. A painting has color; a piece of sculpture consists of heavy stone. "External design" has neither; it is pure outline, sheer form without any material substratum.

"The external design is nothing but that which is circumscribed by form without corporeal substance" (II. 1). Pure outline may form the basis of any real work of art, but in order to transform it into a painting or piece of sculpture one has to add the specific materials, colors or solid matter. Bodiless "external design" appears to Zuccari as line drawing. Pure line comes closest to sheer form; it is "visible substance" per se.[174] Reading Zuccari's praise of pure line, one remembers that in the early Quattrocento outline or pure line drawing fulfilled a similar function. To present the structure of pure space one drew a perspective outline. Alberti in *On Painting* (I, 2) describes the bodiless quality of line by saying that it is "so slender in width that it cannot be split." But while for Alberti the bodiless quality of line makes it particularly appropriate for precise calculations and mathematical models, Zuccari conceives of this quality as immeasureable and rejects mathematics as a "waste of time" and as alien to art. Yet, however "bodiless" pure line may be, it *is* visible; it can be experienced as everything else that is "proper to us painters, sculptors and architects" (II. 1).

Zuccari encounters the problem that has haunted aesthetic thought during the two millennia between Plato and the late sixteenth century: How can we bridge the gap between the internal and the external? That the *principe* was aware of the problem one may infer from his frequent attempts to define line as bodiless. Something bodiless yet visible can function as a connecting link between the internal and the external; it may be comparable to some medieval conceptions of light that, because it is bodiless yet visible, comes closest to the spiritual in the material world. Zuccari must have felt how frail and dubious his position was. "Yet the line itself," he says, probably referring to the line drawn on paper, "as a dead thing, is not the science of *disegno*, nor of painting, but only its execution" (II. 1). In spite of such doubts, he does maintain that the internal design *can* be made visible. "But from the internal design the external one is born"—with this declaration he opens the second book of the *Idea*. The continuity from the mental image to the drawing on paper is the very essence of his theory. He concludes the *Idea* with a diagrammatic table that reveals his intention (Table 5.3).

TABLE 5.3.
Property and Quantity of Design

Name
Divine spark
Quality
Circumscription, mensuration, and form (*figura*)
Substance
Form and figure without substance of body
Appearance
Simple outline
Definition
Forms of all forms
Light of the intellect, and life of all operations
Instruments
The pen and the pencil

The table demonstrates that there is, then, an uninterrupted continuity leading from the "divine spark" in the artist's mind to the material pencil in his hand.

In sum, Zuccari's theory is dominated by *one* question: How does the artist create his work? Literary theorists and philosophers of his time, using a variety of terms, confirmed that this is a mystery. To unravel this mystery Zuccari composed his theory of *disegno.*

Zuccari's doctrine of *disegno,* of the creative process, should, however, be seen not only in the light of contemporary intellectual trends but also as a final step in the unfolding of Renaissance art theory. This began, as we remember, with the quest for scientific rules and principles to guide the artist in his work. At this stage the nature of the creative process was not among the subjects discussed. As art theory gradually became more focused on the artist, the creative process loomed larger as a theme of investigation. Zuccari drew the final conclusion. In his single-mindedness he abandons all the themes of traditional art theory. He disregards the quest for correctness; he gives no advice on how to make a work of art; he is not even interested in the nature of art as such. His thought has one single theme: How does the work of art flow from the artist's vision? In this exclusive concentration on the

artistic process—trying to describe and explain what remains indescribable and inexplicable—Renaissance art theory reaches its end.

NOTES

1. See B. Weinberg, *A History of Literary Criticism in the Italian Renaissance* (Chicago, 1961; reprint 1974), pp. 725 ff. (Fracastoro), 388 ff. (Robortello), 169 ff. (Speroni), 743 ff. (Scaliger).

2. See above, pp. 228 ff.

3. Vincenzo Borghini's writings on art have been edited by A. Lorenzoni *(Carteggio artistico inedito di Vincenzo Borghini)* (Florence, 1912). See particularly pp. 11 ff. Vincenzo Borghini should not be confused with Raffaello Borghini, the author of *Il Riposo.*

4. *Carteggio inedito,* ed. Lorenzoni, pp. 11 ff. See also F. Saxl, *Antike Götter in der Spätrenaissance* (Leipzig and Berlin, 1927), pp. 6 ff.

5. E. Panofsky, *Idea: A Concept in Art Theory* (New York, 1968), pp. 83 ff.

6. Zucchi's *Discorso* is reprinted in Saxl, *Antike Götter,* pp. 37–111.

7. *Le opere di Giorgio Vasari,* (Florence, 1882), VIII, pp. 7–223.

8. For Cesare Ripa's *Iconologia* see above, pp. 267 ff.

9. Vasari is quoted in the edition of G. Milanesi (Florence, 1878 ff.). For the term *rinascita* see vol. I, p. 243 (in the preface to the whole work).

10. *Le vite,* VII, p. 682.

11. Pino's *Dialogo di pittura,* reprinted in P. Barocchi, ed., *Trattati d'arte del Cinquecento* (Bari, 1959), I, p. 126.

12. For discussions of Vasari see T. S. R. Boase, *Giorgio Vasari: The Man and the Book* (Princeton, 1979). Boase's book does not supersede the lucid exposition in A. Blunt, *Artistic Theory in Italy 1450–1600* (Oxford, 1956), pp. 86–102; see also the magisterial discussion in J. von Schlosser, *Die Kunstliteratur* (Vienna, 1924), pp. 253–304.

13. *Le Vite,* I, pp. 9 ff.

14. The term occurs in ibid., II, p. 95.

15. Ibid., I, pp. 369 ff.

16. For Vasari's use of both absolute and historical criteria (i.e., *perfetta regola dell'arte* and *secondo che)* see E. Panofsky, *Meaning in the Visual Arts* (Garden City, N.Y., 1957), pp. 205 ff.

17. *Le vite,* I, p. 168.

18. Now easily available in Barocchi, ed., *Trattati,* I, pp. 211–269, the sentence quoted is on p. 136.

19. *Vasari . . . Le Vite,* ed. K. Frey (Munich, 1911), pp. 103 ff., n. 1.

20. Gabriele Paleotti, *Discorso intorno alle imagini sacre e profane,* reprinted in Barocchi, ed., *Trattati,* (Bari, 1961), II, pp. 110–509. For his discussion of *disegno* see p. 134.

21. Panofsky, *Idea,* pp. 60 ff., 65 ff. See also J. Rouchette, *La Renaissance que nous a léguée Vasari* (Paris, 1959).
22. This origin of the "idea" in accumulated experience is briefly discussed in Panofsky, *Idea,* p. 62.
23. *Le vite,* II, p. 171.
24. Ibid., VII, p. 272.
25. For an interesting though brief discussion of *grazia* in Vasari see Blunt, *Artistic Theory in Italy,* pp. 93 ff.
26. Roman and arabic numerals in parentheses following quotations from Alberti refer to book and paragraph numbers, respectively, in Leone Battista Alberti, *On Painting and On Sculpture,* edited with Introduction, translations and notes, by C. Grayson (London, 1972). Alberti's *De Statua* appears in the same volume *(On Sculpture),* and will be quoted in the same manner.
27. Commentary on the *Symposium* V. 1 (Ficino, *Opera* [Basel, 1561], p. 1336).
28. In Pico della Mirandola's *Commento alla Canzone di G. Benivieni* (Lucca, 1731), p. 113, quoted by W. Tatarkiewicz, *History of Aesthetics,* III (The Hague and Warsaw, 1974), p. 124.
29. See S. Monk, "A Grace beyond the Reach of Art," *Journal of the History of Ideas* 5 (1944): 131 ff. And see Baldesar Castiglione, *The Book of the Courtier* translated by C. Singleton (Garden City, N.Y., 1959). Roman and arabic numerals in parentheses following quotations from Castiglione refer to book and chapter numbers, respectively.
30. Angelo Firenzuola, *Della bellezza delle donne* (Biblioteca scolastica di classici italiani), p. 134.
31. *De imitatione libellus,* quoted by Tatarkiewicz, *History,* III, p. 124.
32. Reprinted in Barocchi, ed., *Trattati,* I, pp. 85–91.
33. *Le vite,* II, pp. 95 ff.
34. Ibid., IV, p. 9.
35. R. Klein, *La forme et l'intelligible* (Paris, 1970), pp. 341–352.
36. *Le vite,* I, p. 151.
37. Leonardo da Vinci, *Treatise on Painting,* translated and annotated by P. McMahon (Princeton, 1956). Numerals in parentheses following quotations from Leonardo refer to the paragraph numbers in this edition.
38. Raffaello Borghini, *Il Riposo* (Florence, 1584), p. 136 (the page number is a mistake; it should be p. 150).
39. G. P. Lomazzo, *Trattato dell'arte della pittura* (Milan, 1584). Roman and arabic numberals in parentheses refer to book and chapter numbers, respectively.
40. *Le vite,* VII, p. 270.
41. E. Kris and O. Kurz, *Legend, Myth, and Magic in the Image of the Artist: A Historical Experiment* (New Haven, 1979).
42. *Le vite,* I, p. 383.
43. For Vasari's concept of "dryness" see Blunt, *Artistic Theory,* p. 95.
44. *Le vite,* IV, pp. 143 ff.
45. Now easily available in Barocchi, *Trattati,* I, pp. 209–269.

46. See ibid., I, p. 324.
47. For Danti's life and background see J. von Schlosser, "Aus der Bildnerwerkstatt der Renaissance," II, "Eine Bronze des Vincenzo Danti," *Jahrbuch des Allerhöchsten Kaiserhauses* 31 (1913–14) pp. 71 ff. And see also D. Summers, *Michelangelo and the Language of Art* (Princeton, 1981), pp. 24 ff.
48. Danti, *Trattato,* p. 209 (dedicatory epistle).
49. Ibid., pp. 241 ff. (stones), 246 ff. (vegetation).
50. Ibid., pp. 211 ff., 267 ff.
51. Schlosser, "Aus der Bildnerwerkstatt der Renaissance," pp. 83 ff.
52. Danti, *Trattato,* p. 268.
53. For the meaning of *imitatio* in the literary theory of the Italian Renaissance see T. Green, *The Light in Troy: Imitation and Discovery in Renaissance Poetry* (New Haven, 1982). See also F. Ulivi, *L'imitazione nella poetica del Rinascimento* (Milan, 1959).
54. A particularly fine illustration is Cennini's advice to use "some large stones rugged and not cleaned up" as models for the depiction of mountains. See *Cennino Cennini The Craftsman's Handbook: Il Libro dell'arte,* p. 57 (chap. 88).
55. Leonardo da Vinci *Treatise on Painting,* ed. and trans. P. McMahon (Princeton, 1956), no. 77.
56. For Bembo's doctrine see esp. H. Gmelin, "Das Prinzip der Imitatio in den romanischen Literaturen der Renaissance," *Romanische Forschungen* 46 (1932).
57. R. Krautheimer, *Lorenzo Ghiberti* (Princeton, 1956), pp. 277–293; H. W. Janson, *16 Studies* (New York, n.d. [1974]), pp. 251–288.
58. Danti, *Trattato,* pp. 264 ff. Cf. Summers, *Michelangelo,* pp. 279–282.
59. Reprinted in Barocchi, ed., *Trattati* (Bari, 1962 III, pp. 239–379.
60. Ibid., pp. 274 ff. See also p. 256.
61. Gilio's treatise is reprinted in Barocchi, *Trattati* (Bari, 1961), II, pp. 3–115.
62. For this subject in general cf. Weinberg, *A History of Literary Criticism,* pp. 349 ff., with further bibliography.
63. Danti, *Trattato,* p. 266. For his sources see Paola Barocchi's valuable commentary at the end of the volume.
64. P. O. Kristeller, *Renaissance Thought: The Classic, Scholastic, and Humanist Strains* (New York, 1961), I, pp. 48 ff.
65. Danti, *Trattato,* passim, esp. pp. 244 ff.
66. Ibid., p. 225.
67. Armenini's doctrines, along with those of a few other late-sixteenth-century authors, have been systematically presented by K. Birch-Hirschfeld, *Die Lehre von der Malerei im Cinquecento* (Rome, 1912).
68. Armenini, *De veri precetti della pittura* (Ravenna, 1586), pp. 9 ff.
69. Ibid., pp. 1 ff.
70. Ibid., p. 20.
71. Ibid., pp. 95 ff.
72. Ibid., p. 103.
73. Ibid., pp. 38 ff.

74. Ibid., p. 89.
75. Ibid., p. 52.
76. Ibid., p. 54.
77. Ibid., p. 132.
78. Ibid., p. 75.
79. Ibid., p. 65.
80. Ibid., pp. 189 ff.
81. Ibid., pp. 191 (Raphael), 192 (Titian).
82. Pino, *Dialogo,* in Barocchi, *Trattati,* I, p. 97.
83. See the Introduction to Pomponius Gauricus *De Sculptura,* ed. and trans. Chastel and Klein (Geneva, 1969), with good bibliographical references.
84. Ibid., pp. 216 ff.
85. See ibid., pp. 92 ff.
86. See ibid., esp. chap. vi.
87. See above, pp. 170 ff.
88. Leonardo da Vinci, *Treatise on Painting,* ed. and trans. McMahon, no. 425.
89. See the Introcution to *Pomponius Gauricus de Sculptura,* ed. and trans. Chastel and Klein, p. 12, with bibliographical references.
90. For a concise presentation see Blunt, *Aristic Theory,* pp. 39 ff. There is a discussion of the general intellectual climate and its impact on the *Hypnerotomachia Poliphilii* in C. Mitchel, "Archaeology and Romance in Renaissance Italy," *Renaissance Studies: A Tribute to the Late Cecilia M. Ady* (London, 1960), pp. 455–483, esp. pp. 463 ff. For a comprehensive work on the author see M. T. Casella and G. Pozzi, *Francesco Colonna: Biografia e opere* (Padua, 1959).
91. Schlosser, *Die Kunstliteratur,* pp. 117 ff.
92. K. Borinski, *Die Antike in Poetik und Kunsttheorie* (Leipzig, 1914), I, pp. 163 ff. For the background cf. R. Weiss, *The Renaissance Discovery of Classical Antiquity* (Oxford, 1969).
93. Reprinted (in photocopy) in 1972.
94. For Doni's *Disegno* we must still rely on the first edition (Venice, 1549).
95. M. Roskill, *Dolce's "Aretino" and Venetian Art Theory of the Cinquecento* (New York, 1968), an edition of the original and an English translation with commentary.
96. Sorte's *Osservazioni* are reprinted in Barocchi, ed., *Trattati,* I, pp. 273–301.
97. Aretino, *Lettere* (Paris, 1609), I, pp. 231 ff.
98. Pino, *Dialogo,* p. 96.
99. Ibid., pp. 113 ff.
100. See above, pp. 224 ff.
101. Roskill, *Dolce's "Aretino,"* pp. 129 ff.
102. Ibid., p. 131.
103. Pino, *Dialogo,* p. 107.
104. Ibid., p. 114.
105. Roskill, *Dolce's "Aretino,"* p. 159.
106. Ibid., p. 117.

107. Pino, *Dialogo,* p. 115.
108. Roskill, *Dolce's "Aretino,"* pp. 129 ff.
109. Ibid., p. 123.
110. Ibid., p. 125.
111. Ibid., p. 129.
112. Ibid., pp. 163 ff.
113. For a more detailed discussion of Venetian color theory see M. Barasch, *Light and Color in Italian Renaissance Theory of Art* (New York, 1978), pp. 90–134.
114. Pino, *Dialogo,* pp. 116 ff.
115. Ibid., p. 117. See also Barocchi's comments to Pino's text.
116. Roskill, *Dolce's "Aretino,"* p. 155.
117. Leonardo da Vinci, *Treatise on Painting,* ed. and trans. McMahon, no. 83.
118. Roskill, *Dolce's "Aretino,"* p. 149.
119. See below, pp. 324 ff.
120. Roskill, *Dolce's "Aretino,"* pp. 115 ff. (painting pleases also ignoramuses and children).
121. Ibid., p. 149.
122. Ibid., p. 175. But see pp. 161 ff. for an elaborate comparison of the styles and scales of value of the two artists.
123. See E. Panofsky, *The Iconography of Correggio's Camera di San Paolo* (London, 1961), pp. 30 ff.
124. *The Hieroglyphics of Horapollo,* G. Boas (New York, 1950), esp. Boas's introduction.
125. *Plotini Operum philosophicarum omnium Libri LIV* V. viii (cf. *Opera* [Basel, 1561], p. 1768). Cf. also G. Boas's Introduction to *The Hieroglyphics of Horapollo* (New York, 1950), p. 28, and A. Chastel, *Marsile Ficin et l'art* (Geneva, 1954), pp. 72 ff.
126. See W. S. Heckscher and K. A. Wirth, "Emblem, Emblembuch," *Reallexikon zur deutschen Kunstgeschichte* (Stuttgart, 1959), V. cols. 85 ff. An exhaustive bibliography of emblems is in M. Praz, *Studies in Seventeenth-Century Imagery,* vol. II (London, 1947). For the problem in general see D. C. Allen, *Mysteriously Meant: The Rediscovery of Pagan Symbolism and Allegorical Interpretation in the Renaissance* (Baltimore, 1970), and J. Seznec, *The Survival of the Pagan Gods: The Mythological Tradition and Its Place in Renaissance Humanism and Art* (New York, 1953).
127. Andrea Alciati, *Emblematum liber* (n.p., 1531).
128. Allen, *Mysteriously Meant,* pp. 201 ff.
129. Boccaccio, *Genealogia deorum gentilium.* For the history of Boccaccio's work cf. Allen, *Mysteriously Meant,* pp. 215 ff., and Seznec, *Survival of Pagan Gods,* pp. 220 ff. Both authors adduce further bibliography.
130. For Giraldi cf. Allen, *Mysteriously Meant,* pp. 221 ff., and Seznec, *Survival of Pagan Gods,* pp. 241 f.
131. Allen, *Mysteriously Meant,* pp. 225–228.
132. Ibid., pp. 228–235. The edition of 1647 of Cartari's *Delle imagini degli Dei de gli antichi* is now easily available in a reprint (Graz, 1963).

133. The first edition, without any illustrations, appeared in Rome in 1593; the third edition, adorned with woodcuts, in Rome in 1603. The third edition is now available in a reprint (Hildesheim, 1970).

134. *Iconologia,* beginning of the epistle, *A lettori.*

135. See E. Mandowsky, "Untersuchungen zur Ikonologie des Cesare Ripa," diss. University of Hamburg, Hamburg, 1934, pp. 26 ff.; E. H. Gombrich, *Symbolic Images: Studies in the Art of the Renaissance* (London, 1975), pp. 12 ff., 139 ff.

136. Seznec, *Survival of Pagan Gods,* pp. 257 ff.

137. Borghini, *Il Riposo,* pp. 54 ff.

138. See above, pp. 281 ff.

139. For references to the *Trattato,* see above, note 39. In references to the *Idea,* see G. P. Lomazzo, *Idea del tempio della pittura* (Milan, 1590). Arabic numbers in parentheses following quotations from the *Idea* refer to the chapters of this work.

140. Particularly clearly with regard to light and color. See Lomazzo, *Trattato,* III and IV, and *Idea,* chap. 13.

141. Leonardo da Vinci, *Treatise on Painting,* ed. and trans. McMahon, no. 70.

142. See above, pp. 329 ff.

143. Panofsky, *Idea,* pp. 140–153.

144. Cf. K. Birch-Hirschfeld, *Die Lehre von der Malerei in Cinquecento* (Rome, 1912), p. 31.

145. Dürer is frequently mentioned in the *Trattato,* as can be seen from the index to the edition of Rome, 1844. In the index of the original edition we also find "Alberto Durero di Nurimbergh" (under A) but without page references.

146. Leonardo da Vinci, *Treatise on Painting,* ed. and trans. McMahon, no. 7.

147. Ibid., no 403.

148. Ibid., nos. 422, 423.

149. See the next chapter, pp. 329 ff.

150. Leonardo da Vinci, *Treatise on Painting,* ed. and trans. McMahon, no. 282.

151. Only Saxl, *Antike Götter,* seems to have noticed and discussed this meaning of "Form" in Lomazzo's art theory.

152. Schlosser, *Die Kunstliteratur,* p. 354. See Lomazzo, *Scritti sulle arti* ed. R. P. Ciardi (Florence, 1973), I, pp. 243–373. See also the edition with French translation and detailed comments by R. Klein.

153. Giulio Camillo, *Idea del Teatro* (Florence, 1550).

154. Roskill, *Dolce's "Aretino,"* p. 159.

155. R. and M. Wittkower, *Born under Saturn* (New York, 1963), is a rich collection of materials, but the analysis is focused on social aspects. See, however, pp. 281 ff. with interesting materials for the views on artists' temperaments.

156. *On the Imagination* by Gianfrancesco Pico della Mirandola; the Latin text, with an Introduction, an English translation, and notes by H. Caplan (Westport, Conn., 1971).

157. Dolce, *Opera* (Basel, 1540), I, pp. 868 ff.

158. Roskill, *Dolce's "Aretino,"* p. 159.

159. For Francesco Patrizi see Weinberg, *A History of Literary Criticism,* pp. 765 ff., 997 ff., 1014 ff. See also T. Klaniczay, *Renaissance und Manierismus* (Berlin, 1977), pp. 134 ff., esp. pp. 185 ff.

160. For Bruno in general see the interesting interpretation by Francis Yates, *Giordano Bruno and the Hermetic Tradition* (London, 1964). For the rebellion against rules cf. Panofsky, *Idea,* pp. 73 ff., and Klaniczay, *Renaissance und Manierismus,* pp. 191 ff.

161. *The Heroic Enthusiasts (Gli eroici furori),* trans. L. Williams (London, 1887–1889).

162. Cf. Blunt, *Artistic Theory,* pp. 137–147; Panofsky, *Idea,* pp. 74 ff., esp. pp. 85–93. W. Friedländer's "The Academician and the Bohemian: Zuccari and Caravaggio" appeared in *Gazette des Beaux-Arts,* 6th ser., 33 (1948) pp. 27 ff.

163. Reissued, as *Scritti d'arte di Federico Zuccari,* ed. D. Heikamp (Florence, 1961), pp. 135 ff. Romano Alberti's notes are reprinted in the same volume, pp. 1–79. Zuccari's *Idea* is referred to by book (roman numeral) and chapter (arabic numeral). For Zuccari's academic activity see N. Pevsner, *Academies of Art: Past and Present* (Cambridge, 1940), pp. 51 ff., 59 ff.

164. *Scritti d'arte di Federico Zuccari,* ed. Heikamp, pp. 27 ff.

165. Ibid., p. 251.

166. Ibid., p. 250 *(Idea* II, 6, a chapter in which Zuccari's program is outlined).

167. Ibid., p. 152 *(Idea* I, 2).

168. Ibid., pp. 300 ff. *(Idea* II, 16).

169. At the beginning of Doni's *Disegno.*

170. Borghini, *Il Riposo* p. 137.

171. *Scritti d'arte,* ed. Heikamp, pp. 165 ff. *(Idea* I, 9).

172. Ibid., pp. 153 ff *(Idea* I, 3).

173. Ibid., pp. 221 ff. *(Idea* II, 1).

174. The expression "visible substance" (sostanza visiua) is Zuccari's; see *Scritti d'arte,* p. 222 *(Idea* II, 1).

6

Classicism and Academy

I. FOUNDATIONS

1. NEW INSTITUTIONS

In the previous three chapters we considered Renaissance theory of art in terms of its historical development, of the problems it raised, and of the particular traditions into which it eventually crystallized. In so doing we hardly left Italy. With the exception of Dürer and of a few other less notable exponents Renaissance theory of art was, in fact, an Italian affair. But, like so much else that was achieved in Italy during the fifteenth and sixteenth centuries, Italian art theory also spread over the rest of Europe. We cannot attempt here to trace the channels by which it reached different countries. Kristeller's concise survey, "European Diffusion of Italian Humanism,"[1] may tell us something about the background of this process, but the particular channels by which Italian art theory was disseminated over almost the whole of Europe still await careful study. Whatever the channels, by the late sixteenth century in all the intellectual centers of Europe there were small, elitist groups of scholars, litterateurs, and artists who had perceived the new gospel of art preached in Italy, had become its disciples, and were eager to spread it farther. They all still looked to Italy, listening atten-

tively to what came forth from "the nurse of the intellect," as the famous Vesalius, the Dutch anatomist, was calling the promised land of humanistic wisdom.

In the seventeenth century, however, this situation underwent rapid changes. Italy still played an important part, both as the guardian of old traditions and as the originator of new developments. Moreover, an essential part of European thought on the visual arts was the outcome of a constant debate with the Italian legacy—whether by way of accepting or of rejecting it. Yet, though Renaissance Italy still loomed large on the intellectual horizon of the time, there can be no doubt that the focus was shifting. Art theory became more cosmopolitan. In western Europe, particularly in France, new centers were successfully competing with Florence and Rome; Italy was no longer able to retain the primacy of aesthetic thought on the arts.

The absorption of Italian doctrines by the different European countries was far from being a matter of slavish acceptance or imitation. First, Renaissance theory of art in itself was not cast in a single mold; one had to select which facet one wished to emphasize. Second, even what was accepted was not taken over as it stood. Rather, it was transformed, adjusted to new conditions, cast into new molds, until it became something new. It is, therefore, no exaggeration to maintain that the seventeenth and early eighteenth centuries, though continuing in the shadow of the Italian Renaissance, was one of the great creative periods in the history of aesthetic thought.

Though diffused all over western Europe, and necessarily tinged by the conditions prevailing in each country or region, seventeenth-century art theory concentrated on a few common themes. The authors of art-theoretical treatises, whether writing in Amsterdam or Rome, Seville or Dresden, have a common mentality, and their points of departure are very similar. Over countries and generations they carry on a vivid, uninterrupted dialogue, and it is indeed possible to present most of seventeenth-century art theory in a single broad picture.

Art theory of that period had, to some extent at least, a new institutional basis. The seventeenth century saw the emergence and rapid establishment of a new type of art student—the learned antiquarian, a scholar for whom Antiquity was not only transmitted in texts but also

embodied in material objects, mainly sculptural fragments, which Italian soil was yielding at an increased rate. Archaeological evidence (or, as one Italian antiquarian called it, *storia per simboli*) was now considered one of the major sources for understanding the classical world as a whole, even if the fragments were not masterpieces.[2] Many of those antiquarians, however, were not only past-oriented, as we would say nowadays; they also had the art of their own time in mind. They studied ancient fragments both in order to understand Antiquity—as archaeologists, in modern parlance—and also to instruct the painters and sculptors of their country or city, as critics, as we may now term it. The idea as such was not new; it formed the background of Renaissance aesthetic thought. Yet the type of the antiquarian, often a man of great erudition, was new. He was rarely an artist himself. But, as his studies of antiquities shaped his taste for modern art, so his acquaintance with the art of his own time contributed toward forming his image of Antiquity. We find this antiquarian-critic first explicitly represented by Franciscus Junius, the Dutch physician and scholar, whose *Painting of the Ancients* appeared in Amsterdam in 1638.[3] It is a mosaic of quotations and paraphrases of passages from Cicero and Quintilian, Vitruvius and Boethius, Philostratus and Seneca. But the doctrines of all these venerable authors are reiterated, and Junius' great erudition was deployed with the intention of shaping seventeenth-century art. In unbroken succession antiquarian-critics cover a century. Their attitude reaches its final formulation in Johann Winckelmann's *Thoughts on the Imitation of Greek Works of Painting and Sculpture* (1755), a little brochure that can surely be regarded as a milestone in the history of art theory.[4]

Are these antiquarians, who were so fervently concerned with the art of their day, spokesmen of classicism? The "classical," a household word in aesthetic literature, is one of the most scintillating terms in the art historian's dictionary, and it should be used with great caution. Yet, whatever seventeenth-century art theory may mean by this term, it constantly compares the ancient and the modern, the classical and the contemporary. The nature of the comparison often radically differs. It can be a "quarrel" (as in the famous *Querelle des anciens et des modernes,* to which we will later return), and it can be a "parallel" (as

Perrault's *Parellèle des anciens et des modernes,* which will also occupy us in the course of this chapter). However the comparison is carried out, its two poles are always present.

Another new institution, one of the lasting legacies of the Renaissance, was the Academy of Art. Although achieving importance only in the seventeenth century, it was the heir of tendencies that pervaded the Renaissance from the beginning. Between the seventeenth century and the nineteenth century the impact of the Academy was overwhelming; its influence made itself felt in many fields, and it also became the home of art theory.

The word "academy" itself, of course, derives from the place near the Acropolis in Athens where Plato and his friends and disciples met to talk about philosophy.[5] This was the original "grove of academe," and the men who walked under the trees were known as the Academy of Plato. When the term was revived in fifteenth-century Florence, in the circle around Ficino and under Medici patronage, it was a proclamation of the new humanist spirit. The Platonic Academy in Florence was not a tightly organized institution; it had no common doctrine (except that of Ficino); and it was composed of scholars and writers who had ideas and interests of their own, often quite different from those of Ficino. Thus, Poliziano, the well-known Renaissance poet, was primarily interested in poetry and philosophy, and Pico della Mirandola busied himself studying Hebrew and Arabic, studies in which Ficino did not participate. Most of the Academy's activities were improvised conversations in imitation of what was imagined as Plato's informal teaching. The Renaissance Academy, then, was inherently opposed to the firmly established, highly organized structure of scholastic teaching, as it was fundamentally in opposition to the closed, hierarchic character of medieval society. The strong antiguild, anticraft direction of the Florentine Academy is one of its most prominent characteristics.

Now let us get back to the theory of art and ask what its connections were with the new Academy of Art. In the fifteenth and sixteenth centuries, we remember, art theory developed outside any firm institutional framework. There were no "schools" in any precise sense of the term, and only in a very loose and broad sense can we speak of art theory having its own tradition. Art theory was a part—and a very

prominent part, for that matter—of the revolt against the narrow and confining workshop tradition of the Middle Ages. But Renaissance art theory did not set up any other firmly established institution to replace the workshop. After Alberti wrote his treatise *On Painting,* a common intellectual attitude obtained among the authors of art-theoretical treatises, but they worked as individuals or in loosely connected groups. In the seventeenth and eighteenth centuries the situation was reversed: the Academy of Art provided a solid institutional framework for the development of art theory, a framework that often, especially later in the period, proved to be confining. This role of the Academy cannot surprise us: the new institution was actually an attempt to realize the aims and to institutionalize the functions of Renaissance theory of art. The Academy intended to train the artist's hand, but even more than this it proposed to educate his mind and to shape his taste and judgment. No wonder, then, that in the Academy's teaching an overall "system" of the visual arts was developed. All this could be done because the Academy was based on a concept of what art, especially "good" art, is, and in what the creative process consists. In all these respects the academies of art, whatever the other factors that contributed to their formation, were following the lines of thought of Renaisance art theory.

At the very beginning of the Academy of Art, in the late sixteenth century, people seem to have been aware of the institution's origin in theory. As Nikolaus Pevsner has shown in his history, *Academies of Art: Past and Present,* this may already have been Vasari's view.[6] Federico Zuccari, in a letter dated between 1575 and 1578, suggests instruction in drawing in the form of amicable advice, but the teaching of theoretical subjects in the form of courses.[7] In 1582 Bartolomeo Ammanati (the well-known Florentine sculptor who recanted the "sin" of representing nudes) suggested that such subjects as composition, perspective, and the treatment of marble should be taught theoretically in any school for artists.[8] And when the Academia di San Luca was finally opened, its first president, Federico Zuccari, stressed the importance of lectures and disputations on the traditional subjects of art theory, as we saw at the end of the last chapter.[9] "Virtuous conversation," the *principe* declared, is the "mother of all studies, and is the fountain of

every science." In the study of art, therefore, one should discuss the precedence of painting over sculpture (that famous topic of *paragone*), the definition of *disegno* (as we have seen, the core of Zuccari's own doctrine),[10] and the rendering of movements and composition. If we review these suggestions for the curriculum of the Academy, the essential topics and basic structure of Renaissance theory of art are easily and immediately recognizable.

Seventeenth-century academies of art were proudly aware that they were heirs of Renaissance thought. It was their intention to further what had been begun by Renaissance authors and to teach artists the "true" doctrine that had been formulated in fifteenth- and sixteenth-century treatises on art.

Bellori. One of the presidents of the Roman Academy of Art during the seventeenth century, the learned cleric Giovanni Bellori, the mouthpiece and universally acclaimed promoter of the classical cause, was also a central figure in the formulation of academic thought on painting and sculpture. In his youth Bellori (1615–1696) had tried his hand at painting and had also made some attempts at writing poetry, but he quickly abandoned these efforts. He was a great scholar, the librarian of the famous Queen Christina of Sweden in Rome, and held the title of "Antiquario di Roma," granted to him by the pope.[11] That title he fully justified. He published many learned works on Roman antiquities (beginning with one on the Arch of Triumph of Titus) and produced catalogues of ancient works of art in Roman collections, both public and private. All these publications were lavishly illustrated by well-known Roman engravers. At the same time, however, he wrote on Renaissance art as well as on the art of his own time. His *Descrizzione* of Raphael's famous frescoes in the Vatican[12] is a crucial document of the then emerging veneration of Raphael that was to dominate the academies during the next two centuries; it is also interesting for the Neoplatonic interpretation of Raphael's iconography. Though he was not a practicing artist, he was a friend of painters and sculptors of his time, especially of Poussin, Duquesnoy, and Bernini. Bellori's major work on the art of his own time is in the biographical tradition, the *Vite de' pittori, scultori et architetti moderni* (1672). Although even the title of the book alludes to Vasari, Bellori's work differs from that of

his predecessor and especially from the writings of Vasari's followers. His *Vite,* Bellori states in the introduction, was composed according to "the counsel of Nicolas Poussin," and we are given to understand that he followed his great friend also in the method of presentation. Indeed, Bellori does not write simple biographies. He was eager to distinguish himself from what he calls the "chroniclers," like Baglione and some other biographers, who "indiscriminately wrote the lives of all those who used a brush or a chisel or piled stones of architecture."[13] Instead of writing catalogues, Bellori discusses examples. Each individual master represents a type, a class of artists. An early critic, Francesco Nazzarini, clearly recognized this characteristic of the *Vite.* Bellori, he wrote, "is not content simply to tabulate, as others do, the canvases and pictures made by the artists about whom he writes . . . from the very reading [of Bellori's text] one can learn not only the exquisiteness and fineness of art, but also the genius and different manners of artists."[14] A theory, then, is at the basis of Bellori's selection of the lives he recounts. His *Vite,* in fact, consists of no more than twelve biographies. By including lives of artists from the north (Rubens, Van Dyck, Duquesnoy) and France (Poussin), in addition to those of Italian artists, he reflects the truly cosmopolitan character of artistic and intellectual life in Rome during the seventeenth century. More important, by selecting artists of different temperaments and manners he presents a classification of styles. In a sense, he is writing theory even where he writes biography. Bellori does not mark the beginning of academic art theory. Other authors preceded him. But for our brief discussion of academic views of art it seems best to start with a mature formulation of this doctrine.

The *Vite* are prefaced by the text of a lecture that Bellori delivered in 1664 in the Academia di San Luca in Rome. Following the fashion of the times, but also reflecting the core of his thought, the lecture is entitled "The Idea of the Painter, Sculptor and Architect, Superior to Nature by the Selection from Natural Beauties."[15] Nowhere in seventeenth-century literature is the academic notion of the artist, of the process of creation, and of what the work of art should be more clearly stated than in this lecture. The ideas Bellori here presented—in ele-

vated though not always clear language—were entirely novel. As was so usual with humanists, he piled up quotations from classical and Renaissance authors to explain and support his views. Yet by markedly shifting the emphasis, and sometimes by setting well-known ideas in less traditional contexts, old and established views were transformed into a new doctrine.

The disposition of the age out of which the classical ideal emerged was radically different from the atmosphere that prevailed a century earlier, when Vasari wrote his *Vite*. Michelangelo surpassed even Antiquity, Vasari believes, and he himself, the great master's contemporary, was witnessing the all-time climax of the arts. An altogether different atmosphere forms the background of Bellori's thought. It is the feeling that the Renaissance unity of style and spirit are broken, the art of the time has lost direction, and is now in need of a guide to lead it back to a major road. Bellori's voice comes, not from the peak of achievement, but from the valley of depression and doubt. He speaks of the "corruption of our age" *(corruzione dell'età nostra)*, perhaps referring to Bernini and Borromini.[16] Classicism emerges from a profound feeling of decline.

When Bellori looked at the art of his time, or that of the preceding generation, he saw it largely split into two trends, in his view both equally wrong: naturalism, on the one hand, Mannerism, on the other. Naturalistic art lacks aesthetic norms. Caravaggio is the corruptor of *buon costume* in painting. Naturalistic painters, Bellori is convinced, do "not carry any idea in [their] mind"; they "accustom themselves to [the] ugliness and errors" in which the physical reality surrounding us abounds; they "swear by the model [found by chance] as their teacher." Those domains of painting which are of a lower character are fitting for naturalistic artists; thus, the "makers of portraits" are "slavishly imitative painters." Naturalism is also defined in terms of social hierarchy; it particularly appeals to the lower classes. "Common people," Bellori says, "refer everything they see to the visual sense [probably to everyday visual experience]. They praise things painted naturally, being used to such things; they appreciate beautiful colors."[17] The noble and learned, it follows, refer what they perceive to ideas rather than to

objects familiar from visual experience; they are enraptured by beauty; and they prefer "beautiful forms," obviously understood as lines, to bright colors.

Mannerism's faults are the opposite ones. Nobody will doubt the Mannerist artist's independence of the model, or of nature in general. On the contrary, his hereditary sin is his derivativeness. The greatness of Raphael's legacy (in Bellori's thought Raphael occupies the place that in the preceding century was held by Michelangelo) was dissipated in the late sixteenth century by painters who, "abandoning the study of nature, corrupted art with manner, or we would say with a fantastic idea, drawing on custom and not on imitation." As against Caravaggio, who "simply copied bodies as they appear," Bellori places Cavaliere d'Arpino, that representative of anemic Mannerism; he "did not consider the natural at all, following the freedom of his instincts." [18] The artificiality of Mannerism derives from its losing contact with nature. Bellori invokes the authority of Plato to lend support to his view that "the idea should be a perfect cognition of a thing based on nature." Echoing Leonardo, Bellori says that artists who borrow from, and copy, ideas of other artists, "create works which are not daughters but bastards of nature." [19] As the naturalistic painters "swear by the model," Manneristic artists "swear by the brush strokes of their masters."

Idealistic art, embodying purified nature and revealing it to our eyes, is the path that leads us beyond the dilemma of either slavishly copying an individual model or derivatively repeating the imagery we have inherited from our masters. The gospel Bellori preaches—and that has haunted art criticism for two centuries—is well known: the work of art, while based on the essence of nature, surpasses nature's individual, specific creation in the perfection of its figures and in the flawlessness of its shapes.

Bellori does not employ the term "Ideal" in the modern sense of the word, but he clearly has in mind what was shortly afterward called *le beau idéal.* What is characteristic of the Ideal is ultimate—one may say, absolute—perfection. But it is not the perfection of the artist's execution, as a modern reader may be inclined to assume. Perfectly skilled and flawless execution of the artist's job is taken for granted (and considered as an absolute requirement), but it does not make a

work come close to the ideal. The perfection of the Ideal refers to *what* is represented, to the figure or other object the artist depicts. Thus, to give one of the examples Bellori mentions, it is not Guido Reni's brush strokes or lines that are perfect but the beautiful shapes of Helen, whose abduction he painted.[20] Perfection is the beauty of the depicted figure.

This beauty or perfection, we remember, does not follow from the artist's whim, from a reliance on prior models. It is "superior to nature by selection from natural beauties." The skeptical reader, not easily taken in by Bellori's exalted metaphors, cannot help asking: What is to guide the artist in his selection of these beauties, or what will enable him to "purify" nature? The question is not new. Alberti suggested that the artist derive from nature a canon of beautiful proportions *(De statua* 2).[21] But when Alberti offers the artist a code of perfect proportions, he presents it as an average of many measurements. He "chose many bodies, considered to be the most beautiful by those who know, and took from each and all their dimensions," which he then proceeded to compare with each other. Leaving out of account the extremes on both sides, he "took the mean [i.e., average] figures validated by the majority of *exempeda,*" that is, measurements. In other words: the statistical average of nature is perfectly beautiful. Nothing of what Bellori says makes it possible for us to assume that this was also his view. Certainly the artist "purifies" nature's shapes, and he may even do so by selection. But what guides him in this act is not the averaging of shapes or measurements. On the contrary, the artist is conceived as creating his work in a process of introspection. The supreme paradigm of the artist, God, created the universe by introspection. That high and eternal intellect, the Creator of nature, so Bellori started his Academy lecture, "in making his marvelous works by reflecting deeply within himself, established the first forms." The artist follows the divine model. "For this reason, the noble painters and sculptors, imitating that first Creator form in their minds also an example of superior beauty and, reflecting on it, improve upon nature."[22] The emendation or purification of nature, then, is not achieved by "many measurements," as Alberti would have it, but by the artist looking into himself.

Nature, God's creation, always strives toward perfect beauty. "Sublunar bodies," however, "are subject to change and ugliness, and, although nature always means to produce her perfect works, nevertheless, forms are debased through the inequality of matter, and human beauty in particular is mixed, as we see from the countless deformities and disproportions that are in us." The inability of matter to be cast into, or to preserve, perfect forms, is, of course, part of the Neoplatonic heritage. But the function Bellori now ascribes to art transcends that tradition. What nature cannot achieve, art can. Art is here granted a metaphysical function: it reveals nature's innermost intentions; it manifests what nature itself cannot manifest. This is possible, so the erudite cleric learned from ancient sources (especially, Proclus' commentary on Plato's *Timaeus,* a venerated text in the sixteenth and seventeenth centuries), "because art works more accurately" than nature. That art should represent the beauty inherent but not visible in nature is also attested by Aristotle, who advised poets and painters to depict men as they *ought* to be rather than as they actually are *(Poetics).* The idealistic view of art is derived not only from ancient sources; modern artists and writers, such as Alberti, Leonardo, Raphael, and Guido Reni, also believe that art should embody the Ideal. The superiority of art over nature sometimes leads to amusing comments: the Trojan War, Bellori believes, was not fought over the real Helen, the woman of flesh and blood. Being made by nature, the living Helen must have had "imperfections and shortcomings." In reality, the Trojan War arose over a *statue* of Helen. That statue, being made by art, could be perfect, and the long war was waged for the sake of its beauty.

Bellori speaks a familiar language. Every concept he mentions and idea he expresses is known to us from Renaissance art theory. Yet by subtly shifting emphasis, and by combining well-known ideas in an unusual order, he produces a new message. When seen in comprehensive historical context, the most prominent feature of his thought is the inclusion of beauty in the theory of art. This, too, is not new. In the fifteenth century Alberti saw beauty and art as closely related to each other (though this relationship remained somewhat problematic in his thought). But, as Renaissance art theory unfolded, beauty and art grew apart. In the sixteenth century, as we have seen, art theory

was rarely concerned with beauty; it focused on the system of art, on characteristic types, and on the process of creation. Beauty, though mentioned, became a marginal value. In a sense, Bellori comes back to the origins of Renaissance thought on the visual arts, but he goes far beyond what his early predecessors attempted. The task of the work of art, he believes, is to embody, or manifest, beauty. Bellori speaks to practicing artists, to students of painting and sculpture; however, he does not speak to them of art, but of beauty. This probably is his most original contribution.

Would not ideal beauty, though perfect, become a pallid, bloodless abstraction? Bellori is too deeply rooted in the traditions of Renaissance art theory, especially of the late sixteenth century, to conceive of beauty as being completely uniform. Winckelmann, Bellori's eighteenth-century follower, once drew the final conclusion from idealistic aesthetics and maintained that "In beauty there is no variety."[23] But Bellori himself can see diverse embodiments of the ideal. Beauty's "forms are diverse." There are beautiful figures who are "strong and magnanimous, pleasant and delicate, of every age and sex." We appreciate, he said in the Academy lecture, the beauty both of the soft Venus and of the huntress Diana. Jupiter's beauty is different from that of Hercules, yet both are ideal. "Different forms [of beauty] suit different persons," the erudite churchman and president of the Academy said to his students; "beauty is nothing else but that which makes things as they are in their proper and perfect nature."[24] This is true not only for different types of figures but also for different states of mind. The painter must represent (with perfection, we understand) "the irascible, the timid, the sad, the glad," the laughing and the crying, the fearful and the bold.

The articulation of types and experience is, of course, not new. We have seen it in some detail in late-sixteenth-century art. What *is* new is that Bellori conceives of their perfection as beauty. We sometimes cannot help wondering what Bellori precisely meant by "beauty" and how far he was aware of the implications of dividing beauty into types. Would this not eventually lead to an "aesthetics of the ugly,"[25] as a famous nineteenth-century book was called? Can, indeed, ideal beauty go together with a variety of types? Does not the contorted posture of

the huntress Diana necessarily go beyond the beautiful? Can the distorted face of the angry or the palor of the frightened be ideally beautiful? These philosophical questions, however, need not detain us here. As Alberti did not realize the contradiction between the correct representation of nature and the representation of the beautiful, so Bellori seems not to be aware of the contradiction between articulating specific types and emotions and embodying ideal beauty. The combination of these two elements—articulate types and emotions on one hand, ideal beauty on the other—became a central theme in classicistic thought, their fusion a utopian goal of the academies of art.

There is still another aspect to Bellori's work that, although explicitly not theoretical, cannot be disregarded when one attempts to understand his theory. The "Idea" (given as an Academy lecture in 1664) is only the preface to a long work dealing with real artists, their actual works, and their "manner." What we read in the book itself is not derived from the "Idea" but is based on a careful, critical study of the schools in Italian painting. Bellori's most important achievement is the dividing of the art of his time into schools, and Schlosser claims for Bellori the merit of introducing the concept of schools (in the modern sense of the term) into art-historical study.[26] The definition of the schools, too, is related to beauty. The Roman school, founded by Raphael and Michelangelo, draws on the beauty of ancient statues. The Venetian school, best represented by Titian, draws on the natural beauty of the model. The Lombard school, perfectly manifested by Correggio, focused on the model's charm, and expresses "grace." The Tuscan school, later replaced by the school of Bologna, reveals the beauty of *disegno* and *relievo*. By thus dividing a broad artistic panorama into schools, and defining the character of each school separately, Bellori almost reaches the modern concepts of style. Here, too, Winckelmann is his direct follower. But, by discovering different beauties in these schools, he further shows how complex and intricate that central aesthetic concept is.

Poussin. Precisely forty years before Bellori delivered his oration at the Academy, a young French painter, Nicolas Poussin, arrived in Rome (1624). At that time he had probably not heard much about Italian

theory of art, but after having spent a lifetime in Rome, he had become a universally acknowledged *peintre-philosophe*. During his forty Roman years he was at the center of the evolving, vital art theory of his time. It was G. B. Marino, the most famous Italian poet of the period and one of those knowledgeable *dilettanti* of painting, who brought him to Rome. In the city itself Poussin was in close contact with collectors like Cassiano del Pozzo and with scholars like Bellori. The painter's home in Rome soon became the goal of intellectual pilgrims from France who came to the Eternal City. Among his friends was Fréart de Chantelou, well known as Bernini's companion during the sculptor's visit to France, and Sieur de Chambray, the first translator of Leonardo's notebooks into French (Poussin himself provided drawings for this translation). Sieur de Chantelou dedicated his *Idée de la parfaite peinture* (1662) to his great painter friend. And Hilaire Pader, the translator of Lomazzo into French, dedicated a copy of his *Peinture parlante* to our master.

Although Poussin was thus in the center of living art theory, he does not seem to have written a treatise of his own. To be sure, Bellori credits him with *Osservationi sulla pittura,* and at the end of Poussin's *vita* he even quotes some extracts from it,[27] but the composition seems to be apocryphal. However, the master's conversations on art with several of his contemporaries were carefully written down and were published in the seventeenth century. Particularly significant are André Félibien's *Entretiens sur Nicholas Poussin* (1685; the ninth and most substantial part of Félibien's *Entretiens sur la vie et sur les ouvrages des plus excellents peintres).* The fragments scattered in all these sources combine to represent an attitude, something that may be called a doctrine.

The sources from which we derive Poussin's views on art pose still other problems. Some parts of what goes under the name of the master's art theory are, in fact, reading notes, excerpts from works he was studying. Anthony Blunt has shown that important passages from Poussin's letters on art, passages to which we shall return in the following pages, are taken directly from a late-sixteenth-century Venetian music theorist.[28] Yet we can venture to say that, even though only a few utterances ascribed to Poussin can be taken as self-sufficient, a

careful study of what has been transmitted as Poussin's views, when seen in context, allows us to speak at least of an attitude, and one of great significance for seventeenth-century art theory.

Two definitions of "painting" are found in Poussin's legacy. They are widely differing, yet they do not contradict each other. Each definition focuses on separate aspects of painting, and each can be traced to a different tradition of looking at art. Their very coexistence in the artist's mind indicates how complex and multilayered was seventeenth-century thought on art. One seems strikingly modern, the other more traditional. Yet we shall try to show that in both, tradition and innovation are inextricably interwoven.

Let us begin with the "modern" one. In a letter to Fréart de Chambray, written on March 1, 1665, only a few months before Poussin's death, the master summarizes his views on painting.[29] Though he refers to what he has learned from Junius' *De pictura veterum,* which appeared in Latin in 1637, Poussin is here clearly presenting his own views. Indeed, this letter has been interpreted as the painter's artistic will. Painting, Poussin writes in his letter, "is an imitation made on a surface with lines and colors of everything one sees under the sun; its end is to please." That painting is the representation of nature ("everything one sees under the sun," in Poussin's words) on a flat surface, by means of lines and colors, is of course nothing new. Alberti opened the third part of *On Painting* by asserting that "the function of the painter is to draw with lines and paint in colors on a surface any given bodies. . . . The aim of the painter is to obtain praise, favor, and good will." (III. 52). This view occurs in many Renaissance treatises, and there is hardly any doubt that Poussin did indeed take it over from Italian theory of art.

More striking is the end of the sentence. Painting's "end is to delight" *(sa fin est la délectation).* To see its significance, it should be placed in its proper historical context. Ancient rhetoric, to which Renaissance art theory owed so much, has frequently taught that the orator's aim is to instruct, to move, and to delight. This triple aim, as we know, was accepted in the Renaissance and made the goal of all the visual arts. Horace, who as a satirist was more detached from emotion than many other writers, limits the range: painting, like poetry, should in-

struct as well as delight (Horace, *Ars Poetica* 333 ff.). We need hardly stress that Poussin was familiar with these classical traditions, especially with their Renaissance variations. The instructive function of the work of art must have had a profound appeal to an artist for whom "reason" constituted a central value of art. We shall shortly see what decisive significance he granted to the painting's ability to move the beholder. And yet he describes delight as the sole "aim" of art. Precisely because he was so familiar with the other definitions, we cannot believe that his omission of "instruction" and "moving" is fortuitous. Did he mean that the work of art is created to give us aesthetic pleasure?

In the theology and moralistic teachings of seventeenth-century France, *délectation* became a much-debated notion, one that was in the center of the religious struggles that characterize the period. *Delectatio* was never a plain, unequivocal notion, but now its inherent polarity was explicitly unveiled. Traditionally, *delectatio* carried mainly the connotation of sensual appetite, but in the mystical trends of the Baroque it was frequently connected with the experience of divine grace. St. Francis de Sales, a French priest and theologian (1567–1622), describes how God delights us in order to indicate his grace.[30] This delectation man cannot resist. Jansenism, the most rigorous Catholic reform movement of that turbulent period, conceived a psychology of grace completely centered on *délectation*. Although it is extremely difficult to interpret Jansenism accurately on the subject of delectation, as Anthony Levi has put it in his fine study, *French Moralists,* the word is used in such a way as to preclude any sense of rational appetite.[31] *Délectation* refers to an inner spontaneity. Our delighting in something can be virtuous or vicious, depending on what evokes it, grace or concupiscence. By the end of the seventeenth century these ideas had fully ripened. The philosopher Nicolas Malebranche (1638–1715) conceived of grace as essentially a state of delight.[32] In the same years François Fénelon, the churchman and writer (1651–1715), spoke of "deliberate delectation."[33] Though he did not discuss works of art, we may here have an early source for Kant's "disinterested pleasure" as the hallmark of aesthetic experience.

Poussin of course knew these ideas. Did they inform his bold assertion that the aim of painting is "delectation"? They in fact come close

to the modern conception of aesthetic delight, a pleasure that does not serve any practical end. Be that as it may, Poussin is the first artist to describe the goal of art as the evoking of delight.

Poussin's other definition of painting is, at least in wording, more traditional. At the end of his biography in the *Vite*, Bellori quotes from the master's written legacy. "Painting," the first quotation reads, "is simply the imitation of human actions, which, properly speaking, are the only actions worthy of being imitated,"[34] though other things can be imitated as accessories. We note instantly the restriction in subject matter. In the letter to Fréart de Chambray, which we have just discussed, painting is "an imitation . . . of everything one sees under the sun." Now it is only human action that should be represented. Félibien, Poussin's close associate during the years in Rome, quotes a remark the master made to him in conversation: "Just as the twenty-four letters of the alphabet are used to form our words and to express our thoughts, so the forms of the human body are used to express the various passions of the soul and to make visible what is in the mind."[35] Man, then, is the principal subject matter of painting; his body, gestures, and movements are the principal medium of representation.

Poussin's formulation reminds us of course of Aristotle's famous statement in *Poetics* (1448a) that "the objects of imitation are men in action." Modern scholars have convincingly shown that Poussin was much more deeply influenced by Stoicism than by Aristotelian tradition. Anthony Blunt has made the striking observation that the word "imagination," a concept strongly condemned by ancient Stoicism, does not occur even once in all of Poussin's letters.[36] Yet the artist's concept of imitation obviously follows Aristotle and ancient rhetoric. The above definition of painting, as we learn again from Blunt, is copied from a theoretical discourse by Tasso, who was preoccupied with the questions raised by Aristotle's *Poetics*. Poussin simply substituted the word *pittura* where Tasso's text had *poesia*. Poussin also refers to Castelvetro, the most famous commentator of the *Poetics* in the late Renaissance.

Making the representation of "human action," that is, passions of the soul and movements of the body mirroring them, into the central

subject matter of painting implies a different artistic aim, namely, to move the beholder. Freely paraphrasing Quintilian *(Institutio oratoria* XI. 3. 1–6), the venerated teacher of ancient rhetoric, Poussin says—again in Bellori's quotation—that "There are two instruments which will affect the minds of your hearers, action and diction. The first is in itself so valuable and efficacious. . . . Quintilian attributes such efficacy and such power to it that he esteems conceits, proofs, and effects useless without it; and without it, lines and colors are useless." Quintilian, it need hardly be said, does not mention lines and colors. He is speaking of the orator, not the painter. But while Poussin adds the painter's specific means to Quintilian's text, he altogether accepts the aim of the ancient author: speech, and therefore also painting, aims at *moving* the public, the hearer in the orator's case, the spectator in the case of the painter.

In his letters and conversations Poussin is often concerned with "reason" *(raison)*. Reason is the source of a picture's value; it is a guideline for the artist in producing it; and it is a criterion of the spectator judging the work of art. "To judge well is very difficult unless one has a great knowledge of both the theory and practice of art," Poussin wrote on November 24, 1647, to Chantelou. "We must not judge by our senses alone but by reason."[37] No wonder that Poussin's conception of art has frequently been classified as "rationalistic." But in what precisely does reason here consist? What embodies it? To be sure, Poussin was close enough to Renaissance traditions to find reason in mathematics and optics and, therefore, to study geometry, perspective, and proportions. Yet in his written legacy we would search in vain for the traditional perspective constructions; and although he spent much time in measuring and drawing antiques, he does not explicitly offer a "canon of beautiful proportions." Reason is found in different manifestations, mainly in clear and unequivocal presentation, in what he sometimes also called "simplicity."

To attain simplicity, the supreme value in painting, the artist must first of all concentrate on the essentials of his story. The artist, so Bellori quotes Poussin, "must avoid excessive details with all his power, in order to preserve the dignity of his story."[38] Preferring strict econ-

omy to the abundance of detail is, of course, the creed of the classicist who rejects the Baroque artist—he who loses "himself in vulgar and frivolous matters." It also shows what Poussin meant by "reason."

More important and original, however, is his application of rational methods to a different field, the representation of emotions. Simplicity is achieved if every figure shows its emotions clearly and unequivocally and if the mood of the scene is convincingly conveyed. In the long letter to Chantelou that we have just mentioned Poussin said that in adjusting the painter's "treatment" to the "nature of the subject," producing the spectator's "state of mind," lies "the whole art of painting." And Bellori makes our master say that "The form of each thing is distinguished by its function and purpose; some are intended to arouse laughter, others terror, and these are their forms." [39] What enables the artist to express the emotions of figures he depicts is not any kind of intuition; it is the mastery of a medium in which there are "rules." The same rules that the artist employs in creating his picture the spectator will assume in looking at it and understanding what he sees. The idea of "reading a picture" is one close to Poussin's heart, and he actually uses the term "reading" *(lecture)*.

How does one make a picture "legible"? Each figure should express only one emotion, and this should be done by means of gestures and movements and, to a lesser degree, by facial expressions. In a letter to a fellow painter, Jacques de Stella, written as early as 1637, Poussin develops a plan for painting the Israelites gathering the manna. "I have found a certain distribution . . . and certain natural attitudes which show the misery and hunger to which the Jewish people had been reduced, and also the joy and happiness which came over them, the astonishment which has struck them, and the respect and veneration which they feel for their lawgiver, with a mixture of women, children, and men, of different ages and temperaments—things which will, I believe, not displease those who know how to read them." [40] About ten years later, after he had executed the picture and was sending it to Chantelou, he writes to his patron: "I think you will easily recognize those [figures] who are languishing from hunger, those who are struck with amazement, those who are taking pity on their companions and performing acts of charity." [41] Obviously, Poussin assumes an alphabet

of gesture; movements form a kind of language that can be read. We should not forget that such legible language also causes pleasure.

Poussin's passion for articulating emotions in a rational system bore still another fruit—the theory of artistic modes. In the letter to Chantelou written in November 1647, to which we have already referred several times, Poussin wishes to tell his patron "something of great importance which will make you see what has to be observed in representing the subjects of painting." What is so important for the understanding of painting is the Greek theory of music. "Those fine old Greeks, who invented everything that is beautiful, found several modes by which they produced marvelous effects." He then proceeds to describe the "modes" the Greeks used in their music. The modes are, broadly speaking, the origins of the modern keys in music; in ancient thought they had precise, expressive connotations. Each mode embodies a specific emotional quality, is connected with a specific range of subject matter, and has "the power to arouse the soul of the spectator to diverse emotions." Thus, the "Doric mode [is] firm, grave, and severe, and they [the ancients] applied it to matters that were grave, severe, and full of wisdom." And passing to "pleasant and joyous things they [the Greeks] used the Phrygian mode because its modulations were more subtle than those of any other mode and because its effects were sharper." Poussin hopes to paint a picture in the Phrygian mode; since it is "vehement, furious, and . . . strikes the spectator with awe . . . frightful wars provide subjects suited in this manner." The Lydian mode is "most proper for mournful subjects because it has neither the simplicity of the Dorian nor the severity of the Phrygian." The Hypolydian mode contains "a certain suavity and sweetness which fills the soul of the beholder with joy. It lends itself to divine matters, glory, and paradise." The Ionic mode, finally, fits the rendering of "dances, bacchanals, and feasts because of its cheerful character."[42]

Poussin's model for different modes is taken from Greek musical theory. In Antiquity, however, the distinction between different types and levels of style, and the attribution of emotional character to each of them, is not limited to music. The differentiations of literature into genres implied a relationship between form, on the one hand, and mood or subject matter, on the other. The meter, rhythm, and choice

of words in an elegy, everybody knew, would differ from those in, say, a comedy. Classical rhetoric, too, distinguished between different levels of style, each of them considered fitting a group of people or a class of subject matter. What is appropriate for a noble hero is not proper for a base slave; what fits an exalted story does not fit an everyday event. In the Middle Ages, as Bialostocki reminds us,[43] with their passion for hierarchic order, we find in poetry the distinction between *stilus humilis, mediocris,* and *gravis.* To each of the styles corresponds a specific profession, animal, tree, and so on. In the Renaissance, we need hardly remind ourselves, the theory of style and decorum dominated aesthetic thought. In the preceding chapters we saw several times how it was combined with the concept of different types of beauty. Behind Poussin's views of the musical modes of the Greeks as a classification of styles there is, then, a continuous tradition of two millennia.

Poussin's direct sources can be identified. Anthony Blunt has shown that in his letter to Chantelou Poussin incorporated, almost verbatim, long passages from a treatise by Gioseffe Zarlino, a late-sixteenth-century Venetian theorist of music, who studied Greek melodies and ideas about them.[44] A vague, and probably isolated, suggestion of the possible significance of musical modes for the painter can be found even before Poussin. Giovanni Coscia, in a lecture he gave on March 17, 1594, in the Academia del Disegno in Rome, maintained that, "just as the musician seeks a harmony which is grave, or gay, or melancholy, so the painter follows the story he has to represent."[45]

Yet though Poussin continued a trend that was in the making, his explicitness in dealing with modes in painting brings us to a new stage in thought on expression and on how the painter achieves it. It makes mood and emotion part of the rational system and of what Poussin called simplicity.

II. THE ACADEMY IN PARIS: RULE OF RULES

1. LE BRUN

Bellori and Poussin are the founding fathers of classicistic academism. Chronologically they may not have been the first artists or authors to

preach the new gospel of canonized perfection, yet all the essential themes and ideas of classicistic academism are fully and explicitly stated in their writings. It is not for us to tell the story of the academies of art as an institution. This has been done, among others, by Nikolaus Pevsner, and to his masterly survey may be added more recent research on individual stages of the Academy's evolution. For our present purpose it will be sufficient to state that the institutionalization of the new teaching of art—both in the older Academy in Rome and in its followers in Paris and other places—enhanced the doctrinaire leanings of the period and hastened the crystallization of established truths. Nowhere can this be studied more clearly than in Paris.

These academic, doctrinaire leanings reached their apex, and most explicit formulation, in the work and literary legacy of the French painter Charles Le Brun (1619–1690), for twenty years the real head of the Parisian Academy, a man who enjoyed almost unrestrained dominion over the artistic scene in France in the late seventeenth century.[46] His lectures, accompanied by drawings and engravings, as well as his large-format paintings, reveal both the philosophical and the practical art theory on which the Academy was based. At the height of his career Le Brun might well have believed that he had definitively constituted the republic of art as a well-rounded and well-ordered cosmos and that he had created for it a permanent basis. The organization of the Academy, the education of the artist, and the philosophical concept of art—all seemed to be harmoniously complementing each other, and they were all dominated by *one* universal power, governing all spheres of life: reason.

Faith in reason did not induce Le Brun to reject the inherited idea that an artist must be born as such, but it buttressed his belief that— at least, within certain limits—art can be taught, both in the technical and the normative sense. Teaching specific rules and providing concrete models has an immediate, tangible effect on the art student: he can learn how to produce his work, and on what to base it. Providing an overall cultural environment that will shape the young artist's taste and direct his imagination may have a less tangible effect, yet it will not be less decisive. An almost religious admiration for the *belles antiques,* in theory shared by artists as far removed from Le Brun's style

as Bernini, is a central part of the encompassing world view as well as of the educational ideal.

This education should lead to *le beau idéal,* to perfection. At no time or place in the history of art theory was the idea of perfection more intensively perceived as the artist's ultimate goal than in the seventeenth-century Academy of Art in Paris. In drawing from nature the painter should correct his model's faults and "improve" nature itself— this High Renaissance creed was endlessly echoed in the halls of the Academy. But in reasserting the superiority of the ideal over reality one could not help raising the irritating question—never unequivocally answered: What should guide the artist in choosing from nature, and according to what should he improve the shapes that reality offered him? Should this be an "Idea" in the artist's mind, as Raphael had it, or should it be nature's own "middle," as Alberti believed? The Academy in Paris had little to add to the general philosophy of the Ideal. What it was concerned with, much more than Bellori, was rather on the practical side, and here Le Brun was the spokesman for his generation. The artist's unmediated encounter with raw nature—simply searching for what is hidden in it—will never enable him to reach the goal of perfection; nor will following out the idea in his mind prepare him for the difficult task. Only what he learns from exemplary traditions will make it possible for him to reach perfection. No artist will be able to produce ideal works without carefully studying ancient statues and reliefs, but recent artistic traditions can also direct him in his observation of nature. Speaking in the Academy, Le Brun told his students that "one should consult Michelangelo, Raphael, Giulio Romano, and the greatest painters in order to learn from them how one should draw from nature, and how to employ antiquity, in what manner they [the masters] knew to correct nature itself, and to grant beauty and grace to those parts [of a body] which are in need of them."[47]

Comparing these words with Leonardo's advice to the painter, one is struck by the difference between the periods. Leonardo, we remember, explicitly warns the young artist not to follow masters but to learn directly from nature. An artist learning from masters rather than from Nature herself is a grandchild of Nature when he could have been her

son. Le Brun, on the other hand, presumes that an unmediated, un-prepared observation of nature will result in a confused, undistilled, and therefore deformed image. For Leonardo painting is an exploration of nature; for Le Brun it is the product of an acquired culture. Inher-ited forms and adherence to tradition are of the essence of academism.

Other differences are less obvious at first glance, yet they are not less profound. Here one thinks of the concern with expression. Re-naissance thought, as we know, considered the expression of emotions to be one of the values of painting and sculpture, but expression never achieved a significance comparable to that of perspective and propor-tions. This, as we have seen, changed in Poussin's thought. His theory of the musical modes was, in essence, a theory of expression. It is not surprisng that in the Academy of Art "expression" became a central part of aesthetic thought. Le Brun brought this theme, too, to its culmination.

This *peintre du Roi* was always concerned with how to depict emo-tions, and in the Academy he included this matter in the curriculum. He lectured on the subject. In 1671 (on March 28, according to the minutes of the Academy) he spoke on physiognomics, showing exam-ples that he drew, "be it of heads of animals or heads of men." In 1674 he took up the subject again, apparently continuing for some years, as we know from different sources (among them, *Sentiments des plus habiles peintres sur la pratique de la peinture et sculpture mis en table de preceptes,* edited by Henri Testelin).[48] In the course of those years he also composed a manuscript that he himself entitled *Traité de la passion,* which was published posthumously, in 1698. One of Le Brun's most important innovations is that his lectures were accompanied by draw-ings, as engravings accompany his printed texts and visually demon-strate what he says.

What Le Brun had to say on the subject did not consist of any new philosophical interpretation of the theme but lay rather in "practical" advice to the painter on how to express emotions. His general defini-tions are vague. But, when it came to what the painter should do, Le Brun became so specific that he was often felt to be constraining. What he aims at, obviously, are not concepts but precepts.

The Renaissance legacy, as everybody knows, instilled in the gener-

ations to come a high regard for expression, but what Renaissance writers had to say about expressing *specific* emotions is rather hazy and limited; theoreticians of the Renaissance adduced very few emotions, and these were always extremes, such as laughter, weeping, anger, and despair. In the seventeenth century psychology flourished, and it included attempts not only to explain our "psyche" but also to describe the different emotions in detail. Descartes' *Treatise of the Passions* (1649) presents a detailed list of "passions," discusses their order (art. liii ff.), distinguished between the few "primitive" passions (art. lxix) and the many others "composed" of them, and even touches on the possible relation between these passions of the soul and their effect on, or origin in, the body. Le Brun studied Descartes' work carefully and borrowed from it, among other matters, the distinction between basic emotions and composite ones. His list of individual emotions, going even beyond that of Descartes, is striking. In his lectures in the Academy, accompanied by examples, he spoke of the following passions: admiration, love, hatred, joy, sadness, fear, hope, despair, audacity, fury, respect, veneration, rapture, disdain, horror, anxiety, jealousy, depression, pain, laughter, weeping, rage. All these passions, our academician believes, can be distinctly conveyed by visual depictions.

No Renaissance artist, however, convinced that the manifestation of emotions was a central value of painting or sculpture, would have dreamed of even aspiring to convey to the beholder such subtle modifications and nuances of emotion as those recorded in Le Brun's list. But Le Brun not only went beyond the Renaissance in the differentiation of the emotions to be depicted; he also focused on a new medium for doing this—the human face. Every single emotion, the head of the Academy taught his students, is clearly mirrored in the human face. To assess Le Brun's historical position it may be useful to remember that in Renaissance theory of art the major—almost the single—medium of expression was bodily movement, that is, postures and gestures. In part, this may be related to the origin of Renaissance art theory in ancient rhetoric. In Antiquity the orator was taught to adjust his gestures and body movements to what he was saying (as he was instructed to inflect his voice accordingly), but hardly anything was said about his facial expression. Observations on facial expression in

Renaissance theory of art are scanty, and they are limited to extreme manifestations. Alberti, as we remember, noted the difficulty in distinguishing between laughing and crying (*On Painting* II. 42), and Leonardo made some, only slightly more detailed, observations on the depiction of emotion in the face.[49] In the late Renaissance only *one* branch of knowledge—not directly related to art theory—was concerned with an interpretation of the human face, and this was scientific physiognomics, best represented in Giovanni Battista Porta's influential work on the subject. In scientific physiognomics a person's face was analyzed to discover (permanent) character rather than (fleeting) emotions. The principal method employed was to compare the structure of a person's head with that of a specific animal, conceived as fully representing certain qualities. That Le Brun was familiar with this science is attested by his Academy lecture of 1671 in which he showed the drawings, "be it of heads of animals or heads of men," which he based on the illustrations to Giovanni Battista Porta's *De physiognomia libri* IV. However, he took a decisive step beyond that tradition, and beyond what was accepted in Renaissance thought, by assuming that all the diverse changeable emotions can also be clearly expressed in the rendering of the face.

What is it that enables the artist to portray these specific emotions in the human face? Where should he find his models? Leonardo advised the painter to carry a little sketchbook in his pocket, so as to be able to make quick drawings of people arguing with each other, or in any other way exhibiting strong emotions. For Leonardo, then, nature was still the storehouse of expressive motifs, and by attentively observing nature the artist acquired the keys to the rendering of emotions. Here, too, Le Brun replaces direct observation by carefully prepared artistic models. He tells his students how the muscles of our faces alter under the impact of every single emotion. The intention, at least, behind his observations was scientific, and his text often reads like a careful anatomical analysis. To give two examples: the face of a person filled with veneration will have pulled-down nostrils and a half-open mouth; the face of somebody horror-stricken will have tightly closed nostrils, the pupils will not be in the center of the eyeballs but rather lowered, and the mouth will be half open though more contracted than in the venerator's case. These descriptions were accompanied by detailed draw-

ings in which all the contractions, movements, and changes that the different emotions produce in a person's face were clearly shown. Le Brun provides the artist with a wide range of finely distinguished, firmly established visual idioms.

Le Brun was probably convinced that he was following the great Renaissance traditions of precisely observing nature. In fact, he was tending to replace direct observation by ready models, or at least to focus his students' attention on certain features and make them disregard others. Culture was replacing experience.

2. "LES RÈGLES"

A young artist diligently studying at the Academy of Art in Paris during the seventies and eighties of the seventeenth century and keenly absorbing the new and fascinating doctrine that his illustrious teachers were working out in the open sessions of that great institution must have felt that everything he learned hinged on *one* point: the idea of rule. The concept of "rule" was endowed with an almost mystical aura. Even where the term itself was not explicitly employed, the idea was always present.

A "rule," as a modern dictionary says, is an established guide for action or conduct. In the seventeenth century literary critics often debated the precise meaning of rules, but they all agreed that rules belong to the realm of doing, that they are employed in the process of forming something. Yet rules are not just auxiliaries, devoid of intrinsic value, something one can do away with after use. Even when one accepts the authority of nature, one cannot discard rules. René Rapin, the seventeenth-century literary theorist who composed the influential *Réflexions sur la poétique en général,* said that poetics is "la nature mise en méthode"; and, he continues, one never reaches perfection otherwise than by rules.[50] Rules have a claim to absolute validity. Descartes gives *Rules for the Direction of the Mind* (as his first book was called, written as early as 1628 but published posthumously); only they will assure our finding the truth (Rule iv). The whole seventeenth century is dominated by the concept that rules are the application of reason to whatever we undertake methodically to study, to perform, or to produce. As nature is subject to certain principles, so are our activities,

and especially the arts, nature's great competitor. As nature has laws, so arts have rules. The parallelism of the arts and the sciences is one of the fundamental theses of French classicism. No wonder, then, that rules are endowed with the same strictness and inevitability as are the laws of nature.

Looking back from the vantage point of the twentieth century, one understands why rules were so important for the Academy of Art. The founders of the Academy, who wished to erect a permanent structure, knew that, in order to ensure the continuing dominance of their doctrine, it would not be enough to discuss "pure," abstract principles of their aesthetic creed. Continuity could be achieved only when these principles were translated into specific counsels and precepts that could be applied in painting and sculpture and that a master could teach his pupils. Le Brun, referring to the aesthetic discussions that formed such an important part of the Academy's curriculum, insisted that "it is necessary to gather the fruits of these conferences and to draw from this work those matters which could be laid down as rules for teaching the youth." [51] This, as we shall shortly see, was indeed done, and even complete tables of rules were formulated.

Now, as everybody knows, the concept of rules in art was not invented in the seventeenth century. The famous teachers of the Parisian Academy took it over from Renaissance art theory. Moreover, in employing the concept of rules they were probably convinced that they were faithfully continuing in the lines laid down by their great predecessors. But *was* academic rule in the seventeenth century the same thing that the Renaissance meant by this term? A close look will show us that the Academy significantly changed the meaning, scope, and character of rules of art. What in the Italian Renaissance was called— rather vaguely—*regola* referred mainly to the scientific foundation of painting, especially perspective construction, and to the basic anatomical structure of the human body. When in the late sixteenth century *regole* were violently rejected, as we saw in the last section of the preceding chapter,[52] it was precisely their mathematical quality that was stressed. The artist's creative personality and imagination were contrasted with the constraint of mathematical rules. Seventeenth-century theorists were acquainted with this passionate rejection of rules.

They reinstated them, but the rules acquired a character different from that negated by Zuccari. André Félibien (1619–1690), a close associate of Poussin and the first secretary of the French Academy, makes fun of the tyranny of perspective rules in judging a work of art. Who will believe, he says, that "in this art" (i.e., painting) all the rules are as certain as in geometry and that you can criticize an excellent picture because in one of its corners the rules of perspective have not been meticulously observed?[53] Questioning the tyranny of perspective had broader implications than doubting the validity of spatial construction alone: it implies a downgrading of "correctness" as a value and as a criterion of appreciating art. Seventeenth-century rules are indeed less strictly measurable; their scientific "truth" cannot easily be proved; but they aim at comprehensiveness. Even though the individual rule cannot readily be pinned down in every detail, the comprehensive system is ultimately of more weight in forming the work of art as a whole.

Academic thought on rules in art was fully formulated in a remarkable work, *Sentiments des plus habiles peintres sur la pratique de la peinture et sculpture mis en table de preceptes (Opinions of the Most Skilled Painters on the Practice of Painting and Sculpture, Put into a Table of Rules)*, which appeared in Paris in 1680. On the title page Henri Testelin is named as the author, but in fact the work consists of the minutes of lectures and discussions held at the Academy of Art; Testelin took notes and prepared them for publication, though he did not mention the names of the different speakers. What we have here, then, is a *collective* work; its true author is the academic tradition itself, especially in its first, formative generation. The *Sentiments* is a revealing document of both the Academy's aspirations and the pressures it must have exerted. The social and legal freedom that the artist acquired with its help (let us remember the Academy's motto: *Libertas artium restituta*) went together with the imposition of a style, often specified in considerable detail.

This important document, the *Sentiments,* also reveals the further development of the theory of art. To be comprehensive, to give the artist an encompassing education, art theory must include everything of importance to the artist; in order to guide the painter and sculptor along a clear path, it must first itself be clearly organized. The new and ambitious tasks set for institutionalized art theory, therefore, inevitably had a profound impact on art theory itself.

The first question is: What does art theory consist of? With what precisely does it deal? These questions could not be avoided, for a curriculum had to be established for the Academy, and they necessarily led to a redefinition of the "parts" of painting, that is, the domains in which rules were pronounced and taught. Following the *Sentiments,* as well as other texts, one can say that by the late seventeenth century four (or five) such fields were acknowledged. They were, first, composition (usually termed *ordonnance*), drawing (frequently also called line), the expressions of emotions, light, and color. By the end of the century, however, the last two were fused and appeared under a single heading, "color."

The division of the "art of painting" into "parts" was, as we know, common in Italian art theory. Yet the system that crystallized in the French Academy, though derived from the Italian Renaissance, has a new character. First one notices that it has contracted: it consists of four parts, whereas the more elaborate Italian systems had seven. The change in number indicates a far-reaching change in character, and it is therefore of interest to note which of the traditional seven parts were discarded. Scientific constructions, of such overwhelming significance in the Italian Renaissance, are now altogether disregarded. Perspective, which in Lomazzo is still one of the seven parts of painting, is omitted, as is the other major field where painting and science merge—anatomy.

The French academic system is characterized not only by what it omitted. The portrayal of "passions," what we would today call expression, as a central category of painting, is one of the most prominent contributions the French Academy made to the theory of art. From Alberti's *On Painting* in 1435 to Lomazzo's *Idea* in 1590 the expression of emotions was of course considered a value of painting. Yet throughout the Renaissance it was not placed in a category of its own; nor was a specific term coined for it. Since "movements of the soul" are manifested in bodily movements, Lomazzo treats both under the heading of *moto.* Thus, even in the last decade of the sixteenth century the physical convulsion of the angry man and the effort of carrying a heavy material load still remained undistinguished in art theory. The founders of French classicism, from Poussin to Testelin and Roger de Piles, singled out the rendering of emotion as the paint-

er's central task, and they believed that it required elaborate means of its own. Though gesture and posture are important means of rendering the passions, their display need not be restricted to bodily motions only.

As we said earlier, academic rules for representing passions were sometimes accompanied by visual models, drawings, or engravings. The model book, a characteristic feature of the medieval workshop, is ideally suited for the propagation of traditional art. During the Renaissance it never completely disappeared, though its role was severely restricted. Renaissance artists, as we know, were fully aware that "what can be shown cannot be said," and therefore they put their ability to show at the service of science in their paintings and sculptures. Art theory, however, especially the treatises composed by humanists, discarded the visual model. As long as the rules presented in these treatises were general principles based on science, one could perhaps do without the visual example (though we should not forget that the treatment of both perspective and anatomy were very often much in need of illustration). But when in the seventeenth century precise guidelines came to be formulated for the rendering of specific emotions, particularly as mirrored in the human face, words alone were not sufficient. Facial expressions could not be fully described in words, and one had to fall back on the visual model. When Le Brun presented his theory of expression, and gave scientific explanations of how certain muscles in the human face change size, shape, and position under the impact of specific emotions, he must have realized how ineffective such purely verbal description would be. As we know, he also presented to his students drawings that "showed" these expressions. His slim but seminal volume, *Méthode pour apprendre à dessiner les passions,*[54] consists of both words and pictures. The new theory, presented to artists, reinstituted the visual model.

Another amplification of the concept of rule—a distinct contribution of academic doctrine to the aesthetics and criticism of painting and sculpture—is the employing of artistic *règles* as criteria in judging works of art. Again, the idea is not altogether new. Throughout the Renaissance the division between pure art theory and the critical appreciation of artists and their works was not watertight. As we saw in

the fifth chapter, the theory of art, originally addressed to the practic-
ing painter and sculptor, became a speculative theory *about* art, mainly
addressed to the educated public. What was implicit in the sixteenth
century—the transformation of art-theoretical concepts into categories
of criticism—became manifest in the late seventeenth century: "rules"
became acknowledged criteria of judgment. This new meaning of "rules"
is fully revealed by an author to whom we shall shortly revert: Roger
de Piles appended to his great work, *Peinture par principes* (1708), a
"Balance des peintres," a comparative list of artists appreciated accord-
ing to specific criteria. This list is foreshadowed in de Piles's earlier
work, *The Idea of a Perfect Painter or Rules for Forming a Right Judgment on
the Works of Painters* (1699; an English translation appeared as early as
1706). It may well be true, as some modern scholars have suggested,
that Roger de Piles compiled his "Balance des peintres" at a patron's
request; it may even have been prepared for the sake of entertainment
rather than for more serious purposes. Whatever the motivation, the
very idea of such a list is typical of academic thought. Roger de Piles
uses the four main fields of painting as defined in art theory (compo-
sition, line, color, the expression of emotions) as domains for judg-
ment. The achievement of every artist in each of these four fields is
evaluated separately, and everyone gets a score according to a scale in
which 20 stands for perfection.[55] A sample of some of these judgments
is shown in Table 6.1.

TABLE 6.1.

"Balance des peintres"

Name	Composition	Line	Color	Expression
Dürer	8	10	10	8
Le Brun	16	16	8	16
The Carracci	15	17	13	13
Leonardo	15	16	4	14
Michelangelo	8	17	4	8
Caravaggio	6	6	16	0
Poussin	15	17	6	15
Rembrandt	15	6	17	12

These are only a few examples from de Piles's extensive list. The distribution makes us wonder what precisely the individual terms meant. What, for instance, does "expression" mean if Caravaggio gets an 0, and Le Brun gets a 16, twice as much as either Dürer or Michaelangelo? A careful study of who gets what scores could certainly help us to a better understanding of many of the concepts in the critical vocabulary of French writers in the seventeenth century. Since such a study, however, is beyond the scope of this work, here we will only emphasize that the scores indicate the preferences of taste dominating academic culture: Raphael gets the highest markings (17, 18, 13, 18). It is also worth noticing that Roger de Piles had a broad taste; he could admire both the Carracci and Rembrandt and, at least in composition, rate them as equals. But what is more important than the preferences in taste is the belief that an artist's achievement can be objectively measured and that it is the "rules" that make such a measurement feasable. This may be a "grotesque" form of rationality, as a modern writer put it, but one cannot doubt that *règles,* as expressions of rationality, here reach an ultimate summit in the criticism of art.

The rationalistic spirit, the endeavor to "divide up" each object of study into as many parts as possible, to arrange them "in due order," and to make their "enumeration complete"—as Descartes recommended in his *Discourse on Method* (art. II)—had yet another outcome in seventeenth-century thought on painting: a complete hierarchy of pictorial "genres." Again, the idea itself is not new. In the preceding chapters we several times had occasion to mention the theory of different levels of style, primarily as taught in ancient rhetoric; we also saw how this idea was revived in the Renaissance and, richly amplified, used in such different texts as Lomazzo's theory of *prattica* (Book VI of the *Trattato*) and Poussin's letter on the musical modes in painting.[56] But only in 1667, twenty years after Poussin wrote his letter, the issue came to full fruition. In presenting the Academy's *Conférences pour l'année 1667,* André Félibien, Poussin's friend, also offered a hierarchy of pictorial genres.[57] Each "genre" is intrinsically related to a mode or level of style in which it should be depicted, as Poussin suggested; it may also be destined for a certain building or a specific place in the building, as Lomazzo wished. However, in the seventeenth-century mind

what determines the "genre" is the contents, the *subject matter* of the painting. Félibien distinguished between the still life and the flower piece, the landscape and the depiction of man. This scheme is remarkable in many respects. First of all, the list is evidence of the fact that the pictorial genres, now fully established, have penetrated aesthetic awareness.

The existence, beauty, and even hierarchy of pictorial genres was not the Academy's invention; nor was the educated public's interest in the different genres provoked by the Academy. In the first decades of the seventeenth century, a man of Cardinal Federico Borromeo's stern principles (he was the author of *De pictura sacra,* 1634)[58] was much attracted by such "trifles" as landscape and still life. By the late sixteenth century, landscape painting had emerged as a legitimate genre, perhaps not uninfluenced by the prominence Pliny (*Naturalis historia* XXXV. 116) gave to the work of the Roman landscape painter Studius. The popular genre, representing common people in scenes of everyday life, had a home in Bologna and was cultivated by such classicistic artists as the Carracci (rather than by Caravaggio).

In spite of all these earlier developments, however, a full-fledged theoretical scale grading the genres in hierarchic order was provided only by the Academy. "To the extent to which painters engage in matter more difficult and more noble, they go beyond what is lower and more common, and they become nobler by an illustrious work." But what does Félibien, who made this categorical statement, mean by "noble" and "low"? It is the painting's subject matter that decides its genre and thus also determines its place in the hierarchic ladder.[59] Each genre's value results from the dignity of its subject matter. Lowest in Félibien's view are the painters of lifeless objects, that is, "objects lacking movement." He specifically mentions shells but adds to this group also flowers and fruits. One rung higher is occupied by landscape painters and painters of moving animals. The representation of man, God's most perfect creation, occupies the highest rank. Academic theory, as one knows, took a further step and divided human figures into different levels, mainly corresponding to social stratification and to the intrinsic dignity of the scene in which they appear. Teniers, by the very choice of his subjects and of the figures who served as his

models, put himself on an inferior plane. In the seventeenth and eighteenth centuries, the works of the brothers Le Nain were regarded with a certain disdain because they depicted simple scenes and common folk. This hierarchy still holds true in Winckelmann.

As we just said, the idea of a hierarchy of values was not new. The Middle Ages arranged the sciences in a hierarchic structure, and Renaissance theory of art extolled *istoria* above all other scenes. Yet it remained for the Academy to draw the final conclusion from all those traditions, to explicitly formulate the genres, to "fully enumerate them," and to consistently "arrange in due order" the different groups of subject matter and works of art. This is another facet of the prevailing spirit of systematic, comprehensive rationalism.

3. "GRAND GOÛT"

To imagine Bellori and Poussin, Félibien and Le Brun, as merely disputing over rational rules and constructing models of ideal types—in short, to make them smell of an academic classroom—would do them a grave injustice. They had a broader and more fascinating vision of which the rules and models were only individual expressions and partial aspects. This comprehensive vision they themselves termed the "grand taste" *(grand goût)*.[60]

As with so many aesthetic concepts, taste, too, goes back to ancient rhetoric. In the Renaissance it was revived in discussions of literature and art; primarily it indicated an individual's subjective preference, the inexplicable personal affinity of a student with his master. In the last decade of the seventeenth century Testelin, the speaker of the Academy, was still saying that "everyone sees nature differently, according to his temperament and to the disposition of his organs; hence the diversity of tastes."[61] But, as Robert Klein has shown, the seemingly paradoxical idea of a normative taste had already emerged in the late sixteenth century.[62] Taste, extricated from purely subjective connotations, came to be regarded as the embodiment of social conventions. This transformation is particularly manifest in the concept of the *grand goût*.

But are not "taste" and "style" different terms for the same thing? Is an artist's taste different from the manner in which he executes his

work? The seventeenth century clearly distinguished between the two concepts. The most precise formulation is found in Du Fresnoy's *Art of Painting,* written between 1641 and 1665, and published posthumously in 1667. "Manner," this painter and *dilettante* scholar says in his rhymed treatise, indicates the "customary practices" of the painter; by this he means some tangible, definable aspects of an artist's work, such as line, color (and invention), and even his brushwork. As opposed to this, "Taste in painting is an idea which follows the inclination painters have towards depicting particular things." With sorrowful resignation Du Fresnoy adds: "One often confuses between taste and manner." Taste, then, is of a comprehensive character. One cannot perceive it as directly and immediately as one perceives a bold brush stroke on the canvas or a fine, elegant line drawn on a sheet of paper. Yet, in spite of its intangibility, taste is not elusive; it is an objective quality, and it can be distinctly grasped. Du Fresnoy speaks of an artist's *personal* taste, a reflection of his individual personality.[63] But like Boileau, whose *Art poétique* (1674), the famous counterpart of Du Fresnoy's work that had appeared seven years earlier, our author, like so many seventeenth-century thinkers, conceives of taste as superpersonal, intersubjective. The *grand goût* is the most perfect reflection of this attitude.

We now turn to the second part of the concept. What is it that makes a taste "great"? Greatness, like taste, cannot be simply defined; yet, not less than taste, it is distinctly perceived. Seventeenth-century theorists drew again from the conceptual legacy of Antiquity, though they greatly amplified that heritage. In the third century A.D. Longinus introduced a new concept in aesthetics, the sublime. The sublime is a mirror of "the greatness of [the artist's or writer's] soul"; it is more important than beautifully ornamented language (*On the Sublime* IX). The concept was revived in Renaissance studies of literature and the visual arts. *Grandezza* is found in different fields and subjects. Francisco de Hollanda, one of Michelangelo's biographers, who claimed to present his master's theory, criticizes Flemish painting: though it pleases the eyes of some people, it lacks symmetry, proportion, and "greatness." Benedetto Varchi said in his famous lectures on the "Nobility of the Arts" (1564) that Michelangelo's work, as well as Dante's, is

characterized by *grandezza e maestà*.[64] Greatness could even be a characteristic of materials: bronze and marble, Varchi believes, have a *grandezza e magnificienza* that white lead and red cinnabar do not possess. Greatness is distinctive and should not be confused with other aesthetic qualities. Francesco Bocchi, a late-sixteenth-century author, stresses that what is beautiful is not necessarily also great. "Greatness," one concludes, was a concept familiarly discussed in late Renaissance theories of art and literature. It is not surprising, then, that in seventeenth-century theory of painting the *grand goût* was more than just a vague sensation or a kind of blurred feeling. The outlines of the concept are more sharply drawn. The painter, says Roger de Piles at the opening of his *Cours de peinture par principes* (1702), has been educated by the study of antiquities, and he follows nature in his work; yet he should not content himself with being "regular" (i.e., in accordance with accepted systems of proportions and ancient models) and "exact" (obviously in the imitation of nature). In everything he produces he should show a "grand taste." "This *grand Gusto* in the Works of the Painters," we read in the English translation, which appeared as early as 1706, "is the use of the choicest Effects of Nature, such as are Great, Extraordinary and Probable. Great, because things are so much the less sensible to us, by how much they are little and divided. Extraordinary, because what is ordinary does not strike us, nor draw our attention. Probable, because 'tis requisite that these great and extraordinary Things should appear to be Possible, and not Chimerical." Later he comes back to the same subject: the grand gusto "is not to be accommodated to ordinary Things. A Mediocrity is not allowable but in the arts which are necessary for common use." In noble painting "there must be something Great and Extraordinary to Surprise, Please and Instruct, which is what we call the *grand Gusto.*" He then adds that in painting "the *grand Gusto,* the Sublime, and the *Marvellous* are one and the same thing."[65] Roger de Piles, as we shall shortly see, was in many respects opposed to the doctrines that originally dominated the Academy, but in exalting the *grand goût* he was speaking for his whole period.

Greatness, we understand, is not limited to any specific aspect of

art; it is not particularly characteristic of either style or even subject matter. Yet it is not elusive. Several features of the *grand goût* in painting have been analyzed and can be indicated.

First of all, there is a cohesion between the *grand goût* and the Ideal. The Ideal is removed from actual reality. While reality is specific and individual, the Ideal is of a lofty anonymity. Classical art is an embodiment of the Ideal precisely because of the perfect, yet somewhat anonymous, character of so many Greek sculptures. In the seventeenth century, as we have learned from Janson, heroic nudity in contemporary figures serves the same purpose of elevating them above specific times and regions.[66] It is logical that in seventeenth-century thought the *grand goût* should have been juxtaposed to the "taste of the nations" *(goût de nations)*. Anything that reminds us of a *particular* nation, of a specific race or country, cannot be ideal and cannot belong to the "grand taste." In tracing the parallels of "Deism and classicism" in the seventeenth century, Arthur Lovejoy, the American philosopher and historian of ideas, finds what he calls "Uniformitarianism" the first, and most prominent, common property. "Anything of which the intelligibility, verifiability, or actual affirmation is limited to men of a specific age, race, temperament, tradition, or condition is *eo ipso* without truth or value."[67] Veneration of the universal leads Du Fresnoy to ask the painter to reject any "foreign ornament." It is not by chance that the art most frequently condemned for lack of greatness is the art most obviously related to a specific country and milieu, that is, Flemish painting or the art of the "German taste, which is usually called Gothic taste." Even in the mid-eighteenth century, Winckelmann still speaks with disdain of "Dutch shapes."[68]

Simplicity is another feature of the "grand taste." Winckelmann, as we know, saw the essence of classical art in "noble simplicity and tranquil grandeur."[69] But greatness and simplicity were already interrelated in the early stages of academic doctrine. The works of good painters, Du Fresnoy wrote, should "have greatness *[avoir du grand],* noble contours, order and simplicity." The good painter, Le Brun indoctrinated his students and his generation, can avoid the fallacy of treating a subject "in the taste of the nations" only by representing

the scene "most simply."[70] It is difficult for us to define exactly what he meant by "simplicity," but it was a required characteristic of the great taste.

Simplicity is also the antidote to individual eccentricity. Raphael's genius is superior to Michelangelo's and Leonardo's, said Roger de Piles. The Neoclassicist distrusted the individual and the particular; he very naturally felt perturbed before the fierce genius—even if of Michelangelo's stature—that contorted and seemed to mar the nature it wished to depict. And indeed, Roger de Piles believes that it is Raphael's genius that is sublime. He goes on to speak of "the beauties of *Design,* the fine choice of the *Attitudes,* the delicacy of the *Expressions,* the fair order of the *Foldings,* and a *sublime Stile* to which the Ancients raised Nature, and the Moderns after them in the beginning of the sixteenth Century."[71]

"Simplicity" and "greatness" are metaphors meant to convey a certain mood or state of mind. Sometimes, however, they were also understood in a more literal sense. Du Fresnoy prescribes how to achieve greatness and simplicity in painting. Pictures, he says, should be clear and coherent, and they "should be composed of few, but large parts." It is often suggested that the actual size of the painting should correspond to the significance and nobility of the scene depicted (though this never became a rule). Where Henri Testelin discusses "Exceeding *[excedent]* subjects," that is, themes in which heroes and giants are represented, he leaves the reader wondering whether "greatness" is a spiritual quality of the figure or scene depicted, or whether it refers to the picture's size. Seventeenth-century thinkers probably felt that both belong together. The same holds true for literature. The Jesuit René Rapin, a literary critic whom we have already mentioned, asserted that what was needed were grand epics and tragedies, not "sonnets, elegies, rondos, all those petty verses of which so much fuss is often made."[72]

Let us summarize: Academic rules are not isolated prescriptions. The *grand goût,* distinct in its values, is the doctrine of rationalistic aesthetics. It is the conceptual frame of academic teaching, and it informs all of its rules.

III. CRISIS OF THE ACADEMY

1. BACKGROUND

Academic thought of the first generation had a utopian air. Artists and authors believed that they could establish a system of infallible rules (*règles assurées,* or *regole sicure,* as the Italian origin has it). These rules would guide the artist to achieve perfection in his work and would provide the spectator with solid criteria for understanding and appreciating the paintings and sculptures he looked at. None of the seventeenth-century authors who preached the gospel of the infallible rules believed, of course, that an artist could simply be "programmed" to produce perfect works. It would be a gross oversimplification even to suggest that the theorists of the Academy conceived of the visual arts as some kind of language whose vocabulary and grammar could be acquired. They were aware of the incalculable quality of genius and that often one cannot pin down exactly what it is that strikes one in a picture. Yet, in spite of this, in Félibien's and Le Brun's thought something of a linguistic approach survived. The mystic, redeeming power of reason, channeled in rules, was at work both in the process of artistic creation and in the spectator's appreciation of the completed work of art.

This almost messianic belief could not prevail. One could not disregard those aspects of reality that cannot be rationalized, nor could one forget that the artist's creative energies do not always travel in the straight grooves of "secure rules." In the late seventeenth century, many thinkers, readers, and spectators suddenly became aware of the significance of these simple truths. It was a profound crisis in the Academy, and it shook the very foundations of academic art theory. The crisis was not restricted to the interpretation of philosophical principles; it also affected the appreciation of the means the artist employed in his work. The revolutionary process reached a height when in 1699 Roger de Piles, most outspoken in doubting the seemingly sacred truths of academic wisdom, was admitted as a member of the Academy.

The crisis of the Academy took place against a broad background, and it may be worth our while to outline it briefly. Intellectual life in

seventeenth-century France did not deal explicitly with aesthetics, yet a great deal of attention was devoted to what would now be considered the foundations of aesthetics. Writers, philosophers, and artists were familiar with classical thought on beauty, especially with the doctrines of Plato, Aristotle, and Plotinus. Continuing some Renaissance traditions, they also reflected on another problem, namely, that the spectator's subjective condition can never be completely rationalized. It was this trend of thought that led them to the increasing awareness that rules can be valid and applicable only in a limited sense.

Descartes, the paragon of seventeenth-century rationality, did not deal with aesthetics as part of his doctrine. In 1630, however, in response to Father Mersenne's (a music theoretician) request for a definition of beauty, the young philosopher reiterated the classical formulation of beauty as the harmony of parts. He also suggested that beauty must be "experienced." Does not the request for experience undermine any rigid conceptual definition of beauty? "What pleases most people can be called simply the most beautiful; but this is not anything well defined," he concludes resignedly.[73] In his last work, *The Passions of the Soul* (written 1645–1656), Descartes came close to formulating the principle of aesthetic pleasure. Stories we read in books or see performed on the stage, by appealing to our imagination, evoke in us joy and sadness, love and hatred. Yet, in addition to experiencing these specific emotions, and as a result of them, we also experience a different kind of pleasure. This pleasure, Descartes says, "is an intellectual pleasure which can arise from sadness in the same way as from the other passions" (art. xciv). Descartes did not say that the "end" of the arts is to produce this pleasure, as Poussin did twenty years later, but the principle is latent in the philosopher's observations. Is it at all certain, one has to ask, that a specific picture will, indeed, evoke joy or sadness or any other defined emotion and, as a result, also cause "intellectual pleasure"? (Descartes speaks of stories in books or plays on the stage, but we may apply his views also to painting and sculpture, particularly since he insisted that beauty has a "special application to sight.") In view of what Descartes says of the spectator's reactions, it is doubtful whether we can establish infallible rules for the expression of emotions, as the Academy tried to do. The same feature or

work may evoke different reactions in different spectators. Our response to what we see (or perceive by our other senses) is determined by the personal recollections stored in our memory. Somebody who connects pleasant experiences with a certain melody, or image, will be pleased to hear (or see) it; others, who have unpleasant recollections, will avoid such melodies or images altogether. As if describing an experiment in a modern laboratory, Descartes says: "If one were to thrash a dog five or six times to the sound of a violin, when he heard that sound again he would surely whine and run away."[74] This view, it seems, totally undermines the very possibility of rules in art. How can one establish rules for evoking the spectator's specific reaction if his reaction is shaped by experiences the artist will never know and if the experiences of one spectator differ from those of another?

In the second half of the century awareness of the irrational dimension of beauty and art increased. Pierre Nicole, a teacher of philosophy and literature at Port Royal, the center of the Jansenist movement, was one of the few seventeenth-century scholars to compose a treatise on beauty. The major part of his treatise was devoted to demonstrating that views about beauty are subjective, divergent, and shaped by chance factors. "True beauty," Nicole believes, does not change. But beauty is not an abstract concept; it is something that must be experienced. "If a thing is to be beautiful," he says, "it is not sufficient that it should be in accord merely with its own nature; it must also have the right relationship to ours." But Nicole knew, of course, that "our," that is, the spectator's, nature is not uniform; not everybody will react in the same way to the same object he perceives: "there is nothing so bad as to be to no one's taste, and nothing so perfect as to be to everyone's taste. Our taste is nearly always determined by custom and the attitude of others."[75] In his philosophic views Nicole may be informed by belief in the uniformity of reason; what he says about taste and the spectator's reaction casts doubts on the general validity of rules.

Blaise Pascal, the great religious philosopher and mathematician of the seventeenth century, takes an additional step away from aesthetic rationalism. An elusive quality, appropriately called *je ne sais quoi* (the *non so che*, "I don't know what," that appeared in Italy in the late sixteenth century), is the mysterious quality that, in a living person as

well as in a work of art, appeals to the beholder. "That *je ne sais quoi,* that unrecognizable trifle set princes, armies, and the whole world in motion. Cleopatra's nose—had it been shorter, the whole face of the world would have been altered," the ascetic philosopher says in his *Pensées* (II. 162). Pascal allowed for a wide range of perfections and beauties. In his *Discours sur les passions d'amour* the modern reader is surprised to learn: "The broader one's mind, the greater the number of diverse beauties one sees."[76]

As beauties can differ from each other, so can the tastes of nations. Charles de Saint-Evremond, a versatile writer and influential literary critic in the second half of the century, questions the authority of Aristotle's *Poetics* on the basis of historical variety of taste. "It must be admitted," he says, "that Aristotle's *Poetics* is an excellent work; but there is nothing so excellent that it might serve as a rule for all peoples at all times."[77]

The trend manifested in the few passages here mentioned could not but erode the basis for ideal regularity. Thus, the famous writer La Bruyère could exclaim in the first part of his *Caractères* (which, in addition to its great artistic merit, was something of a best-seller and profoundly influenced the intellectual life of the period): "How enormous is the difference between a beautiful work and one that is perfect and regular."[78]

In this atmosphere, one must ask, could the claim to universal validity of rules, so essential to the early stages of academic doctrine, still be upheld? The theory of the visual arts could not but be deeply affected by these changes in the intellectual climate of late-seventeenth-century France.

2. ROGER DE PILES

Like most of the authors discussed in this chapter, Roger de Piles (1635–1709) was mainly a theorist. In his youth he made some modest attempts at actual painting. But he soon abandoned them. A scion of an aristocratic family, he spent most of his life in the diplomatic service. Throughout those years, however, he remained in close contact with painters, visited their workshops, and acquired an intimate knowledge of the artist's craft. Accompanying a young nobleman on

educational trips to Italy, Holland, Spain, Portugal, and even to Sweden, he acquired firsthand experience of the different artistic trends prevailing in Europe in his time. Able to discriminate between fine artistic nuances, he perceived the emerging, still half-articulated tendencies of contemporary art. His literary works, especially the *Abrégé de la vie des peintres* (1699),[79] shows an urbane taste and a thorough familiarity with the European scene as a whole. He felt a profound affinity with some of the new trends in the art of his time and spoke out for them. Some of his views, expressed rather bluntly, provoked discussion, even outright antagonism. This may be the reason that endeared Roger de Piles to certain nineteenth-century writers who sometimes pictured him as a modern revolutionary, eager to overthrow traditional art and "established" instructions. This is a distorted image. Roger de Piles did not consider himself an opponent of the Academy. He shared the academicians' concern for the artist's social status, viewing the painter as a nobleman rather than as a manual worker. In his *Abrége* he devoted a chapter to Martin de Charmois, who "was neither a painter nor sculptor by profession"; he did so because it would be "ingratitude" not to mention the merits of this patron and protector of the art of painting in France. Monsieur de Charmois, Roger informs his readers, could not endure to see able painters oppressed, and "he showed them the nobleness of their profession."[80] Roger never doubted the fundamental belief of academism; that art can, and should, be taught, and that the Academy is the proper institution for this purpose. When he emphasized, in the very first sentence of his *Abrégé,* that "Genius is the first thing we must suppose in a painter; 'tis a part of him that cannot be acquired by study and labor" (as the early English translation has it), he was not saying anything new or revolutionary; other academicians would readily have subscribed to this view. Yet none of them thought that genius makes academic study superfluous, and this was also Roger's opinion. Nor did Roger see himself as opposed to Le Brun; he merely diverged from him in certain respects. Earlier in this chapter we quoted excerpts from the "Balance des peintres," calculating each artist's qualitites in numerical terms, which Roger de Piles devised. As we remember, Le Brun scored rather high.

But, though Roger de Piles belonged to the academic tradition, at

least implicitly, he was questioning many of its values, and he found himself the mouthpiece of those challenging the Academy's rule. What was it, then, that made him a revolutionary in spite of himself? His attitude was more open than that customary in the early days of the Academy, and he admitted a variety of styles without hierarchically grading them. "I love everything that is good in the work of great masters," he said. "I love the diversity of schools: I like Raphael, I like Titian, I like Rubens."[81] The acceptance of such diversity cast serious doubt on Le Brun's dogmatism. Le Brun, we remember, took all his models from the tradition of Antiquity-Raphael-Poussin, a tradition he deemed unified, and vastly superior to all the other trends. Recognition of diverging styles implicitly undermined the philosophical conception of the *grand goût* and the dominance of rules derived from it. Many of Roger's contemporaries felt the explosive power, still dormant yet dangerous, in this attitude.

The acceptance of a variety of styles necessarily led to accepting the diversity of "national tastes." At the end of his *Abrégé* the author tells us that "after having written of the painters of several nations in Europe, we thought it might be à propos to say something of the different tastes of these nations." He then goes on to discuss the "tastes" of six nationalities: Roman, Venetian, Lombard, German, Flemish, and French.[82] Roger de Piles has a fine eye for the characteristics of regional styles, yet again he did not grade them. Each taste has its distinctive values and its specific deficiencies. "Roman taste," for instance, excells in design, postures, and expressions, but it is deficient in coloring; "Flemish taste," on the other hand, portrays nature "with her defects" (as does the German taste), but it excels in a great "union of well-chosen colors." Since each style excels in a different quality, one cannot grade them; different styles can be of equal value.

Even "truth" can be of different types. Roger distinguishes three: simple, ideal, and composite truth. "Ideal truth" is a "selection of various perfections which are never to be found simultaneously in one model"; it is therefore based on an idea in the artist's mind. "Simple truth" is the faithful rendering of nature without any selection of its parts. "Composite truth," finally, is a combination of the two. Is this third type meant to bridge the gap between the natural and the ideal?

And do the different types of truth form a hierarchic ladder, so that one is clearly superior to the other? These questions are not easily answered. The absolute superiority of ideal truth, which would be a matter of course for any good academician, is to Roger by no means a forgone conclusion. In his last work, *Cours de la peinture par principes* (1708), he defines, not the noble form, but the "deception of the eye" as the "aim" *(fin)* of painting, and perfect illusion is more closely associated with "simple truth" than with the idealization.

Roger de Piles did not openly reject the academic tradition, but he was moving away from the rigid absolutism of values that dominated its earlier stages. One understands why many of his contemporaries smelled in him a heretic.

3. "LE DÉBAT SUR LE COLORIS"

The best-known clash between two trends, focused on a single issue, was the dispute over the significance of color in painting. This argument, which went on for many years, is now generally known as the *débat sur les coloris.*[83] That the elements, or "parts," of painting, as defined in the Renaissance, are arranged in a hierarchic structure, was a matter of common belief. As we saw in the preceding pages, in seventeenth-century academic doctrine the leaning toward hierarchic arrangement became even more pronounced than before. Drawing, we remember, habitually occupied the highest rung of the ladder; color was usually at the bottom. In the French Academy, under Le Brun's direction, it became a dogma that the value of a painting lies primarily in its drawing (sometimes described as "line" or even as "composition"); its color, being devoid of significance, should always be restrained and completely subordinated to the place assigned to it by drawing. This hierarchy had a metaphysical foundation. Drawing embodies reason and color appeals to the senses; drawing, therefore, is as superior to color as reason is to the senses. It is true that an upgrading of color had already begun in sixteenth-century Venice and Milan, but in Paris it remained surreptitious until it erupted, with volcanic power, in the sixties of the seventeenth century. The "Dispute" over color began.

In 1668 Roger de Piles published a French translation of Du Fres-

355

noy's didactic poem on painting (originally appearing in Latin only one year before) and added to it some comments of his own. In this little work, Roger's first contribution to art theory, he still closely followed accepted academic doctrine; only in his appreciation of color did he deviate from what was taught by Le Brun. This one divergence, a change in the placing of emphasis, was sufficient to start one of the causes célèbres of art criticism in the modern age. Trained in the analytical thinking of his day (which owed much to Scholasticism), Roger de Piles was familiar with the Aristotelian and scholastic method of definition: if you want to define something, you first relate it to its closest group *(genus proximum),* and then, pointing out what distinguished your object from the other members of the group, you show its "specific difference" *(differentia specifica).* This venerable method Roger applies to the study of painting. He finds, not surprisingly, that painting holds most of its elements in common with other arts and sciences. To draw a figure correctly, the artist needs a thorough knowledge of anatomy; to render a proper perspective vista, he needs knowledge of optics. What, then, is the *differentia specifica* of painting? Modulation and tuning of color, he says, can be found in painting only; no other "art," no other branch of science, deals with them. Therefore, he concludes, what is characteristic of painting only is color.

Roger's tone and formulation were modest and restrained, yet what he said challenged the academic doctrine and sense of values. Had this been a purely scholastic question, a matter of definition only, Le Brun's disciples might have disregarded the new critic, who here appeared only as a commentator on Du Fresnoy's highly esteemed test. Yet Roger's statement implied not only that color is "specific" to painting; it also indicated that color is the most valuable feature of the art. At one point, at least, Roger openly challenged the supremacy of line, that absolute dogma of the Academy. Drawing, he said, belongs to the initial, preparatory stages in the production of a work of art. What we see in the *completed* painting is its color area only; the drawing that existed before is now hidden behind the finished surface. This opinion, incidentally, not only testifies to the value now centered on color; it also shows how far removed even as "progressive" a critic as Roger

de Piles was from appreciating anything unfinished, any trace of the creative process itself.

In 1671 a new stage in the dispute on color began, a stage that B. Teyssèdre, the most meticulous student of the *Débat*, termed the "Great Encounter."[84] In June 1671 Philippe de Champaigne—a painter who had developed a northern, lucidly rationalistic style—discussed in an Academy lecture Titian's painting, *The Virgin, Christ, and St. John the Baptist*. He has praise for Titian's colorism, but he criticizes his drawing; the Virgin's legs are too short. Philippe de Champaigne's formulations are aristocratically restrained; yet after one has read through the whole text one is bound to be convinced that color is no more than a sensual seduction, given to the portrayal of ephemeral appearances; one might almost say that it is a temptation to be overcome. To Titian, "the enchanter," he juxtaposes Poussin, "the philosopher." Poussin's linear method, geared toward what is essential, stable, and solid, is "supported by undefeatable reasons." To Philippe de Champaigne, then, color poses a *moral* problem. One should not be dazzled, he said, by "external luster [or flesh]"; rather, one should prefer beauty of the soul. In reading his lecture one cannot help feeling that in painting color stands for "external luster," design for beauty of the soul.

Two years later, in 1673, Roger de Piles was heard again. He published a little treatise in dialogue form, *Dialogue sur le coloris*, refuting the new attack on color by the leaders of the Academy. In this short treatise he did not openly join issue with Philippe de Champaigne's moral argument; yet in some way he replied to it. Though Roger was not a practicing painter—as was Philippe de Champaigne—he opens his treatise with an original contribution to the analysis of painting. One should distinguish, he says at the beginning of the *Dialogue*, between "color" *(couleur)* and "coloring" *(coloris)*. Color is the quality that "makes the [natural] objects accessible to vision"; coloring is one of the "parts of painting." The painter imitates the colors of objects as seen in nature, but he distributes the hues on the canvas according to artistic requirements. *Couleur* is found in nature; *coloris* is what we see in paintings. In proper *coloris*, one concludes (though Roger does not

say so explicitly), one is not dazzled by "external luster [or flesh]". On the contrary, what we have here is a spiritual quality.

Later in the *Dialogue* Roger goes into some detail. Colors in nature are not always suited to direct and faithful imitation in a work of art. The painter must choose between the various colors experience offers his eyes; sometimes he must correct the hues observed according to the criteria of his art. As the draftsman should not slavishly copy the shapes and proportions of his model, "the painter should not imitate all the colors, as they present themselves, indifferently." The picture's "overall unity" is the leading value in coloring. To that unity the painter should subordinate each individual color, in intensity as well as in distribution. "The beauty of the *coloris*," Roger says, "does not consist in the variety of the different colors, but in their proper distribution." And the "proper distribution," as we know, is the one that contributes to the picture's "overall unity." [85] One senses what Wölfflin will call the "pictorial" style.

An educated seventeenth-century reader was familiar with many of these ideas from his study of Italian treatises. But that some of Roger's ideas were foreshadowed in the Renaissance should not prevent us from recognizing his original achievement. He explicitly divorced natural color from color in painting and thus granted to color in art a new status.

But Roger knew that it was not enough to endow coloring with a dignity it did not have before, as long as it remained an abstract concept and its precise scope was not known. Most important was the question whether lights and shadows belong to *coloris*. Roger's answer was unequivocal: light and shadow are part and parcel of *coloris*. He surely knew that here he was contradicting established academic doctrine. Does not shadowing rightfully belong to drawing? asks one of the interlocutors in the *Dialogue sur le coloris*, who answers himself that it does, since drawing is "a work in black and white in which shadowing is observed."[86] This was indeed what was taught in the Academy. But the other speaker in the *Dialogue*, the one who usually expresses Roger's views, reminds us that in everyday experience both light and color are perceived together. "In nature, light and color are inseparable." If we accept nature's verdict, drawing itself will have to

be redefined. And this is indeed what Roger sets out to do. Drawing consists only of what can be represented by line, such as "just measurements, proportions, and the exterior form of objects." (The "exterior form of objects" is, of course, nothing but their outline.) Optical illusion, volume and depth, the bulging body or the dimly disappearing landscape, if created by lights and shadows, are nothing but *coloris*. Coloring, then, is not just what provides the simple folk with a primitive delight in bright, shining colors, as was sometimes believed in the sixteenth century; it is the painter's power to create perfect illusion, to make the spectator believe what he sees. Now we understand why coloring is both the specific feature of painting and its essence. Painting in general is the art of making the depicted seem real, of creating an overall psychological effect. Le Brun's haughty statement made in January 1672 that without drawing painters would not rank higher than color grinders only shows that Le Brun's art did not aim at an overall, all-encompassing illusion.

We cannot here follow all the ups and downs of this debate. This has been done in great detail by some modern historians, notably by B. Teyssèdre. Here let us only note that when, in 1699, Roger de Piles was finally admitted to the Academy of Art, color was being officially declared as the major component of painting.

4. MODERNITY

Reading the literature in which the *Débat sur le coloris* was carried on (minutes of lectures, pamphlets, dialogues, and treatises), one is struck by the intensity of the dispute. To a modern reader such an emotional, passionate tone would seem out of place in the analysis of a rather abstract question: What is more important in painting, line or color? Were there not some other reasons, one asks, that lent such vehemence to a philosophical debate? Did not the term and concepts of the discussion carry some connotations, perhaps hidden from a modern reader's mind, that may explain the psychological violence of the encounter?

From the historical background of the *Débat*, which was of course composed of many factors, we shall single out two traits. These two, we believe, probably suggest more than any other features why certain

359

abstract notions, such as line and color, were able to evoke such a dramatically emotional response. One of them is the sense of modernity, and the pride taken in being modern, that pervaded certain groups in seventeenth-century France. In the history of European literature, many scholars have said, there seems to be a rhythm of adoring the "ancients" (whoever they may happen to be) followed by a self-assertion of the "moderns." E. R. Curtius, in his well-known *European Literature and the Latin Middle Ages,* considers the battle between the ancients and moderns a constant phenomenon in the history of European culture.[87] The word "modern" (related to the Latin *modo,* "now") seems to have emerged only in the sixth century A.D., but the contest between Atticism and Asianism in Hellenistic literature—something that has close parallels in early Christian painting and sculpture—has been defined by twentieth-century scholars as one of the earliest battles between ancients and moderns. Aristarchus of Alexandria, a literary critic of the second century A.D., contrasted Homer with recent writers. In Roman literature such famous poets and writers as Terence, Horace, and Tacitus juxtaposed classical authors with those of their own day. In the twelfth century there was a veritable revolt of the *moderni* against the prestige and authority of the *auctores.* For the Renaissance, as we know, the ambivalent relationship to the past was one of the core problems; the adoration of classical Antiquity was intertwined with the belief that "our own age," to speak with Vasari, had surpassed it.

This age-old controversy reached a climax in late-seventeenth-century France, in the dispute that is now known as the *Querelle des anciens et des modernes.* An important date in the history of the *Querelle* is January 27, 1687. On that date the members of the Académie française and the Academy of Sciences convened to celebrate the recovery of King Louis XIV from an operation. Charles Perrault (1628–1703), a writer who enjoyed considerable fame during this period, read a poem entitled "Le Siècle de Louis le Grand" ("The Century of Louis the Great") in which he compared his own time with the mythical age of abundance and bliss, the period of Augustus.[88] Perrault, of course, admires the greatness of the ancients, but, he says, we do not have to kneel down in awe before them. The progress of the sciences and the

arts made the French king's epoch, that is, Perrault's own time, superior even to that of the Roman emperor. The members of the Académie française reacted violently to such heresy. Boileau, lawgiver of the Parnasse, as he was called, left the assembly full of rage; what Perrault suggested, he said, was "lack of taste resulting from ignorance." Racine, the great tragedian, tried to defend Perrault by suggesting that what he had said was a paradox, ingenious and witty, but not meant to be taken seriously. The *Querelle* has started.

Shortly after he had read his poem, Perrault published a major work on the subject. The book, *Parallèle des anciens et des modernes,* consists of five dialogues, and was published in four volumes (1677–1697).[89] The interlocutors in the dialogues are the Président, a mouthpiece of the orthodox admirers of Antiquity, and the Abbé, the speaker of the progressive party. A Chevalier, a third speaker, sometimes helps the Abbé by referring to *bon sens.* In the *Parallèle* the argument between the ancients and the moderns is fully spelled out and is developed in detail. The first dialogue states principles; the second is devoted to the three visual arts; the third to eloquence, the fourth to poetry, and the fifth to the sciences.

In recent years the *Querelle* has been explored from many points of view, and it is not for us to relate the whole story. We should only like to point out some of the aspects that were of particular consequence for the art theory of the period. Let us start with the simple observation, made by Kristeller, that here we have—probably for the first time—a complete separation between arts and sciences (only music is, traditionally, still discussed as a science).[90] Perrault accepts many premises from Italian thought, yet he altogether rejects the idea, so fundamental for the Renaissance, that art has a scientific function. Clearly the modern concept of art is emerging.

More important for our present purpose is that the *Querelle* led to a deepened awareness of the present's value. Our own days—this was the central message of the *Querelle*—are not a dim reflection of a past glory, a glory that nobody will ever be able to fully recapture, as that past-oriented utopia, consistent classicism, maintained. The moderns tried to demolish the very basis of this belief that the ancients' perfection is beyond reach. Man is now the same as he was in the Rome of

Augustus. Fontenelle, one of the fine minds of the Académie française in the late seventeenth century, wrote in his *Digression sur les anciens et les modernes* (1688) that the centuries make no difference between people.[91] The whole problem of the superiority of Antiquity, so Fontenelle began his *Digression,* boils down to the question whether in Antiquity the trees were taller than they are now. Man, we are made to understand, was not more perfect in Antiquity than he is today. There is, then, no metaphysical reason that would compel us to assume that the ancients tower over the moderns.

We now come to the visual arts, dealt with in Perrault's second dialogue. Painting and sculpture of all periods should be measured by the same yardstick, reason. Apelles and Zeuxis found it sufficient, Perrault boldly asserts, "to charm the eyes and to touch the hearts"; but in satisfying reason they proved deficient.[92] Nobody will doubt that the ancient painters and sculptors were great artists. But the serious difficulty, he continues, "is not so much to prove that [even] today one is carried away by Zeuxis, Timantes and Apelles, but to show that they still have some advantage over the Raphaels, the Titians, the Paul Veroneses, and the other great painters of the last century."[93] To Perrault this is not a matter of comparing individual paintings or sculptures. He is considering art as a whole, and he is particularly aware of the theoretical foundations. "I dare to put forward," the Abbé declares, "that considering art itself, as a system [lit., "an accumulation"] and as a collection of precepts," one will find that in modern times it is more advanced than it had been in bygone ages. Moreover, art's progress has not stopped even since the Renaissance. "Thus I maintain," the Abbé again speaks, "that today painting is more accomplished than even in the century of Raphael."[94] Just compare Paolo Veronese's *Supper in Emmaus* and Le Brun's *The Queens of Persia at the Feet of Alexander,* both to be seen in the king's antechamber. The superiority of Le Brun, Perrault believes, is obvious.[95]

The self-assertion of the moderns is not necessarily a revolt against academism. The dominating ideal is perfection—for the Abbé not less than for the President. H. R. Jauss, the present-day literary historian, is correct in stressing that for Perrault and his followers the superiority of the moderns does not consist in being different from the ancients

but in being more accomplished than they were.[96] The style, or type of art, are the same. Therefore also, as Curtius noted, the juxtaposition of ancients and moderns results in what he calls "canon formation." A "canon" is a list of masters considered classics, and it can perhaps be extended also to a system of rules claiming absolute validity. The moderns develop a canon of their own, and they juxtapose it to the canon of the ancients. The canon of modern masters is the expression of the present's awareness of its autonomy and value.

Another feature of a character altogether different from the *Querelle,* though also related to modernity, is less easily pinpointed. One may perhaps, in a very general way, call it the increasing significance of subjectivity. Emerging subjectivity manifests itself in an almost infinite variety of fields. We shall briefly adduce only one, the new audience of art.

The generations that experienced the *Querelle* and its immediate aftermath also saw the almost sudden emergence of a large lay public, of a new type of art "consumer." Social processes may take much longer to crystallize than literary debates, but the transformation of the public at the turn of the seventeenth century went at a quick pace. In a matter of a few decades a new audience was born. Before the last part of the seventeenth century the group addressed by painters and sculptors was restricted either to a thin layer of artistocratic families or to narrow coteries of elitist art lovers and collectors. In the late seventeenth century, this changed. The Salon of 1699 was already visited by many and different kinds of people, but when in 1725 some academic artists presented a small collection of paintings and sculptures, a huge gathering, which—according to the *Mercure de France*—consisted of "people belonging to all classes, ages, and sexes, crowded the halls of the 'Grand Salon' in the Louvre. They were admiring and criticizing, praising and reprimanding."[97] The large public, visiting exhibitions and actively judging the works of art on display, remained a constant feature of modern life.

This new public could not fail to find its own literary representation. That Roger de Piles saw himself as speaking for the layman one can sense from his violent attack against the "trade judges." Jean-Baptiste Du Bos (1670–1742), an abbé, scholar, and literary critic,

becomes the most important theoretician defending the public's posi-
tion. In his *Réflexions critiques sur la poésie et la peinture* (1719) he rede-
fines the aim of painting. For the classicist Fébilien, we remember, the
supreme task of art was to instruct; for Du Bos, it is "to move." The
spell of reason seems to be broken. Art, he dares say, should appeal
primarily not to reason but to *sentiment.* The concept of *sentiment* is
multifaceted, particularly in the seventeenth century. For Descartes
sentiment is the final product of a psychological process, *sentir.* More
important in our context is what Pascal has to say: *sentiment* is a dis-
position of the soul, a "faculty." One judges on the basis of *sentiment.*[98]
This is also how Du Bos understands this concept. In the aesthetician's
doctrine the concept is, of course, more central than in the philoso-
pher's thought. In Du Bos's system *sentiment* occupies the place *raison*
held in Boileau's. *Sentiment,* he believes indicates *plaire* and *toucher,* that
is, to "please" and "to move," respectively. This is particularly true in
aesthetic judgement. Judgment of matters artistic does not result from
rational deliberation but from a spontaneous act of being pleased or
displeased. "Does the work of art please or doesn't it? Is the work a
good one or a poor one? This is the same thing." *Sentiment,* Du Bos
continues, "is the competent judge of this question."[99] This attitude,
of course, implies that the broad public is the best-qualified judge of
art. People without *sentiment,* this theoretician of the new public be-
lieves, are as rare as people who are born blind.

Making the public a judge of art leads to appreciating the values
that have the greatest appeal. Fénelon, whom we encountered earlier
in this chapter, shows which taste and style were preferred. He praises
a statue of Venus because "the hand of the artist seems to have soft-
ened the marble . . . you can see the nude beneath the drapery." A
Venus by Le Brun, probably rational and linear, is "surely not enough
of a Venus."[100] What these new critics conceive as an ideal is a living,
vibrant beauty, full of movement and tension, a style that forcefully
captivates the beholder's, that is, the public's eye. The emergence of a
new public, like the awareness of modernity, is intimately connected
with a set of specific artistic values and preferences in style.

These processes nourished the debates in theory of art, such as the

Débat sur le coloris, which crystallized in a dispute over a very definite question.

5. POUSSINISTS AND RUBENISTS

The passionate discussion of color, as well as of the other issues that agitated the minds of critics, could not remain divorced from the actual art of the time. These disputes, we remember, took place in the Academy of Art, and the education of the practicing artist was, after all, the Academy's principal task. In spite of the lecturer's theoretical tone, methods of analysis, and the scholastic terminology employed, it was unavoidable that the discussion would turn to the art created in the years in which the lectures were delivered. This art, we remember, determined the theory of art that those lectures tried to formulate.

In these early days of the Academy many of the great lectures that made up such an important part of its curriculum were devoted to single works of art. Le Brun lectured on Poussin's *Miracle of the Manna* and Raphael's *St. Michael Defeating the Demon,* and Philippe de Champaigne lectured on Poussin's *Rebecca and Eliezer;* [101] less famous artists and critics lectured on other paintings and on individual pieces of ancient statuary. But as a rule, these works of art were discussed, not for their individual merits, but as examples of certain theoreticial approaches. The lecturers carefully described and analyzed the paintings in order to show what could be achieved if one applied a certain theory or method. The works of art were treated as models, held up in front of younger artists who were encouraged to emulate their procedures. Under these conditions it is only natural that the lecturers tended to disregard the complexity characteristic of every work of art; they ascribed to the pictures and sculptures discussed a consistency and one-sidedness appropriate to an abstract, dogmatic theory rather than to a real work of art. The same is true, of course, for the way individual artists were seen. When discussing the style of a well-known artist, the lecturers tended so much to emphasize a *certain* quality in his style, a specific trait in his work or manner, that the richness and variety of his work were suppressed; his name came to stand for that *one* quality; he became the exponent of that *one* value.

It is in this light that we should see the confrontation of the two "model" artists, a confrontation that became a cause célèbre and occupied the minds of a whole generation of artists and critics: the dispute between Poussinists and Rubenists.

In the first generation of the Academy the work of Poussin, the patron saint of early academism, was considered an exemplary embodiment of the highest values of art. The excellence of his paintings, critics would agree, might depend more on his genius than on his carefully and conscientiously following some accepted "rules of art." But the lawgivers of academic doctrine showed that these rules were, as a matter of fact, fully realized in his art. Poussin's nature just worked according to the inherent truths of the rules; in modern parlance we would probably say that Poussin intuitively followed the rules. His painting, *Rebecca and Eliezer* (now in the Louvre), shows, to quote Philippe de Champaigne, "the compliance with three or four general and important rules."[102] Here Poussin demonstrated, first of all, that the spectator's eye is instantly attracted by the principal figures and action; the artist composing a work should always keep in mind this important requirement; he must make the principal figure, group, or action easily distinguishable from the others depicted in the same work.

The idealization of figures—in proportions, postures, and gestures—was another value fully manifested in Poussin's work and brought it close to ancient models. Does not such idealization lead to a certain sterility? Not so! said Le Brun: Poussin's figures are close to classical statuary, not because he slavishly copied ancient sculptures, but because he had the principle of idealization in common with the ancients: "learned men who work toward the same discoveries and toward the same end can be found to chance upon the same solutions without deserving the title of imitators or plagiarists."[103]

Other truths, or rules, too, are manifested in Poussin's work. He handled lights and colors "judiciously," subduing them to the more important values of art. In so doing he also achieved a "gentle and imperceptible unification of the landscape and the figures."

In all these respects Poussin's work was canonical. Even where Philippe de Champaigne mildly censured him for not being literally true to the text (omitting the camels explicitly mentioned in the biblical

account of Rebecca and Eliezer), Le Brun took up the master's defense: in the "mode" in which Poussin represented the scene—a mode of sublime and restrained beauty—the ugly shapes of the camels would have been discordant with the general character. It is to be understood that deformity should be banned from idealized art.[104]

The defenders of color criticized Poussin's linear idealization. Poussin's naked figures, Roger de Piles wrote, resemble "painted stone"; "they display the 'hardness of marble' rather than the 'delicacy of flesh, full of blood and life.'" Poussin was so absorbed in the study of antiquities that he paid no attention to the other branches and sources of art. He especially neglected coloring. He knew nothing of local colors or of chiaroscuro: "for which reason almost all his pictures have a certain grey predominant in them, that has neither force nor effect." Wherever he is more forceful in color it is because he happened to be copying Titian. Poussin not only neglected color in painting (probably because he had "a very mean opinion of colors"); he was also never a master of the "theory" of coloring.[105]

To criticize Poussin was tantamount to questioning the truth and validity of academism as such. It meant shaking the very foundations of a doctrine that claimed to have found the ultimate truth of art. But for such revolutionary views to be effective they could not remain within the realm of abstract criticism. One had to show what true perfection is; another model artist had to be placed against Poussin; and the younger generation had to be encouraged to imitate that model. Considering Roger de Piles's commitment to color, one would expect that model to be Titian, the artist who got the highest score for color in Roger's "Balances des peintres." But it was a more recent painter, Peter Paul Rubens, whose work and manner were erected as the ultimate model for imitation. The second part of de Piles's Dialogue sur le coloris is nothing but a hymn to Rubens's art, and in his later writings he came back to Rubens and upheld him as the acme of pictorial perfection. What was it that made Roger and his followers see in Rubens the "absolute painter"?

Weighing Rubens against "the most generally esteemed" Italian painters, Roger pointed out that the Flemish master possessed all the qualities that humanistic culture so highly esteemed in the Italian artist:

he had a profound knowledge of literature; "his invention was ingenious, his disposition advantageous"; he shaped his allegories clearly; he had an intimate knowledge of ancient monuments and brought it to bear on his allegories ("and as allegories are a sort of a language which consequently ought to be authorized by use, and generally understood, he always introduced those symbols in his pieces, which medals and other models of antiquity have rendered familiar, at least to the learned"). Roger admitted that Rubens sometimes "fell into a Flemish character" and that his "knitting of the joints is a little extravagant" (a remarkable observation on Rubens's manner of depicting ankles and fingers), yet, he continues, nobody will accuse him of being ignorant in design. But all these qualities Rubens shared with other masters. What is it, then, that makes Rubens stand out even among the most venerated Italian painters?

To understand the reasons for Rubens's superiority, Roger de Piles maintained, we have to define "the idea of painting." And it is in this attempt of definition that we can see the full scope and understand the real significance of the dispute between Rubenists and Poussinists. Painting, we learn from de Piles, is the perfect imitation of visible objects; its end is the deception of the eye; its aims are to skillfully instruct and to arouse the passions.[106] All the elements constituting this definition are, of course, well known from the literary tradition. What is new here is only the emphasis, especially in defining the aim of art as creating a deception of the eye. This, Roger explicitly stated, is "the essential part of painting." And here Rubens excelled. His skill in drawing he shared with many Italian masters. Some Venetian painters were just as fine colorists as he was (in the "Balance des peintres" Rubens, in fact, ranks slightly behind Titian in his achievements as a colorist: in the color column Rubens scored 17 and Titian 18). What really makes Rubens a model for all painters, what—in the view of Roger de Piles—made him even superior to Poussin is his unmatched mastery in deceiving the eye of the spectator.

"Deception of the eye" is, of course, a well-known topos in the art theory and criticism of the previous periods. Any reader of this literature is familiar with a variety of stories about birds that picked at grapes painted on the wall, or real horses neighing at painted ones; we

also know of Dürer's pet dog touching his master's self-portrait with his muzzle and of other "well-authenticated" stories of this kind. Ernst Kris and Otto Kurz, in a valuable book on the mythical image of the artist that has now been translated into English,[107] have shown how worldwide the distribution of this motif was (though usually the "deception of the eye" was not defined as the "aim of painting").

That a good painting "deceives the spectator's eye" is an age-old formula. Yet obviously most writers who employed this phrase did not intend it literally. Did, for example, Petrarch really believe that beholders mistook the figures Giotto painted for live people? Difficult to accept. What they really wished to say is that the work of art so ascribed makes a lifelike impression, that its style is naturalistic. Roger de Piles was too sophisticated a critic to believe that Rubens's work would literally mislead any spectator and make him forget that what he was seeing were images painted on canvas rather than people of flesh and blood. What he meant was that Rubens's art appeals directly and forcefully to the spectator. In his *Lives of the Painters* Roger slightly modifies his wording, and these changes, though minimal, are significant. The great artist from Antwerp, says Roger, "by his example made the method of pleasing the eyes a precept." Roger here speaks of a "method," of a way of working, and not of a mere effect; and it is equally important to observe that he replaces "deceiving" by "pleasing."[108]

Since Roger here discusses a method of painting, or a quality of style, we can ask what precisely this method is. Roger de Piles is not concerned with any questions of correctness. Lifelikeness, or "pleasing the eyes," refers to certain characteristics of the pictorial representation of nature. Roger stresses Rubens's attentiveness to nature, but he also suggests that naturalism is far from the mechanical copying of reality. Rubens "was so strongly persuaded that the aim of the painter was to imitate nature perfectly that he did nothing without consulting her, and there has never been a painter who has observed and who has known better than he how to give to objects their true and distinctive character. . . . And he carried this knowledge so far, with a bold but wise and skillful exaggeration of these characteristics, that he rendered painting more alive and more natural, so to speak, than na-

ture herself." An interesting passage in the *Lives of the Painters* is more specific. Rubens, we read there, "collected his objects after the manner of a bunch of grapes, of which the grapes that are in the light make altogether a mass of light, and those that are in the dark, a mass of darkness. Thus, all the grapes making one single object, the eyes behold them without distraction, and may, at the same time, distinguish them without confusion."[109] These lines evoke a soft, "pictorial" style, based on color and the broad perception of lights and shadows. It is such a type of art that "pleases the eyes." What Rubens aims at, so we must understand Roger's words, is not the revealing and defining of nature's structure but the imitation of optical perception. In other words, it is the spectator's world that is represented, and the beholder necessarily recognizes what is represented as belonging to his own experience. Maybe this is the reason for Roger de Piles's speaking of the "deception of the eye" as the aim of painting.

Turning the "deception of the eye" (or only "pleasing" it) into the "aim of painting" inevitably leads to a clash with the idealizing trend, even if the clash is not explicit. Roger de Piles indeed maintains that in deceiving the spectator's eyes Raphael's achievement is "only mediocre." The idealized figure differs from the one capable of deceiving our eyes both in its specific details (all irregularities are suppressed) and in its general character. The ideal figure is withdrawn from immediate reality; it is a "heightened" or "purified" nature, as theoreticians of art so frequently said. Even without pondering the philosophy of idealization, we intuitively know that we will never encounter the idealized figure in our experience. When we see it in a painting or a sculpture, we may be inspired with awe, or our mind may be carried away by its beauty, but surely it will not deceive our eyes. What struck and disturbed many seventeenth-century observers of Rubens's work were precisely his deviations from the noble forms to which classicist theoreticians preached adherence. An illuminating example is provided by a letter from Rubens's erudite friend, Nicolas-Claude Fabri de Peiresc. Looking at Rubens's oil sketch, *The Allocution of Constantine* (now in the John G. Johnson Collection in Philadelphia), the learned antiquarian is delighted by the "exactness of the antique military costumes," but he is disturbed by the drawings of the legs "in a curve

rather than straight as is customarily done." Both the ancients and the great masters of the Italian Renaissance (such as Michelangelo, Raphael, Correggio, and Titian) avoided curves, Peiresc says. He must have asked before about the reason for this unconventional shape; he remembers Rubens's answer: the artist is drawing legs in a curve because "this effect appeared in nature, and the critics cannot deny the truth of the effect of nature." The direct observation of nature, then, is placed above ancient and Renaissance models.[110] In other words, the ideal of "deceiving the eye" also affected the attitude toward artistic traditions, and particularly the art of Antiquity, the venerated paradigm of centuries.

Rubens was, of course, a child of his times, and the values accepted in their culture—among them the veneration of Antiquity—were also his. Moreover, he was one of the few artists who had a full command of Latin; was familiar with all the major Roman authors; and had a thorough knowledge of classical monuments, including coins. But his attitude toward classical art as a model of contemporary painting must have been complex and ambivalent. In his last and most comprehensive book, *Cours de la peinture par principes* (1708), Roger de Piles published an essay by Rubens, "On the Imitation of Statues," which reflects this attitude.[111] The study of ancient statuary is essential to the education of all artists; painters should be "thoroughly possessed" of a knowledge of classical statuary so that this knowledge "may diffuse itself everywhere." Yet, obviously, Rubens also had some reservations. The lessons learned from classical art "must be judiciously applied." Intimate familiarity with ancient statuary can have different effects: to some painters it has been extremely beneficial; to others it has been "pernicious" and has even led to the ruin of their art. Rubens explicitly warns of the great dangers of imitating ancient statues without discrimination. The complex composition of natural bodies will "soften . . . the harshness of a great many outlines." In statues "not only the shade but also the lights . . . are extremely different from the natural; for the gloss of the stone and the sharpness of the light that strikes it raise the surface above its proper pitch or, at least, fascinate the eye." Therefore, painters applying without discrimination what they have learned from ancient statuary will produce figures that "smell of stone." Instead of

imitating flesh, "they only represent marble tinged with various colors."

One can easily understand what these sentences mean to Roger de Piles. Here the master himself took the part of color and sanctioned the criticism of "cold" academism. In Roger's criticism of Poussin he, indeed, follows Rubens almost to the letter: Poussin's nudes, he said, resemble "painted stone"; they display "the hardness of marble [rather] than the delicacy of flesh full of blood and life."[112] Rubens's warnings came true in Poussin's work.

It is not our task to trace here in detail the further fate of the disputes between color and line, and between Rubenists and Poussinists. In spite of the formidable power of academism, the revolt against its aesthetic norms was not altogether devoid of the chance of success. In 1681 Roger de Piles had already noticed a certain change in taste. The collectors, he said, were joining his party, and the market was less favorable to Poussin than it used to be. In 1683 the powerful Colbert died, the great statesman and unswerving protector of a strong, rational academism, and in 1690 Le Brun, the most influential and most consistent leader of an academic absolutism. La Fosse, a close friend of Roger de Piles, was elected director of the Academy. When in 1699 Roger himself was elected a full member of the Academy, the victory of color and of Rubenism was complete. The first crisis of the Academy had been overcome, and it soon became part of the past. As early as two years after Roger de Piles's death, in 1709, Antoine Coypel spoke of the "pittoresque bataille" between Poussinists and Rubenists. Only in the middle of the eighteenth century was the problem revived, this time under the influence of Winckelmann and Neoclassicism in their dispute with the concepts and forms of late Baroque art.

NOTES

1. "The European Diffusion of Italian Humanism"; see P. O. Kristeller, *Renaissance Thought* (New York, 1965), II, pp. 69–88.
2. The expression was probably coined by an Italian antiquarian in the late seventeenth century. See A. Momigliano, "Ancient History and the Antiquarian," *Journal of the Warburg and Courtauld Institutes* 13 (1950):285–315.

3. *The Painting of the Ancients in Three Books . . . Written first in Latine by Franciscus Junius, And now by Him Englished . . .* (London, 1638; reprint, 1972).
4. *Gedanken über die Nachahmung der griechischen Werke in der Malerei und Bildhauerkunst* (here quoted after Winckelmann's *Werke,* vol. I [Dresden, 1808]).
5. See H. Cherniss, *The Riddle of the Early Academy* (Berkeley, 1945), pp. 61 ff.
6. (Cambridge, 1940), pp. 42–55.
7. The letter, found by Pevsner, was published in *Mitteilungen des kunsthistorischen Instituts in Florenz,* vol IV (1933). See also N. Pevsner, *Academies of Art; Past and Present* (Cambridge, 1940), p. 51.
8. Ammanati's often quoted letter is now best available in P. Barocchi, ed., *Trattati d'arte del Cinquecento* (Bari, 1962), III, pp. 117–123.
9. *Scritti d'arte di Federico Zuccari,* ed. D. Heikamp (Florence, 1961), pp. 25 ff.
10. See above, pp. 112 ff., 295 ff.
11. On Bellori see J. von Schlosser, *Die Kunstliteratur* (Vienna, 1924), pp. 415 ff.; K. Donahue, "The Ingenious Bellori," *Marsyas,* I. (1941), pp. 107–138.
12. Giovanni Bellori, *Descrizione delle imagini dipinti da Raffaelle d'Urbino nelle camere del Palazzo Vaticano* (Rome, 1695).
13. Bellori, *Vite,* toward the end of the address to the *Lettore* (no pagination).
14. Quoted by Donahue, "The Ingenious Bellori," p. 107, where precise bibliographical references are given.
15. Translated into English several times. See E. Holt, ed., *A Documentary History of Art* (Garden City, N.Y., 1958), II, pp. 94–106; E. Panofsky, *Idea: A Concept in Art Theory* (New York, 1968), pp. 154–175 (original text and translation on facing pages).
16. *Vite,* in epistle to "Lettore," no pagination.
17. Bellori, *Idea,* in Holt, ed., *A Documentary History of Art,* II, passim, esp. p. 104.
18. *Vite,* pp. 201 ff.
19. Bellori, *Idea,* in Holt, ed., *A Documentary History of Art,* II, p. 103. And cf. Leonardo da Vinci, *Treatise on Painting,* ed. and trans. P. McMahon (Princeton, 1956), no. 77. I refer here to the paragraph number in this edition. But note that while Leonardo has "grandson" Bellori has "bastard."
20. Bellori, *Idea,* p. 99.
21. Leone Battista Alberti, *On Painting and On Sculpture,* edited with introduction translations and notes by C. Grayson (London, 1972). Roman and arabic numerals in parenthesis following quotations from Alberti refer to the book and paragraph numbers respectively. Alberti's *De Statua* appears in the same volume *(On Sculpture),* and will be quoted in the same manner.
22. Ibid. p. 95. Note the relation to Zuccari's *disegno interno.* For the latter see above, pp. 300 ff.
23. See particularly the long chapter, "Beauty," which forms a central part in Winckelmann's *History of Ancient Art* (1764).
24. Bellori, *Idea,* pp. 101 ff.
25. Karl Rosenkranz, *Asthetik des Hässlichen* (Königsberg, 1853).
26. Schlosser, *Die Kunstliteratur,* pp. 416 ff.

27. Bellori, *Vite,* pp. 460 ff. For Poussin's art theory see A. Blunt, *Nicolas Poussin* (New York, 1967), pp. 219–247; A. Fontaine, *Les doctrines de l'art en France* (Paris, 1909; reprint Geneva, 1970), pp. 1–40.

28. See A. Blunt, "Poussin's Notes on Painting," *Journal of the Warburg Institute* 1 (1937–1938): 344 ff.

29. *Nicolas Poussin: lettres et propos sur l'art,* ed. A. Blunt (Paris, 1964), pp. 163–165. (hereafter cited as *Lettres*). For an English translation of this letter see Blunt, *Nicolas Poussin,* pp. 371–372.

30. François de Sales, *Traité de l'amour de Dieu* II. 12. See also A. Levy, *French Moralists: The Theory of the Passions 1585 to 1649* (Oxford, 1964), pp. 307 ff.

31. Levy, *French Moralists,* pp. 205–212, esp. pp. 211 ff., 311–316.

32. For Malebranche see Y. de Montcheuil, *Malebranche et le quiétisme* (Paris, 1946), esp. chap. 1.

33. *Lettres au P. Lami sur la grace et la predestination,* letter I, question 4 (see Fénelon, *Oeuvres* [Versailles, 1820], III, pp. 319 ff.). See also Levy, *French Moralists,* pp. 314 ff.

34. Bellori, *Vite,* p. 460.

35. Y. Delaporte, "André Félibien en Italie (1647–1649)," *Gazette des Beaux-Arts* 1 (1958):193 ff. See also Blunt, *Nicholas Poussin,* p. 220.

36. Blunt, *Nicolas Poussin,* p. 219.

37. See *Lettres,* ed. Blunt, pp. 121–125, for this important letter. The sentence quoted is on p. 123.

38. Bellori, *Vite,* p. 461.

39. Ibid., p. 462.

40. *Lettres,* ed. Blunt, pp. 27 ff. And cf. R. Lee, *Ut pictura poesis: The Humanistic Theory of Painting* (New York, 1967), pp. 62 ff.

41. *Corréspondance de Nicolas Poussin,* ed. C. Jouanny (Paris, 1911), p. 211. See also Blunt, *Nicolas Poussin,* p. 223.

42. *Lettres,* ed. Blunt, pp. 121 ff., esp. pp. 123–125. For an English translation see Holt, ed., *A Documentary History of Art,* II, pp. 155–156.

43. J. Bialostocki, "Das Modusproblem in der bildenden Kunst," *Stil und Ikonographie* (Dresden, 1966), pp. 9 ff.

44. See Blunt, "Poussin's Notes on Painting."

45. Reported, under that date, in Romano Alberti's *Origine e Progresso dell'Academia del Disengo.* See *Scritti d'arte di Federico Zuccari,* ed. D. Heikamp (Florence, 1961), p. 63.

46. On Le Brun's theory see Fontaine, *Les doctrines d'art en France,* chaps. 3 and 4 (pp. 61–119); for his academic activity cf. Pevsner, *Academies of Art,* pp. 83–87.

47. See A. Fontaine, *Conferences inédites de l'Académie* (Paris, 1903), p. 116. See also Fontaine, *Les doctrines de l'art en France,* p. 64.

48. For the text see H. Jouin, *Charles Le Brun* (Paris, 1889), pp. 371 ff. An English translation of a selection from the lectures is in Holt, ed., *A Documentary History of Art,* II, pp. 161–163.

49. Leonardo da Vinci, *Treatise on Painting,* ed. McMahon, nos. 418 ff.

50. Rapin, *Reflexions sur la poétique de ce temps* (n.p., 1675), XII, pp. 17–18. See also

W. Tatarkiewicz, *History of Aesthetics*, III, *Modern Aesthetics* (The Hague and War-saw, 1974), pp. 353 ff., 360, with English translation of brief passages.

51. Jouin, *Charles Le Brun*, p. 214.

52. See above, pp. 291 ff.

53. In the introduction to A. Felibien, *Entretiens sur la vies et les ouvrages des plus excellents peintres*. See Fontaine, *Les doctrines de l'art en France*, pp. 45 ff.

54. For Roger de Piles see the summary in Fontaine, *Les doctrines de l'art en France*, chap. 5. The monumental work by B. Teyssèdre, *Roger de Piles et les débats sur le coloris au siecle de Louis XIV* (Paris, 1957), though focused on a specific problem, sheds light on Roger de Piles in general.

55. Roger de Piles, *The Art of Painting and the Lives of the Painters . . . Being the Newest and most perfect work of the kind extant . . .* (London, 1706).

56. See above, pp. 280 ff., 329 ff.

57. For brief but interesting summaries see Fontaine, *Les doctrines de l'art en France*, pp. 56 ff.; K. Borinski, *Die Antike in Poetik und Kunsttheorie* (Leipzig, 1924), II, pp. 98, 101.

58. The first edition seems to have appeared in Milan, though no place is given (reprint Rome, 1754). Federico Borromeo should not be confused with Carlo Borromeo, the sixteenth-century cardinal whose *Instructiones fabricae et supellectilis ecclesiasticae* appeared in 1577.

59. See Fontaine, *Les doctrines de l'art en France*, pp. 56 ff. For the Italian background see the lucid summary in R. Wittkower, *Art and Architecture in Italy 1600 to 1750* (Baltimore, 1958), pp. 18–20.

60. For our purpose see Fontaine, *Les doctrines de l'art en France*, pp. 72 ff.

61. See Testelin, *Sentiments des plus habiles peintres du temps sur la pratique de la peinture recueillis et mis en tables de precepts* (Paris, 1696), p. 40. See also the English translation of this passage in Tatarkiewicz, *History of Aesthetics*, III, pp. 411 ff., no. 19.

62. R. Klein, *La forme et l'intelligible* (Paris, 1970), pp. 341–352, esp. pp. 349 ff.

63. Charles Alphonse Du Fresnoy, *Art of Painting*, translated into English verse by W. Mason, with Annotations by Sir Joshua Reynolds (London, 1783).

64. See above, pp. 191 ff., 223 ff.

65. Roger de Piles, *The Art of Painting and the Lives of the Painters . . .* (London, 1706), p. 19 (chap. vi), and p. 2 (introduction).

66. H. W. Janson, *16 Studies* (New York, n.d. [1974]), pp. 189 ff.

67. A. O. Lovejoy, *Essays in the History of Ideas* (New York, 1960), pp. 78–98.

68. Du Fresnoy, *Art of Painting*, pp. 27 ff.; Winckelmann, *Gedanken über die Nachah-mung*, p. 21.

69. Winckelmann, *Gedanken über die Nachahmung*, p. 31.

70. Du Fresnoy, *Art of Painting*, pp. 24 ff., 47 ff.

71. For this frequently discussed topic see, e.g., de Piles, *The Art of Painting*, pp. 27 ff., 123–130, 156–162.

72. R. Rapin, *Réflexions sur la poétique*, no. xxvii.

73. For the early statement see *Oeuvres de Descartes*, ed. C. Adam and M. Tannery (Paris, 1902), I, pp. 132 ff.

74. In the letter to Mersenne. See *Oeuvres de Descartes,* I, p. 133.

75. P. Nicole, *Traité de la vraie et la fausse beauté* (1659), pp. 170 ff.

76. B. Pascal, *Discours sur les passions d'amour,* in the Pleiade Edition of Pascal's *Oeuvres complètes* (Paris, 1954), p. 540.

77. Charles de Saint-Evremond, *De la tragedie ancienne et moderne,* in his *Oeuvres,* (n.p. [Amsterdam], 1711), III, p. 171. See Tatarkiewicz, *History of Aesthetics,* III p. 380, no. 29.

78. La Bruyère's *Les caractères,* chap. I, "Des ouvrages de l'ésprit." See also Tatarkiewicz, *History of Aesthetics,* III, p. 379, no. 26.

79. de Piles, *The Art of Painting,* pp. 95–397.

80. Ibid., pp. 356 ff.

81. See Fontaine, *Les doctrines de l'art en France,* pp. 133 f. The quotation is from Roger de Piles's last work, *Cours de peinture,* p. 27.

82. de Piles, *The Art of Painting,* pp. 391 ff.

83. See the detailed and analytical survey by Teyssèdre in *Roger de Piles,* and the rich bibliography contained in it.

84. See ibid., pp. 151 ff.

85. Ibid., pp. 188 ff.

86. Roger de Piles, *Dialogue sur le coloris* (Paris, 1699), pp. 12 ff. And cf. Teyssèdre, *Roger de Piles,* pp. 188–197.

87. See the paperback edition of Curtius' work in English translation (New York, 1953), pp. 251–255.

88. See Perrault, *Parallèles des anciens et des modernes en ce qui regarde les arts et les sciences* (Munich, 1964) (a facsimile of the original edition in four volumes [Paris, 1688–1697]), pp. 123 ff. (original edition, I, pp. 90–92).

89. Now easily accessible in a facsimile edition in one volume (Munich, 1964), with an Introduction by H. R. Jauss. See also A. Buck, *Die Rezeption der Antike in den romanischen Literaturen der Renaissance* (Berlin, 1976), pp. 228–236.

90. Kristeller, *Renaissance Thought,* II, pp. 205 ff.

91. Fontenelle, *Digression sur les anciens et les modernes.* See *Oeuvres de Fontenelle* (Paris, 1790 ff.), V, p. 284.

92. *Parallèle des anciens et des modernes.* I, pp. 214 ff.

93. Ibid., I, pp. 220 ff. (p. 156 in the facsimile edition).

94. Ibid., I, p. 237 (p. 160 in the facsimile edition).

95. Ibid., I, p. 221 (p. 156 in the facsimile edition).

96. In Jauss's Introduction to the facsimile edition (ibid.).

97. A. Dresdner, *Die Entstehung der Kunstkritik* (Munich, 1915), p. 128.

98. B. Pascal, *Pensées* I. 3, 4.

99. *Reflexions critiques sur la poésie et sur la peinture* (Paris, 1719), II, pp. 340 ff.

100. For Fénelon's views of art see Fontaine, *Les doctrines de l'art en France,* pp. 142–146.

101. For Le Brun's lecture see Fontaine, *Les doctrines de l'art en France,* pp. 66 ff.; for Philippe de Champaigne's lecture see J. R., Martin, *Baroque* (London, 1977), pp.

290–296. Fontaine, *Doctrines de l'artn France,* p. 106, n. 3, adduces all the sources from which we derive our knowledge of this lecture.

102. Martin, *Baroque,* p. 291.
103. Ibid., pp. 291 f., an interesting document of the emerging appreciation of the artist's originality.
104. Ibid., p. 293.
105. de Piles, *The Art of Painting,* pp. 349 ff.
106. See Teyssèdre, *Roger de Piles,* pp. 319–326 and pp. 250 ff. Cf. also de Piles, *The Art of Painting,* pp. 285–297.
107. See above, Chapter 5, note 41.
108. de Piles, *The Art of Painting,* p. 295.
109. Ibid.
110. *Corréspondance de Rubens,* ed. M. Rooses and C. Ruelens (Antwerp, 1887–1909) III, pp. 85 ff. See also Martin, *Baroque,* p. 47.
111. Rubens's manuscript was owned by Roger de Piles and published in his *Cours de peinture par principes* (Paris, 1708), pp. 139–147. For an English translation see Martin, *Baroque,* pp. 271–273.
112. de Piles, *The Art of Painting,* p. 349.

Name Index

Subject Index

Subject Index